D1591986

INDEX

2 Gopnik (2012). (See chapter 1, n. 3.)

3 The artist and scholar Warren Neidich initiated ArtBrain.org as vehicle for moving toward the intersection between art and brain sciences. See also Brown, S., et al. (2011), (see chapter 2, n. 29); Chatterjee, A. (2011), (see chapter 2, n. 29); Onians, J. (2007), (see chapter 2, n. 29); Ramachandran, V. S., & Seckel, E. (2011), (see chapter 2, n. 30); Skov, M., & Vartanian, O. (2009), (see chapter 2, n. 29); and Zeki, S. (1999), (see chapter 2, n. 28).

4 Vanhaeren, M., d'Errico, F., Stringer, C., James, S. L., Todd, J. A., & Mienis, H. K. (2006). Middle Paleolithic shell beads in Israel and Algeria. *Science, 212*, 1785–1788.

5 Bourriaud, N. (2002). *Relational Aesthetics*. Dijon, France: Les Presse Du Reel.

6 Schwabsky, B. (2010). Scattered threads. *The Nation*, April 8, 2010.

7 Gopnik, B. (2011). Tacita Dean: One of today's 10 most important artists. *The Daily Beast*, June 5, 2011, (http://www.thedailybeast.com/articles/2011/06/05/tacita-dean-one-of-today-s-10-most-important-artists.html).

8 Berlyne (1971). (See chapter 1, n. 23.)

9 Gombrich, E. H. (1995). *The Story of Art* (p 15). London: Phaidon Press.

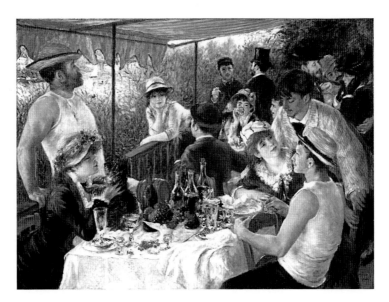

FIGURE 11.4 Renoir, Pierre-Auguste, *Luncheon of the Boating Party* (1881). Oil on canvas. The Phillips Collection, Washington, DC. (See color plate section.)

to another. By following the gazes, one captures various social interchanges—from the lone overseer on the left to other more friendly and flirtatious glances. The painting seems to symbolize the various ways we engage socially with others. Sensory features include Renoir's painterly style, which is, of course, Impressionist. Although the scene is clearly set as a nineteenth century party, it reminds me of lively social gatherings from my own past and the joyful feelings associated with such parties. Thus, the painting sparks personal memories and generates emotional responses. I can empathize with the figures and actually imagine myself in the scene. With semantic knowledge of art and art history, I know that Renoir portrayed his own friends in the painting, offering a link between the artist's experience and my own.

Discussing artworks with others offers a final psychological feature that opens the door to group analysis and the social interchange of ideas. Art experiences can and should influence our mind, our body, as well as the people around us. We must consider multiple approaches, as there are many ways to experience art. In the end, we should keep in mind Gombrich's statement from *The Story of Art*: "Actually, I do not think that there are any wrong reasons for liking a statue or a painting."[9]

■ Notes

1 Cabanne, P. (1967). *Dialogues with Marcel Duchamp* (p. 125). New York: Da Capo Press.

strategy is to notice how your eye moves and see how an artwork guides your sensory experience.

When we consider art with respect to past experiences, we develop a conceptual approach. What memories come to mind? What is the story behind the artwork? How does it act as a symbol or shortcut to an idea, viewpoint, or belief system? How are cultural influences portrayed? With meta-art statements, we must consider the way an artwork represents a commentary about the nature of art itself. From a conceptual approach, we use knowledge to interpret a work, and from that experience we gain knowledge as well. Contemporary works are often difficult to comprehend without extensive prior knowledge. The *DIA:Beacon*, a museum of contemporary art near New York City, is an outstanding place to view new works, as each exhibit includes an information sheet with the biography of the artist and some background information about the exhibit. In this way, one can develop a better understanding of the story behind a piece. This point is not to suggest that contemporary art must only be approached from a conceptual perspective. Any work may (and perhaps should) enhance one's sensory and emotional experience. Yet without developing a conceptual approach, many contemporary works may appear trivial or confusing.

Beauty, disgust, anger, calm, surprise, horror, melancholy, and a myriad of other emotions may occur during your experience with art. Some artworks may generate feelings immediately, while others depend on knowledge, which can be gained by the artwork's title or by an understanding of the events or people portrayed. Knowledge about the intention of the artist may also heighten one's emotional response. Prior knowledge influences the level of surprise or novelty of an artwork, which affects its emotional impact. As suggested by Daniel Berlyne, aesthetic responses are heightened when an artwork is novel or surprising, but not so much so as to create over-arousal or too much tension.[8] Thus, an artwork that is "way out there" may not be enjoyed as much as one that is just outside our comfort zone. Of course, the experience of novelty depends on prior knowledge, so the more you know, the easier it is to assimilate new art.

According to the I-SKE framework, art experiences are heightened when four components—intention, sensation, knowledge, and emotion—are considered. Some works may impact only one or a subset of these components. Under such circumstances, a particular approach (mimetic, formalist, conceptual, expressionist) may be more useful than another. That is not to say that a particular artwork must be viewed from a specific approach. It is hoped that the information presented in this book will provide a toolbox of useful information so that multiple approaches are available.

As a parting illustration, consider one of my favorite paintings, *Luncheon of the Boating Party* by Pierre-Auguste Renoir (Figure 11.4). What is it about this painting that drives my aesthetic response? Why do I like it and find it interesting? Perhaps what first drew me to the painting was the way Renoir used the people's gazes to move attention dynamically from one social group

TABLE 11.1 **At the Museum: Your I-SKE Framework**

First Impressions: Look at the artwork. What's my initial response?

Intention

What do I know about the artist?

What is the historical period or social context?

What is the artist trying to communicate?

Sensation

What is driving the pictorial composition (balance, tension, shapes, colors)?

How is realism represented (linear perspective, shape from shading)?

Is there a grace or flow in the design (is there significant form)?

Where do my eyes move as I look?

Knowledge

What's the meaning or story behind the work?

Does it remind me of any prior experience or concepts?

Does it tell me something about art itself?

Do I find it interesting? Why?

Emotion

Does the artwork arouse me? Does it make me tense or relaxed?

What specific feelings are generated and how did the artist do this?

Do I like it or not? Why?

conceptual framework. Of course, we should always acknowledge that we will never precisely understand someone else's thoughts or feelings. Yet it is satisfying from both an intellectual and personal perspective when we feel we understand the nature of an artist's message—when we can say, "I get it!"

Colors, lines, forms, and the overall perceptual dynamics of an artwork drive our aesthetic response. With a mimetic approach, we consider how well artworks portray realistic scenes. Linear perspective and chiaroscuro are two key elements in representing realistic scenes. From a perceptual standpoint, it is worthwhile to consider the way medieval and early Renaissance artists struggled to create naturally looking scenes. One can then better appreciate artists who excelled in realism, such as Giotto, Masaccio, and Leonardo. Starting in the mid-nineteenth century, we see how artists veered away from mimetic representations and shattered the illusion of space into bits of color, lines, and primitive forms. Rather than a realistic depiction, artists used color combinations, shapes, and balance to create a pleasing flow. When we consider these sensory qualities, we bring a formalist approach to the forefront. Both realistic and abstract art can be evaluated with significant form in mind. One useful

for artist Corin Hewitt, who for several months worked (and cooked) in this enclosure. This exhibit, entitled *Seed Stage*, could be viewed through small slits at the corners of the room where museum-goers watched Mr. Hewitt involved in the creation of his photographic art. In another exhibition, the *Guggenheim Museum* cleared its walls for artist Tino Sehgal's *This Progress*, in which museum-goers were greeted by "interpreters," who strolled along the barren walkway discussing the meaning of progress ("Do you learn from your mistakes?"). The first interpreter was a child, then a teenager, then an adult, and finally an older person. The entire exhibit involved successive social interactions with these interpreters.

From decorative to conceptual works, art has been valued for its capacity to make us see, think, and feel in new ways. What appears lost in contemporary art is the value of permanence. It was once thought that a criterion for fine art was its timelessness, addressing universally human issues and concerns. In contemporary art, there appears to be a rejection of the value of timelessness and a bias toward impressions of current culture-specific experiences. As a result, the value of contemporary art (both aesthetically and financially) may be as ephemeral as the value of this year's clothing design or pop music sound. What is valued these days is the way art is experienced now rather than how it will be experienced a hundred or even a few years from now. Barry Schwabsky, art critic for *The Nation* said: "In the art of our time we seek a reflection of the time, and it's always passing."[6]

Don't Forget Your Schema

As you approach a new work of art, what do you do? A general "first impression" of an artwork is undoubtedly the initial entry, and sometimes we respond very quickly, either positively or negatively. Artworks, however, can grow on you, and when it does it is useful to consider the I-SKE model (see Table 11.1). Just as a new song might take some time to appreciate, it is important to spend time considering artworks more deeply, as first impressions can be embellished or may even be renounced. I always read the printed card next to a piece, which at minimum will identify the artist, the title of the artwork (or lack thereof), and the year it was created. One interesting enigmatic feature to look for is what art critic Blake Gopnik calls the *Cezanne Effect*: "the ability to take a seemingly straightforward look at the world and make it have unending depth."[7]

The I-SKE model highlights the four major components of art experiences. Consider the intention of the artist. Many contemporary art historians and critics argue that we should ignore any reference to the artist's intention. I suggest, however, that we consider intentions as we do any other aspect of an artwork, which could be relevant to our experience or not. Background knowledge about the artist and the historical, cultural, and political forces that may underlie the artwork are helpful in gaining a full understanding of the artwork's

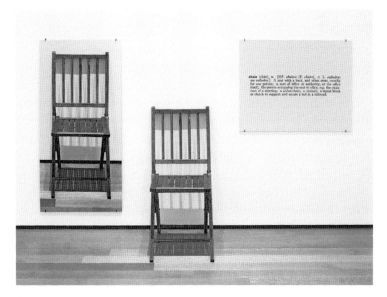

FIGURE 11.3 Kosuth, Joseph (1945-), *One and Three Chairs* (1965). Wooden folding chair, photographic copy of a chair, and photographic enlargement of a dictionary definition of a chair. Chair 32 3/8 × 14 7/8 × 20 7/8 inches; photo panel, 36 × 24 1/8 inches; text panel 24 × 24 1/8 inches. Larry Aldrich Foundation Fund. © ARS, NY. The Museum of Modern Art, New York, NY. Photo Credit: Digital Image © The Museum of Modern Art/Licensed by SCALA / Art Resource, NY.

and Three Chairs (Figure 11.3) only *works* when one considers the piece as a meta-art statement. This gallery installation includes a real chair, a photograph of the same chair, and a dictionary definition of the word *chair*. For each exhibition of this work, Kosuth only provides an enlarged printout of the dictionary definition and instructs the museum installer to select a chair, make a life-sized photograph of it, and display them both with the definition. Thus, the actual chair that is used is different in each exhibition and is selected by the installer rather than the artist. Our appreciation of this artwork is enhanced when we consider philosophical issues associated with art, such as Plato's notion of mimetic representations and cognitive notions of the "language of art." In this way, Kosuth is making a meta-art statement pertaining to the nature of representation: What is represented? Who is doing the representing?

Recently, art has encouraged a more social involvement. Although art has always been valued for its ability to facilitate social bonding, as with religious or political art, contemporary artists have considered their works as meeting places for social engagement. The art critic Nicolas Bourriaud has advocated *relational art*, which is "art taking as its theoretical horizon the realm of human interactions and its social context."[5] In this manner, art serves to encourage group dynamics. In 2008, the Whitney Museum of American Art built a room

in present day Algeria, Israel, Morocco, and South Africa and could be viewed as the earliest existing works of art. These beads were delicately perforated, sometimes colored, and presumably intended for the purpose of instilling an aesthetic response, a sense of pleasure in the beholder. The fact that they decorated the body rather than a wall does not belie their consideration as artworks. Regardless of where they were placed, one could imagine others admiring them for their beauty, design, and craftsmanship.

We admire and value other ancient relics as art, though the creator may not have intended them as such. Prehistoric cave paintings, Egyptian mummy portraits, and ritual tokens were likely intended to embody spiritual properties rather than to be displayed for a beholder's aesthetic evaluation. These artifacts may have been used to encourage the gods or to communicate with the deceased. We now, however, value their craftsmanship and design as art objects. Thus, we may value any object for its aesthetic quality, even though its maker did not intend it to be considered as such. This point is also valid for contemporary artifacts, such as elegantly designed computers, cell phones, cars, and clothing.

The philosophical views of Kant, Hume, and Baumgarten have driven our cultural expectation of what art should be. That is, for most museum-goers, art is created for its depiction of beauty and the sublime. It is created for the sole purpose of instilling an aesthetic response, and this response is meant to be pleasurable for its own sake. There is a sense that aesthetic responses are immediate, without thought or conscious awareness. Most of us have had such immediate first impressions—the kind that give us that "wow" feeling. Yet I have argued that even these first impressions are driven by implicit or unconscious knowledge based on past experiences. From a traditional "aesthetic" viewpoint, art is valued for its expressive quality, driving pleasurable emotions through artistic design. We can, however, value art for its conceptual role in representing a thought or belief. Religious and political art (considered as propaganda if one does not adhere to the politics) is meant to represent belief systems. Such works are not intended to inspire beauty or significant form. Instead, they are meant to inspire faith or allegiance to a conceptual viewpoint. In this role, art is valued as a visual reminder or admonition. We may admire such works for their beauty, design, or expressive qualities, but much more is gained from a conceptual approach.

A more specific value of art is the way it reflects meta-art statements. Modern and postmodern artists have addressed this aspect most vehemently. Rather than realistic views of the world or even conceptual statements about the human condition, these artists force the beholder to consider art in terms of its own history and significance. By the late twentieth century, many artists stripped their works of aesthetic outerwear and simply offered conceptual meta-art statements. These perceptually and emotionally barren works demanded the beholder to think about the process of art making. Joseph Kosuth's *One*

It is driven by biological factors associated with basic drives and motivations. In this way, evaluating art may tell us more about the brain than the other way around.

■ Before You Go

What differentiates looking at art from looking at something else? What is the value of art? Based on past experience, both personal and cultural, we each have developed our own approach to art. I have argued that we can broaden our interest and enjoyment by considering multiple approaches. The I-SKE framework offers a schema for thinking about multiple approaches. When we look at art we must consider how it affects our sensations, knowledge, and emotion. On those rare and exhilarating moments when we have that "wow" experience, I would contend that all I-SKE components are driven to the maximum.

The Value of Art

Why do we look at art? There are numerous reasons why we value such experiences. Perhaps the earliest use of art was for its decorative value. Figure 11.2 shows shell beads crafted one hundred thousand years ago and thought to be the earliest known human ornaments.[4] Such ancient jewelry has been found

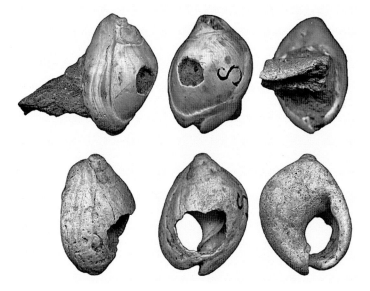

FIGURE 11.2 Perforated shell beads crafted over one hundred thousand years ago. Early artworks? Reprinted from Vanhaeren et al. (2006), *Science, 312,* with permission from The American Association for the Advancement of Science. Photograph courtesy of Dr. Marian Vanhaeren.

pertinent memories and links them to sensory inputs. A painting may remind you of a past experience or a style of a specific artist or period in art history. When you evaluate an artwork and intermix thoughts, personal experiences, and past recollections, there is a dynamic interplay between the prefrontal cortex and posterior regions. A particularly important region in the cortex is the posterior parietal cortex, as it acts as a convergence zone that integrates cortical processing (see Figure 1.9 in chapter 1). Whenever we think about the past or future or take another's perspective, the posterior parietal cortex is involved in creating an imagined scenario.

Other brain regions infuse our experience with emotions. Neural circuits buried in subcortical regions arouse bodily responses, such as increasing heart rate, muscle tension, and body temperature, thus preparing the body for fighting, fleeing, or mating. The amygdala interprets sensory signals and determines if a situation is threatening or arousing. In the cerebral cortex, the insula, anterior cingulate cortex, and orbitofrontal cortex are particularly involved in emotional responses. The insula processes gustatory responses associated with our reactions to disgusting stimuli, whereas the anterior cingulate cortex registers pain and emotional conflict. The neurochemical dopamine and its activation of the reward circuit plays a vital role in experiences of pleasure. Finally, the orbitofrontal cortex modulates and interprets emotional signals and links them to social and cognitive factors. These emotional circuits are co-opted and thus engaged when we experience art from an expressionist approach.

How far can we go in developing a brain-based analysis of art? Can we really understand the nature of aesthetics by looking at how neurons fire? Some have their doubts,[2] though a growing number of neuroscientists are conducing research in *neuroaesthetics*.[3] In this book, we have considered the beholder's brain in driving our experience with art. Without a doubt, our aesthetic experience can be approached from a biological perspective, as it is clear that brain circuits contribute to this and other similarly pleasurable experiences. In this way, aesthetic science can be linked to the way psychological processes are driven by what interests us. The advent of functional neuroimaging techniques, particularly fMRI, has paved the way for fruitful analysis of the neural basis of our art experience. Yet, as mentioned above, there is no art appreciation center of the brain. Instead, when we experience art we engage brain regions used in everyday activities to derive an aesthetic evaluation.

Aesthetics is not tied to art. I have defined aesthetics as a hedonic evaluation based on pleasure or interest. As such, we apply aesthetics on a daily basis as we are always determining what we like or don't like or what is interesting or not. In an evolutionary sense, one could argue that aesthetic responses are essential as survival depends on our ability to determine what is good or bad for us. These days, whenever we decide to purchase a new product, go out to eat, develop a new friendship, or plan a vacation, we are making an aesthetic evaluation. Thus, aesthetics is primary and not simply a reaction to artworks.

just like the title of an artwork or any other feature, and we can decide to pay attention to that part or ignore it.

Is there any accounting for taste? Are there universal features in art that we all would agree is beautiful or interesting? Art experiences are driven by our personal knowledge, and thus tastes in art must always be subjective and personal. You may have a fondness for the ocean and particularly enjoy seeing it depicted in art. Conversely, you may have had a traumatic experience at the beach, and this experience may impact negatively whenever you encounter such depictions. Regardless of personal experiences, there are sensations, memories, and feelings that we all share as humans. Common experiences lend certain depictions in art to be universally understood. Humans depend on fresh water and healthy food for survival and must avoid polluted streams and maggot-infested fruit. Thus, most people prefer saturated blues over dark browns and yellows. Symmetry in faces and certain body proportions are preferred because they denote youthfulness, fitness, and health. A smile or frown elicits a recognizable emotion in all humans. Artists represent these human features, and beholders from all cultures appreciate them in similar ways. Yet cultural knowledge can take such influences and place them in a unique social context defined by group history, myths, and morals. When we experience art we bring with us all of these influences and so there will always be universal, cultural, and personal factors driving our aesthetic evaluation.

Your Brain on Art

Experiencing art is a whole brain phenomenon. There is no *art center* in the brain. Neurons are highly interconnected and dynamically interact to drive experiences. There is, however, a division of labor as different brain regions serve different functions. Visual information from the retina enters the cerebral cortex at the most posterior part of the occipital cortex (V1). From there processing takes two major paths. The ventral path manufactures forms by accentuating and organizing lines, edges, and shapes. The dorsal path constructs a first-person view of space by interpreting the image on our retina as a window to a 3-D world. These two visual paths work together to place objects into a coherent spatial environment. To guide visual processing, the prefrontal cortex sends feedback signals back to regions along the dorsal and ventral paths. These signals modulate processing by enhancing some sensory features and suppressing others. In this way, the prefrontal cortex acts as a CEO, ensuring that the entire machinery is working in a coherent manner. This kind of top-down or metacognitive processing allows us to focus on specific sensory features, move our eyes to relevant locations, and consider the spatial environment as an organized whole.

The prefrontal cortex controls our thoughts and memories by maintaining and updating the contents of what is in consciousness. It selects and retrieves

impressions of the world as is. We accentuate edges, alter colors, and attend selectively to pertinent objects and locations. Artists, of course, do the same in developing a point of view. A rather large proportion of our brain is geared toward sharpening the retinal image and highlighting pertinent features of our visual world. With our "corporate" brain, different regions participate in manufacturing a representation of the world around us. I suggested that the reverse of this process occurred in art during the twentieth century as styles moved from Impressionism to Cubism and then to Minimalism. From a formalist perspective, these styles took realistic scenes and broke them down, thus forcing the beholder to consider patterns of colors, anonymous forms, and nondescript textures. In the end, rather than providing a natural scene, modern artists made us look at the raw canvas as a flat surface.

With respect to the art of knowing, prior experience *always* guides our perceptions and emotions. Often, we are not even aware that such top-down processes are engaged as our brains apply highly overlearned knowledge in an implicit or unconscious manner. Our brains know very well how the retinal image changes when we move, how shadows are cast, and what familiar objects look like at various orientations and distances from us. We also know that a painting is a flat surface that can mimic the experience of looking at a real scene. We know that artworks are created by an individual. Our experience with art is heightened by such semantic knowledge, particularly information about the cultural and art historical context within which an artwork was created. Finally, from personal experiences we develop a unique perspective. In every art experience, we apply implicit, semantic, episodic, and cultural knowledge. Thus, the more we know, the better we see.

In the art of feeling, sensations and knowledge intermingle and drive our emotional response. We may like an artwork or not, find it interesting or not. It may arouse us, make us tense or calm, inspire beauty, or put us in awe. We empathize with individuals portrayed in an artwork, sensing their feelings as if they are our own. We may empathize with the artist and evoke the same feelings that the artist felt when the work was being created. Our emotional response has often been considered the end point of an art experience, and in many instances this hedonic evaluation still applies. We might, however, go deeper in our understanding and ask, *what is the artist trying to say?* All artists offer the beholder a *viewpoint* that is meant to stir our feelings, thoughts, or both. One prominent difference between looking at nature and looking at art is that we know that the latter was intended by an individual for an art experience. We revel at the products of such creativity, such as the subtle chiaroscuro of Leonardo or the forceful brushwork of Van Gogh. By considering the artist as communicator, an artwork is meant to inform us and express the human condition. Yet as postmodern critics have suggested, knowledge of the artist's intention is not imperative (and may even be irrelevant). Perhaps the best way to approach the role of intention is to consider the artist as part of the artwork,

FIGURE 11.1 Pere Borrell del Caso, *Escaping Criticism* (1874), Banco de España, Madrid.

■ The Power of Mind

Duchamp was correct when he stated that art should be "at the service of the mind." He was incorrect, however, when he shunned earlier artworks as "retinal."[1] As we have discussed, the retina is the canvas onto which light from the outside world is projected. From that point on, the brain acts to accentuate, fill-in, segregate, and organize patterns of light into recognizable forms within a spatial environment. Thus, all art, and in fact everything you see, is at the service of the mind.

Seeing, Knowing, and Feeling

In the art of seeing, a coherent spatial world is created from a jerky, ever-moving jumble of images. Despite this erratic input, our brains are able to recognize objects, perceive depth, and move about. Brains and artists must learn to create this world by applying the geometry of optics (linear perspective) and rendering shape from shading (chiaroscuro). Yet our perceptions are not simply 3-D

11. CODA

Both artists and brains manufacture an experience that is composed of sensations, thoughts, and feelings. As we stroll around an art museum, we may ask: *Why do I like this artwork? What makes it interesting? What is the artist trying to say?* These questions pertain to our aesthetic response to art, and I have argued that our brains have co-opted psychological processes used in everyday experiences in the service of driving our experiences with art. I have also argued that there are various ways to approach art, and we can capture the essence of these appoaches by evaluating the art of seeing, knowing, and feeling. The more we understand these aspects of our psyche, the more we gain from our experiences with art. Thus, knowledge—of art, of life, and of ourselves—enables us to break out of our usual way of looking.

The boy in Pere Borrell del Caso's *Escapando de la crítica (Escaping Criticism)* (Figure 11.1) makes his own breakout in this playful trompe-l'oeil painting. The boy is depicted in exquisite 3-D rendering, including the shadows cast on the painted frame as he "exits." This painting was made in 1874, the same year as the first Impressionist exhibition at which Monet, Renoir, Cezanne, and Degas displayed their works that were rejected by the *Académie des Beaux-Arts*. In many ways, del Caso's work leaps ahead toward a postmodernist view, as the title, *Escaping Criticism*, suggests a meta-art commentary on what a painting should be. Rather than playing with the breakdown of a realistic scene, as the Impressionists did, Caso used traditional painterly techniques to make a conceptual point about the nature of painting.

20 Hartt, F. (1987). *History of Italian Renaissance Art: Painting, Sculpture, Architecture* (3rd ed., p. 628). Englewood Cliffs, NJ: Prentice-Hall. See also, Peterson, G. (2006). Titles, labels, and names: A house of mirrors. *Journal of Aesthetic Education, 40,* 29–44.

21 Millis, K. (2001). Making meaning brings pleasure: The influence of titles on aesthetic experiences. *Emotion, 1,* 320–329.

22 Leder, H., Carbon, C.-C., & Ripsas, A.-L. (2006). Entitling art: Influence of title information on understanding and appreciation of paintings. *Acta Psychologica, 121,* 176–198.

23 *Who the #$&% Is Jackson Pollock?* (2007). New Line Home Video.

24 Hoving, T. (2008). The fate of the $5 Pollock. *Artnet.com,* November 6, 2008. http://www.artnet.com/magazineus/features/hoving/hoving11-6-08.asp.

25 See Dutton, D. (1979). Artistic crimes. *The British Journal of Aesthetics, 19,* 302–341.

26 Barthes (1977, p. 148).

27 Wimsatt, W. K., & Beardsley, M. C. (1946). The intentional fallacy. *The Sewanee Review, 54,* 468–488.

28 *Art:21 (Art in the 21st Century).* PBS series. Interview with Mike Kelley. Program 10: Memory, http://www.pbs.org/art21/artists/kelley/.

29 Rosenberg, H. (1972). *The De-Definition of Art.* (Chicago: The University of Chicago Press).

30 Lewitt, S. Paragraphs on conceptual art. *Artforum,* June 1967.

31 Darwin, C. (1965, p. 253). (See chapter 8, n. 3.)

32 Rozin, P. (2008). Hedonic "adaptation": Specific habituation to disgust/death elicitors as a result of dissecting a cadaver. *Judgment and Decision Making, 3,* 191–194 (p. 191).

33 Rozin, P., & Fallon, A. E. (1987). A perspective on disgust. *Psychological Review, 94,* 23–41.

34 Steiner, W. (1995). *The Scandal of Pleasure: Art in an Age of Fundamentalism.* Chicago: University of Chicago Press.

35 Danto, A. C. (2003). *The Abuse of Beauty.* Peru, IL: Carus Publishing Co.

36 Gardner, H. (2011). *Truth, Beauty, and Goodness Reframed: Educating for the Virtues in the Twenty-First Century.* Basic Books: New York.

3 Smith, A. (1853). *Theory of Moral Sentiments*. London: Henry G. Bohn.

4 Hume, D. (2000). *A Treatise of Human Nature*. Oxford: Clarendon Press.

5 Titchener, E. B. (1909). *Experimental Psychology of the Thought-Processes*. New York: Macmillan.

6 Vischer, R., Fiedler, C., Wölfflin, H., & Goller, A. (1994). *Empathy, Form, and Space: Problems in German Aesthetics, 1873–1893*. Santa Monica, CA: Getty Center. Jahoda, G. (2005). Theodor Lipps and the shift from "sympathy" to "empathy." *Journal of the History of the Behavioral Sciences*, 4, 151–163.

7 Batson, C. D., Lishner, D. A., Carpenter, A., Dulin, L., Harjsola-Webb, S. H., et al. (2003). "...As you would have them do unto you": Does imagining yourself in the other's place stimulate moral action? *Personality and Social Psychology Bulletin*, 29, 1190–1201.

8 Provine, R. R., Krosnowski, K. A., & Brocato, N. W. (2009). Tearing: Breakthrough in human emotional signaling. *Evolutionary Psychology*, 7, 52–56.

9 Elkins, J. (2004). *Pictures and Tears: A History of People Who Have Cried in Front of Paintings*. New York: Routledge.

10 Rodman, S. (1957). *Conversations with Artists*. New York: Devin-Adair.

11 See Casile, A., Caggiano, V., & Ferrari, P. F. (2011). The mirror neuron system: A fresh view. *The Neuroscientist*, 17, 524–538. Freedberg, D., & Gallese, V. (2007). Motion, emotion, and empathy in esthetic experience. *Trends in Cognitive Science*, 11, 197–203. Gallese, V., Keysers, C., & Rizzolatti, G. (2004). A unifying view of the basis of social cognition. *Trends in Cognitive Science*, 8, 396–403. Iacoboni, M. (2009). Imitation, empathy, and mirror neurons. *Annual Review of Psychology*, 60, 653–670.

12 Buccino, G., Binkofski, F., Fink, G. R., Fadiga, L., Fogassi, L., Gallese, V., et al. (2001). Action observation activates premotor and parietal areas in a somatotopic manner: An fMRI study. *European Journal of Neuroscience*, 13, 400–404.

13 Hume, D. (2000).

14 Saxe, R., & Wexler, A. (2005). Making sense of another mind: The role of the right tempor- parietal junction. *Neuropsychologia*, 43, 1391–1399.

15 Singer, T., Seymour, B., O'Doherty, J., Kaube, H., Dolan, R. J., & Frith, C. D. (2004). Empathy for pain involves the affective but not sensory components of pain. *Science*, 303, 1157–1162 .

16 Decety, J., & Jackson, P. L. (2006). The functional architecture of human empathy. *Behavioral and Cognitive Neuroscience Reviews*, 3, 71–100. Singer, T., Critchley, H. D., & Preuschoff, K. (2009). A common role of insula in feelings, empathy, and uncertainty. *Trends in Cognitive Science*, 13, 334–340.

17 Danto, A. C. (1981). *The Transfiguration of the Commonplace: A Philosophy of Art* (p. 119). Cambridge, MA: Harvard University Press.

18 Merleau-Ponty, M. (1962). *Phenomenology of Perception*. New York: Routledge & Kegan Paul.

19 See Van Gogh Museum weblink of translated letters from *Vincent van Gogh, The Letters*. http://vangoghletters.org/vg/letters/let898/letter.html.

manufacturers spend enormous amounts of money, time, and effort to provide consumers with products and advertisements that are meant to please the eye. From automobiles to clothing to computers and cell phones, commercial design is meant to attract and extol a sense of elegant beauty. It may be that commercial art has replaced the fine arts as the place to find beautiful objects these days.

■ Once Again, With Feeling

Art arouses us. It instills a myriad of feelings, including pleasure, beauty, pain, melancholy, anger, and disgust. When we consider the emotional impact of an artwork we adopt an expressionist approach. We empathize with individuals portrayed in an artwork and place ourselves into a scene, as we might do in Christina's field or at Hopper's late night diner. Emotions are enhanced when we gain knowledge about the artist's life experiences. In this way, the blending of an expressionist and conceptual approach enhances emotion and interest. In our experiences with art, empathy is a natural response and one that has its own brain circuitry. Regions in the prefrontal and parietal cortices (so-called mirror neurons) are active when we imagine the action of others. Other brain regions, including the anterior cingulate and insula, are active when we feel the emotion of others. Under heightened emotional experiences we may shed tears of sorrow or joy. Such tears, though perhaps rare when we encounter paintings, flow readily at the end of a movie or as we listen to a particularly moving piece of music. Emotions are a whole-body experience, as they act to arouse our bodies, strike the heart, and at times turn our stomach.

Postmodern artists veered away from traditional notions of art as pleasing and beautiful. Some artists completely denied emotions by focusing solely on conceptual statements, not unlike a scholar writing a thesis about the meaning of art. Such artworks may not have any more impact visually or emotionally than a copy of a book written by a philosopher. Other artists have reveled in disgusting the beholder. In its most horrific moments, we see the artist perform masochistic acts of self-mutilation. Of course the desire to shock and disturb the beholder has been a notable artistic act for centuries. Yet I would argue that beauty and the pleasure of viewing art have never left the beholder's interests. We will always look for beauty in art (and nature), be it skin deep or embodied conceptually. As such, we should always consider an expressionist approach to art and never deny ourselves the pleasures of an emotional art experience.

■ Notes

1 Meryman, R. (1996). *Andrew Wyeth: A Secret Life*. New York: Harper-Collins.
2 Barthes, R. (1977). The death of the author. In S. Heath (trans.), *Image-Music-Text (pp. 142–148)*. New York: Farrar, Straus, & Giroux.

meaning. In such cases, both the sensory and conceptual experience make the artwork beautiful.

These days, beauty in art cannot merely be canvas deep, as it is the idea of beauty and how the sensual qualities of an artwork highlight this idea that makes an artwork beautiful. Not all artworks need to extol the nature of beauty. Indeed, when one experiences Picasso's *Guernica*, it is difficult to call it beautiful. Such a work, as Danto suggests, may be less an elegy and more a cry of anger against the horrors of war and injustice. Interestingly, Danto's approach to beauty encourages a combined formalist, expressionist, and conceptual approach to experiencing art. In this way, his approach is to consider beauty by maximizing all of the properties of the I-SKE framework.

Another contemporary analysis of beauty was espoused by the eminent psychologist Howard Gardner in his treatise *Truth, Beauty, and Goodness Reframed.*[36] Gardner suggests that a twenty-first century view of beauty is a decidedly subjective or relative one, as it must be filtered through our historical, cultural, and personal experiences. He considers three essential features that define one's sense of beauty—an object must be interesting, its form must be memorable, and it must invite further encounters. These three features, Gardner argues, create pleasurable experiences of beauty. Interestingly, these features, by themselves, seem to have only peripheral associations with emotions, yet perhaps together they help define a positive or pleasurable hedonic response. In fact, rather than a definition of *beauty*, these three features seem to capture exceedingly well a contemporary definition of *aesthetics*.

Given our analysis of beauty with respect to faces, bodies, and other universally significant forms, I would maintain that beauty is not merely a subjective experience. There are biological and evolutionary factors that we have co-opted for our art experience. Such aesthetic features as symmetry, balance, and color combinations are determined both by our genes and by experience. Moreover, I would suggest that the appreciation of beauty (or its opposite) is an essential feature of art as much as storytelling is part of literature. The endurance of Homer's epic poems and other classic stories demonstrate our appreciation in the telling of a good tale. Yet twentieth century novelists have played with the medium and made their own meta-fictional statements about the practice of writing. James Joyce's *Finnegans Wake* is a potent example of taking a conceptual, meta-fictional perspective. Despite such experimental works, a core feature of fiction is and will always be the storytelling. One could argue that anti-aesthetic movements in art during the twentieth century were reactions against the seeking of beauty, in much the same way experimental literature during the early twentieth century was a reaction against standard narratives.

It is probably fair to say that the seeking of beauty has always been in the minds of beholders, if not in the minds of artists. Beauty attracts, and most of us take pleasure in seeking beauty, whether in nature, people, or art. Although we may not find many "beautiful" works in a contemporary art museum,

Postmodern artists have also co-opted our response to disgusting experiences. Damien Hirst's work entitled *A Thousand Years* consists of a Plexiglas case in which a rotting cow's head infested with maggots is enclosed. In another rather infamous work, Andres Serrano used funds from the National Endowment of the Arts (NEA) to create *Piss Christ*, a large (60 × 40 inches) color photograph of a crucifix submerged in urine. This work disgusted many, including a number of politicians, who threatened the future of the NEA. The incident led to legislative restrictions on federal funding of "obscene" art.[34] Perhaps even more disturbing is Andres Serrano's photograph entitled *The Morgue (Fatal Meningitis II)*. What first looks like a child sleeping is, as the title indicates, a corpse. This photograph is conceptually interesting as it uses the title to create a disturbing emotional experience in what appears to be a peaceful scene. Other photographs in this series are both conceptually and perceptually disturbing. Piero Manzoni's *Merda d'artista (Artist's Shit)* is a series of 90 sealed tin cans, each with a label stating that the can includes 30 grams the artist's feces. Can No. 004 was bought in 2000 by the Tate Gallery for $52,000.

Performance Art, which had its heyday in the 1970s, reveled in disgusting acts for art's sake. Artists became their own art object, and some focused on the nature of pain and sadomasochism. Ana Mendieta decapitated a chicken and let its blood spurt all over her nude body. Paul McCarthy smeared himself with paint, ketchup, raw meat, and feces and used his body to "paint" on the wall. In *Shoot*, Chris Burden had a friend fire a bullet into his left arm at close range with a .22 rifle. Marina Abramović carved a bloody star around her navel with a razor blade. Stelarc suspended himself from the ceiling using meat hooks pierced through his skin. Finally, Bob Flanagan hammered a nail through his penis and impaled it onto a wooden board. These artists worked hard to instill feelings of horrific disgust in the beholder.

The Reemergence of Beauty

Art in the twentieth century moved from espousing the beauty of significant form to denials of beauty, and then purely to conceptual, meta-art statements. After that, postmodern artists offered disgusting scenes and grotesque live acts. We seem to have gone from turning the eye to turning the stomach. Postmodernism has forced the beholder to develop an alternative to the seeking of beauty. Recently, however, there seems to be a diminishing desire for this anti-aesthetic mentality, and with it a reemergence of the concept of beauty. Most prominent is Arthur Danto's *Abuse of Beauty*, in which he suggested a "detoxification of beauty in contemporary art."[35] Danto argued that artworks can embody the concept of *internal beauty*, where beauty is driven by the underlying conceptual features that are inherent in a work. He points to Motherwell's *Elegies* (Figure 10.7) and Maya Lin's *Vietnam Veteran's Memorial* as examples of works that are beautiful with reference to their embodied

not eat soup that we just ate and then spit out into a bowl, even though the mixture of saliva and soup in the bowl would be exactly what had been in our mouths moments ago. Furthermore, we may be reluctant to drink water from a toilet, even if it were affirmed that the toilet is brand new. It is as if these items have imaginary "cooties," and we are disgusted even by the thought of potential contamination.

We have already mentioned the insula in neuroimaging studies involving brain responses to emotional stimuli. This brain region is tucked under the folds of the frontal and temporal lobes and is thus hidden from view. When the outer folds are removed, one can see the insula as an enfolded "island" of cortical tissue (Figure 10.8). The anterior insula (AI) is particularly involved in disgust responses. Not only is it connected to critical emotional centers, such as the amygdala and orbitofrontal cortex, it is where neural impulses activated by taste buds on the tongue first enter the cerebral cortex. In this way, the insula is an integral part of our gustatory response to taste. Yet not only does this region respond to taste, but like mirror neurons, the insula is active when we watch someone else eat something disgusting or show the facial expression of disgust. It appears that our brains have co-opted these taste region to respond generally to disgusting stimuli—real or imagined. In this way, the insula is a part of the emotional circuit involved in empathetic emotions.

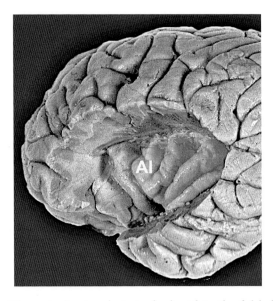

FIGURE 10.8 The anterior insula is tucked within the folds between the frontal and temporal lobes. The anterior insula (AI) responds to disgusting stimuli, both physical and imagined. Brain image reprinted with permission from Digital Anatomist Interactive Atlas, University of Washington, Seattle, WA, copyright 1997.

As symbolized by Morris in *Litanies*, the key (or, literally, keys) to this work is Duchamp's notion inherent in *Fountain* and his other works. In the latter half of the twentieth century, artists embraced the notion of a conceptual approach, as exemplified by this statement by conceptual artist Sol Lewitt, "The idea becomes a machine that makes the art."[30] That is not to say that all works under the rubric of *Conceptual Art* are to be viewed without feeling. It is, however, likely that encounters with postmodernist works will be enhanced when considered from a conceptual approach, because artists were, and many still are, primarily interested in representing an idea or concept. Often the concept refers to the nature of the art process itself, a self-referring process that I have called *meta-art* (see chapter 1).

That's Disgusting

Imagine that someone has just placed a bowl of fresh feces under your nose. That expression on your face—the crinkled nose and narrowing of the eyes—is the universal sign of disgust. Charles Darwin in his seminal book, *The Expression of the Emotions in Man and Animals*, described disgust as our response to "something revolting, primarily in relation to the sense of taste, as actually perceived or vividly imagined."[31] Disgust originated as an avoidance response to bad-smelling foods, which can protect us from ingesting something poisonous, thus literally saving our lives. Our disgust response has broadened, however, to include other real and imagined situations. The noted psychologist Paul Rozin pioneered the scientific study of disgust and stated the following:

> Humans live in a disgusting world. The air we breathe comes from the lungs of other people, the chairs we sit in were exposed to the buttocks of many others, our silverware was in the mouths of many others, the toilet seat we use in a public bathroom was touched by the bare buttocks of many unknown others, the money we use was handled by many other people, the air contains molecules vaporized from animal and human feces, most of the molecules in the water we drink were at one point or other part of urine and some once passed through the body of Adolph Hitler.[32]

Interestingly, infants and toddlers do not elicit disgust responses to rotten odors and many will eat what looks and smells like dog feces.[33] By the age of three years, children respond to rotting meats and bodily excrements with the same disgust response as adults. Intensely disgusting odors can induce visceral responses, such as gagging and vomiting. From knowledge (learned directly and from others), we develop disgust responses to specific items. As such, one might experience a disgust response to a particular item, whereas another would find the same morsel rather tasty. We also broaden our disgust response to include "conceptually" contaminated items. For example, many of us would

statements have proliferated over the years to the point that a formalist or expressionist approach to contemporary art is sometimes difficult to maintain and often considered passé.

Who Needs Feelings?

In 1963, Robert Morris created *Litanies*, a lead plate that included 27 keys that hung from a key ring. On each key was inscribed a word translated from a quote by Duchamp. The piece was purchased by the noted architect Philip Johnson. After waiting months to be paid for the piece, a frustrated Morris created *Document*, which included the following "Statement of Esthetic Withdrawal," signed by the artist and notarized:

> The undersigned, ROBERT MORRIS, being the maker of the metal construction entitled LITANIES, described in the annexed Exhibit A, hereby withdraws from said construction all aesthetic quality and content and declares that from the date hereof said construction has no such quality and content (signed and dated, November 15, 1963).

We have come to accept an object as "art" if one offers it for aesthetic evaluation. Can an artist revoke the quality of "art" from an object? Clearly not, as both *Litanies* and *Document* are now part of the collection of the *Museum of Modern Art* in New York, both having been purchased by Philip Johnson and later donated to the museum. Indeed, a good deal of art since the 1960s is best considered from a conceptual approach, putting sensory and emotional qualities aside. When Morris "created" *Document*, he stated that, as artist, he could control the aesthetic value by simply denying it. In a similarly controversial act, Robert Rauschenberg took a drawing by Willem de Kooning, and, with the artist's permission, erased it so thoroughly that what was left were barely perceptible traces of ink and crayon. By this act, Rauschenberg intentionally destroyed a work of art by a famous artist. Of course, the now virtually blank sheet is its own artwork by Rauschenberg, entitled *Erased de Kooning Drawing*.

 The story behind the artwork is often the key to understanding postmodern art. An erased piece of paper or a notarized "Statement of Esthetic Withdrawal" does little in terms of sensory and emotional impact unless we know the history of the work. Only by considering such works from a conceptual approach can we fully appreciate their significance. According to the noted art critic Harold Rosenberg, postmodern art has become "de-aestheticized."[29] Such works are intended to be experienced from a conceptual rather than an expressionist, mimetic, or formalist approach. In fact, many artists began to establish their works as purely conceptual statements. This movement had many followers during the late twentieth century, and we now consider this movement under the moniker of *Conceptual Art*.

different intention while creating an artwork than what it communicates to you. As an example, Mike Kelley is known for his installations that include worn-out, grimy stuffed animals either bound together or splayed on the ground. In an interview from the PBS series *Art:21* (*Art in the 21st Century*), Kelley stated, "I have a real interest in ritual . . . I see all art as materialistic ritual."[28] Interestingly, some have interpreted Kelley's soiled stuffed animals as a reflection of child abuse, and assumed that Kelley himself experienced abuse as a child. In actuality, Kelley was never abuse as a child nor were his artworks intended to reflect such experiences. Yet such responses to his art led Kelley to consider abuse in later works. Thus, ironically, the artist's intention was misconstrued by beholders, but that misconstrual led the artist to adopt the beholder's interpretation in later works.

Thoughts and feelings never intended by the artist may drive a beholder's experience. These experiences are of course valid, and one should be encouraged to develop a personal perspective of any artwork, thus disregarding the artist's or anyone else's interpretation. As our episodic memories are key in our art experience (as described in chapter 6), we can expect artworks to be experienced from a deeply personal perspective. If one interpreted Kelley's work to reflect the emotional upheaval of child abuse, then regardless of the artist's intention, such a deep emotional interpretation is significant and valid.

Rather than fully rejecting the intention of the artist, however, I suggest we consider it with the knowledge that we will never fully understand the inner psyche of anyone, even ourselves. With background knowledge of the artist's intention or state of mind, we can enhance our art experiences. Such knowledge certainly enhances one's interpretation of Wyeth's *Christina's World* or Van Gogh's *Wheatfields and Crows*. Thus, we may consider an artist's statement about his or her intentions in the same way we consider any statement about an artwork, be it from an art critic, art historian, or layperson standing in front of a painting. With respect to the intentional fallacy, we simply need to acknowledge that it is not necessary to consider or believe the artist's stated intentions, but that does not mean we should completely ignore them either. Instead, we may want to learn about the artist and the context in which an artwork was created to help us interpret it more fully. In the end, we always develop our own personal vantage point as we impart our personal, cultural, and episodic knowledge whenever we experience art. Emotional responses to artworks are always driven by such knowledge.

■ Feelings in a Modern World

Who needs the artist? Who needs beauty? Who needs any emotion at all? Such questions have been raised by artists over the past half century in what historians describe as the postmodern era. Indeed, conceptual analyses of meta-art

statement. It may, of course, communicate all of these things at the same time. Often the artist's intention is rather obvious: a work may represent a significant moment in history. It may instill peaceful feelings in its depiction of a beautiful landscape or communicate a rather explicit moral concept, such as a *memento mori*. With some background knowledge, we may comprehend rather clearly the intention of the artist. At a still deeper level, we may get *inside the head* of the artist. We might ask, what is the artist thinking or feeling? What life events triggered such creativity? Was the artist onto something or just on something? Often we seek information about the artist's life and the political, historical, and cultural milieu within which an artwork was created. When we experience art from this perspective, we seek knowledge to understand better the artist's intentions. In this way, we become amateur psychotherapists trying to abstract deeper meaning from the artwork, as if the artwork will unlock deep secrets of the artist's psyche.

As interesting it may be to psychoanalyze the artist's intentions, we may only be able to go so far. Can we really get inside the head of an artist and experience exactly what he or she felt or thought while creating an artwork? We may certainly try, as our tendency to empathize is strong. Yet it may be a rather futile exercise to seek the exact nature of another's psyche from any artwork. Moreover, there are always unconscious or implicit forces that drive thoughts and feelings, and these unconscious influences will not even be available to the artist. As a result, even if we were able to discuss the meaning of an artwork with the artist or read documents written by the artist describing his or her intentions, these overt pronouncements, though interesting and informative, cannot address unconscious motivations that the artist would not be able to articulate. Moreover, in interviews and writings, an artist may alter or fail to remember conscious intentions after the fact.

Many philosophers and art critics have shunned the artist and have argued that information about the artist's intentions is irrelevant to the beholder's experience. As mentioned earlier, in the essay *Morte d'Author* (*Death of the Author*), Barthes rejected the importance of considering the author's background and interests in developing an understanding of an artwork, in this case literary art. What's important is the way the beholder interprets the work: "A text's unity lies not in its origin but in its destination."[26] In another well-known essay on this issue, Wimsatt and Beardsley defended the *Intentional Fallacy* with their assertion "that the design or intention of the author is neither available nor desirable as a standard for judging the success of a work of literary art."[27] The rejection of the author in our art experience is a prominent feature of postmodernist analyses.

By disregarding the artist's intentions, we focus on the beholder's experience. Who cares what the artist was thinking or feeling when the artwork was created? The essential factor is what the artwork says to *you*, how *you* interpret its meaning, what emotions *you* feel. Indeed, the artist may have an entirely

been painted by Jackson Pollock.[23] Horton paid $5 at a thrift shop in California for the large drip painting and was planning to give it to a friend as a joke birthday gift. When someone suggested that the painting might be a valued Pollock, Horton replied, "Who the [expletive] Is Jackson Pollock?" In the documentary, some art experts attest to the similarity of the painting to Pollock's style, though Thomas Hoving, former director of the Metropolitan Museum of Art, refuted such claims and asserted the painting a fake.[24] More intriguing is the finding of a fingerprint which, according to an expert, matches a fingerprint taken from Pollock's studio (though other experts have since refuted the match). The International Foundation for Art Research (IFAR), an organization of art experts who authenticate unknown works, refused to authenticate Horton's painting as a Pollock. If the painting were truly created by Pollock it would garner a purchase price in the tens of millions (Pollock's *No. 5, 1948,* was sold in 2006 for $140 million, which at that time was the highest paid artwork ever sold at an auction). In the documentary, Horton is reported to have been offered $9 million from a collector, but she refused to sell it at that price. In 2008, the painting was displayed at the Gallery Delisle in Toronto with a selling price of $50 million, though it was not sold.

The Horton case, and many like it, demonstrate the significance in knowing *who* created an artwork. What does it mean when an artwork is valued differently on the basis of whether it is authenticated to be by a famous artist or determined to be a forgery? Clearly, it is not the sensory experience, as many forgeries are so well crafted that art experts disagree as to their authenticity. Interestingly, not only does the monetary value of an artwork change when viewed as a fake, but the actual aesthetics of a work seem to change. In 1947, Han van Meegeren, a master of art forgery, was tried for selling an actual Vermeer to Hermann Göring, the notorious Nazi military leader. Facing conviction for selling valuable Dutch cultural property to the Nazis, which would have been considered an act of treason, van Meergeren admitted to forging the painting. Prior to the trial, many art experts were fooled by his forgeries and considered them fine examples of Vermeer's oeuvre. In fact, van Meergeren had to prove that he painted the work by re-painting one of his "Vermeers" in front of a group of art experts. Once the paintings were revealed as forgeries, their appeal plummeted. Such stories reinforce the point that artworks are endowed with a history, and their value is driven by *knowledge* of this history.[25]

Intentionally Yours

As described by the I-SKE framework, an artwork is defined as a product of a creative experience, and this product is offered to us with the *intention* of instilling an art experience. At a deeper level, we acknowledge that the artist intends to communicate *something* to the beholder. That *something* may be a view of the world, a sense of significant form, a feeling, or a conceptual

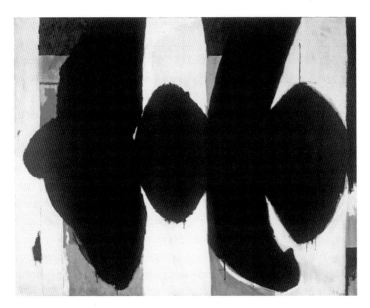

FIGURE 10.7 Motherwell, Robert (1915–1991), *Elegy to the Spanish Republic No. 34* (1953–1954). © VAGA, NY. Oil on canvas, support: 80 × 100 inches (203.2 × 254 centimeters). Gift of Seymour H. Knox, Jr., 1957. Albright-Knox Art Gallery, Buffalo, New York, New York. Photo Credit: Albright-Knox Art Gallery / Art Resource, NY.

gain a deeper understanding of the artist's intention and how art can communicate mournful feelings not unlike those experienced at war memorials.

Psychological studies have analyzed the way titles influence our art experience. In one study, individuals viewed unfamiliar paintings of pictorial scenes and were asked to rate them on the basis of "aesthetic experience" (enjoyment, interest, emotion).[21] The pieces were given elaborative titles (e.g., "Prohibition"), descriptive titles (e.g., "Bar Scene"), or no titles. Artworks presented with elaborative titles were rated as having stronger aesthetic appeal. Another study used abstract paintings with or without elaborative titles, such as "Tears" for an abstract painting by Franz Kline.[22] For abstract works, titles increased ratings of meaningfulness, yet they did not increase ratings of emotional appeal or interest. These findings suggest that titles can facilitate our aesthetic appreciation but only to a point. What if we were confronted with a beautiful abstract work that was entitled "Tribute to Fascism"? Such a title may give the beholder a deeper understanding of the artist's intention, but it may significantly diminish the aesthetic appeal of the work. Thus, knowledge does not always translate into liking.

As with titles, the very name of the artist can influence our art experience. In the documentary film, *Who the #$&% Is Jackson Pollock?*, Teri Horton, a retired truck driver, is featured as the discoverer of a canvas alleged to have

doubly represented as both protrayer and portrayed. These personal statements are particularly poignant as we see the artist as reflected by his or her own hands. When we acquire knowledge about an artist's experience and personal strife, artworks become time capsules that reveal thoughts and feelings at a particular moment in time. By further exploring an artist's biography we develop a deeper appreciation, which can create a strong emotional bond.

What's in a Name?

When I confront an unfamiliar work of art at a museum, I typically read the little card associated with it, as it can offer clues to the artist's intention. For example, the painting we know as "Whistler's Mother" is actually titled *Arrangement in Grey and Black*. Presumably, the artist wanted us to consider the painting as a formalist exercise in color and shading. Titles of abstract works give a sense of the artist's intention as in Piet Mondrian's *Broadway Boogie-Woogie*. Other titles are satiric, such as Marcel Duchamp's *In Advance of a Broken Arm*, which is an ordinary snow shovel circa 1915 that he christened as art. When an artist decides not to title an artwork, that fact in itself conveys a sense of indifference to verbal labels and invites the beholder to consider the work *as is*.

It was not until the mid-nineteenth century when artists regularly titled their own works, though we have long-standing monikers for earlier pieces, such as Leonardo's *Mona Lisa* and Rembrandt's *The Night Watch*. In fact, Rembrandt's famous painting is a classic case of a misnomer, as it actually depicts a sunlit scene. The artwork was titled as such over 100 years after Rembrandt painted the work, as by that time the painting's varnish darkened so much as to make the painting look like a night scene. Another interesting case is Paolo Veronese's huge painting which was intended to depict the Last Supper. In Veronese's painting, a rather bawdy scene is presented, showing "buffoons, drunkards, dwarfs, Germans, and similar vulgarities"[20] Given the seemingly sacrilegious portrayal, the artist was sent to the Holy Office of the Inquisition where he was charged with heresy. Veronese complained but ultimately acceded, and the painting was renamed *Feast in the House of Levi*, which is the title displayed at the Academia in Venice where the painting is now housed.

Titles offer important clues as they often refer to historical events. Indeed, the feelings experienced by Picasso's *Guernica*, Goya's *Third of May*, and Robert Motherwell's *Elegy to the Spanish Republic* (Figure 10.7) are accentuated with knowledge of the political sentiments depicted. Motherwell described his series of elegies as a "lamentation or funeral song." From his title and knowledge of the tens of thousands of Spanish citizens who were executed by Franco's fascist regime, we experience and empathize with Motherwell's deep sense of sorrow and grief. He painted over 100 of these abstract elegies, which typically include deep black regions against stark backgrounds. Without knowledge of the title and political context, we experience a rather stark abstract painting. With the title, we

in particular have a way of enhancing the bond between creator and beholder, because we have physical evidence of the artist's hand.[18] That is, with a painting we can see the actual brushstrokes made by its creator. The canvas that we behold was handled, manipulated, and embellished by the artist. In other art forms, such as in movies, music, or literature, the product that we physically behold has never been physically touched by its maker. By analogy, some may have a more personal experience in reading a card sent by a friend rather than reading the same message via email. For artworks that move us, we comprehend and empathize with the artist's message. Although we can glean much from the artwork alone, knowledge of the social and emotional context in which the artwork was created can enhance our experience. Thus, it is quite reasonable (and perhaps expected) to confront an unfamiliar artwork and ask, "What is the artist trying to say?"

When we resonate with an artist's viewpoint—when we understand the message—feelings generally follow. Van Gogh's *Wheatfields and Crows* (Figure 10.6) offers a window into this artist's emotional disposition. The contrast between the bright, erratic wheat field and foreboding sky gives the painting an eerie sense. The ambiguity of the direction of the bird's flight and the foreboding path leading toward the horizon enhance the unsettling nature of this painting. In a letter to his brother Theo and sister Jo van Gogh-Bonger, Van Gogh wrote: "I've painted another three large canvases...They're immense stretches of wheatfields under turbulent skies, and I made a point of trying to express sadness, extreme loneliness."[19] These feelings are heightened in us with the knowledge that Van Gogh committed suicide a few weeks after painting this scene.

In creating self-portraits, such as Frieda Kahlo's *The Broken Column* (Figure 6.4 in chapter 6), Lucien Freud's *Hotel Bedroom* (Figure 6.9, also in chapter 6), and Chagall's *L'Anniversaire* (Figure 5.5 in chapter 5), the artist is

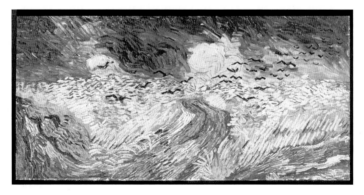

FIGURE 10.6 Gogh, Vincent van (1853–1890), *Wheatfields and Crows* (1890). Van Gogh Museum, Amsterdam, The Netherlands. Photo Credit: Art Resource, NY. (See color plate section.)

newspaper into even strips. Then he goes out to buy flour. His mother comes home and throws all the newspaper strips away." In order to understand the story, it is necessary to take on the feeling of the mother and how it would differ from the son's. When individuals read stories that involve perspective-taking, the temporoparietal junction is active.

Perspective-taking is only one part of an empathetic response. What is also needed is experiencing the *emotion* of another. Neuroimaging studies have identified other brain regions that are active when we imagine someone else's emotion. In one neuroimaging study, couples participated by having the female partner placed in the scanner while the male partner sat beside her.[15] In the scanner, the female subject would sometimes receive a shock to her hand and at other times she would watch her partner receive a shock. Brain responses to the shock activated the anterior cingulate cortex and insula, which are related to the brain's response to physical pain. These same brain regions were active when the subject watched her partner receive the shock. This finding showed that the brain's response to empathy (i.e., sensing one's pain) is similar to experiencing physical pain.[16]

■ The Artist and You

Every work of art presents a personal point of view. In realistic paintings, we may be granted a scene that is infused with emotion. Alternatively, the artist may want to communicate a conceptual statement about the world, human condition, or art itself. We often consider an artwork as a personal message, as if the artist is "speaking to you." With background knowledge of the artist we may develop a "relationship" with him or her, identifying with feelings expressed or resonant with a viewpoint.

Becoming the Artist

Rothko, as we have seen, wanted the beholder to have the same emotional reaction to his paintings as he had when he painted them. It is often the case that when we consider the viewpoint of the artist we in a sense become the artist. The philosopher Arthur Danto said "responding to a painting complements the making of one, and spectator stands to artist as reader to writer in a kind of spontaneous collaboration."[17] This kind of social bond is similar to the way we empathize with fictional characters depicted in paintings. When we empathize with the artist, we become the artwork's creator rather than characters depicted in it. This relationship bridges the intention of the artist with the experience of the beholder.

Emotional responses are amplified when we develop a connection with the artist. The philosopher Maurice Merleau-Ponty suggested that paintings

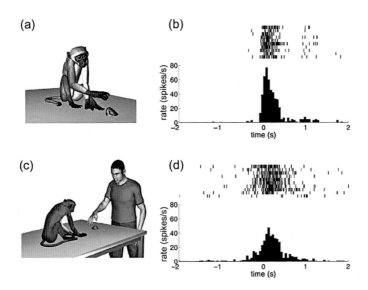

FIGURE 10.5 Mirror neurons respond when a monkey grabs an object and when someone else grabs the same object. From Casile, A., Caggiano, V., & Ferrari, P. F. (2011). The mirror neuron system: A fresh view. *The Neuroscientist,* April 5, 2011 (Epub ahead of print), copyright © 2011. Reprinted by permission of SAGE Publications.

is grabbing the object. In another study, neurons that fired when the monkey ripped a piece of paper also fired when it heard a paper being ripped.[11]

Since the discovery of mirror neurons in monkeys, neuroimaging studies have found similar activations in humans. In one study, subjects watched videotapes of actions, such as biting an apple or grasping a ball.[12] While watching these actions, activity occurred in comparable brain regions where mirror neurons have been found in monkeys. Certain disorders, such as autism, cause problems in perspective-taking or what psychologists call developing a "theory of mind." These findings along with findings of mirror-neurons lend support to the kind of kinesthetic responses suggested by philosophers in their analysis of empathy (i.e., *Einfühlung*). Indeed, Hume wrote "the minds of men are mirrors to one another."[13] As mentioned earlier, both Vischer, Lipps, and Titchener considered empathy as actively embodying the actions or feelings of others.

The posterior parietal cortex (see Figure 1.9 in chapter 1) is particularly involved in imagining the action of others. We have already encountered this brain region in discussions of episodic memory (chapter 6), as this region is active when we recollect and imagine past moments in our lives. In neuroimaging studies, Rebecca Saxe and colleagues have studied the role of a particular region in the posterior parietal cortex, the temporoparietal junction, in perspective-taking.[14] In one study, individuals read the following story: "*A boy is making a paper mache project for his art class. He spends hours ripping*

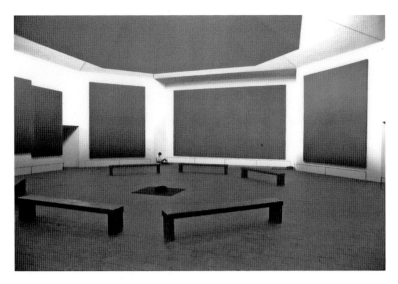

FIGURE 10.4 Rothko, Mark (1903–1970), *Chapel.* © ARS, NY. Rothko Chapel, Houston, Texas. Photo Credit: Nicolas Sapieha / Art Resource, NY.

It is not uncommon for religious works to induce tears as they remind the beholder of an immense commitment to faith and the sacrifice that others have taken on one's behalf. In Rothko's works, we are confronted with portals of eternal darkness that evoke an intensely sublime emotional response. In such cases, art has given the beholder a transcendental experience. Crying may also be a reaction to a deep, overwhelming sense of time. For example, a sense of lost time may be related to those tearful moments we experience when we witness a close relative or friend pass through a threshold, such as college graduation or a wedding ceremony. In such instances, we may be experiencing feelings of melancholy and loss as we remind ourselves of cherished moments of the past that will never be repeated. In the same way, a photograph of a loved one now deceased may bring sorrowful tears as one remembers moments lost in time.

The Empathetic Brain

In 1996, Giacomo Rizzolatti and colleagues discovered an interesting property of neurons in the cerebral cortex. In the macaque monkey, neurons that responded when the animal made a motor movement, such as grabbing an object, were also active when the animal watched someone else make the same movement (see Figure 10.5). These so-called *mirror neurons* were located in the prefrontal cortex and seemed to reflect the animal imagining or simulating an action. Subsequent studies have shown that mirror neurons respond to a variety of imagined actions. In fact, even if the final act is not observed, such as concealing the object that an actor will grab, a neuron will fire as if the monkey

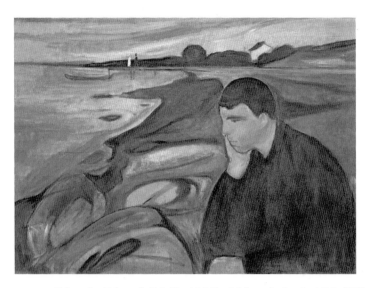

FIGURE 10.3 Munch, Edvard (1863–1944), *Melancholy*. © ARS, NY.
Billedgaleri (Picture Gallery), Bergen, Norway. Photo Credit: Erich
Lessing / Art Resource, NY.

family or breakup of a relationship. Sometimes we cry when we are happy, as
at graduations and weddings. Why do we shed tears during emotional experi-
ences? Young children often cry after a physically painful situation, and such
overt signals encourage social bonding. Emotional *cries for help* during adult-
hood may be a byproduct of this bonding behavior.[8]

You may have cried while watching a movie, reading a novel, or listen-
ing to music, but have you ever cried in front of a painting? The art historian
James Elkins invited individuals to submit personal stories about paintings that
made them cry.[9] From these submissions, he abstracted features of artworks
that evoked such experiences. He found that many people wept in front of a
painting because it made them feel unbearably empty, dark, or "painfully vast."
Others cried because they felt overwhelmed. These sentiments appear close to
Kant's notion of the sublime in which we sense the unbearable vastness of the
universe. One modern work that induces tears is at a chapel in Houston, Texas,
where in a quiet room stands fourteen large, serenely dark canvases painted
by Mark Rothko (Figure 10.4). From the chapel's guestbook, it is evident that
many people have cried in response to these paintings. Interestingly, Rothko
intended his paintings to evoke such emotions. In a 1957 interview, he stated:

> I'm interested only in expressing basic human emotions—tragedy, ecstasy,
> doom, and so on. And the fact that a lot of people break down and cry
> when confronted with my pictures shows that I can communicate those
> basic human emotions… The people who weep before my pictures are
> having the same religious experience I had when I painted them. And if
> you, as you say, are moved only by their color relationship, then you miss
> the point.[10]

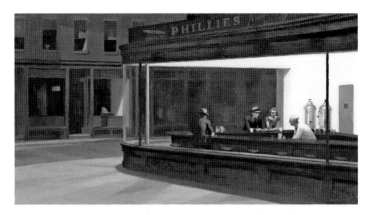

FIGURE 10.2 Hopper, Edward, *Nighthawks*. (See color plate section.)

and diminutive figures accentuate these feelings. Many of the paintings already discussed, such as Kahlo's *The Broken Column* (Figure 6.4 in chapter 6) and Chagall's *L'Anniversaire* (Figure 5.5 in chapter 5), project emotions through empathy.

Edvard Munch, the Norwegian artist who gave us *The Scream*, delved into the human psyche in an unique and emotionally charged manner. His childhood was fraught with disease and guilt, as his mother died of tuberculosis when he was five years old, and his father was a harsh, puritanical overseer. When he was 15 years old, his beloved sister, Sophie, succumbed to tuberculosis. His other sister, Laura, became delusional, hallucinated, and experienced signs of schizophrenia throughout her life. As a young man, he himself was bedridden with tuberculosis and rheumatic fever. Illness, depression, and death seep into many of Munch's paintings. Even in love, Munch was met with anxiety, pain, and jealously. In his *Frieze of Life—A Poem about Life, Love and Death*, the series that includes *The Scream*, Munch gives us an array of dark feelings associated anguish and sadness.

Many of Munch's works are titled with respect to feelings and expressive moments, such as *Anxiety, Puberty, The Kiss, Attraction, The Day After, Separation, Fear, Jealousy*, and *Dance of Life*. In *Melancholy* (Figure 10.3), he depicts that forlorn and desolate feeling. The man, with head leaning on hand, offers the universal expression of weariness and despair. It is as if the man is so worn, physically and mentally, that he cannot hold up his own head. His surroundings melt into indistinct forms, which seem to portray the man's internal world as much as his external world. From *The Scream* to *Melancholy* and in between, Munch offered a world full of intense and expressive characters with whom we empathize.

Crying Over You

The emotional experience of crying is a particularly human response. We weep during intensely sad or emotionally painful moments, such as the death in the

Philosophers have considered the distinction between sympathy and empathy. Hume said that sympathy engendered a mixture of contempt, pride, and goodwill, whereas empathetic responses initiated "benevolent behavior."[4] Though philosophers, such as Smith and Hume, described what we today call *empathy*, the actual word did not appear in its present connotation until 1909 when the eminent psychologist Edward Titchener coined the term as a translation of the German word *Einfühlung* (literally, *feeling-into*).[5] Titchener considered empathy as a kind of "kinesthetic" feeling in which we imagine bodily feelings or sensations associated with other objects, be they animate or inanimate. He adopted this notion from German philosophers, such as Robert Vischer and Theodor Lipps,[6] who characterized the phenomenology of *Einfühlung* with respect to aesthetic experiences. They suggested that we embody or personify objects depicted in art. A central question for these aestheticians was whether or not empathetic experiences actually induced bodily or kinesthetic responses.

As psychological science advanced, the notion of *empathy* became linked more directly to the way we experience the feelings of others. Empathy research has focused on *perspective-taking* and the way such experiences encourage us to help others. In a clever experiment,[7] individuals were given a choice of assigning themselves to a favorable task (earning raffle tickets) or to a dull task that did not include any incentives. They were told that whichever task they chose, the other task would go the next subject, though that person would not know how he or she was placed. They were given a coin to flip, if they wanted to determine the choice randomly, but they didn't have to use it. Some subjects, prior to making the decision, were asked to "imagine how the other participant would likely feel." This opportunity to empathize doubled the frequency with which subjects decided to give the favorable task to the next subject. Interestingly, it did not increase the frequency of using the coin to determine the selection, which would have been the fairest thing to do. Another curious finding was that some who said they used the coin apparently did not, because the frequency of selecting the favorable choice for themselves was much greater than chance! When we take on the perspective of others, we increase empathetic feelings, which can lead to altruistic or benevolent behavior. This response is exactly what Hume and Smith suggested as the motivation for moral behavior.

It is not uncommon to develop empathetic responses to individuals depicted in art. Indeed, our emotional involvement with a work of art—be it a painting, novel, or movie—is often driven by the degree to which we identify with individuals portrayed. When we project ourselves into an artwork, a range of emotions can be generated, such as happiness, sadness, anger, surprise, horror, disgust, and relief. Even more complex emotions can be felt, such as jealousy, envy, and melancholy. Many of Edward Hopper's paintings, such as *Nighthawks* (Figure 10.2), portray individuals in emotionally desolate predicaments. When we place ourselves in a Hopper painting, the prominent feelings are alienation, longing, and resignation. In *Nighthawks*, the stark lighting, angles,

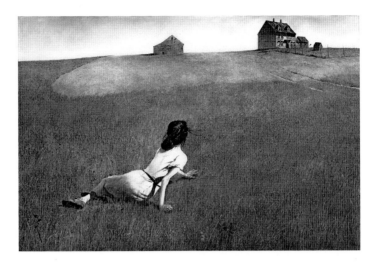

FIGURE 10.1 Wyeth, Andrew (1917–2009), *Christina's World*. © Copyright, 1948. Tempera on gessoed panel, 32 1/4 × 47 3/4 inches. Purchase. The Museum of Modern Art, New York, NY. Photo Credit: Digital Image © The Museum of Modern Art/Licensed by SCALA / Art Resource, NY. Courtesy of Andrew Wyeth Office. (See color plate section.)

put ourselves in another's predicament. In our experiences with art, we resonate with the feelings of characters portrayed in the same way we do with real individuals.

Getting Involved

When we feel with others, two kinds of emotional reactions can be experienced. First, with knowledge of the circumstances, such as Christina's plight, we may experience sympathy. Sympathetic feelings, such as pity, encourage helping behavior. A mother might sympathize with her baby crying in a crib and nurture the child. Such emotions, according to philosophers, can be used to explain moral behavior. They drive altruistic behavior by encouraging a desire to help others. A second more direct response is empathy. Instead of pitying someone's predicament, empathy is based on actually imagining oneself in someone else's shoes. Thus, when we experience *Christina's World,* we may actually sense her feelings, pain, and isolation. Adam Smith, the economic philosopher, considered such responses in his 1853 work *Theory of Moral Sentiments*:

> By the imagination, we place ourselves in his situation, we conceive ourselves enduring all the same torments, we enter as it were into his body, and become in some measure the same person with him, and thence form some idea of his sensations, and even feel something which, though weaker in degree, is not altogether unlike them (p. 9).[3]

10. I FEEL FOR YOU

When we read a novel, watch a drama, or behold a painting, we often feel as if we are experience life through the eyes, thoughts, and feelings of another. That is, we *empathize* with others, feeling their pleasures and pain as if they are our own. In Andrew Wyeth's *Christina's World* (Figure 10.1), a woman peers longingly toward her home. The painting is made more poignant by the fact that Wyeth based this work on Christina Olson, a neighbor who was stricken with a degenerative disorder with polio-like symptoms. Wyeth once saw Christina crawling outside on the grass toward her kitchen door. That evening, he sketched a drawing placing her out in a field with the Olson house in the distance.[1]

Our feelings for others, and more specifically our feelings as others, have powerful effects in driving our emotions. With *Christina's World*, background knowledge enhances our experience as we consider what it would be like to be paralyzed. We empathize with characters portrayed and also empathize with artists as we imagine their emotional struggles in creating art. Many have considered the artist's intention to be critical in our art experience. Indeed, some have argued that the main purpose of art is to communicate feelings between artist and beholder. Others, however, particularly with postmodernist views, have veered away from this empathetic relationship. The literary critic Roland Barthes in a famous essay *Morte d'Author (Death of the Author)* argued that we should abandon any interest in the creator of an artwork.[2]

■ Empathy in Art

In everyday experiences, social interactions are infused with a sense of emotional bonding as we attempt to empathize with another's dilemma. We often say, "I know how you feel" or "I understand your situation," as if we are able to

(2001) Male facial attractiveness: Evidence for hormone mediated adaptive design. *Evolution and Human Behavior, 22,* 251–267.

14 Little, A. C., Jones, B. C., Penton-Voak, I. S., Burt, D. M., & Perrett, D. I. (2002) Partnership status and the temporal context of relationships influence female facial preferences for sexual dimorphism in male face shape. *Proceedings of the Royal Society of London, B., 269,* 1095–1101.

15 Zebrowitz, L. A., & McDonald, S. M. (1991), The impact of litigants' baby-facedness and attractiveness on adjudications in small claims courts. *Law and Human Behavior, 15,* 603–623.

16 McManus, I. C., & Humphrey, N. K. (1973). Turing the left cheek, *Nature, 243,* 271–272.

17 For more on profiles, see Chatterjee, A. (2002). Portrait profiles and the notion of agency. *Empirical Studies of the Arts, 20,* 33–41. Jensen, B. T. (1952). Left-right orientation in profile drawing. *The American Journal of Psychology, 65,* 80–83.

18 Nicholls, M. E. R., Clode, D., Wood, S. J., & Wood, A. G. (1999). Laterality of expression in portraiture: Putting your best cheek forward. *Proceedings of the Royal Society of London, B, 266,* 1517–1522.

19 Livingston, M. (2002). *Vision and Art: The Biology of Seeing.* New York: Harry N. Abrams.

20 Gross & Bornstein (1978). (See chapter 4, n. 26.) Jaynes, J. (1977). *The Origin of Consciousness in the Breakdown of the Bicameral Mind.* Boston: Houghton Mifflin.

21 Ekman, P. (2009). *Telling Lies: Clues to Deceit in the Marketplace, Politics, and Marriage.* New York: W. W. Norton & Company.

22 Yarbus (1967). (See chapter 4, n. 38.)

23 Kawashima, R., Sugiura, M., Kato, T., Nakamura, A., Hatano, K., Ito, K., et al. (1999). The human amygdala plays an important role in gaze monitoring: A PET study, *Brain, 122,* 779–783. Yoshikawa, S., Kochiyama, T., & Matsumura, M. (2004). The amygdala processes the emotional significance of facial expressions: An fMRI investigation using the interaction between expression and face direction, *NeuroImage 22,* 1006–1013.

24 de Gelder, B., Snyder, J., Greve, D., Gerard, G., & Hadjikhani, N. (2004). Fear fosters flight: A mechanism for fear contagion when perceiving emotion expressed by a whole body. *Proceedings of the National Academy of Science, 101,* 16701–16706.

25 Clark, K (1956).

26 For an interesting analysis of portraits by Kokoschka and two of his Viennese compatriots, Gustav Klimt and Egon Schiele, see Kandel, E. (2012). *The Age of Insight: The Quest to Understand the Unconscious in Art, Mind, and Brain, from Vienna 1900 to the Present.* New York: Random House.

27 Burgess, Gelett. (1910). Wild men of Paris (pp. 400–414). *Architectural Record,* May, 1910.

28 Flam, J. (1995), p. 121. (See chapter 1, n. 6.)

■ Notes

1 Actual measurements suggest that a man's arm span tends to be slightly longer than his height. Schott, G. D. (1992). The extent of man from Vitruvius to Marfan. *Lancet, 340,* 1518–1520.

2 The golden ratio (approximately 1.62) has been used to define the ratio between a man's height (H) with respect to the height of the naval (N), so that H/N = 1.62. Thus, the height to the navel of a 6-foot man would be 3.71 feet.

3 Clark, K. (1956). *The Nude: A Study in Ideal Form* (p. 36). New York: Pantheon Books.

4 Di Dio, C., Macaluso, E., & Rizzolatti, G. (2007). The golden beauty: Brain response to classical and renaissance sculptures. *PLoS ONE, 2,* e1201.

5 Cela-Conde, C. J., Marty, G., Maestú, F., Ortiz, T., Munar, E., Fernández, A., et al. (2004). Activation of the prefrontal cortex in the human visual aesthetic perception. *Proceedings of the National Academy of Sciences, 101,* 6321–6325. Cupchik, G. C., Vartanian, O., Crawley, A., & Mikulis, D. J. (2009). Viewing artworks: Contributions of cognitive control and perceptual facilitation to aesthetic experience. *Brain and Cognition, 70,* 84–91. Jacobsen, T., Schubotz, R. I., Hofel, L., & Cramon, D. Y. (2006). Brain correlates of aesthetic judgment of beauty. *Neuroimage, 29,* 276–285.

6 Singh, D., & Young, R. K. (1995). Body weight, waist-to-hip ratio, breasts, and hips: Role in judgments of female attractiveness and desirability for relationships. *Ethology and Sociobiology, 16,* 483–507.

7 Gangestad, S. W., Simpson, J. A., Cousins, A. J., Garver-Apgar, C. E., & Christensen, N. P. (2004). Women's preference for male behavioral displays change across the menstrual cycle. *Psychological Science, 15,* 203–207.

8 Streeter, S. A., & McBurney, D. H. (2003). Waist-hip ratio and attractiveness: New evidence and a critique of "a critical test." *Evolution and Human Behavior, 24,* 88–98. Tovee, M. J., & Cornelissen, P. L. (2001). Female and male perceptions of female physical attractiveness in front-view and profile. *British Journal of Psychology, 92,* 391–402.

9 Oliver-Rodriguez, J. C., Guan, Z., & Johnston, V. S. (1999). Gender differences in late positive components evoked by human faces. *Psychophysiology, 36,* 176–185.

10 For further information, see Johnston, V. S. (2006). Mate choice decisions: The role of facial beauty. *Trends in Cognitive Science, 10,* 9–13. Rhodes, G. (2006). The evolutionary psychology of facial beauty. *Annual Review of Psychology, 57,* 199–226.

11 Little, A. C., & Jones, B. C. (2006). Attraction independent of detection suggests special mechanisms for symmetry preference in human face perception. *Proceedings of the Royal Society B, 273,* 3093–3099.

12 Langlois, J. H., & Roggman, L. A. (1990). Attractive faces are only average. *Psychological Science, 1,* 115–121. See also Rhodes (2006).

13 Penton-Voak, I. S., Perrett, D. I., Castles, D. L., Kobayashi, T., Burt, D. M., Murray, L. K., et al. (1999). Menstrual cycle alters face preference. *Nature* 399, 741–742. Johnston, V. S., Hagel, R., Franklin, M., Fink, B., & Grammer, K.

During the Renaissance, more natural, realistic bodies and facial features were presented. In later works, the artist expressed feelings through bodily forms by representing the human experiences of love, death, sadness, joy, fear, and melancholy. When an expressionist approach is applied, we entertain emotions that artists evoke by their portrayals of the human form.

It is often said among actors that dying is easy but comedy is hard. Artists do appear to spend more time canvassing the negative side of life rather than its lighter side. Yue Minjun is an exception as he has excelled in playful depictions of a happy face. Many of his paintings depict a caricature of himself with a hilarious expression. In *Untitled* (2005), Minjun exhibits multiple versions of himself in party hats laughing at something that we cannot see (Figure 9.13). The humor is accentuated by the bold colors and the shiny skin that gives the figures the appearance of being made of molded plastic. In so many ways, from ancient Greek art, to Renaissance perfections, and on to modern art's breakdown of the human shape, we can appreciate the representation of the body in art as expressive forms.

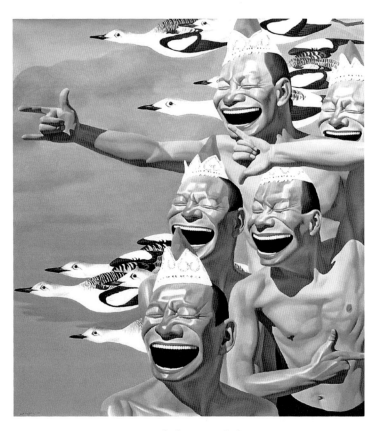

FIGURE 9.13 Yue Minjun, Untitled, 2005. Oil on canvas, 220.3 × 200 centimeters. Reproduced with permission from Yue Minjun Studio. (See color plate section.)

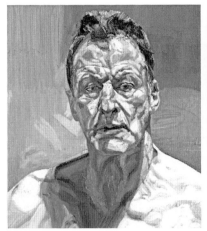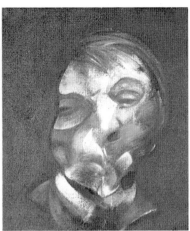

FIGURE 9.12 *(a)* Lucian Freud, 1985. Oil on canvas, 22 × 20 inches (56 × 51 centimeters). Courtesy of Lucian Freud Archive. *(b)* Bacon, Francis (1909–1992), *Self-Portrait*, 1971. Oil on canvas, 35.5 × 30.5 centimeters. © ARS, NY. Inv.: 1984–485. Photo: Philippe Migeat. Musee National d'Art Moderne, Centre Georges Pompidou, Paris, France. Photo Credit: CNAC/ MNAM/Dist. Réunion des Musées Nationaux / Art Resource, NY.

seemingly "airbrushed" nudes of the nineteenth century and earlier. By magnifying faults of the human body, such as those incurred by age or obesity, Freud gives us stark images of the human condition. These images, as opposed to the perfect *David* or *Venus*, express normal bodies replete with blemishes, saggy skin, and all.

Perhaps the most disturbing portrayer of the human body is Francis Bacon. His grotesque portraits with their oddly proportioned features transmit a dark, menacing nature. In *Self-Portrait* (1971) (Figure 9.12b), Bacon reveals himself with gross asymmetries in facial composition. The face has the appearance of being deformed by a terrible accident. Whereas Picasso's cubist portraits break down the face into primitive perceptual facets, Bacon's distortions offer fragments of rudimentary emotions. Like Munch, he was interested in the emotional impact of the scream and tried to depict it as silent anguish. He has said that he considers death on a daily basis. His paintings do suggest a brooding, foreboding sentiment.

■ Bodily Functions

From Greek sculptures of perfection to gross distortions by modern artists, the human form has played a significant role in art. Medieval portrayals often appear unnatural, either by design or failure to depict correct proportions of the body. In these works, shading and linear perspective are not well characterized.

essay about the 1908 Salon des Indépendants, where Picasso, Matisse and other avant-garde artists exhibited their works: "Suddenly I had entered a new world, a universe of ugliness...It was Matisse who took the first step into the undiscovered land of the ugly."[27] An interesting illustration of Matisse's reconfiguration of the body can be seen in his development of *Large Reclining Nude*. For six months he worked on the painting and during that time he took 22 photographs of its development. Figure 9.11 shows three of these photographs depicting stages in his interpretation from a natural pose of a woman reclining on a couch to one that distorts body and space. Indeed, the background of this painting evolved from a well defined spatial environment to a colorful flattened design with an abstract flower vase. Matisse's primary interest was to represent emotions. He said: "Why should I paint the outside of an apple, however exactly? What possible interest could there be in copying an object which nature provides in unlimited quantities and which one can always conceive more beautiful. What is significant is the relation of the object to the artist, to his personality, and his power to arrange his sensations and emotions."[28]

Lucian Freud's self-portrait (1985) (Figure 9.12a) is pretty ugly. Every wrinkle and loose piece of skin is highlighted and accentuated. It is as if Freud intended to confront us with the most unsympathetic representation of himself. Many of his nudes have this same enhanced ugliness. Interestingly, they actually instill a more natural sense of the human form than the pristine,

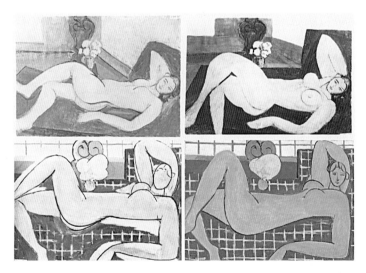

FIGURE 9.11 Evolution of Henri Matisse's *Large Reclining Nude* (completed October 31, 1935): *Top left*: State I (May 3, 1935); *Top right*: State V (May 20, 1935); *Bottom left*: State XXI (October 16, 1935); *Bottom right*: completed painting, oil on canvas, 26 × 36 1/2 inches (66 × 92.7 centimeters.). The Cone Collection, Archives and Manuscripts Collections. Reproduced with permission from The Baltimore Museum of Art. (See color plate section.)

shapes, flattened perspectives, and bold, unnatural colors. With respect to the body, modernist painters rejected standard notions of beauty and aesthetic proportion. We have already seen Picasso's foray into bodily deconstructions, as depicted in his portrait of *Dora Maar* (Figure 4.8 in chapter 4). With respect to universal features of idealized bodies, Picasso's depictions are peculiar and disconcerting. Yet, artistically, they advanced the way we consider how bodies can be represented or abstracted in paintings.

Likewise, Oskar Kokoschka developed an unique creative style in representing bodies, as exemplified in *The Bride of the Wind* (1913) (Figure 9.10).[26] This painting depicts a "stormy" view of his relationship with Alma Mahler, with whom he had a passionate love affair that inspired over 20 paintings of her. Although Alma ultimately rejected Kokoschka, he could never relinquished his love for her. In this painting, the two lovers are immersed in a frenzy of brush strokes. Alma appears restful, whereas Kokoschka seems well aware of his tempestuous surroundings. In many of Kokoschka's works, bodies are represented as bold strokes of paint. They have sinewy appearances as if skin is stripped from muscle. As a result, they have an intense raw quality, which heightens emotions.

Matisse also experimented with modernist reconfigurations of the body. For Matisse, color was a not just a sensory quality but a central feature of art. Stark colors substituted for subtle shadings. Art critic Gelett Burgess wrote in a famous

FIGURE 9.10 Kokoschaka, Oskar (1886–1980), *The Bride of the Wind* (Windsbraut) (1914). © ARS, NY. Alma Schindler-Gropius, later married to Gustav Mahler and poet Franz Werfel, here with her lover Oskar Kokoschka. Kunstmuseum, Basel, Switzerland. Photo Credit: Erich Lessing / Art Resource, NY.

FIGURE 9.9 El Greco (Domenikos Theotokopulos) (1610–1614), *Laokoon and His Sons.* Canvas, 142 × 193 centimeters. National Gallery of Art, Washington, DC. Photo Credit: Erich Lessing / Art Resource, NY.

painting flows with El Greco's characteristically elongated and stylized forms. Musculature shape is exaggerated and the bodies have an unearthly look that is characteristic of El Greco's unique style. These artistic expressions create an intense emotional scene filled with anguish.

In sculpture, painting, and photography, the nude has offered a showcase for artists to depict the beauty and flow of the human body.[25] Depiction of male nudes was more common in ancient Greek statutes, though female nudes are much more common in paintings and photographs. Of course, in erotic art, the nude has been used and abused in many ways, shapes, and combinations. Eroticism may have been an underlying motive in some academic works, though such intentions were adequately concealed with the appropriateness of depicting Greek gods and other mythic characters who seemed to spend a good deal of time in the nude. Indeed, Manet's portrayals of nudes in contemporary settings, such as in *Le déjeuner sur l'herbe* (*The Luncheon on the Grass*) and *Olympia*, were scandalous when first exhibited. Yet consider Weston's nude (Figure 1.5 in chapter 1) or El Greco's *Laocoön* (Figure 9.9), both of which appear decidedly nonerotic and, instead, express significant form in Weston's case and emotional anguish in El Greco's.

Pretty Ugly

By the turn of the twentieth century, realism was out. The subtle use of chiaroscuro and the ability to apply linear perspective were replaced by cubist

a stimulus suggests an emotional response, the amygdala sends signals to brain regions involved in emotional processing (e.g., fight-or-flight response, reward processing).[23]

■ Figuratively Speaking

From the Renaissance through the nineteenth century, artists keyed on realism and emotional expression in portraits. Just as a face communicates a multitude of feelings, body position and attitude reveals much about a person. Artists used the body as a way of transmitting a spectrum of emotions, and elsewhere in the book we have seen portrayals of joy by Chagall (Figure 5.5 in chapter 5), pain by Kahlo (Figure 6.4 in chapter 6), and death by Géricault (Figure 8.4 in chapter 8). When modernist artists escaped from the shackles of realism, they began to explore formal aspects of the body. By the beginning of the twentieth century, this new look took hold, and the image of the idealized body was replaced by images that distorted and exaggerated the human form. In this section, we explore the many ways the body communicates feelings.

Revealing Bodies

We respond emotionally through body posture as we do with facial expressions. Hand gestures readily signal emotions, such as a comforting hand on the shoulder or a clenched fist. In a neuroimaging study, individuals viewed video stills of actors in body positions that signaled various emotions. In one still, an actor was arched back with his hands out, a posture that clearly signals fear. Faces were covered so that only body posture communicated emotion. When the fearful posture was viewed, brain regions involved in emotional processing, such as the amygdala, orbitofrontal cortex, and insula, were active.[24] Thus, body posture, along with facial expressions, are laden with emotional significance, and our brains readily pick up these signals. In Murillo's *Two Women at a Window* (Figure 8.3 in chapter 8), we see the artist using body language to express embarrassment as the demure hand of the older woman covers her mouth.

Renaissance artists were determined to depict accurately the proportions and form of the body. These artists perfected the method of painting realistic or at least idealistic views of the body on canvas. Later, during the period art historians call *Mannerism*, artist veered away from presenting a naturalistic form and considered more expressive shapes. Consider El Greco's *Laocoön* (Figure 9.9), which depicts the tragic myth of the Trojan priest who tried to warn his compatriots that the "gift" of the gigantic Horse was actually a devious trick by Greek invaders. Laocoön was ultimately punished by the Greek goddess Athena who sent two sea serpents to kill him and his two sons. The

FIGURE 9.8 *(a)* Mona Lisa (correct orientation): da Vinci, Leonardo (1452–1519), *Mona Lisa*, detail. Oil on wood, 77 × 53 centimeters. INV779. Photo: Hervé Lewandowski / Thierry Le Mage. Louvre, Paris, France. Photo Credit: Réunion des Musées Nationaux / Art Resource, NY. *(b)* Mona Lisa (mirror-reversed).

sinister squinty-eyed expression. A downcast gaze expresses sadness or shame, and a direct gaze suggests interest, dominance, or even aggression. Pupil dilation is a sign of arousal and focused attention, as it occurs during the brain's fight-or-flight response, as does blushing and sweating. An artist's ability to capture these social signals on canvas heightens the emotional impact of a portrait. Studies of eye movement behavior while scanning portraits or photographs of faces show that we spend a good deal of time fixating at the eyes.[22]

One particular social signal is the direction of gaze. We are particular sensitive in determining where someone is looking—whether right at you, at something else, or shifted slightly to the side. Understanding one's gaze can determine if a person should be avoided or approached. If someone is showing fear and looking to the left, odds are that we should pay attention to the direction of gaze. In a neuroimaging study, male subjects watched a video in which a young woman looks directly at the camera as if making eye contact with the viewer. When the actor's gaze meets the viewer's, the amygdala becomes active. In another study, the amygdala is active when an angry face is looking directly at the subject. As mentioned in chapter 8, the amygdala acts as an interface between conceptual and emotional processing. When our appraisal of

the *Mona Lisa*. It is known that the emotional content of the portrait is driven primarily by the smile, as the upper half of her face alone does not carry significant emotional expression. A prominent feature of the smile is Leonardo's use of *sfumato*, the overlaying of glazed paint to produce a blurred, smoky appearance. Leonardo developed this technique as a way of creating subtle gradations of tone. When the noted neuroscientist Margaret Livingston looked at the *Mona Lisa*, she found that the enigmatic smile would come and go depending upon where she fixated.[19] The smile was more apparent when she looked away from the mouth but then it seemed to vanish when she fixated directly at it. She conjectured that the application of sfumato around the mouth blurred the area to make the smile ambiguous. When we look directly at the mouth, we see with clarity that Leonardo's sfumato suggests subtle shading with the expression evoking its characteristic smirky look. When we look away, the mouth is seen in the periphery, which reduces visual acuity. This has the effect of creating more blur around the mouth (as if seeing an image with only low spatial frequencies), so that the curvature of the lips is accentuated and depicts a more smiley grin.

Another curious feature of Mona Lisa's smile is that it is asymmetric. When we look at the portrait, it is the right side of the mouth that is curved up, whereas the left side does not. As mentioned in chapter 4, we tend to scan paintings from left to right, thus paying more attention to the left side, which in Mona Lisa's case is the side that is not expressive. Compare Mona Lisa's expression with a mirror-reversal of her face (Figure 9.8). The mirror-reversed face seems to have a slightly more expressive smile, particularly if you scan the portrait from left to right. Individuals shown simple line drawings with asymmetric grins judge faces with left-sided grins as happier than those with right-sided grins.[20] Thus, Mona Lisa's asymmetric grin and our scanning behavior may contribute to her evocative and enigmatic smile.

Here's Looking at You

It has been said that the eyes are windows to the soul. Rembrandt was exceedingly adept at verifying this adage. He painted over 90 self-portraits, and the evolution of his artistic skill is evident across these works. His latter self-portraits, particularly the one he painted at the age of 53, reveals somber, thoughtful eyes, which are depicted in sharp detail compared to the rest of the painting. Rembrandt often blurred the periphery as way of directing the beholder to the thematic center of the painting. As a result, we are guided by the artist to confront his expressive eyes, and when ours meet his, there is a realism that makes you feel he is in the room.

Eyes communicate a multitude of feelings and thoughts.[21] The muscles surrounding the eyes can shape the eyelids and create a wide-eyed surprised look, a quizzical asymmetric expression (e.g., raising of one eyebrow), or a more

There is a positional bias in the depiction of faces in portraits. Faces are rarely shown from a direct frontal view but are usually angled showing one side more than the other. In a statistical analysis of 1474 portraits, the left side of the face was found to be shown more often than the right. It has been suggested that the bias is attributed to the relative ease with which right-handed artists can draw the left side of faces. Try to draw a right and left facing profile. For a right-hander, it is easier to draw a nose pointing to the left than to the right, and people tend to do so when asked to draw a profile.[16] Yet other findings suggest that this factor cannot fully account for the bias. First, the left side bias is more often found in portraits of women (68%) than portraits of men (56%). Second, an analysis of left-handed artists (Raphael and Hans Holbein) showed that they too exhibited the same left-face bias as right-handed artists. Third, the left-face bias has been observed even in photographic portraits of high school students who could decide which way to pose.[17]

Several other explanations of the left-face bias have been proposed. The best explanation relates to the sitter's choice of which face to present to the beholder. For instance, in self-portraits, the artist is both painter and sitter, and thus can chooses which side to present. Yet artists often use a mirror as an aid in painting self-portraits. If the left-face bias were due to the ease in painting a left profile, then artists should present their right side to the mirror which would then be reflected and allow them to paint a left-sided profile. In an analysis of self-portraits, there is actually a right-side bias, as if artists have chosen to present their left side. In another study, subjects were given one of two cards to read before deciding which way to pose for a photograph.[18] One card asked the subject to pose for an emotional portrait as a family gift: "You are going overseas for a year…You are a warm-hearted and affectionate person…put as much real emotion and passion into the portrait as you can." The other card asked for an impassive portrait to honor scientists inducted to the Royal Society: "You are a successful scientist…You are a cool-headed, calm and reasonable person…give the impression of an intelligent, clear-thinking person." A left-face bias was observed when individuals were asked to give an emotional portrait, whereas a right-face bias was observed when individuals were asked to give an impassive portrait. Thus the emotional context of the portrait may determine the choice of showing one's left or right side. The sex difference in the left-face bias may be the result of a male sitter preferring to portray an impassive pose (or the artist preferring a male sitter to take on an impassive pose).

Mona Lisa's Smile

Leonardo's *Mona Lisa*, perhaps the most famous painting ever created, carries that evocative expression that makes us ask—*what is she thinking?* That glint of a smile suggests to us that she knows something we don't. How did Leonardo create such a curious expression? Much has been written and discussed about

FIGURE 9.7 Funeral portrait of Aline. From Hawara, Fayum Oasis, Egypt. Painting on canvas. Roman period (*c.* 50 AD). Aegyptisches Museum, Staatliche Museen, Berlin, Germany. Photo Credit: Erich Lessing / Art Resource, NY. (See color plate section.)

in Northern Egypt, were not discovered until the seventeenth century and thus were unknown to medieval and Renaissance artists. They offer evidence to show that such early artists were extraordinarily adept at creating realistic shapes from shading.

Expressive Faces

When artists rediscovered the technique of depicting faces in a natural manner, they were hampered by the limited range in shadings that can be painted on a canvas compared to the variation of light reflected off real objects. Even more problematic is the manner in which we perceive subtle changes in colors when presented under different levels of light. Highlights and shadows can subtly change the color of objects and careful application of chiaroscuro is necessary to produce realistic skin tones in portraits. By the late Renaissance, exquisite depth in portraiture was accomplished by two Venetian painters, Giovanni Bellini and his more prolific student Titian. One can stand in front of many Titian portraits and experience an uncanny sense that you have an understanding of the person portrayed.

such as Cary Grant and George Clooney. Interestingly, women's preferences for male faces are less consistent than men's preference for female faces. Some women prefer strongly masculinized faces, whereas others prefer more boyish, feminized faces, characterized by actors such as Leonardo DiCaprio and Johnny Depp. Women from the United Kingdom and Japan preferred male faces that were more feminized than average, whereas women from the United States preferred male faces that were more masculinized.[13] The variability in preferences may be attributed to contrasting factors that drive mate selection. A masculinized face signals muscular strength, yet a more feminized face suggests a person with warmth, friendliness, and cooperativeness. Consistent with this explanation is the finding that woman prefer feminized male faces when selecting a long-term mate.[14]

Feminized faces in both men and women reflect a more youthful appearance. The so-called baby face is characterized by a round face, large eyes, small jawbone, curved forehead, and lower placement of eyes, nose, and mouth. We of course respond to children with affection, warmth, and protectiveness. Interestingly, these same responses are bestowed on adults with baby face features. In court proceedings, adults with baby faces are viewed as more honest yet more naïve. Thus, they are blamed less for intentionally committed crimes but are reprimanded more for negligent crimes.[15] Stephen Jay Gould, the prominent evolutionary biologist, described the "evolution" of the appearance of Mickey Mouse, who started as an adult-like "ratty" form and morphed over the decades to a more juvenile look. As Mickey's physical features became more youthful, his personality softened. Thus, along with symmetry, averageness, and hormones, a youthful "baby face" also increases facial attractiveness.

■ Making Faces

Over the centuries, portraiture has been a prevailing genre in art. Portraits offer reminders of loved ones and act to memorialize prominent individuals, such as religious figures, politicos, royal families, and, of course, artists themselves. A realistic portrait depends on the ability to create subtle depth and shaping of form. We have already discussed the importance of chiaroscuro in the rendering of 3-D forms and marveled at the exquisite manner in which Leonardo perfected this technique (see Figure 1.3 in chapter 1). Although medieval painters were not adept at creating natural looking faces, earlier artists had developed the skill, as evidenced by archeological finds of ancient frescos and paintings. Figure 9.7 is a portrait found in a tomb that was created during the first century AD. The subtle highlighting of the forehead, cheeks, and nose in this exquisite portrait demonstrates the artist's awareness of how light reflects off surfaces. This portrait, however, was not meant for any living beholder. It was found buried together with a mummy. Such mummy portraits, unearthed

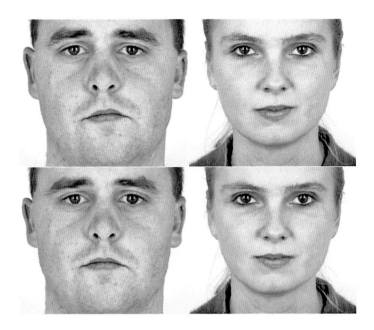

FIGURE 9.5 Influence of symmetry on facial attractiveness. The top two faces are actual photographs of individuals, whereas the bottom two have been modified so that the faces are perfectly symmetrical along the vertical axis. Reprinted from Little, A. C., & Jones, B. C. (2006). Attraction independent of detection suggests special mechanisms for symmetry preference in human face perception. *Proceedings of the Royal Society B*, *273*, 3093–3099, with permission of the Royal Society of London.

Just as body shape is influenced by the release of sex hormones during puberty, facial features are also affected. Estrogen suppresses male characteristics and creates a "feminized" face, marked by a narrow jaw and chin, high cheekbones, full lips, and larger eyes relative to head size. Women with heightened feminized features are rated more attractive than the average face. In men, testosterone release during puberty does just the opposite, as it broadens the jaw, cheekbone, and brow. This "masculinized" face is typified by actors

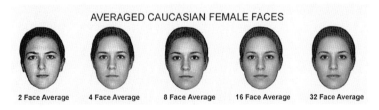

AVERAGED CAUCASIAN FEMALE FACES

2 Face Average 4 Face Average 8 Face Average 16 Face Average 32 Face Average

FIGURE 9.6 Facial attractiveness as a result of increasing the number of faces used in a morphed average. Photograph reproduced with permission of Dr. Judith H. Langlois.

Facing Beauty

Like it or not, attractive people are perceived as healthier, more successful, friendlier, and even smarter. When you meet a person, facial attractiveness is the primary feature that determines your first impression. In fact, in less than a half a second our brains show a heightened response to attractive faces.[9] Add a friendly smile to an attractive face and many are swooned. What accounts for such immediate responses? As with our preferences for body shape, facial beauty is predominantly based on biology and evolution. Newborns recognize faces, and as discussed in chapter 3, there are brain regions specifically devoted to the processing of them. Facial expressions can signal a variety of strong to subtle feelings as they are controlled by as many as 43 different facial muscles. Manipulating these muscles allows us to do rather rapid "speed dating" as we decide from facial expressions whom we find attractive (and willing).[10]

Several factors drive our response to faces. One is symmetry or the degree to which the left and right sides match. All faces have some asymmetrical features, such as a nose curved to one side or eyes that are not quite the same. Many of these are natural occurrences though some can be attributed to birth defects or disease. In Figure 9.5, the faces on top are actual photographs of individuals, whereas the bottom ones were digitally modified so that the left and right sides of each face is perfectly symmetrical.[11] Note that both faces, regardless of how attractive they are in actuality, are made more attractive through symmetry. Evolution has apparently created brains that make us prefer facial symmetry. Indeed, it may be this bias that drives our general aesthetic appeal for balanced forms.

A rather surprising finding is that average faces are more attractive than unique or exotic faces. Figure 9.6 shows composite faces of women made by morphing 2, 4, 8, 16, and 32 faces together. As more faces make up the composite or average morph, attractiveness increases.[12] Why do we respond favorably to *average* faces? With the addition of faces to the mix, oddities, such as blemishes, unattractive skin tone, and otherwise unusual features, are smoothed and diminished. Moreover, these blended faces become more symmetrical. Evolutionarily speaking, there is a strong reason for preferring average features. Average individuals are those that best represent the genetic mixture that has been successful in breeding. Anomalous features may suggest genetic oddities that have occurred within a limited gene pool. A notable example of such an oddity occurred within the House of Habsburg, the royal family that ruled much of Europe for centuries. In the fifteenth century, Duke Ernst married Cymburga of Masowia, who introduced into the Habsburg lineage a genetic disorder, *mandibular prognathism*, which causes an over-grown jaw and protruding chin. As the Habsburgs practiced extensive familial inbreeding to broaden their reign, this genetic disorder was inherited across generations and became a hallmark feature—the *Habsburg jaw*, a trait that can be seen at art museums all over Europe in the portraits of the royal Habsburg family.

male has a WSR of 0.6, which is exemplified by such well-proportioned actors as Hugh Jackman and Daniel Craig. This male body has been preferred by women from many countries, including the United States, the United Kingdom, and Sri Lanka. Another factor is women's preference for body hair on the chest and abdomen. Interestingly, women's preferences can vary depending on where they are in their menstrual cycle. During their fertile period, preferences are biased toward men with more masculine features (e.g., more masculine faces and more muscular bodies). These effects appear to be hormonally driven, as women whose estrogen levels are controlled with oral contraceptives do not show such fluctuations across menstrual phases.[7]

What determines these preferences? Biology and evolution are prime contributors. A woman's body changes during puberty as a result of estrogen release. These changes include increased fat deposits in the breasts and hips, thus reducing the WHR to less than 1.0. During middle-age, waist size tends to increase, thus increasing WHR. As a result, the hourglass figure offers an overt signal of fertility in young women. Also, the ideal WHR is related to better health and more successful births. In evolutionary terms, these two factors— fertility and health status—are prominent as they would increase reproductive success. In other words, the ideal WHR proportion offers a rather clear physical stimulus for the male brain to initiate genetic mixing. The male preference for WHRs of 0.7 has been observed in many cultures, though there is some contro-versy over the influence of Western styles in mediating this preference.[8]

Recall that body fat is independent of the WHR, as a woman of any weight can have a more tubular or curvaceous figure. With respect to the ideal amount of body fat, there are cultural influences. Men consider the ideal BMI to be 19.4, which describes a 5' 4" woman weighing 112 lbs. As the average Ameri-can woman with a height of 5' 4" weighs 140 lbs, this preferred body mass is significantly less than average. In cultures where food resources are scare, men favor overweight women, as those with less than average weight are associated with malnutrition or poor health status. In Western societies with abundant food resources, the ideal female body appears biased toward the fertility factor indexed by greater waist–hip curvature.

A man's body changes during puberty as a result of testosterone release, which increases muscle mass and expands the ribcage. As a result, increased musculature drives the male shape toward the ideal WSR, which is defined by the V-shape torso in muscular men. In evolutionary terms, muscle mass pro-vides a marker for strength and aggressiveness, two factors that would increase a woman's success in securing adequate shelter and food. Thus, women's pref-erences of this body shape, just as men's preferences for the ideal female body, are mediated by biological and evolutionary influences. These findings suggest that there are factors of physical beauty that are universally appreciated among all humans. Yet, as always such preferences are also guided by cultural and per-sonal factors, such as food scarcity and perceived need for muscular men.

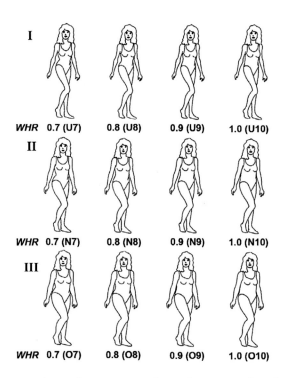

I

WHR 0.7 (U7) 0.8 (U8) 0.9 (U9) 1.0 (U10)

II

WHR 0.7 (N7) 0.8 (N8) 0.9 (N9) 1.0 (N10)

III

WHR 0.7 (O7) 0.8 (O8) 0.9 (O9) 1.0 (O10)

FIGURE 9.4 Stimuli used to assess male preference in female body shape as a function of WHR (waist-hip ratio, 0.7 to 1.0) and body mass (I = underweight, II = normal, III = overweight). Reprinted from Singh, D., & Young, R. K. (1995). Body weight, waist-to-hip ratio, breasts, and hips: Role in judgments of female attractiveness and desirability for relationships. *Ethology and Sociobiology*, *16*, 483–507, with permission from Elsevier.

men judged the attractiveness of female figures that varied in WHR from 0.70 (ideal) to 1.0 (no narrowing) (see Figure 9.4). Also shown were figures that varied in overall weight from underweight, normal, to overweight. Within each weight class, the most attractive body was the one with a WHR of 0.70, and the least attractive figure had a WHR of 1.0. Bodies that were normally weighted were judged more attractive than underweight or overweight bodies. As such, the most attractive female body had normal weight and a WHR of 0.70. This figure was also rated as looking most healthy. The next highest rating went to the underweight body with a WHR of 0.70.

Male body shape has been classified in terms of four body types, mesomorphic (muscular), average, ectomorphic (skinny), and endomorphic (fat). The order of these body types in the previous sentence corresponds to the order of women's preferences in male bodies, from best to worst. A more quantitative method, the *waist-to-shoulder ratio* or *WSR*, defines muscularity in terms of the broadness of the chest with respect to the waist. Indeed, the ideal muscular

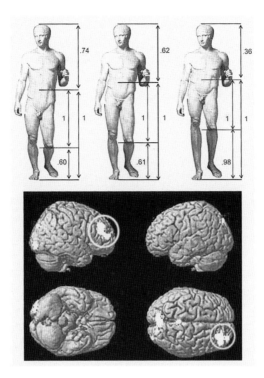

FIGURE 9.3 fMRI study of brain response to body proportion. The left statue has an elongated torso, the middle statute has actual (idealized) proportions, and the right statue has elongated legs. Brain scans show activations in prefrontal cortex in response to the idealized body proportions. Figure originally published in Di Dio, C., Macaluso, E., Rizzolatti, G. (2007). The golden beauty: Brain response to Classical and Renaissance sculptures. PLoS ONE 2(11), e1201 a doi: 10.1371/journal. pone.0001201 and reproduced under Open-Access License.

drapery that clings from her hips. Her prototypical "hourglass" shape is defined by bust, waist, and hip measurements, though contemporary studies of body shape have focused particularly on the *waist-to-hip ratio* or *WHR* (i.e., waist size divided by hip size). The WHR describes the degree to which the body narrows at the waist. A WHR of 1.0 defines a tubular shape with no difference between waist and hip size. A woman with the so-called ideal measurements of 36-24-36 inches would have a WHR of 0.67 (24/36). The *Venus de Milo* has a WHR of 0.68, and Miss America winners and *Playboy* centerfolds have had WHRs that range between 0.68 and 0.72.

Despite the trend toward thinner Miss America pageant winners, the WHRs of these idealized women have been quite consistent. Those buxom beauties of the 1940s and 1950s, such as Sophia Loren, and the later rail-thin models, such as Twiggy, all had WHRs around 0.70. In a psychological study,[6]

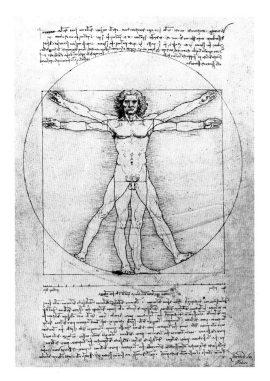

FIGURE 9.2 da Vinci, Leonardo (1452–1519), *Vitruvius Man* (called "Vitruvian Man") (*c.* 1492). Drawing of ideal proportions of the human figure according to Vitruvius', first century AD. Treatise "De Architectura." Accademia, Venice, Italy. Photo Credit: Alinari / Art Resource, NY.

is the result of numerous calculations, carried to within a hair's breadth."[3] In a neuroimaging study of beauty in body proportions,[4] drawings of Polykleitos's famous sculpture, *Doryphoros* (*Spearbearer*), were used to represent a perfectly proportioned male as it adhered to proportions described by Vitruvius. Subjects viewed the figure as well as other versions that distorted the body so that the torso or legs were disproportionately elongated (Figure 9.3). Individuals judged these distorted bodies to be less attractive than the actual one. While viewing the ideally proportioned body, a brain network was activated that included the prefrontal cortex, amygdala, and insula. The role of the prefrontal cortex in evaluations of beauty suggests that aesthetic judgments are cognitively complex and require metacognitive control.[5] The insula, which will be discussed further in chapter 10, is particularly activate in response to pleasant and unpleasant (i.e., disgusting) stimuli.

The most famous of ancient sculptures is of course the *Venus de Milo*, which was discovered in 1820 and created around 100 BC. This statute of the Greek goddess of love has become so familiar that it is difficult to look at it anew and appreciate its true beauty. With fresh eyes, one can admire the sculptor's ability to create in marble the suppleness of a woman's body and the seductive

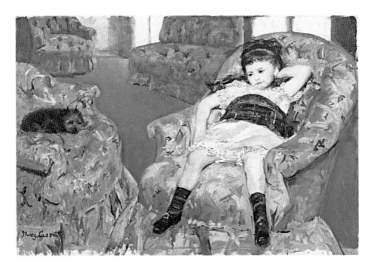

FIGURE 9.1 Cassatt, Mary (American, 1844–1926), *Little Girl in a Blue Armchair* (1878). National Gallery of Art. Oil on canvas. Overall: 89.5 × 129.8 centimeters (35 1/4 × 51 1/8 inches); framed: 114.3 × 154.3 × 5.7 centimeters (45 × 60 3/4 × 2 1/4 inches). Collection of Mr. and Mrs. Paul Mellon, NGA 1983.1.18.

Body Shop

In the first century BC, the Roman architect Vitruvius, considered the ideal design of buildings and bodies. He suggested that architecture is a natural outgrowth of human ecology, just as a nest is an outgrowth of a bird's existence. He developed a framework for "building" the idealized male body. He said that when a well-proportioned man lies on the ground and extends his arms, the distance between his outstretched hands equals his height.[1] Thus, a man could be inscribed within a square with the sides equaling his height and outstretched hands. Vitruvius also stated that the navel defines the midpoint of a circle created when the arms are lifted up and the legs extended out. The most famous illustration of the "Vitruvian Man" was made by Leonardo, who placed the ideal man within Vitruvius's square and used the golden ratio to define the circle (Figure 9.2).[2]

Following Vitruvius' analysis, Leonardo studied the manner in which dimensions of various body parts are proportional to one another. He determined how the width of the torso, length of an arm, and size of the head could be drawn in relation to each other. The cubit, an ancient measure of length, was defined with respect to body parts: a man's height (6 feet) = 4 cubits (1½ feet), 1 cubit = 8 palms, 1 palm = 4 fingers. Leonardo gained an understanding of body proportion by dissecting cadavers and making sketches of his analyses. These drawings revealed both skeletal and muscular anatomy in exquisite detail.

Ancient Greek sculptors were adept in depicting the human body. Polykleitos, one of the most famous of Greek sculptors said, "a well-made work

9. BODY LANGUAGE

We communicate our moods and thoughts often without uttering a word. Consider Mary Cassatt's *Little Girl in a Blue Armchair* (1878) (Figure 9.1).The signals sent by this girl's body language is well understood. We can almost hear her whine, "I'm bored. There's nothing to do." Evolutionarily speaking, body language is essential for survival. It can determine the chances of having a main course for dinner or being one. It also increases the chances of mating, thus affording more opportunities to transmit one's genes to the next generation. In art, the body is the most frequently depicted object and has thus been represented and positioned in a multitude of ways.

■ Beauty and the Body

We delight in the beauty of a well-proportioned body. For both sexes, there is an ideal human form, and biology plays a critical role in shaping these preferences. Yet as described in chapter 7, culture also has a role, as demonstrated by changes in Western preferences for thinner women and more boyish facial features in men. What makes an attractive body? For better or worse, our genes have endowed each of us with a certain set of physical characteristics, such as body fat distribution, potential for muscular development, and facial attractiveness. Of course what we do with our bodies over time (e.g., what we put into them) molds our body shape in conjunction with our genetic predilections. Artists have spent considerable time acquiring the skills needed to depict human features in an idealistic or realistic manner.

32 Brown & Mann (1997). Kawabata, H., & Zeki, S. (2004). Neural correlates of beauty. *Journal of Neurophysiology, 91*, 1699–1705. Kirk, U., Skov, M., Christensen, M. S., & Nygaard, N. (2009). Brain correlates of aesthetic expertise: A parametric fMRI study. *Brain and Cognition, 69*, 306–315.

33 Ishizu, T. & Zeki, S. (2011). Toward a brain-based theory of beauty. *PLoS ONE. 6.* E21852.

34 Blood & Zatorre (2001).

35 Brown & Mann (1997).

36 Csikszentmihalyi, M. (1990). *Flow: The Psychology of Optimal Experience.* New York: Harper & Row.

37 Csikszentmihalyi, M., & Robinson, R. E. (1991). *The Art of Seeing: An Interpretation of the Aesthetic Experience.* Los Angeles: J. Paul Getty Museum.

38 Csikszentmihalyi & Robinson (ibid.), p.148.

39 Dewhurst, K., & Beard, A. W. (1970). Sudden religious conversions in temporal lobe epilepsy. *British Journal of Psychiatry, 117*, 497–507. Waxman, S. G., & Geschwind N. (1975). The interictal behavior syndrome in temporal lobe epilepsy. *Archives of General Psychiatry 32*, 1580–1586.

40 Egbert, D. D. (1967). The idea of "avant-garde" in art and politics. *The American Historical Review, 73*, 339–366.

41 Picasso on Gertrude Stein portrait, Metropolitan Museum of Art website:http://www.metmuseum.org/works_of_art/collection_database/modern_art/gertrude_stein_pablo_picasso/objectview.aspx?collID=21&OID=210008443

42 Berlyne (1971). (See chapter 1, n. 23.)

43 Kreitler, H., & Kreitler, S. (1972). *Psychology of the Arts.* Durham, NC: Duke University Press.

44 Lazarus, R. S., Opton, E. M., Nomikos, M. S., & Rankin, N. O (1965). The principle of short-circuiting of threat: Further evidence. *Journal of Personality, 33*, 622–635.

45 Actually, to some, clowns are inherently scary, which may potentiate the disturbing quality of Nauman's video.

46 Danto, A. C. (1983). *The Transfiguration of the Commonplace: A Philosophy of Art.* Cambridge, MA: Harvard University Press.

47 That year, the Turner Prize was awarded to Damien Hirst, who exhibited dead animals, such as a cow and sheep, in formaldehyde. Wallinger did win the Turner Prize in 2007 for his work entitled *State Britain*, which was a re-creation of a sidewalk display of posters and banners protesting Britain's involvement in the Iraq war.

48 Greenberg, C. (1968). Avant-garde attitudes. Lecture delivered at the University of Sydney, May 17, 1968, available at http://www.sharecom.ca/greenberg/avantgarde.html

Menon, V., & Reiss, A. L. (2003). Humor modulates the mesolimbic reward centers, *Neuron, 40*, 1041–1048. Koeppe, M. J., Gunn, R. N., Lawrence, A. D., Cunningham, V. J., Dagher, A., Jones, T., et al. (1998). Evidence for striatal dopamine release during a video game. *Nature, 393*, 266–268.

16 Blood, A. J., & Zatorre, R. J. (2001) Intensely pleasurable responses to music correlate with activity in brain regions implicated in reward and emotion. *Proceedings of the National Academy of Sciences, 98*, 11818–11823.

17 See Biderman, I., & Vessel, E. (2006). Perceptual pleasure and the brain. *American Scientist, 94*, 247–253.

18 Schachter, S., & Singer, J. (1962). Cognitive, social, and physiological determinants of emotional state. *Psychological Review, 69*, 379–399.

19 Dutton, D. G., & Aron, A. P. (1974). Some evidence for heightened sexual attraction under conditions of high anxiety. *Journal of Personality and Social Psychology, 30*, 510–517.

20 Barrett, L. F., Lindquist, A., & Gendron, M. (2007). Language as context for the perception of emotion. *Trends in Cognitive Science, 11*, 327–332.

21 LeDoux, J. (1994). *The Emotional Brain.* New York: Touchstone.

22 Hariri, A. R., Tessitore, A., Mattay, V. S., Fera, F., & Weinberger, D. R. (2002). The amygdala response to emotional stimuli: A comparison of faces and scenes. *NeuroImage, 17*, 317–323. Phelps, E. (2004). Human emotion and memory: Interactions of the amygdala and hippocampal complex. *Current Opinion in Neurobiology, 14*, 198–202.

23 Baumgartner, T., Lutz, K., Schmidt, C. F., & Jancke, L. (2006). The emotional power of music: How music enhances the feeling of affective pictures. *Brain Research, 1075*, 151–164.

24 Hamann, S. B., Ely, T. D., Hoffman, J. M., & Kilts, C. D. (2002). Ecstasy and agony: Activation of the human amygdala in positive and negative emotion. *Psychological Science, 13*, 135–141.

25 Susskind, J. M., Lee, D. H., Cusi, A., Feiman, R., Grabski, W., & Anderson, A. K. (2008). Expressing fear enhances sensory acquisition, *Nature Neuroscience, 11*, 843–850.

26 MacMillan, M. (2000). *An Odd Kind of Fame: Stories of Phineas Gage.* Cambridge, MA: MIT Press.

27 Harlow, J. M. (1868). Recovery of an iron rod through the head. *Publications of the Massachusetts Medical Society, 2*, 327–347.

28 Landesman, P. (2000). Speak, memory. *New York Times Magazine,* September 17, 2000, http://partners.nytimes.com/library/magazine/home/20000917mag-landesman.html

29 Shimamura, A. P. (2002). Muybridge in motion: Travels in art, psychology, and neurology. *History of Photography, 26*, 341–350.

30 *San Francisco Chronicle,* February 7, 1875.

31 Miller, Z. A., & Miller, B. L. (2011). A cognitive and behavioral neurological approach to aesthetics. In Shimamura & Palmer (2012). (pp. 356–374).

3 Darwin, C. (1965). *The Expression of the Emotions in Man and Animals.* Chicago: University of Chicago Press. (Originally published in 1872. London: John Murray.)

4 Ross, M. D., Owren, M. J., & Zimmermann, E. (2009). Reconstructing the evolution of laughter in great apes and humans. *Current Biology, 19,* 1–6. Izard, C. E., & Malatesta, C. Z. (1987). Perspectives on emotional development I: Differential emotions theory of early emotional development. In J. D. Osofsky (Ed.), *Handbook of Infant Development* (2nd ed., pp. 494–554). Oxford, UK: John Wiley & Sons.

5 Ekman, P., & Oster, H. (1979). Facial expressions of emotion. *Annual Review of Psychology, 30,* 527–554. Ekman, P., & Friesen, W. V. (1971). Constants across cultures in the face and emotion. *Journal of Personality and Social Psychology, 17,* 124–129.

6 Galati, D., Scherer, K. R., & Ricci-Bitti, P. E. (1997). Voluntary facial expression of emotion: Comparing congenitally blind with normally sighted encoders. *Journal of Personality and Social Psychology, 73,* 1363–1379.

7 Matsumoto, D. (1990). Cultural similarities and differences in display rules. *Motivation and Emotion, 14,* 195–214.

8 Klaske, M., & Phillips, D. (2003). *Picturing Men and Women in the Dutch Golden Age.* New Haven, CT: Yale University Press. Brown, J., & Mann, R. G. (1997). *Spanish Paintings of the Fifteenth Through Nineteenth Centuries.* Princeton, NJ: Princeton University Press.

9 For various views of the components of emotion, see Barrett, L. F., Mesquita, B., Ochsner, K. N., & Gross, J. J. (2007). The experience of emotion. *Annual Review of Psychology, 58,* 373–03. Ortony, A., Clore, G. L., Collins, A. (1988). *The Cognitive Structure of Emotion.* Cambridge, UK: Cambridge University Press. Reisenzein, R. (1994). Pleasure-arousal theory and the intensity of emotions. *Journal of Personality and Social Psychology, 67,* 525–539.

10 Ekman, P., Levenson, R. W., & Friesen, W. V. (1983). Nervous system activity distinguishes among emotions. *Science, 221,* 1208–1210.

11 Davidson, R. J. (2000). Affective style, psychopathology, and resilience: Brain mechanisms and plasticity. *American Psychologist, 55,* 1196–1214.

12 Zenter, M. R. (2001). Preferences for colours and colour-emotion combinations in early childhood. *Developmental Science, 4,* 389–398.

13 Olds, J., & Milner, P. (1954). Positive reinforcement produced by electrical stimulation of septal area and other regions of rat brain. *Journal of Comparative and Physiological Psychology, 47,* 419–427.

14 Small, D. M., Zatorre, R. J., Dagher, A., Evans, A. C., & Jones-Gotman, M. (2001). Changes in brain activity related to eating chocolate: From pleasure to aversion. *Brain, 124,* 1720–1733.

15 Ahrons, I., Etcoff, N., Ariely, D., Chabris, C. F., O'Connor, E., & Breter, H. C. (2001). Beautiful faces have variable reward value: fMRI and behavioral evidence. *Neuron, 32,* 537–551. Mobbs, D., Greicius, M. D., Abdel-Azim, E.,

approach in addition to any other perspective. Thus, though not inherent in *all* artworks, we generally seek positive feelings and pleasure when we experience art. It is important, however, to realize that our feelings are based primarily on a cognitive appraisal. In particular, our personal episodic memories and cultural experiences guide our emotional response. As such, a painting may evoke pleasure in one individual and sadness in another. Cognitive appraisal always occurs, and even those artworks that appear to immediately "hit us in the gut" or "send chills down our spine" are based on some kind of cognitive analysis, consciously or unconsciously driven.

We are endowed with brain circuits that interpret and respond to emotional events. These circuits are essential for survival, because they tell us what things to approach and what things to avoid. Moreover, they determine how to respond in social situations. The hypothalamus links the brain with the body by inducing a fight-or-flight response that arouses bodily functions, such as increasing heart rate, respiration, glucose metabolism, and muscle tone. The brain's reward circuit responds to pleasurable events by stimulating the release of dopamine. Both the fight-or-flight response and reward circuit are activated by the amygdala, which is the link between emotional circuits and the cognitive appraisal of events. We are, however, not slaves to our emotions. We can suppress them or elicit them depending on the social context. It is the orbito frontal cortex, the CEO of our emotions, that monitors and controls whether we express or suppress our feelings.

In an expressionist approach, we have co-opted these emotional brain circuits in the service of generating emotions to art. Art allows us to imagine ourselves in emotional circumstances without having to actually involve ourselves in real-life events. An important feature of art is novelty. We seek new and different experiences when we view art. Yet as Berlyne noted, an artwork that appears too novel or too surprising may induce negative feelings. Importantly, our sense of what's new is a moving window, as the more knowledge we acquire, the more things become familiar. In many ways, our own art experiences recapitulate art history. At first we may have enjoyed Impressionist paintings but found works by Cezanne, Matisse, and Picasso rather odd. As we gained a better understanding of the principles of modern art, we may begin to appreciate abstract artists, such as Kandinsky, Pollock, and Newman. With an appreciation of the conceptual nature of postmodern works, we may even associate such works with positive feelings. The bottom line is that what you know is how you feel.

■ Notes

1 *Sketches of Frank Gehry* (2006). Sony Pictures Home Entertainment.
2 See Sapolsky, R. M. (1994). *Why Zebras Don't Get Ulcers*. New York: W. H. Freeman and Co.

Such works, in Arthur Danto's view, are *transfigured*—having been glorified and raised to the status of high art.[46] In the context of an art museum, such familiar objects elicit emotions linked to novel experiences, such as surprise, bemusement, and perhaps annoyance.

For over a hundred years, artists have attempted to shock us with new and surprising works. They have pushed the boundaries of what "art" can be, so much so that now virtually any *thing* can be presented as a work of art. The artist Mark Wallinger was shortlisted for the 1995 Turner Prize, the prestigious award which acknowledges the best in British contemporary art, for his work entitled *A Real Work of Art*. Wallinger's art piece was an actual racehorse that he purchased and had entered in a race.[47] In the postmodern artworld, any object, including a living animal, can be submitted as a work of art. Artists have used their bodies and excrements as artworks, sometimes in vividly sadomasochistic ways. Art critic Clement Greenberg went on to state that "in this context, the Milky Way might be offered as a work of art," though he acknowledged that christening the galaxy as art would be "banal."[48] When so much has been offered in the name of art, it becomes exceedingly difficult to shock. Nothing these days is so novel as to generate much surprise. When all of the boundaries have been extended, what is the avant-garde artist to do? Many view the last quarter of the twentieth century as the demise of avant-gardism, as we have extended the boundaries of art so far that it is difficult if not impossible to shock the art world anymore.

What happens when the novelty wears offs? Familiarity can be so damning that it becomes difficult to truly appreciated very familiar artworks, such as the *Venus deMilo* or *Mona Lisa*. They have become as habitual as a dining room chair, and we are blind to their aesthetic value. To make such works new again, we must find ways of seeing and thinking about them in a new light. If an artwork is complex or interesting enough, it can be viewed, interpreted, and felt in new ways. As our aesthetic feelings of novelty and surprise are based primarily on our cognitive appraisal, a familiar artwork can look new and refreshing when considered from a different conceptualization or perspective. Also recent life experiences, whether joyful or sad, can make a familiar, perhaps previously uninteresting, artwork have new meaning and emotional impact.

■ In the Mood

With the art of feeling, we are driven by arousal and hedonic value. According to eighteenth century views of *the* aesthetic experience, art is meant to induce feelings of beauty and sublimity. Such feelings are considered the *sine qua non* of the art experience, and we seek them because they give us pleasure. Although we could take a strict conceptual approach to art, keying only on the intellectual aspects of an artwork, most beholders take an expressionist

to link up with prior knowledge and experiences. Familiarity is the flip side of novelty. We find comfort in familiar objects and often prefer them over things that are completely new. With overly repetitive experiences, however, we can become desensitized. Consider the various objects in your home. Many are so familiar that you pay little attention to them. This tendency to become indifferent to familiar objects has evolutionary significance, because if every single stimulus grabbed our attention, the mental load would lead to unbearably high stress levels. Instead, we have the capacity to pay special attention to novel or unfamiliar events. Why waste mental effort on things that you already know and expect not to change? As such, there is no reason to pay special attention to the chairs in your dining room; yet if one suddenly caught fire, the object would certainly capture your interest.

Sometimes the familiar can be made novel by changing its context or scale. Claes Oldenburg creates such objects by constructing enormous sculptures of familiar objects, such as his 45-foot-high, 10-ton sculpture in downtown Philadelphia called *Clothespin* (1967) (Figure 8.12). By changing the scale and context of this familiar object (at least familiar to an older generation), we cannot possibly pass it without appreciating its novelty. When common objects are presented as works of art and placed in the context of an art museum, such as Duchamp's urinal or Warhol's *Brillo Boxes*, their meaning and status changes.

FIGURE 8.12 Oldenburg, Claes, *Clothespin*, a 45-foot high sculpture in downtown Philadelphia, Pennsylvania.

The imaginative nature of our art experience allows us to entertain thoughts and feelings that we would never actually "act out." Thus, art has the ability to place in our minds new experiences in the safety of an art museum, movie theatre, or our own living room. Works that instill horror, threat, anger, sadness, or disgust may do so by creating imagined as opposed to real tension. Freud believed that the primary purpose of art is to channel our anxieties and personal tensions in a way that is socially acceptable—such as an artist creating paintings with horrific scenes or a beholder imagining being the person depicted in a horrific scene. Freud thought that art could be therapeutic as it allowed one to redirect or *sublimate* sexual and aggressive tensions through imagination rather than through overt behavior.

We tend to vary the degree to which we become emotionally involved. In a psychological study, individuals were shown a grisly industrial safety film in which careless workers are portrayed in workshop accidents, such as a person cutting off his finger with a milling machine.[44] The emotional response to the film clip, as measured by heart rate and skin conductance (i.e., sweaty palms), was modulated by creating psychological distance from the depiction. For example, emotions were reduced by telling subjects that the film was meant to frighten people and actually depicted actors simulating the accidents. When we experience art, we vary our emotional involvement. For example, our emotional response to Géricault's *The Raft of the Medusa* (Figure 8.4) may be determined by how closely we imagine ourselves on the raft. Knowing that this painting depicts an actual event may bring us closer to it. On the other hand, we may decide not to get pulled into the scene and appreciate the formal qualities of the painting. In our experiences with art, we have the capacity to create emotional tension or turn away from it.

Emotional tension was clearly the intent of Bruce Nauman's video installment entitled *Clown Torture* (1987). Our experiences with clowns are generally pleasurable; they make us laugh by their raucous and befuddled nature. We would never have imagined seeing them as they are depicted in Nauman's video art. In one scene, we see a terrified clown sitting on the floor with raised and shaking hands and feet as he screams "NO!, NO!" The clown's fright appears to be directed at us. On another video, a clown is using a public toilet. The use of clowns to portray these acts imparts considerable tension as we know them to be the embodiment of mirth and amusement. These novel and shocking depictions are quite disturbing, particularly because of our knowledge of what clowns represent. Nauman plays on these tensions and delivers to the beholder an emotionally charged experience.[45]

The Flip Side of New

We enjoy novelty in artworks, as we desire some tension and arousal in our art experience. But we lose interest quickly if an artwork is too novel or fails

Of course, what is new to one person (or generation) may be familiar and old hat to another. Feelings of novelty depend upon one's existing knowledge and prior experiences. Often one hears that an experience—perhaps eating sushi, listening to Stravinsky, or appreciating Minimalism—is an "acquired taste." This term suggests that knowledge and experience are necessary for full enjoyment. If a particular artwork is too far from one's prior experiences, it may not be easily understood and thus viewed negatively. Consider the evolution of jazz, which in the early swing era was novel yet familiar enough in melodic and rhythmic form to appeal to the masses. Later, bebop appeared, and its complex chromatic transitions and odd rhythms put off many of those who enjoyed swing. To appreciate fully these later jazz musicians, such as Thelonious Monk and John Coltrane, it is useful to have knowledge and experience of the evolution of jazz forms. Indeed, to enjoy fully any new work of art, it is important to have knowledge and experience of its history. Picasso understood this point: when someone viewed the *Portrait of Gertrude Stein* and said that it didn't look like Gertrude Stein, Picasso answered, "it will."[41]

Tension in Art

Novelty can create a sense of discomfort or tension as we try to interpret new works from our existing knowledge schema. We might use terms such as "odd," "weird," or even "silly" to characterize our feelings. If we succeed in accommodating a new work into our knowledge base—that is, if we can appreciate it—there is a feeling of satisfaction as tension is released. Many art theorists have considered tension and its resolution as central features in our art experience. Arnheim considered perceptual tension caused by asymmetrical or non-central placement of objects as a way of creating visual dynamics in paintings (see chapter 4). Berlyne suggested that tension increases emotional arousal.[42]

Hans Kreitler and Shulamith Kreitler developed a theory of aesthetics that is based on tension and its relief.[43] They suggested that all art forms, including visual, musical, dramatic, and literary artworks, create tension which we try to resolve. By this view, we gain pleasure from an artwork because it evokes emotional tension, which then gets resolved by our understanding of it. This view is more readily understood by considering our emotional involvement with a novel or movie. Tension builds as we involve ourselves in a story and follow the trials and tribulations of the characters. We gain pleasure in this imaginative experience and seek resolution of the story. Likewise, when we experience a painting for the first time, we may become emotionally involved by its odd or surprising nature. Tension builds as we try to understand the intentions of the artist or try to concoct our own interpretation of the artwork. If the painting depicts a scene, we may put ourselves in it. Pleasure is gained from this experience and, in particular, from the feelings we get when we develop an understanding of an artwork.

Morton College Library Cicero, ILL

FIGURE 8.11 Caravaggio, Michelangelo Merisi da (1573–1610), *Death of the Virgin* (1605). Louvre, Paris, France. Photo Credit: Erich Lessing / Art Resource, NY. (See color plate section.)

approach, beholders could appreciate an artwork for its perceptual qualities without having to consider or interpret the "representation" of objects. When formalist artists were accepted, others moved to the front line and rejected the importance of the visual form. We have already described the Dada movement and its later offspring, Pop art, which emphasized the conceptual nature of art. As defined by Duchamp's *Fountain*, art was not meant to evoke significant form or even an aesthetic feeling of beauty. When we behold Duchamp's art, we must question the meaning of art itself and wonder why one would include such pieces in an "art" museum.

Caravaggio's realism, Impressionism, Duchamp's objects, and other avant-garde works were considered at first shocking and unappealing. By Berlyne's view, these works were negatively disposed because they were too new or too arousing. For a few beholders, these novel renderings were interesting and provocative. Gertrude Stein, the American writer, admired and collected works by Cezanne, Picasso, and Matisse at a time when most viewed their art as crude, awkward, and distasteful. The *Portrait of Gertrude Stein* (1906) by Picasso portrays a rather coarse figure if one considered it a realistic painting (i.e., viewed from a mimetic approach). In this portrait, painted a year before *Les Demoiselles d'Avignon*, we see Picasso's burgeoning interest in African masks and the breakdown of form.

■ The Chic of the New

As Berlyne described, we are aroused by new and surprising works. Indeed, artists often attempt to impress us, and even shock us, with new and creative works. When taken too far, new works may engender feelings of confusion or even disgust. These days it has become more and more difficult to create novel art experiences, as much has appeared in the name of art. By the twenty-first century, we seem to have seen almost everything as art, and the *shock of the new* has turned into the *chic of the new*.

What's New?

There is a well-described stereotype of the *avant-garde* artist, that marginalized bohemian whose new works are not yet appreciated. These artists push the boundaries of acceptable art, and, if considered worthy, they are honored by such adjectives as "innovative," "fresh," and "cutting edge." The French socialist thinker Henri de Saint-Simon laid out the platform for avant-garde artists when he suggested that they stand above scientists and industrialists in their zeal to put on canvas powerful new ideas.[40] During the nineteenth century, avant-garde artists rejected the established norms and formed their own counterculture. Most notable among these renegade artists were those associated with the *Salon des Refusés*, such as Manet, Whistler, and the Impressionists. These artists set up galleries next to the Academy's salons and showcased the works that were not accepted by the establishment. By the beginning of the twentieth century, the Academy appeared stodgy and overly conservative, and it was these outcast avant-garde artists who seemed to express the feelings of their time.

The excitement and shock of the new goes back even further, at least as far back as Caravaggio. A dandy and rather scurrilous character, Caravaggio depicted scenes from the Bible with such realism that it shocked beholders. Many found his works vulgar and distasteful, such as *Death of the Virgin* (Figure 8.11). This painting was to be placed as an altarpiece in the Carmelite church of Santa Maria della Scala in Rome. When the Carmelite monks saw it, they rejected it because of its shocking rendering of the Virgin, who was shown as a swollen dead carcass in a starkly realistic pose. It was said that Caravaggio used a prostitute to model the pose. It was never placed in the church, though other painters at the time, such as Rubens, admired the painting.

The story of twentieth century art includes many chapters of the rise and fall of avant-garde artists. By the beginning of the century, Impressionism was generally accepted and admired by the establishment. Other artists, such as Cezanne, Picasso, and Matisse, then pushed the boundaries with further innovations and surprises. As described in our analysis of the *Art of Seeing*, these early modernist painters decomposed the visual form into primitive components, such as basic shapes, colors, and lines. By considering a formalist

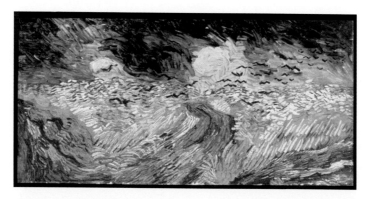

FIGURE 10.6 Van Gogh, Vincent (1853–1890), *Wheatfields and Crows* (1890). Van Gogh Museum, Amsterdam, The Netherlands. Photo Credit: Art Resource, NY.

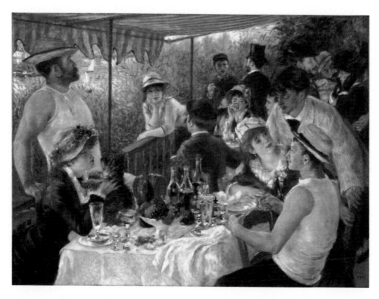

FIGURE 11.4 Renoir, Pierre-Auguste, *Luncheon of the Boating Party* (1881). Oil on canvas. The Phillips Collection, Washington, DC.

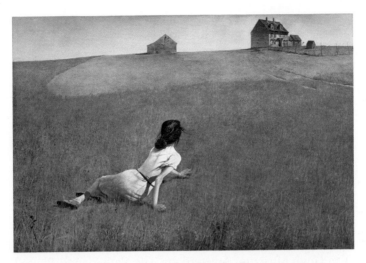

FIGURE 10.1 Wyeth, Andrew (1917–2009), *Christina's World*.
© Copyright, 1948. Tempera on gessoed panel, 32 1/4 × 47 3/4 inches.
Purchase. The Museum of Modern Art, New York, NY. Photo Credit:
Digital Image © The Museum of Modern Art/Licensed by SCALA / Art
Resource, NY. Courtesy of Andrew Wyeth Office.

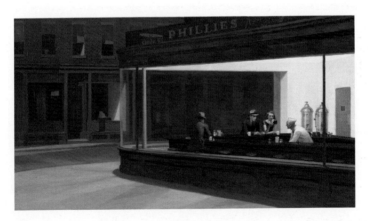

FIGURE 10.2 Hopper, Edward, *Nighthawks*.

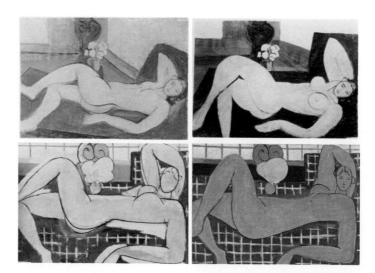

FIGURE 9.11 Evolution of Henri Matisse's *Large Reclining Nude* (completed October 31, 1935): *Top left*: State I (May 3, 1935); *Top right*: State V (May 20, 1935); *Bottom left*: State XXI (October 16, 1935); *Bottom right*: completed painting, oil on canvas, 26 × 36 1/2 inches (66 × 92.7 centimeters.). The Cone Collection, Archives and Manuscripts Collections. Reproduced with permission from The Baltimore Museum of Art.

FIGURE 9.13 Yue Minjun, Untitled, 2005. Oil on canvas, 220.3 × 200 centimeters. Reproduced with permission from Yue Minjun Studio.

FIGURE 8.11 Caravaggio, Michelangelo Merisi da (1573–1610), *Death of the Virgin* (1605). Louvre, Paris, France. Photo Credit: Erich Lessing / Art Resource, NY.

FIGURE 9.7 Funeral portrait of Aline. From Hawara, Fayum Oasis, Egypt. Painting on canvas. Roman period (*c.* 50 AD). Aegyptisches Museum, Staatliche Museen, Berlin, Germany. Photo Credit: Erich Lessing / Art Resource, NY.

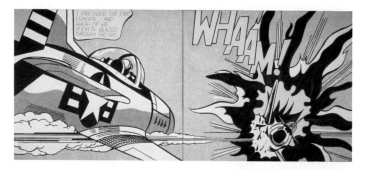

FIGURE 7.9 Lichtenstein, Roy (1923–1997), *Whaam!* © Estate of Roy Lichtenstein (1963). Magna acrylic and oil on canvas. 2 canvases, each 68 × 80 feet (172.7 × 203.2 centimeters). Photo Credit: Tate, London / Art Resource, NY.

FIGURE 8.10 Kline, Yves (1928–1962), Untitled Anthopometry (1960). © ARS, NY. Pure pigment and synthetic resin on paper. 194 × 128 × 2.7 centimeters. Museum Ludwig, Cologne, Germany. Photo Credit: Banque d'Images, ADAGP / Art Resource, NY.

FIGURE 7.1 (a) Ancient Greek statue known as the *Pelpos Kore.* with Dorian peplos (Inv. 679) (*c.* 530 BC). Marble. H.: 48 inches (122 centimeters). Acropolis Museum, Athens, Greece. Photo Credit: Nimatallah / Art Resource, NY. *(b)* Painted model of the statue reconstructed from archeological information. Photograph courtesy of Ulrike Koch-Brinkmann.

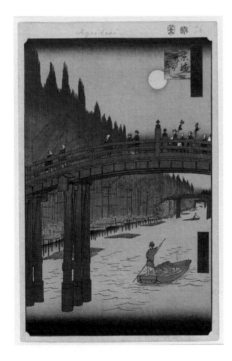

FIGURE 7.4 Hiroshige, Utagawa (Ando) (Japanese, 1797–1858), *Bamboo Yards, Kyobashi Bridge, No. 76* from *One Hundred Famous Views of Edo*, 12th month of 1857. Woodblock print, Sheet: 14 3/16 × 9 1/4 inches (36 × 23.5 centimeters). Brooklyn Museum, Gift of Anna Ferris, 30.1478.76.

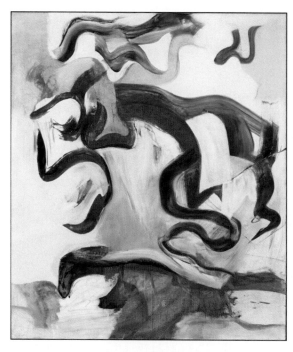

FIGURE 6.3 de Kooning, Willem (1904–1997), *Untitled V and Untitled 1987* (1982). Oil on canvas, 6 feet, 8 inches × 70 inches (203.2 × 177.8 centimeters). © ARS, NY. Gift of Philip Johnson. Photo Credit: Digital Image © The Museum of Modern Art/Licensed by SCALA / Art Resource, NY.

FIGURE 6.9 Lucian Freud (British, b. 1922), *Hotel Bedroom* (1954). Oil on canvas, 91.1 × 61.0 centimeters. Gift of The Beaverbrook Foundation, The Beaverbrook Art Gallery, Fredericton, NB, Canada.

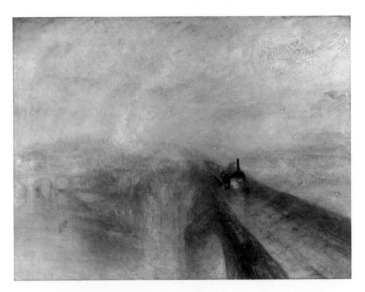

FIGURE 5.11 Turner, Joseph Mallord William (1775–1851), *Rain, Steam and Speed—The Great Western Railway* (1844). Oil on canvas, 91 × 121.8 centimeters. The scene is fairly certainly identifiable as Maidenhead railway bridge, across the Thames between Taplow and Maidenhead. The bridge, which was begun on Brunel's design in 1837 and finished in 1839, has two main arches of brick, very wide and flat. The view is to the east, towards London. Turner Bequest, 1856 (NG538). National Gallery, London, Great Britain. Photo Credit: © National Gallery, London / Art Resource, NY

FIGURE 6.1 Chagall's *I and the Village*. Chagall, Marc (1887–1985) © ARS, NY. *I and the Village* (1911). Oil on canvas, 6 feet, 3 5/8 inches × 59 5/8 inches. Mrs. Simon Guggenheim Fund. Photo Credit: Digital Image © The Museum of Modern Art/Licensed by SCALA / Art Resource, NY. (See also note 2.)

FIGURE 5.7 Rousseau, Henri (1844–1910) *Le Douanier* (The Merry Jesters) (1906). Oil on canvas, 57 3/8 × 44 5/8 inches (145.7 × 113.3 centimeters). The Louise and Walter Arensberg Collection, 1950. Philadelphia Museum of Art, Philadelphia, Pennsylvania. Photo Credit: The Philadelphia Museum of Art / Art Resource, NY.

FIGURE 5.5 Chagall, Marc (1887–1985), *L'Anniversaire* (1915). Oil on canvas. 31 3/4 × 39 ¼ inches. © ARS, NY. Acquired through the Lillie P. Bliss Bequest. The Museum of Modern Art, New York, NY. Photo Credit: Digital Image © The Museum of Modern Art/Licensed by SCALA / Art Resource, NY.

FIGURE 4.8 Picasso, Pablo (1881–1973), Portrait of Dora Maar (1937). Oil on canvas, 92 x 65 centimeters. © ARS, NY. Photo: Jean-Gilles Berizzi. Musee Picasso, Paris, France. Photo Credit: Réunion des Musées Nationaux / Art Resource, NY.

FIGURE 4.6 *Top*: Vincent Van Gogh, *Le café de nuit* (The Night Café). Yale University Art Gallery. Bequest of Stephen Carlton Clark, B. A. 1903. *Bottom*: Three different vanishing points based on receding lines.

FIGURE 4.7 Cezanne, Paul (1839–1906), *Still Life With Cherries And Peaches* (1885–1887). Oil on canvas, 19 3/4 × 24 inches (50.165 × 60.96 centimeters). Gift of Adele R. Levy Fund, Inc., and Mr. and Mrs. Armand S. Deutsch (M.61.1). Los Angeles County Museum of Art, Los Angeles, CA. Photo Credit: Digital Image © 2009 Museum Associates / LACMA / Art Resource, NY.

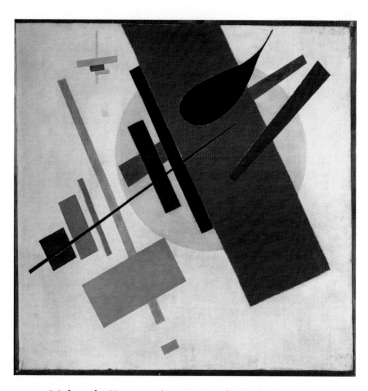

FIGURE 3.9 Malevich, Kazimir (1878–1935), *Suprematism, (c.* 1917). Oil
on canvas, 80 × 80 centimeters. Museum of Fine Arts, Krassnodar, Russia.
Photo Credit: Erich Lessing / Art Resource, NY

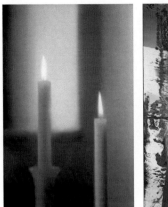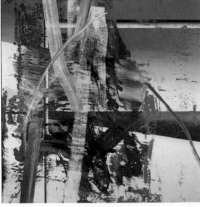

FIGURE 2.10 *Left*: Richter, Gerhard. *Two Candles* (*Zwei Kerzen*) (1982). *Right*: Richter, Gerhard. *Station* (1985). Both images reproduced with permission from © Gerhard Richter 2012.

FIGURE 3.7 Cezanne, Paul, (1839–1906), Mont Sainte-Victoire (*c.* 1902–1906). Oil on canvas, 22 1/2 × 38 1/4 inches (57.2 × 97.2 centimeters). The Walter H. and Leonore Annenberg Collection, gift of Walter H. and Leonore Annenberg, 1994, bequest of Walter H. Annenberg, 2002 (1994.420). The Metropolitan Museum of Art, New York. Photo Credit: Image copyright © The Metropolitan Museum of Art / Art Resource, NY.

FIGURE 2.1 Church, Frederic Edwin (American, 1826–1900), *Twilight in the Wilderness* (1860). Oil on canvas, 124 × 185 centimeters. The Cleveland Museum of Art. Mr. and Mrs. William H. Marlatt Fund 1965.233.

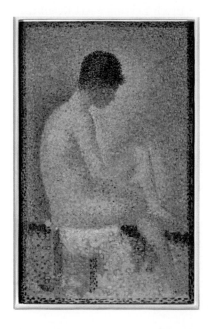

FIGURE 2.6 Seurat, Georges (1859–1891). Sitting model, profile. Musee d'Orsay, Paris, France. Photo Credit: Erich Lessing / Art Resource, NY.

FIGURE 2.7 Stained-glass illusion.

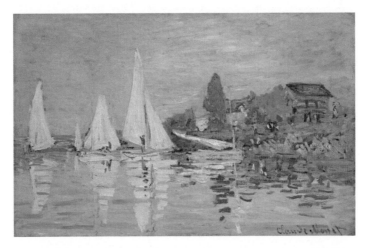

FIGURE 1.1 Monet, Claude (1840–1926). *Regatta at Argenteuil* (*c*.1872). Musee d'Orsay, Paris, France. Photo Credit: Erich Lessing / Art Resource, NY. (See also note 1.)

Representational "VA" Indeterminate "RP" Abstract "AB" Scrambled "SC"

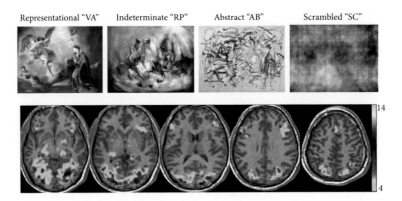

FIGURE 1.11 In a fMRI study, subjects viewed various types of paintings (representational, indeterminate, and abstract) and a scrambled visual image (*top row*). Brain images (*bottom row*) show horizontal scans at five levels with heightened activations (shades of blue) when the viewing of paintings is compared to the viewing of a scrambled visual image. Reprinted from Fairhall, S. L., & Ishai A. (2008). Neural correlates of object indeterminacy in art compositions. *Consciousness and Cognition, 17*, 923–932. Copyright (2008) with permission from Elsevier.

FIGURE 8.10 Yves Kline (1928–1962), Untitled Anthopometry (1960). © ARS, NY. Pure pigment and synthetic resin on paper. 194 × 128 × 2.7 centimeters. Museum Ludwig, Cologne, Germany. Photo Credit: Banque d'Images, ADAGP / Art Resource, NY. (See color plate section.)

There is a rare brain disorder that can elicit an experience similar to a flow experience. Patients with temporal lobe epilepsy (TLE) often experience otherworldly or even spiritual experiences.[39] Epilepsy causes momentary electrical storms (i.e., seizures) in the brain that begin at a focal point and then spread to other brain regions. It is one of the oldest known neurological disorders and has various causes, such as malformations from birth or tissue irritation following brain injury. Before or after a seizure some patients with TLE exhibit strange alterations in consciousness. They may feel a heightened sensory experience, even hallucinations. They may also exhibit feelings of *déjà vu* (illusions of familiarity) or its complement, *jamais vu*, feelings of strangeness or unfamiliarity in a familiar setting. TLE appears to heightened emotional experiences and can even cause feelings of hyper-religiosity. There are documented cases of TLE in which individuals have a religious conversion experience. Some describe a feeling of spiritual elation, as if ascending to heaven. Unlike a brain lesion, where an area becomes damaged and thus deactivated, TLE induces over-excitation of brain regions. Such activations may on rare occasions mimic the kind of heightened perceptual, cognitive, and emotional activations that occur during flow experiences.

as a sense of satisfaction for no other reason than feeling the pleasures of the activity. Flow can be achieved during many activities, including bodily movement (dance, sports), cognitive activity (science, math), and play (music, art, video game playing). An essential condition for flow is having attained a high level of proficiency in a skill or intellectual endeavor.

Csikszentmihalyi and Robinson[37] noted shared qualities between flow and aesthetic experiences, as both involve heightened emotions, a loss of perceived time, and an autotelic (i.e., disinterested) disposition. To assess the link between the two, they interviewed professionals in the art world, such as museum curators, art historians, and art directors, about their art experiences. For virtually all of these professionals, the emotional quality of an artwork was essential. Just as important, however, was the cognitive challenges embodied by an artwork. Thus, these professional beholders considered both an expressionist and conceptual approach to art. Many stated that when emotional and conceptual processes are heightened, aesthetic experiences seemed to elevate them to a higher plane. In response to a question in the survey, one museum professional stated:

> I remember [Yves] Klein paintings that seemed to me immediately accessible, were immediately wonderful: had that sort of "knock-you-back-and-lift-you-off-the-feet" sense to them. You have an immediate emotional or intellectual connection with the painting…[38]

Yves Klein, the noted conceptual artist often used "living paintbrushes." He anointed nude bodies with blue paint and directed these people to roll around or had them dragged across a large canvas thus creating a record of their performance (see Figure 8.10). With knowledge of the painting process and the rather beautiful abstractions created by the body prints, one can understand this professional's remark about art creating both as an emotional response and a conceptual challenge.

Considering the aesthetic experiences of these professionals, the beholder's share may best be viewed as *thinking with feeling*. At their most heightened moments, such experiences may be akin to flow, wherein the beholder is *in the groove*. In this way, an artwork can be a portal to a rather unusual consciousness during which time stands still and one becomes intently focused on the artwork's perceptual, conceptual, and emotional qualities. One can imagine the brain's activation during such moments as running full tilt. That is, brain regions associated with visual perception (occipital cortex, the ventral and dorsal pathways), thoughts and memories (prefrontal cortex, hippocampus, posterior parietal cortex), and emotions (fight-or-flight response, reward circuit, amygdala, orbitofrontal cortex) may be at full throttle and channeled to create a heightened aesthetic experience. It is perhaps no wonder that these wow experiences are rather rare. It may be that all of these brain processes must be highly active and coordinated to render such flow experiences.

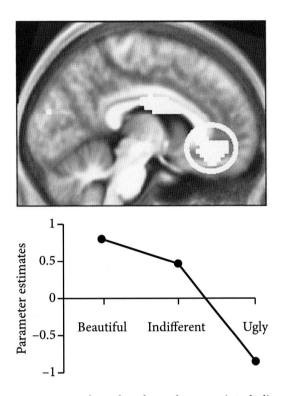

FIGURE 8.9 Activation in the orbitofrontal cortex (circled) when individuals rated paintings as beautiful compared to indifferent or ugly. Reproduced from Ishizu, T., & Zeki, S. (2011). Toward a brain-based theory of beauty. *PLoS ONE. 6.* E21852.

increased activity in response to beautiful works. While listening to classical music that was rated as intensely pleasurable (e.g., Rachmaninoff's *Piano Concerto No. 3 in D Minor, Opus 30*) the orbitofrontal cortex was also very active.[34] In fact, many pleasurable experiences, including looking at paintings, listening to music, eating chocolates, and sniffing wine, activate the orbitofrontal cortex, though it appears that each sensory experience (vision, audition, taste, smell) activates a different area within this region.[35]

In the Groove

There are times when one feels so attuned to the moment that emotional and cognitive processes are dialed to the maximum. Skilled performers, such as musicians and athletes, often say that they are "in the groove" or "in the zone." Psychologist Mihaly Csikszentmihalyi defined such optimally pleasurable experiences as *flow*.[36] The *flow* experience consists of a heightened focus of attention, a merging of awareness and action, a clear sense of goals, and a loss of time. A key feature is its *autotelic* quality, which Csikszentmihalyi defines

Muybridge appeared sane and stable during his trial. Muybridge was acquitted, however, because members of the jury could not condemn Muybridge, as they would have done the same under similar circumstances. Following the jury's pronouncement, it was reported that...

> a convulsive gasp escaped the prisoner's lips, and he sank forward from his chair... His emotion became convulsive and frightful. His eyes were glassy, his jaws set and his face livid. The veins of his hands and forehead swelled out like whipcord. He moaned and wept convulsively, but uttered no word of pain or rejoicing. Such a display of overpowering emotion has seldom, if ever, been witnessed in a Court of justice.[30]

Muybridge's head injury occurred before he began his career as a professional photographer. Thus, his emotional disturbance did not seem to deter his creative abilities. It did lead to obsessive-compulsive behavior, as evidenced by his catalog of over 20,000 photographs of animals and people in motion. Social disinhibition is also apparent by the fact that he himself posed nude in several of his photographic series of people in motion. It is interesting to speculate whether orbitofrontal damage actually enhanced his creative abilities. One could suppose that disinhibited emotions can heighten one's creativity. Interestingly, Dr. Bruce Miller, a neurologist at the University of California, San Francisco, has studied artistic abilities in patients with orbitofrontal damage due to a neurological disorder called frontotemporal dementia (FTD).[31] These patients develop a particular interest in creating art. One possibility is that FTD patients are less inclined to inhibit or suppress their emotions, and as a result become more expressive. Thus, it is not that orbitofrontal damage makes one more creative or more artistic in an aesthetic sense. Instead, individuals with orbitofrontal damage may be less inhibited in expressing their emotions overtly, as in the creation of art.

As the supervisor of feelings, the orbitofrontal cortex is critical in the appraisal and expression of emotions. You may feel angry or extraordinarily aroused in a classroom or during a meeting at work, but your brain's CEO will encourage you to suppress your emotions as there may be negative consequences if you act out in that context. Whenever we are confronted with an emotional experience, the orbitofrontal cortex is there to monitor emotions and prevent us from doing something we may regret later. This form of emotional metacognition appears to be a highly evolved function, perhaps allowing us to disengage from the present and consider future ("what if...") scenarios.

In neuroimaging studies, the orbitofrontal cortex is particularly active when we evaluate beauty in artworks.[32] In one study, subjects viewed paintings and rated their aesthetic impression as beautiful, indifferent, or ugly. The orbitofrontal cortex was particularly active for paintings rated beautiful, and this activity decreased for paintings rated indifferent and ugly (Figure 8.9).[33] Other areas, such as the cingulate cortex, insula, and parietal cortex, also showed

impairment, his emotional disposition changed dramatically, as described by the physician who treated Gage, John Martyn Harlow:

> He is fitful, irreverent, indulging at times in the grossest profanity (which was not previously his custom), manifesting but little deference for his fellows, impatient of restraint or advice when it conflicts with his desires, at times pertinaciously obstinate, yet capricious and vacillating, devising many plans of future operation, which are sooner arranged than they are abandoned in turn for others appearing more feasible… In this regard his mind was radically changed, so decidedly that his friends and acquaintances said he was 'no longer Gage.'[27]

Damage to the orbitofrontal cortex affects one's ability to regulate or control emotions. Patients with damage to this area act out their feelings and desires with reckless abandon. They have problems socially because they respond before appraising the consequences of their behavior. If they feel angry, they become aggressive; if they are sexually aroused, they may immediately act out their feelings. This brain region is thus critical for pulling the reins on our emotional responses and allowing us to think about the future consequence of our behavior. Consider Samantha Fishkin, who was ejected out the window of an overturning pickup truck as her boyfriend swerved to avoid another vehicle. Samantha hit a concrete embankment that fractured her skull and caused severe frontal lobe damage. In a *New York Times* Magazine article about her brain injury, the author, Peter Landesman, wrote: "the new Samantha was savagely disinhibited. Breaks in her neural web had erased all sense of social convention. She couldn't control her desire to talk, her anger, her sexual urges."[28] Orbitofrontal damage disrupts the ability to control one's emotion and thus causes emotional outbursts, inappropriate social behavior, risk-taking behavior, and obsessive-compulsive disorder.

What happens when an artist incurs orbitofrontal damage? The life of nineteenth century photographer Eadweard Muybridge offers some insight. As mentioned in chapter 5, Muybridge is known for his artistic and scientific application of photography to capture animals in motion. He was also an extraordinary landscape photographer and the inventor of one of the first motion picture projectors.[29] Muybridge's life was significantly affected when he was thrown from an out-of-control stagecoach and hit his head against a boulder. This brain injury led to emotional outbursts and aggressive behavior, as evidenced by the fact that Muybridge murdered his wife's lover after finding out that the baby his wife bore was likely not his. During the murder trial, Muybridge's defense lawyers entered a plea of insanity, using as evidence the brain injury incurred from his stagecoach accident. Friends and colleagues testified that prior to his accident Muybridge was a good businessman, genial and pleasant in nature; but after the accident, he was irritable, eccentric, a risk-taker, and subject to emotional outbursts. The jury, however, did not accept the insanity plea, as

why these images have become so iconic is that they depict the frightful scream with convincing authenticity. Interestingly, fear acts to enhance sensory processes.[25] The wide-eyed look facilitates fixations to targets in the environment, and the flared nose enhances air inhalation. Just the opposite occurs with the expression of disgust as the eyes squint and the nasal passage narrows.

Controlling Our Emotions

As with all high-level mental processes, it is the prefrontal cortex, the brain's CEO, that oversees and controls emotional events. The prefrontal cortex is not needed when eliciting an emotional response driven by the hypothalamus or reward circuit. Indeed, patients with damage to the prefrontal cortex, specifically the *orbitofrontal cortex*, exhibit exaggerated emotions, as if they lack the ability to control their feelings. The orbitofrontal cortex is situated at the bottom of the prefrontal cortex adjacent to the bony openings in the skull where the eyes are set (i.e., the eye orbits) (Figure 8.8a). The role of the orbitofrontal cortex as an emotional regulator was made clear by the neurological case of Phineas Gage. Gage was a railroad foreman known to be a good worker and friend among colleagues. On September 13, 1848, he was involved in a bizarre accident when an explosion sent an iron rod, harpoon-like, entering up into Gage's cheekbone, passing through his orbitofrontal cortex, and exiting out his skull (Figure 8.8b). Amazingly, Gage survived the accident and lived for another 11½ years.[26] Although he did not appear to exhibit any intellectual

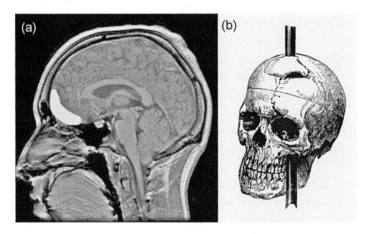

FIGURE 8.8 *(a)* The orbitofrontal cortex is situated just above the skull's opening for the eye orbits. Photograph courtesy of Paul Wicks. *(b)* In 1848, Phineas Gage survived a bizarre accident when an iron rod was driven through his skull damaging his orbitofrontal cortex. Drawing reproduced from Harlow, J. M. (1868). Recovery of an iron rod through the head. *Publications of the Massachusetts Medical Society, 2, 327–347.*

appear tearfully sad. Thus, in some situations it is important to identify the emotional context to understand fully whether individuals are expressing positive or negative feelings.

In moments of emotional arousal, we appraise an event as carrying positive or negative value. The *amygdala* (Latin for *almond*), a spherical structure situated in front of the hippocampus (Figure 8.7, left panel), is the brain's interface between conceptual and emotional processes. It receives signals from the cerebral cortex and relays them to brain regions involved in arousal, such as the hypothalamus and the reward circuit. Moreover, the amygdala sends signals back to the cerebral cortex and hippocampus, which act to amplify and focus cognition. Without the amygdala, there is a disconnection between conceptual and emotional processes, and it becomes impossible to appraise or interpret our feelings.[21] In neuroimaging studies, the amygdala is particularly responsive to fearful or threatening stimuli, such as fearful faces or a stimulus that signals an impending electric shock.[22] In one study, amygdala activity was enhanced when mournful music was played along with photographs depicting sad or frightening events.[23] Positive stimuli, such as pictures of appetizing foods, cuddly babies, and sexually arousing nude photos activated the left amygdala specifically.[24] As these studies compare emotional stimuli with neutral ones of like kind (e.g., fearful versus neutral faces), it is the emotional impact rather than the processing of objects themselves that activated the amygdala.

The expression of horrific fear is universally understood as depicted in such memorable instances as Munch's *The Scream* and Vivian Leigh's shower scene in Alfred Hitchcock's *Psycho* (Figure 8.7, right panel). With wide eyes, nose flared, and mouth open, the expression of fright is unmistakable. Munch accentuates this expression through the harsh swirls of color in his background, whereas Hitchcock intercuts his scene with turbulent action. One the reasons

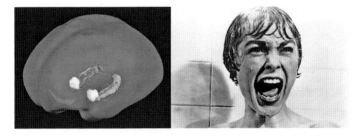

FIGURE 8.7 *Left*: The almond-shaped amygdala sits in front of the hippocampus and is active during the presentation of emotional stimuli, such as a fearful facial expression. Reproduced from Phelps, E. (2004). Human emotion and memory: Interactions of the amygdale and hippocampal complex. *Current Opinion in Neurobiology, 14*, 198–202, with permission from Elsevier. *Right*: Janet Leigh in *Psycho* (1960), Universal Studios.

and following the interview, the interviewer wrote down her name and phone number on a card, and offered it to the subject in case he wanted further details about the survey. For another group, the same interview was conducted by the same researcher after crossing a nearby bridge which was wider, made of solid wood, and only 10 feet above a shallow stream. Thus, compared to the Capilano Bridge, this bridge was hardly arousing. Half of the males who crossed the Capilano Bridge phoned the female researcher for "further information," yet only an eighth of those who crossed the other, less arousing bridge, phoned the same researcher. Of course when the interviewer was a male, hardly any male subjects phoned back. Thus, the arousal induced by the precarious suspension bridge was misinterpreted as arousal toward the researcher.

Emotional moments, whether good or bad, are determined by the way we appraise the situation. We may feel anger when we witness an injustice or joy at the sight of a bride walking down the aisle. These emotional experiences are appraised on the basis of semantic, cultural, and personal knowledge. Yet sometimes an emotional response is generated by unconscious activations, and thus we may not even know why we are feeling emotional. As described in chapter 5, unconscious or implicit associations may drive preferences. For example, you may find a stranger attractive (or unattractive) because the person unconsciously reminds you of someone else. Although our appraisal of emotions is generally clear and universally understood, there are occasions when emotional displays are ambiguous.[20] Consider Figure 8.6a, which appears to show a man displaying an angry expression. In actuality, the photograph is of Jim Webb celebrating his election after the 2006 Virginia Senate race which he just narrowly won Figure 8.6b. What appears to be a overt expression of anger is one of excitement and joy. Another ambiguity of emotional expression occurs during weddings and school graduations in which audience members

FIGURE 8.6 What appears to be a highly charged anger expression when taken out of context, is actually a jubilant Jim Webb celebrating his closely won Virginia Senate race in 2006. Reproduced from Barrett, L. F., Lindquist, A., & Gendron, M. (2007). Language as context for the perception of emotion. *Trends in Cognitive Science, 11*, 327–332, with permission from Elsevier.

our actions. Of course some feelings may occur quite spontaneously and thus without much thought. Yet in most cases, feelings are generated by a rather complex interpretation of a social situation, be it at work, among friends, or with family.

Emotional responses can be driven by memories of the past. Proust derived pleasant feelings when reminiscing about the taste of a Madeline cookie. Similarly, art can remind us of past moments and bring back related feelings. Some memories may be charged with the kind of excitement associated with the fight-or-flight response. For example, I can recollect episodes of being on the swim team in high school, and the mere reminiscence of standing on the block waiting for the start gun makes my heart race and palms sweat. When we recollect past experiences, a variety of feelings can be induced, such as joy, warmth, anger, anxiety, or sadness. These feelings are evoked by artworks as well. They may be rather subtle or intense, happy or sad, pleasant or unpleasant. Of course, one's emotional response to an artwork depends critically on the personal memories that are evoked by it.

There is a dynamic interplay between emotion and knowledge. Most of the time we maintain a rather cool-headed, thought-oriented disposition. When a situation is interpreted as emotionally arousing, our fight-or-flight circuit kicks in. In a clever psychological study, the influence of cognitive interpretation of one's arousal was assessed.[18] Individuals were told that they were going to receive an injection of a vitamin supplement and then have their vision tested. In actuality, they received an injection of adrenalin, which produced feelings of arousal that included increased heart rate, blood pressure and respiration. Other subjects were injected with an inert saline solution (i.e., a placebo). Half of those injected were informed of the side effects of adrenalin, whereas the others were told that the injection would have no side effects. While supposedly waiting for their vision test, a research assistant who was posing as another subject began to act out. For some subjects, the poser was playful, goofed around, and made paper airplanes. For others, the poser became angry, complained about the experiment, and stomped out the room. Afterwards, subjects were asked to rate the pleasantness of the experience. Individuals given adrenaline but not informed of its side effects attributed their physiological arousal as a reaction to the poser's behavior and rated their experience as pleasurable when the poser was giddy and unpleasant when the poser was angry. Subjects who were told of the side effects or those in the placebo condition did not exhibit these influences. These findings demonstrate that we interpret emotional responses both on the basis of our cognitive appraisal of the situation and on our physiological response.

Other studies have shown that people misinterpret or displace the reasons for their feelings. In one study, male subjects were interviewed by a female researcher after crossing the Capilano Suspension Bridge, a pedestrian bridge that hangs rather precariously 230 feet above a deep ravine in Vancouver, Canada.[19] The researcher asked questions about scenic attractions in the area,

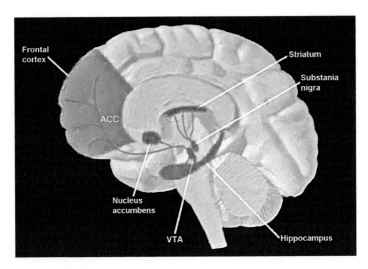

FIGURE 8.5 The dopamine reward circuit includes the nucleus accumbens, ventral tegemntal area (VTA), and frontal cortex (ACC = anterior cingulate cortex). Figure from *NIDA Research Report Series— Methamphetamine Abuse and Addiction*, National Institute of Drug Abuse.

■ Thinking With Feeling

The pleasure we gain from aesthetic experiences is different from feelings driven by more primitive factors, such as hunger, thirst, and sex. As Kant noted (see chapter 1), we view art from a disinterested perspective. Art excites, surprises, and humors us by creating an imaginary world filled with ideas and feelings. In this manner, aesthetic experiences arouse our perceptions, memories, and emotions without any reason other than to evoke pleasure. It is often the intention of the artist to make us perceive, think, and feel in new and different ways. This view of the artist and beholder is the essence of the I-SKE model. Given this framework, art can be construed as thinking with feeling. Here we discuss how thoughts and feelings interact with each other.

Interpreting the Moment

In our civilized society, which includes rules of etiquette, traffic laws, and grocery supermarkets, the *fight-or-flight* response does not typically occur during fight or flight. These days, feelings are more complex, as we are strapped by cultural restraints and rarely act out our emotions with physical immediacy. Most feelings are based on an interpretation or appraisal of a social situation. Longing, alienation, embarrassment, jealousy, pride, and enthusiasm are modern emotions that require cognitive analysis. Before acting on our emotions, we use cultural and personal knowledge to evaluate the future consequences of

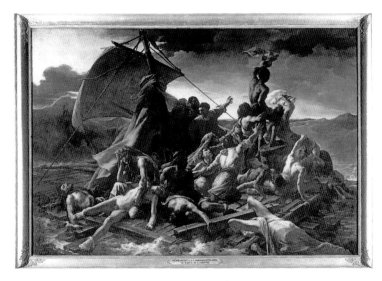

FIGURE 8.4 Gericault, Theodore (1791–1824), *The Raft of the Medusa* (1819). Oil on canvas, 491.0 × 716.0 centimeters. Inv. 4884. Photo: Daniel Arnaudet. Louvre, Paris, France. Photo Credit: Réunion des Musées Nationaux / Art Resource, NY.

midbrain would self-stimulate themselves constantly just to excite this area.[13] These animals appeared addicted to the stimulation, sacrificing food, water, and receptive sexual partners for it. Subsequent research has shown that pleasurable experiences are driven by a "reward" circuit that includes medial regions, such as the ventral tegmental area (VTA), striatum, substantia nigra, and nucleus accumbens (Figure 8.5). This reward circuit stimulates the release of *dopamine*, an essential neurochemical involved in experiencing positive feelings. Highly addictive drugs, such as cocaine and nicotine, activate dopamine in the brain, thus stimulating this reward circuit. Dopamine is chemically related to adrenaline, which acts outside the brain to increase heart rate and blood pressure.

In neuroimaging studies, this reward circuit is active when one experiences pleasurable events. In one study,[14] chocolate lovers exhibited strong activation in the VAT when given chocolate pieces to melt in their mouths. After becoming satiated with the treats, which took from 16 to 74 pieces, the experience of eating yet another piece was rated less pleasurable and VAT activation decreased. Thus, this brain region responded to the experience of pleasure rather than to the taste itself. Other studies have shown that the reward circuit is activated when reading comics, playing video games, or looking at attractive faces.[15] In one study, reward centers became active while individuals listened to highly pleasurable music and said that the music sent "shivers-down-the-spine."[16] These brain responses are accompanied by increased heart rate and respiration. Taken together, they identify a critical brain circuit involved in pleasurable experiences, including aesthetic experiences.[17]

That Old Aesthetic Feeling

As described in chapter 1, Alexander Baumgarten coined the term *aesthetics* to describe his philosophical interest in understanding the nature of beauty. According to Baumgarten, features of an object evoke beauty, but the experience itself is purely a mindful event. The sole purpose of art is to create artifacts that evoke a feeling of beauty. In this way, Baumgarten initiated the modern usage of the term *aesthetics* and set the stage for his more illustrious contemporaries, Hume and Kant (see chapter 1). These days we adopt different approaches to art, but that "wow" feeling still describes a heightened sense of beauty or sublimity in responses to art. According to our emotional map, beauty can be viewed as an emotion extremely high in both positive value and arousal. As with all emotional experiences, the evocation of beauty is idiosyncratic as it depends upon personal and cultural knowledge.

Kant's inclusion of sublimity as beauty's partner in aesthetic experiences suggested a different, more magnificent expression than that of beauty. Sublimity refers to that sense of awe and even terror that occurs when confronted with larger-than-life experiences, such as a volcanic eruption, an exploding atomic bomb, or the birth of a child. Such encounters are arousing, though different from a feeling of beauty. Sublime experiences induce awe, which may be associated with either negative or positive sentiments. Of course, both awe and beauty may be experienced together, as some may experience while viewing Michelangelo's *David*.

The traditional notion of aesthetics, that of beauty and sublimity, form the basis for an expressionist approach to art. From these eighteenth century views to the beginning of the twentieth century, an expressionist approach was the prime motivator for creating and experiencing art. During this time, Romanticism offered dramatic portrayals, such as Théodore Géricault's *The Raft of the Medusa* (Figure 8.4). This almost life-sized painting illustrates an actual event—the aftermath of a tragic wreck involving the French naval ship *Méduse*, which ran aground off the West African coast. A makeshift raft was constructed and drifted at sea for 13 days. Of the 146 people who made it onto the raft, only 15 were finally rescued. Géricault's depiction shows the moment when survivors see a ship that has come to their rescue. This horrific drama is captured by two triangular forms, one of despair on the left and another of hope on the right. In *The Raft of the Medusa*, we witness a sublime moment filled with terror and awe.

With an expressionist approach, we envelope ourselves within an emotional experience and the effect involves both brain and body. We often say that art "warms our heart," "hits us in the gut," or "sends chills down our spine." These metaphors refer to bodily sensations associated with the *fight-or-flight* response. We generally seek pleasure from our aesthetic experiences, and it is of course the brain that provides us with pleasurable feelings. Early physiological studies showed that rats with electrodes implanted in a particular spot in the

this a romantic story of an admiring young woman and equally admiring but less bold older woman? Regardless of the original intention, the expressions displayed by the two woman are rather obvious and transmit much in terms of social communication and display rules.

As a form of social communication, facial expressions, such as an amorous smile, tearful eyes, disgusted look, or angry frown, motivate us to approach or avoid a situation. Such expressions also induce varying degrees of arousal. Sadness and boredom are emotions low in arousal, whereas rage and terror are highly charged emotions. The variety of human emotions can be characterized in terms of two dimensions—hedonic value (from negative to positive) and arousal level (from low to high). Any emotion can be represented or mapped with respect to these two dimensions. A feeling of *interest* is mildly positive and mildly arousing, whereas *excitement* is strong on both dimensions. With this emotional coordinate system, one can describe and interrelate many different types of human feelings.[9]

Emotions influence the body and brain in a variety of ways. Anger and fear increase heart rate, but anger is different from fear in that it also increases skin temperature.[10] With respect to hedonic value, the two cerebral hemispheres play somewhat different roles. The left hemisphere is more associated with positive emotions, whereas the right hemisphere is more associated with negative emotions. For example, after left hemisphere damage, particularly damage to the left prefrontal cortex, patients exhibit diminished positive emotions, which can lead to chronic depression. Right hemisphere damage can lead to *anosognosia*, a disorder in which patients have no awareness of their impairment. Such patients are insensitive to their emotional trauma and are not particularly bothered by their injury. Neuroimaging studies have generally confirmed this bias for the left hemisphere to process positive experience and the right hemisphere to process negative experiences, though it is acknowledged that both hemispheres are involved in the processing of all kinds of emotions.[11]

We associate colors to both objects and feelings, and these associations have great impact on our aesthetic preferences. The association of red, orange and yellow to "warm" colors is likely due to the relation of these colors to properties of naturally warm objects, such the sun and fire. Cool colors, such as green, blue, and violet, are associated with water, shade, and ice. We also link colors to human characteristics and emotions. In one study, adults and three-year-olds were shown a drawing of a sad, happy, and angry face and asked to associate each face with a color (from a set of nine colors).[12] For the sad face, 67% of adults associated it with black; for the happy face, 60% associated it with yellow; and for the angry face, 73% associated it with red. These associations developed with age, as three-year-old children showed more variability in their selections. Children generally linked dark colors with sad and bright colors with happy, though within each emotion, the specific color selected varied.

Ekman identified six basic facial expressions—disgust, fear, happy, sad, surprise, and angry—which are well understood among all humans. When and where they are expressed, however, are governed by cultural rules. In one study, Japanese and American individuals watched a disturbing film that depicted a surgical arm amputation. When viewed alone, both groups elicited facial expressions of disgust. Yet when there was someone else in the room, Japanese individuals inhibited their expressions, often masking them with a smile.[7] Display rules vary across culture, gender, age, and social context. Consider Bartolomé Esteban Murillo's *Two Women at a Window* (1670) (Figure 8.3), in which the facial expressions of two women tell a story. The young woman displays a longing, amorous expression, whereas the other woman appears amused or embarrassed. This painting was once titled *Las Gallegas* (The Galician Women). Galicia is a region in the northwest of Spain known at the time to harbor courtesans. The low-cut blouse and overt gaze of the young woman suggests a courtesan's solicitation. Yet the original title of the painting is not known, and the embarrassed pose of the other woman does not particularly suggest a procuress or madam, thus allowing us to consider other possible narratives.[8] Is

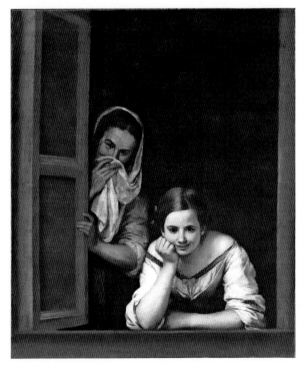

FIGURE 8.3 Bartolomé Esteban Murillo (Spanish, 1617–1682), *Two Women at a Window* (c. 1655–1660). Oil on canvas. Overall: 125.1 × 104.5 centimeters (49 1/4 × 41 1/8 inches). Framed: 182.3 × 160.3 centimeters (71 3/4 × 63 1/8 inches). National Gallery of Art. Widener Collection 1942.9.46.

infants. Infants can display various feelings, including joy, contentment, disgust, and pain, suggesting a strong genetic basis for primary emotional expressions.[4]

A good deal of our social communication comes in the form of nonverbal messages. A welcome smile or frightful look communicates more than words as to whether one should advance or stay away. Facial expressions are in large part universal across cultures. Figure 8.2 displays six basic facial expressions around a neutral (center) expression. Psychologist Paul Ekman and colleagues conducted cross-cultural investigations of these basic expressions.[5] In one study, natives of Papua New Guinea who had little outside contact were able to identify facial expressions from photographs of Caucasians. Also, individuals blind from birth exhibit comparable, though not exactly the same, facial expressions as sighted individuals.[6]

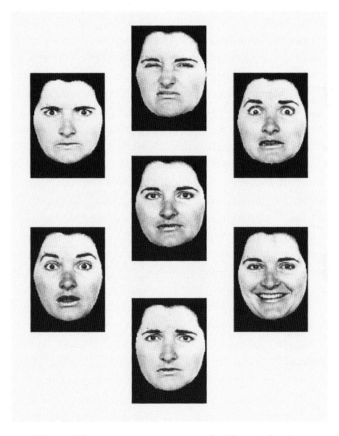

FIGURE 8.2 Neutral face in center surrounded by six basic expressions (from top and clockwise): disgust, fearful, happy, sad, surprise, and angry. Reprinted from Eimer, M., Holmes, A., and McGlone, F. (2003). The role of spatial attention in the processing of facial expression: An ERP study of rapid brain responses to six basic emotions. *Cognitive, Affective, & Behavioral Neuroscience*, 3, 97–110.

gland to secrete adrenalin. In our postmodern lives, emotional situations come in the form of confrontations at work or problems with close relations. These stressors are mentally rather than physically challenging, though evolution has programmed the brain to arouse the body during all emotional situations.[2]

Our response to art includes excitement, fascination, curiosity, and surprise. With intense responses, we may even be aroused enough to experience bodily sensations, such as increased heart rate or "tingles up the spine." As mentioned earlier, the psychologist Daniel Berlyne developed a model of aesthetic responses in which arousal is mediated by specific features in an artwork, such as novelty, complexity, surprise, uncertainty, and incongruity. He called these features "collative" properties, because elements of an artwork are compared or put together in order to drive one's aesthetic experience. The greater the number of collative properties in an artwork, the greater our arousal. Berlyne argued that we like some novelty, surprise, and incongruity, but too much arousal will lead to a negative response. His model explains why individuals across time and cultures differ in their hedonic response to art. Consider the mid-nineteenth century individual who has only viewed the kind of mimetic art displayed in parlors and salons. Impressionist paintings may have been considered so surprising and incongruous that they would have generated too much arousal and thus be judged as disturbing and distasteful.

We, however, have been exposed to all kinds of abstract forms of art, not only in museums but also on television and websites. For most people, Impressionist paintings may be just different enough from mimetic art to be pleasing and moderately arousing. With more extensive experience and knowledge about twentieth century art, some may find works by Cezanne, Picasso, and Matisse to be interesting and pleasurable, but not so arousing as to induce a negative reaction. Even further knowledge of modern art may allow one to garner positive hedonic value from the styles of abstract expressionism, surrealism, and minimalism. Thus, Berlyne's model accounts for changes in aesthetic evaluation as a result of knowledge and past experience. The more we know, the more we can appreciate the complexity of new works and not view them as so strange as to be considered disturbing or ugly.

Varieties of Emotion

Dog owners will tell you that their pet exhibits a variety of emotions—from friendly licks to angry snarls. Charles Darwin, in his seminal book *The Expression of the Emotions in Man and Animal*,[3] postulated that certain emotional expressions are universal across species. In a drawing from his book, he illustrated a "disappointed and sulky" chimpanzee after it was given an orange and then had it taken away. Recently, "laughing" in response to being tickled has been shown to be universal among gorillas, chimpanzees, and orangutans. In fact, vocal patterns of apes when tickled are similar to those elicited by human

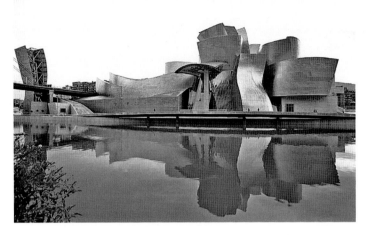

FIGURE 8.1 Guggenheim Museum Bilbao, Frank Gehry, architect. Photograph courtest of the Visual Resources Collection, School of Architecture, The University of Texas at Austin.

artists, the primary intention of art is to induce in the beholder such arousing experiences. Even in contemporary art, Damien Hirst, the noted artist, has stated: "I like the idea of a thing to describe a feeling."

Pumping Up

Consider the following scenario: you are about to give a speech to a large audience. As you wait to be introduced, your heart begins to pound, your palms sweat, muscles twitch, and you feel that uneasy fluttering in your stomach. This physiological response is primitive as it has occurred in humans for millions of years, though more frequently when confronted with predators or prey than being introduced to an audience. This emotional *fight-or-flight* response pumps you up for intense physical activity. When we experience art we may not evoke such extreme feelings, but we often become excited and aroused, and these responses are mediated by the same brain mechanisms as those that drive the fight-or-flight response.

Changes in respiration, heart rate, body temperature, and muscle tone occur during highly charged experiences. These bodily responses prepare us for physical exertion: to run faster, fight harder, and reproduce more readily. They are initiated by a cascade of biochemical processes that begin with the brain interpreting a potentially stressful fight or flight (or sexual) situation. Under such encounters, neural signals are sent to primitive regions of the brain, such as the hypothalamus, which initiates signals to other parts of the body to increase blood flow, respiration, and glucose metabolism. A particularly important process involves the hypothalamus in signaling the adrenal

8. AROUSING EMOTIONS

Ask most people and they will tell you that art is meant to arouse us, to evoke feelings. From this expressionist approach, we elicit an aesthetic evaluation—you like it or you don't, it's interesting or not, it's good or bad. You might even experience that "wow" moment, as some might while viewing the exterior of the *Guggenheim Museum* in Bilbao, Spain (or even just a photograph of the building) (Figure 8.1). This impressive structure, designed by the noted architect Frank Gehry, does not adhere to the adage of *form follows function*. Indeed, many of Gehry's buildings appear as large sculptural works rather than functioning environments. In the documentary film *Sketches of Frank Gehry*,[1] the architect discussed his intentions: "I was looking for a way to express feeling in three-dimensional objects." Of course, not everyone responds to an artwork in the same way. Some find Gehry's architecture to be overdone and wasteful of space and resources. As we have discussed, one's aesthetic evaluation depends significantly on personal and cultural knowledge, which directs preferences to certain artistic styles and genres. To a large extent, beauty is in the brain of the beholder.

■ The Pleasures of Art

That "wow" feeling describes an intense aesthetic experience, and yet for most of us, such extreme experiences are rare. However, in the same way a facial expression—a smile, a frown, or a sullen look—can evoke various emotions, art can likewise elicit a range of feelings with varying intensities. The pleasure we gain from art is driven by a set of brain processes that are involved in arousing us. Moreover, emotional responses are whole-body experiences, as they act to increase blood flow, respiration, and metabolism. For Gehry and many other

ACT III

THE ART OF FEELING

18 Greene, J. D., Sommerville, R. B., Nystrom, L. E., Darley, J. M., & Cohen, J. D. (2001). An fMRI investigation of emotional engagement in moral judgment. *Science, 293*, 2105–2108.

19 Tolstoy, L. (1996). *What Is Art?*. London: Penguin Classic Books.

20 Panofsky, E. (1972). *Studies in Iconology: Humanistic Themes in the Art of the Renaissance*. New York: Harper & Row.

21 Clark, T. J. (1999). *Image of the People: Gustave Courbet and the 1848 Revolution*. Berkeley: University of California Press.

22 Agee, J., & Evans, W. (1988). *Let Us Now Praise Famous Men*. New York: Houghton Mifflin.

23 Whitford, D. (2005). The most famous story we never told. *Fortune Magazine*, September 19, 2005, http://money.cnn.com/magazines/fortune/fortune_archive/2005/09/19/8272885/index.htm.

24 Maharidge, D., & Williamson, M. (1995). *And Their Children After Them*. New York: Pantheon.

25 Danto, A. (1964). The artworld. *The Journal of Philosophy, 61*, 571–584. Wolfe, T. (1975). (See chapter 1, n. 16.)

26 Brewer, M. B. (2007). The importance of being we: Human nature and intergroup relations. *American Psychologist, 62*, 728–738.

27 Tajfel, H., Billig, M. G., & Bundy, R. P. (1971). Social categorization and intergroup behavior. *European Journal of Social Psychology, 1*, 149–178.

28 Nochlin, L. (1971). Why have there been no great women artists? In T. B. Hess & E. C. Baker (Eds.), *Art and Sexual Politics: Women's Liberation, Women Artists, and Art History* (pp. 1–39). New York: Macmillan Publishing Co.

29 Eisenberg, N. I., Lieberman, M. D., & Williams, K. D. (2003). Does rejection hurt? An fMRI study of social exclusion. *Science, 302*, 290–292.

30 Sherif, M., Harvey, O. J., White, B. J., Hood, W. R., & Sherif, C. W. (1988). *The Robbers Cave Experiment: Intergroup Conflict and Cooperation*. Middletown, CT: Wesleyan University Press.

31 Wolfe, T. (1975, p. 23). (See chapter 1, n. 16.)

32 For interesting insight into graffiti art, the movie *Exit at the Gift Shop* (2010, Revolver Entertainment) documents the escapades of Banksy and other graffiti artists.

33 Latour, I. H. (2009). Edward Weston and Wildcat Hill. *Ira H. Latour: Seven Decades (1935–2003)*.

34 Thompson, D. (2008). *The $12 Million Stuffed Shark: The Curious Economics of Contemporary Art*. New York: Palgrave Macmillan.

35 The reported sum of Cohen's purchase of the shark has varied from eight to twelve million dollars.

36 For further analysis of this issue, see Currie, G. (2011). Art and the anthropologist. In Shimamura & Palmer (2012). (See chapter 1, n.2.)

37 Thornton, S. (2008), *Seven Days in the Art World* (p. 62). New York: W. W. Norton & Company.

38 Gopnik, B. (2011). Aesthetic science and artistic knowledge. In Shimamura & Palmer (2012).

2 Goodman, N. (1977). When is art? In D. Perkins & B. Leondar (Eds.), *The Arts and Cognition* (pp. 11–19). Baltimore: Johns Hopkins University Press.

3 BMI is defined as one's weight (kg) divided by height (m) squared. A BMI of 18.5–25 kg/m^2 is considered normal.

4 Rubenstein, S., & Caballero, B. (2000). Is Miss America an undernourished role model? *Journal of the American Medical Association, 283,* 1569.

5 Wypijewski, J. (Ed.). (1998). *Painting by Numbers: Komar and Melamid's Scientific Guide to Art.* Berkeley: University of California Press.

6 Eysenck, H. J. (1983). A new measure of "good taste" in visual art. *Leonardo, 16,* 229–231. Gotz, K. O., Borisy, A. R., Lynn, R., Eysenck, H. J. (1979). A new visual aesthetic sensitivity test: I. Construction and psychometric properties. *Perceptual and Motor Skills, 49,* 795–802.

7 Iwawaki, S., Eysenck, H. J., & Gotz, K. O. (1979). A new Visual Aesthetic Sensitivity Test (VAST): II. Cross-cultural comparison between England and Japan. *Perceptual Motor Skills, 49,* 859–862.

8 Chan, J., Eysenck, H. J., & Gotz, K. O. (1980). A new Visual Aesthetic Sensitivity Test (VAST): III. Cross-cultural comparison between Hong Kong children and adults, and English and Japanese samples. *Perceptual Motor Skills, 50,* 1325–1326.

9 Deregowski, J. B. (1976). On seeing a picture for the first time. *Leonardo, 9,* 19–23.

10 Jones, R. K., & Hagen, M. A. (1980). A perspective on cross-cultural picture perception. In M. A. Hagen (Ed.), *The Perception of Pictures* (pp. 193–226). New York: Academic Press.

11 Hong, Y., Morris, M. W., Chiu, C., & Benet-Martínez, V. (2000). Multicultural minds: A dynamic constructivist approach to culture and cognition. *American Psychologist, 55,* 709–720. Morris, M. W., & Peng, K. (1994). Culture and cause: American and Chinese attributions for social and physical events. *Journal of Personality and Social Psychology, 67,* 949–971.

12 Matsuda, T., Gonzalez, R., Kwan, L., & Nisbett, R. E. (2009). Culture and aesthetic preference: Comparing the attention to context of East Asians and Americans. *Personality and Social Psychology Bulletin, 34,* 1260–1275.

13 Gutchess, A. H., Welsh, R. C., & Boduroglu, A. (2006). Cultural differences in neural function associated with object recognition. *Cognitive, Behavioral, and Affective Neuroscience, 6,* 102–109; Han, S., & Northoff, G. (2008). Culture-sensitive neural substrates of human cognition: A transcultural neuroimaging approach. *Nature Reviews Neuroscience, 9,* 646–654.

14 Hong et al. (2000).

15 Barasch (1998). (See chapter 1, n. 1.)

16 For a fascinating twenty-first century perspective on the good, bad, and beautiful, see Gardner, H. (2011). *Truth, Beauty, and Goodness Reframed.* New York, Basic Books.

17 Thomson, J. J. (1986). *Rights, Restitution, and Risk: Essays, in Moral Theory.* Cambridge, MA: Harvard University Press.

our own cultural background, can we fully appreciate artworks from other cultures? To the extent that an artwork presents a story about a particular time and place, it is important to acquire knowledge about the cultural context in which an artwork was produced. We may never fully appreciate works from another culture, because we are not fully aware of the beliefs, ideas, and practices that define such works. Yet, as we have discussed, there are experiences that are universal among us all, and we can appreciate representations of such experiences in art whenever or wherever it was created. Thus, we must keep in mind that art embodies both culture-specific knowledge and universal knowledge granted to us as members of the human race.[36]

A conceptual approach to art relies heavily on the art of knowing and the knowing of art. Many feel bewildered by contemporary art. What is important in experiencing all forms of art, but perhaps particularly contemporary art, is the fact that we need to consider a conceptual approach, as perceptual and emotional features are often not emphasized or even considered. What is the artist trying to say? How does a work relate to the story of art (i.e., is the work intended as a meta-art statement)? Charles Gaines, a conceptual artist and faculty member of the California Institute of the Arts, stated that "art should interrogate the social and cultural ideas of its time."[37] Thus, art is meant to mark a specific time and place that is of course embedded within a culture's beliefs and practices. The more you know about the cultural context in which a work was created, the better prepared you will be in understanding it.

In these three chapters on the art of knowing, we have considered the way prior knowledge and past experiences influence the way we look at art. All experience is influenced by what we know, and in many instances we are not even aware that we are applying knowledge when we look upon the world. Thus, implicit, semantic, episodic, and cultural knowledge all play a role when we consider a work of art. Based on our I-SKE framework, knowledge is a primary component, along with sensation and emotion, in driving our art experience, though it is often neglected or downplayed. Even among philosophers and psychologists, the role that knowledge plays on aesthetics usually takes a backseat, with perceptions and feelings placed at the forefront. On the other hand, contemporary critics and historians often take a decidedly conceptual approach to art and seem to deny the importance of sensory and emotional factors by only considering the underlying semantics or "meaning" of artworks.[38] Here, I argue for a balanced, "embodied" approach to experiencing art by considering knowledge as equally important along with sensation and emotion.

■ Notes

1 Pazanelli, R., Schmidt, E., & Lapatin, K., (Eds.). (2008). *The Color of Life: Polychromy in Sculpture from Antiquity to the Present*. Los Angeles: Getty Research Institute.

Indeed the value of an artwork (whatever it looks like) depends significantly on whether the piece is by a hot artist or purchased from a well-known dealer or seller. At the high end of contemporary art, the buyer may purchase a new work without even seeing the actual piece.

The marketing of contemporary art is not unlike the marketing of any other stock commodity and is subject to similar market trends and practices. Sometimes an artwork may be sold and then, soon after, put back on the market and "flipped" for profit. The art market is of course vulnerable to global market trends, just as any other commodity. The market crash of October 2008 significantly affected the value of contemporary art. In May 2008, Sotheby's auctioned a total of $362 million worth of contemporary (postwar) art, with the single highest purchase being $86 million for *Triptych* (1976) by Francis Bacon. A year later, Sotheby's entire auction brought in only $47 million. As the market goes, so goes the value of art.

Rather than artists slowly achieving recognition through their *oeuvre* and maintaining their high status, a contemporary artist may rise very quickly and sometimes fall just as quickly out of fashion. If one were to ask in-group members of the art world to list the 20 most important artworks or the 20 most important artists in the past two decades, the consensus would not be impressive. Of course, many of us who enjoy art and visit museums are not card-carrying members of the art world—that is, we are not the artists, critics, curators, dealers, and collectors who define what's in. Yet the economics of art has significantly affected anyone with an interest in experiencing art. When we visit a contemporary art museum, we should not bring with us the expectation (i.e., schema) that such works have any long-lasting significance or should be honored as great. We must evaluate such works, and indeed all works, with a conceptual approach that allows us to consider what the piece means to us personally. How does the work fit with our cultural experience? What does it mean for us as individuals? What story is it trying to relate? Although the marketing of contemporary art has adopted the kind of practices used in marketing pop music or Hollywood films, we must evaluate for ourselves the worth of a piece from our own sensory, conceptual, and emotional perspective.

■ Getting to Know You

We have considered experiences with art as inextricably embedded within our cultural beliefs, knowledge, and practices. Culture defines the styles we prefer. Whether this influence is based on religious, political, national, or art world knowledge, the experiences we share as a member of a group influence the way we approach art. Interestingly, art also gives back to culture by providing a historical record of trends, fashions, and ideas. Artworks created at different times and locations reveal how body shape, clothing, architecture, rituals, and even artistic styles are defined by a culture. Given the inescapable influence of

For What It's Worth

How is contemporary art evaluated? What's *in* these days? With the christening of Pop art as high art (and vice versa), the art world expanded to include many more collectors and dealers interested in "buying stock" in contemporary artists. Before the advent of Pop art, the monetary value placed on contemporary artworks was minimal, because the demand was so low. There were not many collectors interested in purchasing these works, and artists were aware of that fact. Thus, before 1960, artists tended to work and create with the acknowledgement that they were out-group individuals millions of miles away from the mainstream of popular culture, which in many ways was true.

Photography before the 1960s was also not treated as high art, as collectors, art museums, and galleries were generally not interested in the medium. Ira Latour, an historian and accomplished photographer, wrote that in the early 1950s, Edward Weston sold his photographs for $25, which Latour stated "was a significant portion of my monthly stipend under the 'G. I. Bill.'"[33] Now an Edward Weston vintage photograph can sell in the half-million dollar range, a value that is above the *annual* income of 98% of Americans. Moreover, the 400 first edition copies of Ed Ruscha's photographic book *Twenty-six Gasoline Stations* (1963), which originally sold for $3.50, can now be purchased for $22,500.

These days the marketing of art is truly big business. Dan Thompson's book entitled *The $12 Million Stuffed Shark: The Curious Economics of Contemporary Art*[34] offers a peek at the business side of art. The title refers to Damien Hirst's *The Physical Impossibility of Death in the Mind of Someone Living*, a 14-foot tiger shark floating in a tank of formaldehyde, which was bought by billionaire Steven A. Cohen in 2004. At the time, Hirst's shark was one the most expensive contemporary artworks ever sold at an auction.[35] Yet to place the purchase in perspective, Thompson calculated that the cost to the billionaire was a mere five days' income (considerably less in functional value than the price Latour paid when he bought a Weston photograph). Interestingly, the shark that Cohen purchased is actually not the one used in the original piece, as the original shark was not preserved appropriately and its skin deteriorated. Hirst secured another shark, injected it with a higher concentration of formaldehyde, and had a new enclosure built. Thus, just as with Duchamp's replicas of *Fountain*, of which several are now placed in prominent art museums, Hirst's replica is just as valuable as the original (if not more so due to it being better preserved). Clearly, for these works, the fact that they are not original pieces has no bearing in terms of its monetary (or artistic?) value. For such conceptual works, it's the thought that counts.

Like pop music or the latest clothing fashion, what's hot in contemporary art moves in and out at a rather rapid pace. Where once critics and museum curators decided which contemporary works were to be given the stamp of approval as great art, it is now the case that dealers and collectors drive the market. Just as in pop music, the art world now brands certain artists, dealers, and buyers as hot, and that branding may be temporary or long-lasting.

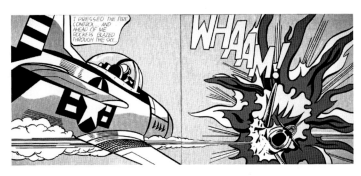

FIGURE 7.9 Lichtenstein, Roy (1923–1997), *Whaam!* © Estate of Roy Lichtenstein (1963). Magna acrylic and oil on canvas. 2 canvases, each 68 × 80 feet (172.7 × 203.2 centimeters). Photo Credit: Tate, London / Art Resource, NY. (See color plate section.)

manufactured many copies of his works using a silkscreen process similar to that used in mass-produced art posters. Roy Lichtenstein, as exemplified in *Whaam!* (Figure 7.9), used comic book images as models for his paintings. He mimicked the printing process known as Ben-day dots, a four-color pointillist method used extensively by comic book publishers. These works brought the artifacts and styles of popular culture into the domain of high art.

Ed Ruscha painted and photographed scenes of popular culture. In *Twenty-six Gasoline Stations* (1963), Ruscha photographed these iconic American structures as he drove along Route 66 from Los Angeles to Oklahoma City. These photographs, printed together in a book, are reminiscent of the set of travelogue woodblock prints by Hiroshige entitled *The Fifty-Three Stations of the Tōkaidō*. Ruscha's photographic set took the mundane views of everyday life and relegated them to the status of high art. Ironically, Hiroshige's woodblock prints were also mass produced and considered at the time as lowbrow works of art.

In the 1980s, New York City artists such as Jean-Michel Basquiat and Keith Haring took to the streets and subways with spray can in hand and turned a lowbrow art form, graffiti art, into a genre that now can be had on canvas at a cost of over a million dollars. With interest from the art world, these gritty yet colorful graffiti images became fashionable. As a result, a cadre of formerly out-group artists now became rather wealthy as dealers and collectors flocked to purchase their works.[32] Acceptance of such works was made apparent in an important art exhibition at the Museum of Modern Art in 1990 entitled *High and Low: Modern Art and Popular Culture*. The exhibition presented an ambitious display of twentieth century art that exhibited 250 works, including a replica of Duchamp's *Fountain*, Oppenheim's fur-lined cup (Figure 5.8 in chapter 5), and works by Picasso, Cindy Sherman (Figure 6.7 in chapter 6), and Basquiat. This exhibition acknowledged a new world order in which the border between two sides—high and low art—disintegrated.

were going to be without any water (a sack had been used by the experimenters to plug a main faucet). The two groups worked together to solve the problem and ultimately found the cause and unplugged the faucet. This joint effort significantly reduced conflicts between the two camps.

Findings from the Robbers Cave study suggest that tolerance of out-group individuals can be achieved by working cooperatively on social problems that affect everyone. Simply meeting together or having multigroup social events will not reduce friction between groups. It seems that working together helps develop a broader in-group association, a kind of *we are all in this together* attitude. In this manner, the Golden Rule can be applied to a more inclusive group. Ironically, this solution suggests that worldwide problems that threaten us all, such as global warming, international economic collapse, or perhaps alien attack, may have positive results, as such negative events may encourage us all to be members of the in-group called the human race.

High and Low Art

The art world itself forms a culture in which like-minded individuals determine what's in and what's out. Up through the mid-twentieth century, the art world consisted of a select group of individuals consisting primarily of artists, critics, curators, and collectors whose responsibility was to relegate certain artworks to the status of *high art*. These folks were the refined culurati—the intelligent, knowledgeable, and "cultured" aesthetes who reveled in fine art, classical music, and great literature. If you appreciated Abstract Expressionism—if you *understood* it—you could be part of this elitist in-group. As Tom Wolfe wrote in *The Painted Word*, "the public is not invited (and never has been)."[31] In contrast, art for the masses or *low art*, such as decorative art (jewelry, fashion design, or commercial art) and other popular art forms (movies, cartoons, pop music, comic books) were considered crude, petty, and low brow.

During the 1960s, the distinction between high and low art blurred and was forever changed with the advent of *Pop art*, which pushed icons of popular culture to the heights of fine art. Its acknowledged leader, Andy Warhol, used pop images, such as Campbell soup cans, Elvis Presley, and Marilyn Monroe, as prime symbols in his works. As described in chapter 5, he constructed sculptural pieces, such as *Brillo Soap Pad Boxes* (Figure 5.12), that looked exactly like objects one could see at the grocery store. Warhol was one of the few artists who attained celebrity status in both high and low art. Works by other Pop artists incorporated culture symbols, such as Jasper Johns's painting of the American flag and Robert Rauschenberg's collages which used newspaper clippings.

In *Pop art*, symbols and media of everyday culture became acceptable to the high art establishment. Mass marketing, previously associated with lowbrow art, was now viewed as innovative (and profitable). For example, Warhol

FIGURE 7.8 *Top*: Playing *Cyberball*. Figure reproduced with permission from Dr. Kipling Williams. *Bottom*: When players are socially rejected, the anterior cingulate and right ventral prefrontal regions are activated. Reprinted from Eisenberg, N. I., Lieberman, M. D., & Williams, K. D. (2003). Does rejection hurt? An fMRI study of social exclusion. *Science, 302*, 290–292 with permission from AAAS.

viewed as outside the domain of those defined as "others" in the Golden Rule. This fact is not to say that the forming of in-groups is a negative thing. Indeed, it is part of human nature to affiliate with those with similar views and beliefs, and in-group membership certainly has many positive attributes. Culture is essentially another name for an in-group.

It is, however, possible to maintain one's in-group status and still be tolerant of those with other views. In a classic social psychology experiment, known as the Robbers Cave study, boys at a summer camp were placed into one of two groups.[30] The experimenters first fostered in-group affiliation by isolating the two groups and having them select their own leaders. Competition between the two groups was encouraged through sports activities, and during these interactions conflicts occurred, such as name calling and attempted fights between the two groups. After establishing in-group affiliation, the experimenters tried to reduce conflicts by having the two groups join together in social events, such as eating together, watching movies, and enjoying a fireworks display. These attempts simply led to more conflicts (e.g., food fights) as the boys still tended to band together within their groups. After many attempts at reducing friction, the experimenters contrived a problem that threatened both groups. The boys were told that something had happened to the water supply and the two camps

SHE SAW HIM DISAPPEAR BY THE RIVER,
THEY ASKED HER TO TELL WHAT HAPPENED,
ONLY TO DISCOUNT HER MEMORY.

FIGURE 7.7 Lorna Simpson, *Waterbearer* (1986). Reproduced with the artist's permission.

potent and ironic by the allusion to the astrological sign of the water bearer, Aquarius, the mythic character who symbolizes the flow of knowledge and individual freedom.

Out-group ostracism is of course hurtful and derogatory. Not only seen in gender and racial bigotry, such tendencies can be seen in the playground and streets, as cliques and gangs confront out-group individuals. In an fMRI analysis of out-group rejection, individuals play a video game called *Cyberball*, in which a ball is tossed between you and two other "players" (Figure 7.8).[29] When the ball is tossed to you, you have the choice of throwing it back to one of the two other players. In actuality, you control your tosses, but the experimenter controls the other players' tosses. Initially, the game seems to be played cooperatively with everyone participating and tossing the ball to one another. Yet at one point the other two players throw the ball back and forth to each other, and you are denied from playing. One can imagine the hurt of being socially rejected and the conflict that occurs when dealing with such a situation. Indeed, the brain areas that are active during moments of such social rejection—the anterior cingulated gyrus and ventral prefrontal cortex—are the same areas active during the administration of physical pain. Thus out-group ostracism is hurtful and its effect is readily observed in the brain as painful.

What happened to "doing unto others as you would have them do unto you?" Throughout history, the Golden Rule has been generally restricted to in-group members, as out-group individuals are viewed as not worthy of such sentiments. Thus aggression against nations, religious sects, women, races, and anyone else perceived as an out-group individual occurs because they are

rather quickly as demonstrated in one study in which individuals were pre-
sented abstract paintings by Klee and Kandinsky and asked to make prefer-
ence judgments.[27] They were told that according to their responses, they were
placed in one of two groups: those who like Klee and those who like Kandinsky.
In actuality, the assignment to the groups was random. Later, they played a
game in which they could give rewards or penalize others in the experiment.
Although it was possible to allocate equal amounts to in-group and out-group
members, people favored giving more rewards to in-group compatriots than to
out-group members.

For some cultures, membership is determined by genetics. Both gender
and race have been used as criteria for in-group status. In these cases, unlike
religious or political affiliation, out-group membership is obvious, as it is not
easy to conceal one's gender or racial affiliation. Thus, in a male-dominated
culture, women are often denied the same benefits and privileges as men. With
respect to art, the historian Linda Nochlin asked, "Why Have There Been No
Great Women Artists?"[28] She answered her query in the following manner:

> Thus the question of women's equality—in art as in any other realm—
> devolves not upon the relative benevolence or ill-will of individual men,
> nor the self-confidence or abjectness of individual women, but rather on
> the very nature of our institutional structures themselves and the view of
> reality which they impose on the human beings who are part of them.

Feminist art grew out of such ostracism, as woman artists developed
their own in-group style and practices, focusing on women's experiences
and attitudes. In the 1970s, Judy Chicago and Miriam Schapiro founded the
Feminist Art Program at the renowned California Institute of the Arts, where
like-minded women could explore their creativity in a secure and cooperative
manner.

Racial ostracism also creates a subculture in which those who are not a
member of the majority race share experiences of prejudice, cultural detach-
ment, and bigotry. Piper Adrian, a conceptual artist and Kantian scholar,
addressed such issues in her art, such as the video *Cornered* (1988) in which
she sits in a corner of a room and discusses issues of racial identity. In 1973,
she donned an Afro wig, fake mustache, and sunglasses, and created the *Mythic
Being*, the stereotypical African-American male as perceived by mainstream
society. In this persona, the artist performed on the street strutting her male-
ness and was even photographed in a choreographed mugging of another male.
In *Waterbearer* (1986), Lorna Simpson (Figure 7.7) interweaves photographic
image and text to represent the insidiousness of in-group/out-group conflicts.
The photograph depicts a woman whose head merges into the void of the back-
ground. The contrast between the silver pitcher and plastic container offers a
juxtaposition of wealth and poverty. The text (e.g., "only to discount her mem-
ory") reflects distrust of out-group members. The image is made even more

Political art demands a conceptual approach. Whether sympathetic or antagonistic to the political sentiments described, it is necessary to know and understand the point of view that is being represented. If preaching to the converted, such art reinforces moral values. For others, it is important to understand the historical and cultural context within which such artworks were produced. In this manner, political art can teach and extend one's understanding of other cultures.

■ Cultivating Culture

Within cultures there are subgroups of individuals who affiliate and coalesce among themselves. There are Catholics versus Protestants, Shiites versus Sunnis, Democrats versus Republicans, and so on. These cultural kinships offer social groupings in which beliefs, ideas, and practices are mutually shared. When group affiliation is cultivated, members gain comradeship and solace with like-minded individuals. Even those who feel ostracized because their beliefs are divergent from the "mainstream" often group together and coalesce into a "counterculture." Thus, over the past half century, we've seen groups identified as "beats," "hippies," "punks," and "hipsters." These names, originally used as pejorative monikers, have come to symbolize subcultures, each with their own beliefs, styles, and practices. Art has its own cultural landscape. The term *art world* is often used to represent an *in-group* of cultured individuals who determines what is new, exciting, and valued in art.[25]

Are You In or Out?

As soon as a cultural grouping is defined, a border is set with individuals on the inside who share certain beliefs and those on the outside who do not. By being a card-carrying member of a culture, you are granted all of the benefits of a social affiliation. You can attend gatherings and rituals, enjoy the company of like-minded individuals, and feel secure among fellow members who will defend established beliefs. In particular, you will be protected from the conceptual (and sometimes physical) barrage inflicted by those on the outside, those *out-group* individuals who do not share your beliefs and practices. Loyalty is strong among in-group members. Moreover in-group members are presumed to be smarter, more content, and have worthier moral standards than out-group individuals. Radical in-group members are exceptionally exuberant in their belief system. Even today, one can purchase bumper stickers that state *America: Love it or Leave it*, despite the fact that the country was founded on a tolerance of beliefs.

Social psychologists have studied the dynamics of in-group/out-group interactions.[26] Social groupings offer solace and security. They can be formed

FIGURE 7.6 Evans, Walker (1903–1975), *Bud Fields and His Family in Bedroom, Hale County, Alabama* (August 1936). Walker Evans Archive, 1994 (1994.258.310). © Walker Evans Archive, The Metropolitan Museum of Art. Photo Credit: Image copyright © The Metropolitan Museum of Art / Art Resource, NY.

glimpse of hardship and poverty. Likewise, in film, *neorealism* took hold in Italy following World War II as filmmakers such as Roberto Rossellini and Vittorio de Sica depicted simple stories of ordinary people. For example, in de Sica's *Ladri di biciclette* (*Bicycle Thieves*), we are introduced to a downtrodden man who needs his bicycle for a new job but has it stolen during his first day of work. The rest of the film follows him and his son in search of the perpetrator. These Italian filmmakers used untrained actors and everyday settings that gave the films a sense of "realism" or authenticity. Thus, in both the story and artistic method, neorealism presented simple stories with strong emotional and political sentiments.

One concern with using art to represent political sentiments is that such works border on propaganda. Indeed, during World War II art was used to bolsters morale both in American troops and in Hitler's soldiers. Often, the people or events portrayed in such works are exploited or characterized in a biased manner. Indeed, with respect to Agee and Evans's *Let Us Now Praise Famous Men* (1941), David Witford went back to Alabama and interviewed family members of those depicted in the photographs.[23] Many people felt exploited and embarrassed by their portrayal in the photographs and narrative.[24] It was not that the book was untrue or meant to deceive, rather it was that the families felt invaded and exposed in a shabby light. The process left them feeling ashamed and merely used as political puppets.

Linking symbolic art to cultural knowledge reinforces beliefs, and thus we are reminded of our moral obligations. When we view art in this manner, we apply a conceptual approach. As an "outsider," we can learn about another culture's beliefs and practices from an understanding of the symbolic references portrayed in artworks.

Art and Politics

Political sentiments weigh heavily on our sense of morality. Liberal versus conservative, collectivists versus individualists, capitalists versus socialists—whatever one's political leanings they act to influence and guide behavior. Political art reminds us of our beliefs in much the same way as religious art. Throughout history, political sentiments have identified "good guys" and "bad guys," which of course is relative. War, revolution, terrorism, economic decline are cultural experiences earmarked by emotionally charged moments in history that define political viewpoints. Art depicts these moments and represents—indeed propagandizes—a point of view. Such art can be used both as reminders and teachers of our cultural heritage.

Artists capture political sentiments by their representation of momentous events. Prominent paintings, such as Delacroix's *28 July 1830: Liberty Guiding the People* or Francisco Goya's *The Third of May 1808* (1814), offer potent depictions of political strife. Less charged but still emotionally forceful is the style of social realism during the mid-nineteenth century, marked by painters such as Gustave Courbet and Jean-François Millet. These realists rejected the romantic, melodramatic approach to painting that was popular at the time and instead showed that ordinary life can be just as potent in describing the human condition. This view is consistent with Marxist philosophy which defines a collectivist view and stresses the importance of raising the socioeconomic status of the working class in all aspects of life, including art. The rejection of art as a trifle pleasure for the rich and sophisticated marked an important shift in the role that art can play in society. In fact, this shift toward social realism is often considered the beginning of a modernist approach to art. Whereas Manet is generally viewed as a harbinger of modernism from a formalist perspective (see chapter 1), Courbet is considered the initiator in art that describes a modern conceptual or socio-political perspective.[21]

In photography, social realism became prominent during the Great Depression, as Dorthea Lange, Walker Evans, and others portrayed economic blight in the United States. These photographers portrayed a social landscape marked by despair, poverty, and helplessness. The photograph in Figure 7.6, *Bud Fields and His Family, Hale County, Alabama, Summer 1936,* by Walker Evans was published in a book with a narrative by James Agee entitled *Let Us Now Praise Famous Men* (1941).[22] Agee and Evans spent several weeks living in Alabama with three sharecropper families. The photographs offer a disheartening

this weaponry. Thus, art itself can pose moral dilemma and conceptual conflicts that force us to think and evaluate our ethical standards. Aesthetics and morality do not always go together as what is beautiful may not be morally just. Art can act to both affirm and question our moral views.

Myths, Allegories, and Symbols

Embedded within every culture are myths that define who we are, where we come from, and what will happen after we die. These stories, often told in the form of fables, poems, and legends, are morality plays that illustrate by example the standards by which we ought to live. Joseph Campbell, already mentioned for his analysis of the monomyth (chapter 6), identified myths from many cultures that reinforce universal human experiences, such as love, war, duty, and death. According to Campbell, every culture characterizes and colors these primal experiences as "masks," mythical tales that reveal our inner feelings, desires, and intentions.

With familiarity of cultural knowledge, a mere mention of a fairy tale or myth will immediately call to mind a moral code. In Western cultures, Aesop's fables have long instantiated ethics in children. One only needs to mention a title, such as *The Tortoise and the Hare*, and many can recite the moral, "slow and steady wins the race." In the *Bible*, the Hinduist's *Purana*, Ovid's *Metamorphoses*, and in many other ancient texts, stories about spirituality and the human condition are told, and for those with knowledge of these tales, one only needs to begin a line and the moral behind the story is immediately known. In art, we have already considered Bruegel's painting depicting the myth of Icarus (Figure 5.9 in chapter 5). Such works serve as visual links to myths, reminding us of our cultural knowledge.

In its most obvious form, an allegorical painting presents images meant to symbolize or represent a concept or belief. To understand such paintings, it is necessary to decipher the visual symbols. These symbols, like a culture's mythical tales and fables, act as reminders to cultural knowledge that the beholder is expected to have. As in the memento mori (see Figure 6.11 in chapter 6), references to our own mortality and the vagaries of time are symbolized in the objects portrayed, such as a used candle, watch, and disheveled desk. Such symbols act as shortcuts to cultural beliefs and morals, allowing an object to represent an entire knowledge schema. Analyses of such iconography offer guidance to deciphering symbolic references in art.[20] Of course, visual forms can take on very different meanings depending upon one's belief. In Christian art, dragons are the embodiment of the devil, whereas in Chinese art, they are the guardians of the Buddhist faith and associated with spring and the coming of rain.

Myths, allegories, and symbols portrayed in paintings demand cultural knowledge. Without knowing the underlying iconography embedded in an artwork, one cannot fully appreciate or "read" the story embodied by it.

dilemma: You are standing on a footbridge next to a large person. As before, you see a trolley rumbling down the track heading toward five workers who will certainly be killed. You can, however, push the large person over the bridge to his death and, in doing so, halt the trolley and prevent the death of five workers. Do you push the individual onto the tracks? Most people say "no," even though the same moral justification could be used as in the previous dilemma. What's the difference?

Philosophers suggest that these two moral dilemma differ in terms of letting die versus killing.[17] In the act of switching the trolley to another track, you let someone die, as it is the runaway trolley that is the agent of the death. In the act of pushing an individual off the bridge, you are intentionally killing someone by your own physical actions. This scenario causes significant conflict and is more emotionally charged than deciding to pull the switch. Cognitive neuroscientist Joshua Greene used fMRI to assess the brain areas that are responsive to these kinds of moral dilemmas. In high-conflict moral conditions, such as considering to push an individual off a bridge to stop a trolley, medial prefrontal regions known to be involved in monitoring cognitive and emotional conflict are particularly active. Also active are regions in the posterior parietal cortex, which we have already discussed are involved in retrieving personal, episodic memories.[18] These posterior regions are involved because we imagine ourselves within the context of the moral scenario. When dealing with a moral dilemma we put ourselves in the situation, imagine doing something, and weigh the consequences of the action. We experience conflict, because the right thing to do is not obvious.

When we experience art from a moral perspective, we consider the ethical implications that are represented in an artwork and weigh our own actions (both past and future) in terms of these implications. In *What Is Art?*, Tolstoy[19] argued that this seeking of moral implications in art is its primary function. He said that good art is not meant to portray beautiful or pleasurable things but instead it is created to reinforce moral values of good and truth. By this definition, artworks should not be considered for their formalist or expressive value but must describe and define a particular set of ethics or beliefs. In this way, the approach to art is primarily a conceptual one, as art must link itself to cultural knowledge of moral behavior. Art must therefore be created to remind us of our cultural practices and moral obligations. Of course, Tolstoy was particularly thinking of the socialist practices inherent in his own cultural beliefs.

When we consider the moral implications of an artwork, it may conflict with our appreciation of beauty. As in the trolley dilemma, we may experience conflict as we view an artwork, because what moral implications are portrayed may conflict with visual aesthetics. From a strictly formalist approach some may experience beauty or a sublime feeling when shown a photograph of an atomic bomb detonation, with its billowing mushroom cloud. Of course, conflict and guilt arises when one considers the many people who have died from

CHAPTER 7: You Are Cultured

The Good, Bad, and Beautiful

What is the right thing to do? Philosophers have grappled with this seemingly simple question for millennia. Much of our cultural knowledge is grounded upon an understanding of ethical codes ("thou shalts") that define a group's rules for living a good and just life. One suspects (or hopes) that there are certain *do's* and *don'ts* that are universally accepted, such as to do unto others as you would have them do unto you. This *Golden Rule* or "rule of reciprocity" is not only prominent in Judeo–Christian thought but is also represented in the Buddhist and Hinduist notion of *karma*. A corollary of this rule is that heinous acts, such as murder and rape, must not be allowed. Such ethical rules are, of course, group guidelines or standards that may or may not be followed by any single individual.[16]

Each culture embraces ethical rules. Some may be common among many if not all human cultures, whereas others are specific to a particular group's philosophy. The Japanese have a saying, *deru kui wa utareru* ("the stake that sticks out gets hammered down"). As this collectivist proverb portends, one shouldn't stick out as conforming to the group's norm is a virtue. In the United States there is the saying, *the squeaky wheel gets the grease*. This proverb stresses individualism and the benefits reaped from outspoken behavior. Clearly, the "squeaky wheel" suggests a diametrically opposite metaphor than the "stake that sticks out." Thus, human nature, our desires and needs, must be molded within a group's ethics. How you ought to behave is determined by a set of beliefs and practices, which may be different from that encouraged by another culture.

It is expected by your group's affiliation that you follow a set of moral guidelines. Yet conflicts may occur between personal desires and group ethics. You may want to covet your neighbor's wife, but to do so will violate your ethics. Freud's theory of the psyche being composed of three components, the id, superego, and ego makes reference to such conflicts. The id represents our animalistic, self-gratifying drives and is countered by the superego, which represents our moral standards. The ego balances these two forces and attempts to behave in socially acceptable ways and, at the same time, satisfy our personal drives. According to Freud, how successful the ego is in mediating the conflict between the id and superego determines our mental health.

In some circumstances, you may be morally conflicted because deciding on the right thing to do may not be simple. Consider the following dilemma: You are standing by a track switch and you see a runaway trolley rumbling down the rails unable to stop in time to prevent killing five individuals further down working on the rail. If you engage the switch, you'll divert the trolley to a sidetrack and away from the five workers, but that action will certainly kill a lone worker on the sidetrack. Do you pull the switch? Most people say "yes," as it seems morally justified to kill one person to save five. Yet consider another

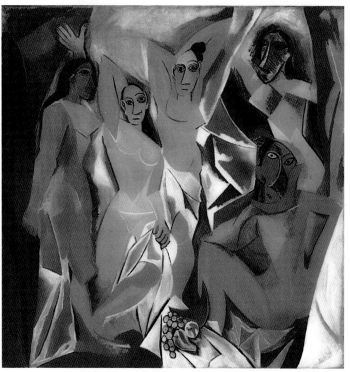

FIGURE 7.5 (a) African Mask: Fang Mask from Gabon, nineteenth century. Wood, caolin, brass nails, h. 66 centimeters. Inv: 71.1965.104.1, from the Musee de l'Homme. Photo: Hughes Dubois. (b) Picasso, Pablo (1881–1973), Les Demoiselles d'Avignon. Paris (June–July 1907). Oil on canvas, 8 feet × 7 feet 8 inches. Acquired through the Lillie P. Bliss Bequest. © ARS, NY.

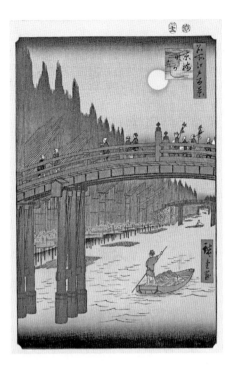

FIGURE 7.4 Hiroshige, Utagawa (Ando) (Japanese, 1797–1858), *Bamboo Yards, Kyobashi Bridge, No. 76* from *One Hundred Famous Views of Edo*, 12th month of 1857. Woodblock print, Sheet: 14 3/16 × 9 1/4 inches (36 × 23.5 centimeters). Brooklyn Museum, Gift of Anna Ferris, 30.1478.76. (See color plate section.)

the African motif (Figure 7.5a) is characterized in the faces of the women (Figure 7.5b). Picasso's "African" period occurred just before he delved fully into Cubism, and in *Demoiselles* one can see the beginning of the breakdown of space into more primitive forms.

■ Do the Right Thing

Whether religious, political, or familial, we all have developed moral standards. These cultural guidelines encourage us to do the right thing—to adhere to an ethical code. From childhood we are taught what is good and bad, proper and improper, right and wrong. In fables, myths, and legends we are told stories that define morality embedded within a cultural context. These stories remind us of the benefits we reap from doing the right thing. Art informs us of our morality. This function existed long before we entertained a disinterested (*art for art's sake*) viewpoint. When we consider art from a moral perspective, we reinforce our cultural heritage, knowledge, and values.

Other findings suggest that East Asians make decisions based upon context or surrounding circumstances. By this Eastern sentiment, things do not stand alone but are embedded within a contextual framework.[12] Westerners adhere more strongly to an Aristotelian logic in which decisions are categorical—it's either this or that, good or bad. This fundamental difference in reasoning is perhaps the reason why Chinese respondents in Komar and Melamid's poll often marked "not sure" or "depends" when asked about their aesthetic preferences. One's preferences may depend upon circumstances—are we talking about the color of a painting or clothing, landscape or abstract work? Interestingly, cross-cultural neuroimaging studies show that this pattern of thinking is evidenced in brain activations.[13] When shown isolated objects, such as a picture of an elephant, Americans activated more ventral, object-processing areas than East Asians (from China and Hong Kong).

Cultural identities are, however, not cemented in one's psyche. We all behave differently depending on the situation in which we find ourselves. For example, East Asians who have spent years living in the United States take on individualist attitudes and habits. When they return to Asia, they switch back to behaviors consistent with Eastern cultural norms. This form of bicultural *frame switching* is quite common among individuals who have had the advantage of experiencing multiple cultures.[14] Just as we experience art from different approaches, bicultural individuals perceive the world from different perspectives. With respect to East–West mixing, the opening of Japan to foreign trade during the mid-nineteenth century led to increased exposure of Asian art to Europeans. The first formal exhibition of Japanese art in Europe took place at the 1867 World's Fair in Paris, though prior to that event many Japanese artifacts, including woodblock prints, decorative fans, and silk kimonos, had reached European aesthetes through trade.

When Japan opened for trade, European artists were intrigued by the colorful images and unusual perspectives presented in Japanese woodblock prints, especially those by Hokusai and Hiroshige (Figure 7.4). James Whistler was an avid collector of Asian art and even added a red seal to his paintings which mimicked the seals used by Japanese artists. He also incorporated in his own works features found in woodblock prints. Yet it was less the pictorial themes and more the tonal and formal quality of Japanese art that intrigued Whistler, as evidenced by his use of musical terms in his titles, such as *Nocturne, Symphony,* and *Harmony.*

The beginning of the twentieth century brought another cultural influence to Europe. Maurice de Vlaminck, one of the *Fauves* artists, saw two African statuettes in a Paris bistro and was so fascinated by them that he bought them.[15] Derain, another Fauvist, bought one mask and hung it in his studio, where Picasso and Matisse admired it. It was, of course, Picasso who incorporated African motifs into his works, particularly the use of African masks in his paintings. In one of his most famous paintings, *Les Demoiselles d'Avignon,*

the American West to Italian audiences. In *Sukiyaki Western Django*, samurai swords, pistols, bow and arrows, and even a Gatling gun are used in battles between two gangs dressed as either samurai, gunslingers, or both. The characters are played by Japanese actors who speak in English. The movie acknowledges the long tradition of both Japanese and American films in intermixing themes and morals defined by the samurai and gunslinger.

With respect to a culture's myths and morals, the samurai and gunslinger each represent socially defined archetypes that reinforce each culture's values. Both heroes symbolize strength through force and moral commitment. Yet the samurai's duty is always to his master, sacrificing himself for the good of the clan. The gunslinger represents the epitome of independence, following his own moral compass. Thus, these two archetypes symbolize opposite ends of a political spectrum: the samurai honors collectivism or group needs, whereas the gunslinger represents individualism and independence. Since antiquity, Eastern philosophies, such as Confucianism and Buddhism, have reinforced collectivist views; whereas Western philosophies have reinforced individualist views.

Social psychologists investigate how culture influences the way we perceive, think, and feel. Deep-rooted influences formed by culture can appear even in rather mundane situations. In one study, Chinese and American individuals watched videos of fish moving together and apart.[11] In one video, five fish move together, but suddenly four stop while the one in front continues on (Figure 7.3). When asked about the lone fish's movement, Chinese individuals described the fish as an outcast and being ostracized by the others. Americans described the lone fish as boldly making its own path and leading the others. Thus, the same video elicits diverse interpretations, which define a collectivist view for Chinese individuals and an individualist view for American individuals.

FIGURE 7.3 Display used in analysis of Chinese and American individuals' impression of social interactions. The four fish in the rear stop moving, whereas the front fish keeps on swimming. Reproduced from Hong, Y., Morris, M. W., Chiu, C., & Benet-Martínez, V. (2000). Multicultural minds: A dynamic constructivist approach to culture and cognition. *American Psychologist, 55,* 709–720, American Psychological Association.

FIGURE 7.2 Items from the *Visual Aesthetic Sensitivity Test*. Reproduced from Gotz, K. O., Borisy, A. R., Lynn, R., Eysenck, H. J. (1979). A new visual aesthetic sensitivity test: I. Construction and psychometric properties. *Perceptual and Motor Skills, 49*, 795–802, with permission from Ammons Scientific, Ltd.

upon her head a four-gallon tin—a common sight in those parts."[9] In this case, what looks to a Westerner as a window that is situated just above and behind a woman in a home is interpreted as an tin container commonly seen on top of women's heads. The way one interprets this single object changed the entire scene from a depiction of an interior room to an outdoor scene. Such differences in what is "seen" suggests that the way we interpret the world is guided significantly by cultural knowledge.[10]

Cultural Identity and Mixing

With the advent of the World Wide Web and internationally distributed movies, magazines, and television programs, cultural styles from around the world have mixed and influenced each other. These mixings offer new and interesting blends in artistic style. The 2007 film *Sukiyaki Western Django* by the Japanese director Takashi Miike is an example of both cultural identity and mixing. This quirky film is an homage to *Spaghetti Westerns*, an earlier mixing of cultures by Italian directors, such as Sergio Leone (*The Man With No Name* trilogy) and Sergio Corbucci (*Django*). These earlier filmmakers brought the tradition of

differences. Respondents from Finland, Iceland, Kenya, and the United States elicited very similar responses, which were different from those elicited by respondents from France, Ukraine, and Russia. Responses from China were the most different, primarily because of the preponderance of "not sure" or "depends" answers. For example, 42% of Chinese respondents marked "not sure" for the question, "What is your second favorite color?" whereas only 2% of US respondents marked that answer for the same question. With respect to color, every culture rated blue as the most favored color and green as the second favorite color (except for Denmark respondents who rated red as second favorite). Orange was usually ranked as the least favorite color. Komar and Melamid went a step further and used these results to paint each country's "Most Wanted" and "Most Unwanted" painting. Every country's *Most Wanted* painting included outdoor scenes with a body of water, blue sky, animals, and people. The *Most Unwanted* paintings were abstract designs that typically included orange and brown. It is difficult to take these paintings seriously, as they simply include an amalgamation of the various most (or least) preferred features. They perhaps best exemplify the Gestalt adage that aesthetics is more than the sum of its preferred parts.

In a more scientific analysis, psychologist Hans Eysenck conducted cross-cultural experiments of visual aesthetics. He and artist Karl Götz devised the *Visual Aesthetic Sensitivity Test* in which 42 pairs of designs were created, with one design in each pair identified as being more aesthetic than the other.[6] These preferred choices were selected unanimously by eight artists on the basis of having good artistic form (see Figure 7.2). The *Visual Aesthetic Sensitivity Test* has been administered to individuals from various cultures. In one study, children were shown the pairs and asked to select the one that they thought was most harmonious and thus preferred by professional artists.[7] Across various countries the children performed similarly. For example, pairs that were ranked as easy, moderate, and difficult by British children were similarly ranked by Japanese children. However, overall scores did vary as Japanese children (aged 11–14) performed better than British children. Interestingly, British college students performed better than Japanese students, suggesting that education may influence performance. In another study, Chinese adults and children from Hong Kong scored lower than the Japanese and British groups, despite coming from comparable socioeconomic levels.[8] One issue is that the test itself was designed in the West and thus could be biased toward Western views of aesthetic forms.

Cultural practices and traditions influence what we see, what we learn, and how we feel. In an interesting analysis, the psychologist Jan Deregowski tested cross-cultural interpretations of drawings. He showed a drawing that, to most Westerners, depicts an African family relaxing together inside their home. Deregowski, however, found that, when shown the same picture, East Africans interpreted it as a scene outside "in which a young woman carries

became increasingly biased toward thinner and thinner figures. This trend echoed America's cultural shift from the buxom film stars of the 1940s and 50s to rail-thin models of the 1990s. Sadly, these cultural influences forced fashion models to be so thin that their BMIs were below the World Health Organization's cutoff for malnutrition. Fortunately, in more recent years, there has been a trend toward pageant winners with somewhat higher BMIs. Another cultural shift during this period seems to have occurred in the perception of the idealized male. During the mid-twentieth century male film stars generally exhibited that strongly masculine, chisel-faced look, characterized by actors such as Cary Grant and Charlton Heston. A half century later, more boyish traits became favored, as exemplified by actors such as Johnny Depp and Brad Pitt.

Culture defines our preferences, desires, and morality, and art reflects them. Over time, styles evolve and form distinctive patterns. In Western art, we can identify painterly styles from the mimetic trends of the Renaissance artists to more expressive and exaggerated styles of Baroque and Romantic artists. Moreover, we can observe the way artists reflect their own cultural styles and preferences in how they portray people and places. I am often amused by gladiator movies made during my childhood in which the hairstyles and fashions of Roman women look very much like the style of women in the 1960s. It is thus useful to consider both the cultural context in which the work was created and our own cultural environment in driving our art experience.

The Geography of Aesthetics

To what degree do people from other cultures differ in aesthetic preferences? In 1993, Vitaly Komar and Alex Melamid, two artists from the former Soviet Union, initiated a survey of preferences in art.[5] With funding from *The Nation Institute*, a nonprofit branch of *The Nation* magazine, they conducted a telephone poll of over 1000 Americans and asked 102 questions, most of which pertained to preferences and interests in visual artworks. Realistic paintings were favored over abstract ones. In fact, 60% said they enjoyed paintings more when "they resemble a photograph." This preference suggests a mimetic approach to art. Of those polled, 88% preferred outdoor scenes, particularly paintings that included animals and water (lakes, rivers, oceans). Fall scenes were most preferred (33%) followed by spring (26%), summer (16%), and winter (15%). When asked to evaluate specific artists, 43% gave Norman Rockwell the highest ranking compared to 20% for Picasso and 24% for Monet. Of those polled, 77% said that they had some form of visual art in their home (e.g., sculpture, painting, drawing, photograph) other than family snapshots.

Following the American poll, Komar and Melamid organized polls in 13 other countries: China, Denmark, Finland, France, Germany, Holland, Iceland, Italy, Kenya, Portugal, Russia, Turkey, and Ukraine. Remarkably high concordances in responses were obtained across cultures, though there were

Since the eighteenth century, the tradition of Western art has tended toward *art for art's sake*. As Kant described, we view art in a disinterested manner, without any purpose other than seeking beauty or sublimity. Prior to the eighteenth century, objects that we now readily call art were not meant to be viewed as such. For example, most medieval and Renaissance paintings were commissioned strictly for religious purpose. Thus, even familiar "artworks," such as paintings by Leonardo and Raphael, were not intended as objects to admire simply for their aesthetic appeal. Of course, we now view these paintings as "art" in the Kantian sense and take an aesthetic approach by considering the perceptual, conceptual, and emotional qualities of such objects. Even further, a postmodernist perspective takes primarily a conceptual approach and considers the political, cultural, and historical forces that influence art. Issues of beauty and sublimity are far from the minds of those who experience art from strictly a conceptual perspective.

Prehistoric works, such as the cave paintings of *Lascaux* and ancient statuettes, such as the *Venus of Hohle Fels* (Figure 1.6 in chapter 1), present an even thornier predicament. We see artistic skill in these works, but we can only speculate on their function among individuals who inhabited the earth 15,000 to 35,000 years ago. Cave paintings are found in deep recesses that are hard to find and hard to illuminate. They clearly were not meant as a way to showcase an artist's skill. Likewise, ancient wood and ivory carvings have been viewed as spiritual icons, perhaps used to celebrate or encourage fertility. From our own enculturation, we appreciate these prehistoric artifacts as intriguing works of art, though we must keep in mind that their original function will never be fully understood and was likely much different from the way we consider them now.

With respect to the human body, artistic renditions have changed considerably over time as cultural styles and interests have defined preferences for a particular physique, disposition, or fashion. Prior to the fifth century BC, Greek statues often depicted individuals with rather pleasant smiles, such as shown in the *Pelpos Kore* statue in Figure 7.1. This so-called *archaic smile* is found in many statues discovered around the Aegean Sea and though friendly in disposition, their bodies are rigid and unnaturally erect. By the fourth century BC, the smile disappeared, and faces exhibited that staid, nondescript expression familiar to us as exemplifying classic Greek sculpture. Interestingly, these later Greek statues exhibited a more relaxed posed with knees slightly bent (the art historic term is *contrapposto*). Just as fashions change over time, preferences for styles in art are always evolving.

Cultural forces place significant pressure on what we like and consider as beautiful. During the twentieth century, Western views of the ideal female body changed from average-weighted women to very slender figures. In an analysis of this trend, the body mass index (BMI), a measure of body fat,[3] was assessed in Miss America Pageant winners from 1922 to 1999.[4] During this period, the BMIs of Pageant winners declined considerably, as the ideal woman

FIGURE 7.1 *(a)* Ancient Greek statue known as the *Pelpos Kore.* with Dorian peplos (Inv. 679) (*c.* 530 BC). Marble. H.: 48 inches (122 centimeters). Acropolis Museum, Athens, Greece. Photo Credit: Nimatallah / Art Resource, NY. *(b)* Painted model of the statue reconstructed from archeological information. Photograph courtesy of Ulrike Koch-Brinkmann. (See color plate section.)

observed in museums and art books. Our conception of these works is a product of our own cultural upbringing, and this fact forces us to acknowledge that our art experience is inextricably embedded within the time and place of viewing.

When Is It Art?

Artistic styles change over time, even across rather short intervals. Consider the advent of rock and roll music, which during the 1950s and 1960s revolutionized the form and content of popular music. Stylistic changes are often catalyzed by technological advances, such as the introduction of the electric guitar in music or photography in art. At other times a thought or idea germinates within a group of artists and grows into a movement that reflects and even changes the cultural landscape. Impressionism is an example of such a movement. During the twentieth century, further explorations advanced, which were marked by a progression of styles or "isms" (e.g., Fauvism, Surrealism, Futurism) that revolutionized the very concept of art. Such developments led philosopher Nelson Goodman to redirect the question of "What is Art?" to "When is Art."[2] That is, any object, be it a Christian altarpiece, *Brillo* box, or even a urinal, may be considered art at one time, and not art at another.

7. YOU ARE CULTURED

What we perceive, think, and feel is largely determined by where and when we live. In the previous two chapters we considered semantic and episodic memories and how they influence our experience with art. These two aspects of knowledge are filtered through the styles and preferences that define us as a member of a culture, be it a national, religious, political, or more narrowly defined group (e.g., art culture, counterculture). Here we use the term "culture" rather loosely and designate it as any group sharing the same attitudes, beliefs, or practices. Thus, no individual is an island as we are all grounded by group memberships. We have religious beliefs, political biases, and a national sentiment, and these dispositions drive the way we live and behave. Cultural factors also determine the way we appreciate artworks and even define what we decide to consider as "art."

■ A Matter of Style

Over time and geography, styles in art change and evolve. Consider ancient Greek statues. These remarkable pillars of Western culture have been admired for their exquisite rendering of the human form. Renaissance artists used these ancient forms (or at least Roman copies of them) as models for their own works, such as Michelangelo's *David*. Yet we view these artworks much differently than how their creators intended. For example, archeologists have found remnants of pigment on the marble of ancient statues, which tell us that these works were rather wildly colored.[1] Figure 7.1 shows the statue known as the *Pelpos Kore*, which was found in Athens and sculpted in the fifth century B.C. The statute as it would have looked to ancient beholders appears somewhat garish to our eyes, which have grown accustomed to the pristine, unadulterated marble forms

memory loss. *Philosophical Transactions of the Royal Society of London, B. 352*: 1747–1754.

16 Markowitsch, H. J. (2003). Psychogenic amnesia. *NeuroImage, 20*, S132–S138.; Yasuno, F., Nishikawa, T., Nakagawa, Y., Ikejiri, Y., Tokunaga, H., Mizuta, I., et al. (2000). Functional anatomical study of psychogenic amnesia. *Psychiatry Research: Neuroimaging, 99*, 43–57.

17 Johnson, S. C., Baxter, L. C., Wilder, L. S., Pipe, J. G., Heiserman, J. E., & Prigatano, G. P. (2002). Neural correlates of self-reflection, *Brain, 125*, 1808–1814; Kelley, W. M., Macrae, C. N., Wyland, C. L., Caglar, S., Inati, S., & Heatherton, T. F. (2002). Finding the self? An event-related fMRI study. *Journal of Cognitive Neuroscience, 14*, 785–794; Ochsner, K. N., Knierim, K., Ludlow, D. H., Hanelin, J., Ramachandran, T., Glover, G., et al. (2004). Reflecting upon feelings: An fMRI study of neural systems supporting the attribution of emotion to self and other. *Journal of Cognitive Neuroscience, 16*, 1746–1772.

18 Maddock, R. J., Garrett, A. S., & Buonocore, M. H. (2003). Posterior cingulate cortex activation by emotional words: fMRI evidence from a valence decision task. *Human Brain Mapping, 18*, 30–41.

19 Gieser, L., & Stein, M. I. (Eds.). (1999). *Evocative Images: The Thematic Apperception Test and the Art of Projection*. Washington, DC: American Psychological Association.

20 Warner, M. Lucian Freud: The unblinking eye. *New York Times Magazine,* December 4, 1988, http://www.nytimes.com/1988/12/04/magazine/lucian-freud-the-unblinking-eye.html

21 Jung, C. G. (1981). *Archetypes and the Collective Unconscious*. Princeton, NJ: Princeton University Press.

22 Jung, C. G. (1917). *Psychology of the Unconscious*. New York: Moffat, Yard and Co.

23 Campbell, J. (1949). *The Hero with a Thousand Faces*. Princeton, NJ: Princeton University Press.

■ Notes

1 Tulving, E. (2002). Episodic memory: From mind to brain. *Annual Review of Psychology, 53*, 1–25.

2 Janson, H. W. (1977). *History of Art* (2nd ed., pg. 658). New York: Prentice-Hall.

3 Proust, M. (2002). *In Search of Lost Time (À la Recherche du Temps Perdu).* (C. Prendergast, transl. ed.). New York: Viking Press. The title was previously translated as *Remembrance of Things Past.*

4 Scoville, W. B., & Milner, B (1957). Loss of recent memory after bilateral hippocampal lesions. *Journal of Neurology, Neurosurgery and Psychiatry, 20,* 11–21; Corkin, S. (2002). What's new with the amnesic patient H.M.? *Nature Reviews Neuroscience, 3,* 153–160.

5 Milner, B. (1970). Memory and the medial temporal regions of the brain. In K. H. Pribram and D. E. Broadbent (Eds.), *Biology of Memory* (pp. 31–59). New York: Academic Press.

6 Libby, L. K., & Eibach, R. P. (2002). Looking back in time: Self-concept change affects visual perspective in autobiographical memory. *Journal of Personality and Social Psychology, 82,* 167–179; Nigro, G., & Neisser, U. (1983). Point of view in personal memories. *Cognitive Psychology, 15,* 467–482.

7 Shimamura (2011). Episodic retrieval and the cortical binding of relational activity. *Cognitive, Affective, and Behavioral Neuroscience, 11,* 277–291.

8 Eich. E., & Macaulay, D. (2000). Are real moods required to reveal mood-congruent and mood-dependent memory? *Psychological Science, 11,* 244–248.

9 Intraub, H., & Richardson, M. (1989). Wide-angle memories of close-up scenes. *Journal of Experimental Psychology: Learning, Memory, and Cognition, 15,* 179–187.

10 Carmichael, L., Hogan, H. P., & Walter, A. A. (1932). An experimental study of the effect of language on the reproduction of visually perceived form. *Journal of Experimental Psychology, 15,* 73–88.

11 Bartlett, F. C. (1932). *Remembering: A Study in Experimental and Social Psychology.* Cambridge, UK: Cambridge University Press. Roediger, H. L. III, Bergman, E. T., & Meade, M. L. (2000). Repeated reproduction from memory. In A. Saito (Ed.), *Bartlett, Culture, and Cognition,* 115–134. London, UK: Psychology Press.

12 Bartlett (1932).

13 Loftus, E. F., & Ketcham, K. (1992). *Witness for the Defense: The Accused, the Eyewitness, and the Expert Who Puts Memory on Trial.* New York: St. Martin's Press.

14 Loftus, E. F., & Greene, E. (1980). Warning: Even memory for faces may be contagious. *Law and Human Behavior, 4,* 323–334.

15 Kritchevsky, M., Zouzounis, J., & Squire, L.R. (1997). Transient global amnesia and functional retrograde amnesia: Contrasting examples of episodic

we attach our own personal experiences. Campbell and Jung understood the universality of these myths. All forms of art express the nature of the human condition, and though they are created from personal experience, they can be shared collectively among us all.

■ This Is Your Life

Art and memory, the two are intricately intertwined. Both sweep us away from the present and drop us at another time and place. From our scrapbook of personal memories we recollect stories that include sad, joyful, funny, and horrific moments. Although we try to fix our memories as static snapshots of the past, they change over time, redesigned and reconstructed after each reminiscence. Even impressions of an artwork can change over time. Have you ever found a painting, song, or movie to affect you differently upon reexperiencing it at a later time? As noted earlier, my own aesthetic response to paintings by Jackson Pollock has changed considerably over time. I now see them as active and emotionally driven dances, a feature I didn't appreciate when first encountered.

Human existence is predicated on a sense of time. Memories remind us what we and the world were like in the past. Without a sense of time we have no past or future. In an ambitious ongoing work, On Kawara commented on the nature of time in his *Today* series. Since 1966, he has created paintings that consist of the current date written in the style of the place where he is located. The date is typically written in block print against a solid background of black, gray, blue, or red. If he is not finished with a painting by midnight, it is destroyed. Sometimes he completes more than one painting in a single day. Each painting is placed in a box with a page from that day's local newspaper. Sometimes a subtitle provides a personal experience from that day, such as "Janine came to my studio" or "I thought about memory and sense." Kawara's paintings from the *Today* series are shown individually or grouped, sometimes with the painting alone and other times with the box and newspaper clippings. Kawara has made over two thousands of these paintings and does not plan to stop until his death.

We are defined by our personal memories. When we experience a new culture, friendship, love, birth, or someone's death, we change and learn from the experience. Episodic memories shape the way we see, think, and feel. Without these personal memories we lose our self identity. Yet the paradox of episodic memories is that as personal as they are, we all share common experiences. Moreover, we are all guided by essential human needs. In art, like our episodic memories, these universal experiences are remembered as we are transported to another time and place. Art offers a slice of life and tells a story about the human condition that we link to our own experiences. Indeed, we can only understand art by relating it to our own memories—to our own self identity. Without our personal memories, art simply becomes a document.

The primary archetype is the *Self* which acts as the protagonist in our life story. It must counteract the *Shadow*, our negative, morally reprehensible nature. Both the good and "dark side" exists in us all, a Jungian theme highlighted in the *Star Wars* epic. Jung identified other archetypes, such as the *Mother, Wise Old Man, Child*, and *Trickster*. These archetypes play on our life's stage, guiding and motivating us to act in certain ways. The *Self* is the *Hero* and must follow a morally righteous path by overcoming the *Shadow*. Archetypes are universal to all humans, as they are created by "impressions of ever-repeated typical experiences."[22] That is, we all experience people in our lives who represent parental figures, lovers, negative instigators, and playful or needy children. That is why these stereotypical personalities are so often portrayed in art. Thus, even our "personal" memories are part of a collective set of human memories founded upon universal experiences.

From Grimm's fairy tales to Arthurian legends, from the *Wizard of Oz* to the *Star Wars* epic, there is a central theme of the hero's journey. The mythologist Joseph Campbell in his seminal book *The Hero with a Thousand Faces*[23] describes this universal story as the *monomyth*, as its features are common across many if not all cultures. Like Sir Galahad, Dorothy, or Luke Skywalker, we must take a journey that leads to a righteous path. In Campbell's portrayal of the monomyth, the journey begins with a call to adventure, and the hero must leave the comforts of home and family and dutifully set forth. Danger awaits as the hero passes through a threshold and enters a dark and forbidden terrain. There, the hero must endure tests that require cunning and bravery. Often there is assistance by a sagacious wizard or friendly helper, who guides the hero through these struggles. Following the successful passing of these tests, the hero returns home with fruits of the struggles and of course makes the world right again.

Campbell drew heavily on the Jungian notion of archetypes and their universality. He discovered the universal nature of the monomyth by studying the stories and myths from many cultures and religions. Consider Dorothy's plight in the *Wizard of Oz*. She is swept away and placed in a strange land. There she meets a Mother figure, *Glinda the Good Witch*, as well as her *Shadow*, the *Wicked Witch of the West*. She is assisted by a *Wizard*, as well as brotherly compatriots—the *Scarecrow, Tin Man*, and *Cowardly Lion*. As is essential in the monomyth, the hero must ultimately endure the final battle alone and defeat the *Shadow* by taking the righteous path to glory. Following her success, she must now find her way back home. She returns with a new sense of compassion, bravery, and wisdom. She of course realizes the importance of friends and family and that "there's no place like home."

The hero's journey is a metaphor for our own life's story. We all must take the journey away from home and set forth, passing the threshold to the unknown terrain called adulthood. Our encounters and experiences in life are in many ways tests that we must endure. The monomyth provides a schema onto which

experience the same sense of intrigue as when we travel to faraway lands, only without the jetlag.

Universal Experiences

Regardless of time, place, or culture, there are experiences that we all share. These universal experiences include simple pleasures, such as a warm summer day, a fine meal, or a lovely sunset. Alongside these pleasantly mundane events are life-changing experiences, such as our first love, leaving home, marriage, the birth of a child, or the death of a loved one. These universal experiences are filled with emotional import, and vivid recollections of them attest to their significance. We learn and grow from these experiences. We also share them with others as they are essential features of the human condition. One of life's universal truths, our mortality, has its own artistic genre in the *memento mori* (remembering one's mortality). In these paintings, we are presented with somber reminders of the inevitability of death. In addition to the skull, as depicted in Pieter Claesz's *Vanitas* (Latin for emptiness) (Figure 6.11), other symbols include the spent candle, the opened watch, a used goblet, and books of learning. These symbols of the ephemeral nature of life tell us that we should be prepared for what will certainly lie ahead.

In art as in our lives, we share experiences that define the human condition. Carl Jung, the noted psychologist, considered the universality of basic human experiences and coined the term "collective unconscious" to refer to common forces that influence our psyche. The collective unconscious includes primordial *archetypes* or personality blueprints that guide behavior.[21]

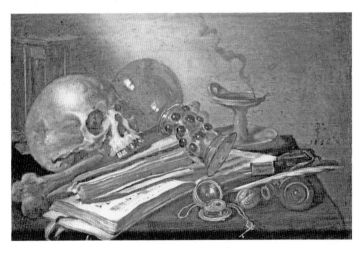

FIGURE 6.11 Claesz, Pieter (*c.*1590–1661), *Vanitas*—Still life (1656). Kunsthistorisches Museum, Vienna, Austria. Photo Credit: Erich Lessing / Art Resource, NY.

to the south seas and settled in Tahiti where he painted scenes of the people and places he encountered. In *The Black Pigs* (1891) we get a glimpse of life on the islands (Figure 6.10). Gauguin spent the rest of his days in Tahiti in virtual artistic exile, as he gained so much fame as the presenter of these foreign lands that he could not break away from the reputation. His paintings are distinctive, with their signature shades, flattened perspective, and *femmes de Tahiti*. They offer a romantic view of life in the tropics, one that is as much imagined as real.

In Chinese handscrolls, we experience scenes as they unfold in time. These long, horizontal scrolls are usually rolled up and stored in boxes until one decides to experience them. The beholder begins at the right edge and unrolls the scroll slowly, revealing more of the left side while at the same time rolling up the right side. With this method of viewing, the feeling of place is expressed in a wonderfully serene manner by the unfolding of the scenery. Often, we gain insights about our own environs from a newcomer's perspective. In 1955, the Swiss-born photographer Robert Frank traveled around the United States and turned the photographic snapshot into an artful experience. He took over 28,000 photographs during his travels and 83 of them were showcased in a highly influential book called *The Americans*. These images portray scenes of daily life from various social strata and from unusual perspectives. We are often so familiar with our own locality that we become blind to the scenery around us. It thus takes a visitor or newcomer to appreciate both the excitement and difficulty of places that are so familiar to the natives. We should be encouraged to walk around familiar places with fresh eyes and minds. In this way, we may

FIGURE 6.10 Gauguin, Paul (1848–1903), *Why Are You Angry? (No Te Aha Oe Riri)* (1896). Oil on canvas, 37 1/2 x 51 3/8 inches (95.3 x 130.55 centimeters). Photo Credit: Scala/White Images / Art Resource, NY.

FIGURE 6.9 Lucian Freud (British, b. 1922), *Hotel Bedroom* (1954). Oil on canvas, 91.1 x 61.0 centimeters. Gift of The Beaverbrook Foundation, The Beaverbrook Art Gallery, Fredericton, NB, Canada. (See color plate section.)

or at least ambiguous motives. The disconcerting pose of the clothed woman in bed also suggests a variety of emotions. As beholders, we create a story, perhaps about an entangled and complicated romance. The painting actually depicts Freud with his young wife, Caroline Blackwood. A *New York Times* article,[20] stated that Freud's wife "is lying in bed dressed because it was winter and it was cold, and Lucian had broken the window behind him in order to make room to paint." As in many of our imagined stories, we create a melodramatic tale that is overwrought with emotion. It is a human characteristic to "read" more into a scene than what has actually occurred. This tendency is reflected both in the imagined lives we create and in the reconstructions of past events from our own lives. In this sense, we have a natural tendency to view both artworks and our own lives from a expressionist approach.

Oh, the Places You'll Go!

Art has the capacity to take us on journeys to awe-inspiring locales, fantasy islands, and beyond. It can also take us to urban decay, nightmarish landscapes, and hell itself. The places we visit are packed with emotion, be it exciting, wonderful, or dreadful. Paul Gauguin epitomized the artist's journey to faraway lands. Steeped in poverty and lacking recognition in France, Gauguin sailed

FIGURE 6.8 Image used in the original Thematic Apperception Test. Reproduced from Gieser, L., & Stein, M. I. (Eds.). Evocative Images: The Thematic Apperception Test and the Art of Projection. Copyright © 1999, with permission from the American Psychological Association.

Apperception Test (TAT), a test in which people are asked to tell stories about the characters portrayed.[19] What kind of story did you create? Is the man at fault or is the woman to blame? Is the man dead, sick, or merely sleeping? This drawing was redrawn from an illustration about a short story published in *Woman's Home Companion*. In the story, the couple had recently eloped after a brief romance, and the woman has just discovered that she is pregnant. She wants to tell her husband who is "reeked with the smell of whiskey and pulsed with his slobbering snores." In TAT drawings, there can be many interpretations, and psychologists use the test to help bring out the patient's own thoughts, fears, and conflicts.

One can play the TAT game with paintings, such as *Hotel Bedroom* by Lucian Freud, the renowned British painter who was also Sigmund's grandson (Figure 6.9). The shadowy figure in the background seems to suggest nefarious

interest in creating stories about people we encounter, even though they may be based on a mere glance. When we imagine the lives of others, we consider our own experiences, impart our own morality, and perhaps wonder if our lives might have been similar under more or less favorable circumstances.

Artists not only tell stories about their own experiences but also create for the beholder stories of imagined lives. In a remarkable series of photographs entitled *Untitled Film Stills* (1977–1980) Cindy Sherman created imaginary roles by dressing up and taking photographs of herself in poses that resembled motion picture scenes. In these photographs, Sherman depicted herself in a variety of culturally defined stereotypes, from the innocent girl just off the bus in the big city (see Figure 6.7) to a brash starlet hiding away at a seaside motel. These 8 x 10-inch photographs look so much like movie stills that we create the movie ourselves and consider the story behind these women, even though no such movie exists. As a social statement, these images force us to consider the manner in which our culture portrays women.

Consider the drawing in Figure 6.8 and tell a story about the two people. Why is the woman upset? What is she thinking? When we create stories, we disclose our own desires, thoughts, and feelings. Psychologists have been aware of this kind of self-disclosure in the stories we tell and have developed personality tests around this fact. This drawing is from the first version of the Thematic

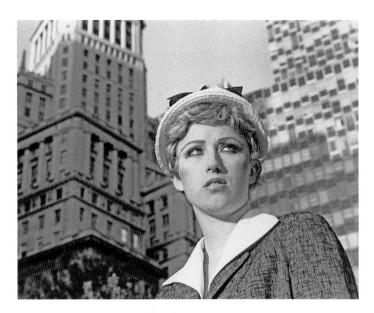

FIGURE 6.7 Cindy Sherman (b. 1954), Film Stills. © Metro Pictures, NY. Still from an Untitled Film; Untitled Film Still #21. Depicted: New York, New York (1978). Gelatin silver print: 18.7 x 23.9 centimeters (7 3/8 x 9 7/16 inches). Purchase, The Horace W. Goldsmith Foundation Gift, through Joyce and Robert Menschel, 1992 (1992.5147). Photo Credit: Image copyright © The Metropolitan Museum of Art / Art Resource, NY.

likely related to the severe emotional duress. Psychogenic amnesia falls in the category of other psychiatric disorders of self-identity, known in the field as dissociative disorders (e.g., multiple personality disorder). At this time, these disorders are not well described in terms of the specific brain regions that are affected.

Recently, neuroimaging studies have attempted to find the "self" in the brain. In these studies,[17] subjects determine how statements, such as "I forget things" or "My future is bright," pertain to themselves. When making such self-reflective judgments, a neural circuit is activated that includes the prefrontal cortex, PPC and two medial regions (i.e., on the inner surface of the cortex) situated at the anterior and posterior ends of the cingulated gyrus. These regions are also involved in the retrieval of emotional and personal memories[18] and interact with other brain regions as a way of integrating or binding oneself into a memory. As such, these brain regions may facilitate our ability to do mental time travel. They, however, must work in conjunction with all of the other brain regions involved in storing the features of a prior event. By this view, a good many brain regions are involved in retrieving an episodic memory, though each region may contribute to this process in a different way. As a result, there won't be a brain lesion that causes complete loss of self-identity, unless much of this network is disrupted.

■ Once Upon a Time and Place

Fictional narratives, as in novels, plays, and movies, guide us through stories of imagined lives. We place ourselves within these stories, experiencing the protagonist's thoughts, feelings, and actions. Regardless of the genre, be it romance, comedy, action, or science fiction, we attach our own psyche onto the hero's dispositions as the story is told. We take journeys to foreign cities, wild jungles, and even alien planets. In many ways, we become the hero. Paintings and photographs offer the same kind of experience only they depict encapsulated moments of life. Such static art forms can be viewed as short stories and give us a glimpse or slice of a life experience. Indeed, as discussed in the previous chapter every picture tells a story, and our episodic memories enable us to gain a fuller meaning of it.

Imagined Lives

Have you ever observed a stranger—perhaps sitting on a park bench or waiting for a bus—and imagined his or her life story? The downtrodden fellow walking on the street seems to tell a story of financial woes and the vagaries of drug abuse, whereas a rude encounter with a salesperson makes us construct a lifetime of failed relationships and anger management issues. We have a peculiar

crimes that only the robber could have known. On review of the incident, it was discovered that witnesses were given misleading information. Prior to picking out Pagano from lineup photographs, the witnesses were told by police that the robber might have been a priest.[13] Psychological studies have shown that recollections can be strongly influenced by false or misleading information, such as suggesting that an assailant had curly hair or that a car "smashed" into another.[14] As these findings attest, our personal recollections are reconstructions of past experiences. They can be quite accurate, though clearly affected by expectations, interpretations, suggestions, and misattributions. As we are not very good at stamping the date of our experiences, memories for events often merge with others and intermix.

Finding Oneself in the Brain

If we were completely devoid of personal memories, then who would we be? We have already discussed organic amnesia, in which individuals lose the ability to store experiences that occur after the onset of brain injury. In these cases, older memories, such as memories of childhood, are intact, and thus these patients know who they are and have a full sense of self-identity. We, however, are all familiar with the movie (or cartoon) plot in which someone is hit on the head and loses all episodic memories, thus appearing to have lost knowledge of oneself. In these fictional portrayals, it takes a second bonk on the head to recover from this amnesic disorder. There is no known brain damage that will cause such a specific and severe loss of episodic memories. A head injury severe enough to cause a temporary loss of consciousness would likely produce confusion and amnesia for events that occurred just prior and after the insult. Such brain trauma, however, would never produce a total loss of one's self-identity.

There are, however, cases in the psychiatric literature, and in the occasional newspaper clipping, in which a person is found wandering and claims to have lost all episodic memories. These individuals appear to have lost their entire autobiography. Typically, it becomes evident that they had experienced an emotional trauma, such as the death of a loved one, a ruined marriage, or dire financial problems. This kind of disorder is called psychogenic or functional amnesia, because there is no firm organic basis for it. Such cases are rare, and in some it is revealed that the individual was faking a loss of memory as a way to avoid a difficult predicament.[15]

Psychogenic amnesia can last for days, months, or even years. Symptoms are generally the opposite of organic amnesia as the individual actually retains memory for events that occurred since being found, though they cannot remember any personal events before that time. Usually, memory for skills and semantic knowledge (facts about the world) are intact. Neuroimaging scans of individuals with psychogenic amnesia suggest some abnormalities,[16] but hardly enough to cause a total loss of episodic memories. Such brain abnormalities are

FIGURE 6.6 *Left*: Painting from memory by Franco Magnani, © Franco Magnani. *Right*: Photograph of same location by Susan Schwartzenberg, © Exploratorium. Reproduced with permission from the San Francisco Exploratorium, http://www.exploratorium.edu.

In another study, subjects were asked to read a passage from a Native American folktale, which included an odd storyline with strange metaphors.[11] After reading the passage, they were asked to recall it after delays of 15 minutes, 1 week, and 6 months. As time passed, recollections became distorted, as they included inaccurate information or added information to the story based on their own expectations. For example, individuals erroneously recalled that two men went out to hunt during the day instead of the night. Such distortions are likely due to filling in missing information that fits our expectations of what we think happened. When we reconstruct a memory, we use our conceptual knowledge to change, remodel, and add to it. Such distortions occur more so when one individual hears a story and retells it to another, as in the children's game *Telephone*. After several retellings, the story becomes hardly recognizable from the original one.[12] Of course, this is an easy way for false rumors to get started.

As memories age, they become more susceptible to interference from other intervening episodes. In legal cases of eyewitness testimonies, distortions in memory can lead to horrendous consequences. Consider the case of Father Bernard Pagano, a Roman Catholic Priest who was tried for being the "Gentleman Bandit." The burglar committed a string of armed robberies in Delaware, but he did so in a gentlemanly fashion. Pagano was identified as the robber by seven eyewitnesses, though he maintained his innocence throughout the proceedings. The case was highly publicized because of the considerate style of the robber and the fact that Pagano was a priest. The trial was halted suddenly when Robert Clouser came forward and confessed to the crimes after hearing that a priest was on trial. Clouser was able to describe details of the

of time passed, the paintings are a testament to remembering, though some distortions did occur. For example, steps to a doorway were painted larger than they actually were, perhaps because Magnani remembered them from a child's perspective. Some scenes were distorted as they could not be photographed from one viewpoint. Magnani was remembering and depicting more than what could be gleaned from one perspective. Despite these distortions, one can appreciate the accuracy in Magnani's recollection of childhood scenes from his past.

The Illusion of Memory

As accurate as our recollections can be or at least seem to be, they are fraught with distortions. In the film *Gigi*, Maurice Chevalier and Hermione Gingold sing the following duet:

Chevalier: We met at nine.	*Gingold: We met at eight.*
I was on time.	*No, you were late.*
Ah yes! I remember it well	
We dined with friends	*We dined alone.*
A tenor sang.	*A baritone.*
Ah yes! I remember it well…	

Our recollections often appear so vivid and authentic that we take them to be accurate portrayals of the original event. Yet, like a painter's application of pentimento, we change, remodel, and cover over pieces of the past. These alterations are made rather subtly each time we revisit a memory, such that we are not even aware that the original event has changed. Psychologists have analyzed the ways in which our memories become distorted. One kind of distortion is *boundary extension*. We tend to add more information to the surroundings of a memory than what was actually there.[9] Franco Magnani showed boundary extension in the painting shown in Figure 6.6 (left image). When compared to the photograph, one can see that he extended the boundaries by including more of the scene outside the window than what could actually be seen from the viewpoint.

We often distort the past by adding our conceptual interpretations. In a psychological study,[10] subjects were presented abstract forms to study and also given "cues" that were meant to facilitate memory for the forms. For example, when shown two circles with a horizontal line connecting them, half the subjects were given the conceptual cue of "eyeglasses," whereas others were given the cue of "dumb bells." Later when asked to draw the abstract form from memory, recollections were distorted according to the cues they were given. Subjects given the cue "eyeglasses" drew a curved line between the two circles, whereas those given the cue "dumb bells" drew a thicker horizontal line between the two. Thus, the subjects' conceptual interpretation distorted later recollections.

recent dinners or remembering where you were at the time. By directing your search to more and more refined clues, you may have been able to retrieve the memory.

Even if your brain were endowed with a brilliant scavenger hunter, you wouldn't be able to retrieve a time capsule if it had not been properly bundled and stored at the start. Initial storage of our memories depends on the prefrontal cortex working with brain regions in the posterior regions to activate relevant event features. With respect to our metacognitive model (see Figure 5.6 in chapter 5), event features are stored broadly in many *object-level* units in the posterior cortex. The difficulty in retrieving an episodic memory is that one must recollect a specific bundle of features defined by a time and location from one's past. Neuroimaging studies have identified a brain region, the posterior parietal cortex (PPC), that is particularly active when one has successfully retrieved an episodic memory. This brain region is situated between the ventral and dorsal visual paths and is adjacent to areas involved in language and semantic memories. It is also intricately linked with the prefrontal cortex (see Figure 1.9 in chapter 1). In fMRI studies, the PPC is highly active during moments when we have recollected an episodic memory.[7] This brain region seems to facilitate the reconstruction of bundled event features—such as reconstructing objects, thoughts, and feelings linked to a specific event. By this view, episodic recollection depends on integrating and linking event features involved in the "what" and "where" of a past experience.

As time goes by, it becomes difficult to recollect a past experience, because the links that bind an episodic memory fade or become confused with links to other episodes. Thus, by using sensory stimuli to remind us of a past experience, such as the taste of a Madeleine cookie, we can facilitate the retrieval of episodic memories. Such cues help to pinpoint perceptual features associated with an episodic memory. Psychological studies have shown that memory retrieval is strongly facilitated by providing cues that help to recreate the perceptions, thoughts, or feelings associated with a past experience. For example, your emotional disposition during retrieval can facilitate recollections of past events that occurred in that same mood.[8] Thus, one tends to recollect pleasant experiences when in a happy mood and unpleasant experiences when in a sad mood (an unfortunate vicious circle for individuals suffering from depression). Artworks provide strong cues to episodic memories as they remind us of perceptions, thoughts, and feelings related to our own personal experiences.

An interesting exercise in episodic retrieval was conducted by Franco Magnani, a San Francisco artist who painted scenes of his childhood from memory. Although Magnani had not been to his hometown, Pontito, Italy, in over 20 years, his depictions of the area are quite accurate (see Figure 6.6, left panel). In 1987, the *San Francisco Exploratorium* science museum sent photographer Susan Schwartzenberg to Pontito with Magnani to photograph the same places depicted in his paintings (see Figure 6.6, right panel). Considering the amount

scene, such as your waiter just before ordering a meal, or an emotionally charged experience, such as yourself in the middle of a heated argument? Against this schema of what a snapshot should represent, Nan Goldin captured intimate moments of herself, friends, and lovers when for others the thought of a snapshot would seem inappropriate at best. These photographs are often exhibited as a slide show, but not like any seen at a family gathering. Many depict disturbing and gritty scenes of sexual and drug abuse. For Goldin and for us all, a record of personal moments can be informative and therapeutic. Memories remind us of who we are, who we have been, and who we shall never be again.

■ Reconstructing Memories

Unlike photographs, images from our mental scrapbook are dynamic as they change over time. Recollections are actually re-creations of past events which we piece together and construct each time we revisit a memory. Missing or vaguely remembered parts are filled in or revised. *Pentimento* is a technical term that describes the way artists redesign and paint over awkward or rough spots of a painting. The term may also be considered with respect to episodic memories. We often reinterpret and repaint old memories according to our current thoughts and desires. In this way, our memories are part portrayal of the original event and part accumulation of additions, distortions, and deletions caused by intervening recollections.

You Must Remember This

We have construed episodic memories as time capsules formed by bundling together the sights, sounds, thoughts, and feelings associated with a personal event. The hippocampus is crucial for the initial bundling or binding of event features. Later, when we try to retrieve an episodic memory, the brain searches for links to specific time capsules. If found, we open this bundle and reconstruct the experience by putting together the features of the event. This recollection process typically occurs without the benefit of the actual sights and sounds or the exact thoughts and feelings as before, and so we must work to reconstruct the past. Recollections tend to involve extensive metacognitive processes as retrieval depends on monitoring and controlling our search through memory. In short, it often takes mental effort to dig up these buried time capsules.

Whenever we apply mental control or effort (i.e., metacognitive processes), it is our prefrontal cortex, the brain's CEO, that coordinates the activity. During memory retrieval the prefrontal cortex is highly active as it attempts to search through our mental scrapbook. It orchestrates retrieval by selecting relevant clues to the desired memory. As you tried to recollect what you had for dinner two days ago you probably attempted to generate clues, such as listing

many prior recollections of the event and may have even been blended with other childhood birthdays (and old snapshots). Psychologists have shown that such third-person recollections tend to occur for very old memories, though first-person perspectives may persist for highly emotional experiences.[6]

In Diego Velázquez's masterpiece, *Las Meninas* (*The Maids of Honor*) (Figure 6.5), a unique vantage point is offered of the artist's studio. The central figure of the painting is the finely dressed girl tended by her maids. Yet rather than focusing fully on the young girl, people in the painting appear to be gazing out towards us. Upon closer inspection, one sees on the left edge what looks to be a part of an easel with Velázquez himself standing behind it with brush and palette in hand. It is as if we just took a snapshot of the scene from the exact vantage point of the sitters for the painting. Thus, it appears that we are the focus of the painting! At the back wall there is a mirror which reveals the actual sitters, King Philip IV of Spain and his wife, Queen Mariana. The scene is in the King's palace where Velázquez had his studio, and the young girl is Princess Margarita. Thus, in *Las Meninas*, Velázquez offered a unique perspective of both the life of royalty and of himself.

These days, personal moments are readily captured by digital cameras and cell phones. Given the innumerable snapshots of smiling faces, goofy poses, and happy family events, it is clear that our photographic record of the past is exceedingly selective. Would you consider taking a photograph of a mundane

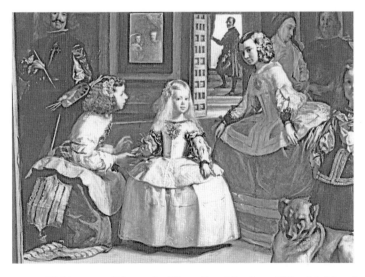

FIGURE 6.5 Velázquez, Diego de Silva, *Las Meninas* (The Maids of Honor)—detail (1656). Oil on canvas, 318 x 276 centimeters. Velazquez (in a self-portrait) paints the Spanish royal couple, Philip IV and his wife Mariana (visible in the mirror in back). Their only child, Margarita, is surrounded by maids of honor and court dwarfs. Photo Credit: Erich Lessing / Art Resource, NY.

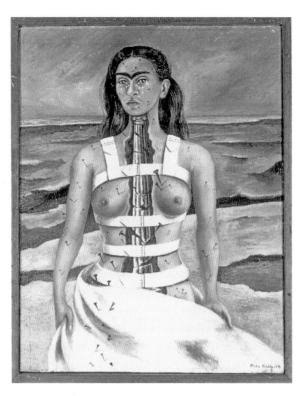

FIGURE 6.4 Kahlo, Frida (1907–1954), *The Broken Column* (1944).
© ARS, NY. Photo Credit: Schalkwijk / Art Resource, NY.

pain Kahlo suffered after a bus accident that fractured her spinal column, collarbone, ribs, and pelvis. Rendering such personal experiences enables artists to explore their self-identity and share this analysis with others. As beholders, we have the opportunity to consider the lives of others and interpret them from our own perspective and experiences. Thus, in both life and art, when we venture back to the past, we encounter a myriad of self-reflections. At different moments, we see ourselves as happy, sad, exhilarated, and exasperated.

With the passage of time, we evaluate past experiences from different vantage points—both perceptually and emotionally. Our recollections are sometimes viewed as if we are seeing a different person. For example, sometimes we might recollect an episodic memory not from a first-person perspective, in which we visualize the event in the same manner as we viewed it originally, but as seen from a third-person point of view, as if we are observing the scene from a distance. For example, I remember a childhood birthday party with friends and a particularly good birthday cake with strawberries and whipped cream topping. My image of this party is from a third-person vantage point in that I see myself sitting with friends around a picnic table getting ready to enjoy my birthday cake. This memory may have been altered as a result of

memory, language, attention, and reasoning. The abstract expressionist painter Willem DeKooning exhibited significant memory decline during the 1980s and was ultimately diagnosed with Alzheimer's disease. His paintings during this period, such as *Untitled V* (1982) (Figure 6.3), are marked by a fluent, graceful style that is different from yet reminiscent of his earlier works. Critics disagree as to the significance of these late works, which were likely created in the shadow of severe cortical deterioration. Interestingly, early stages of his disease would not affect sensorimotor skills, and we can assume that De Kooning's artistic skills were generally intact. Near the end of the decade, however, the disease would have stripped him of many cognitive functions, including art knowledge, planning, and organization, and his final works from the latter half of the 1980s seem to reflect this condition.

Personal Moments

Artists offer their own time capsules in depictions of personal moments. These moments are often fused with emotional significance, such as Frieda Kahlo's *The Broken Column* (1944) (Figure 6.4). This self-portrait makes visual the chronic

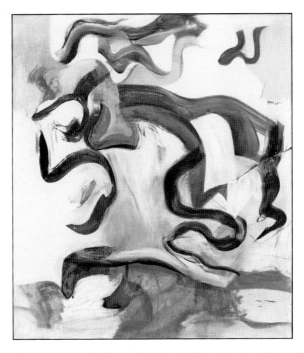

FIGURE 6.3 de Kooning, Willem (1904–1997), *Untitled V and Untitled 1987* (1982). Oil on canvas, 6 feet, 8 inches x 70 inches (203.2 x 177.8 centimeters). © ARS, NY. Gift of Philip Johnson. Photo Credit: Digital Image © The Museum of Modern Art/Licensed by SCALA / Art Resource, NY. (See color plate section.)

moment appears as an isolated, unconnected experience, as if we just woke up from a dream. Hippocampal damage can occur from stroke, disease, or trauma, and memory impairment like the kind observed in Molaison is common. Such individuals lose the ability to record or store experiences since the onset of brain injury. In very severe cases, as soon as information is out of conscious experience, it is forgotten. Despite this deficit, these patients can think, use language, and recollect older episodic memories.

Investigations of individuals with organic amnesia stand as a milestone in our understanding of memory in the brain. Such research has provided crucial evidence for the role of the hippocampus in memory formation and storage. As these patients are able to recollect older experiences (i.e., those that occurred prior to brain injury), their deficit is not one of retrieving but instead a deficit in storing memories. You might wonder why a rather small part of the brain would be so critical? Given the broad nature of episodic memories, one would think that it would depend on widespread brain activity and involve all sorts of mental activities, such as attending to sensory inputs, organizing thoughts, and inducing feelings. It is true that all of these processes are important, but it turns out that a good deal of activity in the cerebral cortex converge onto the hippocampus, which seems to link or connect what's going on in your brain as a packaged bundle. By this view, many brain regions are involved in experiencing an event, but it is the hippocampus that binds the various features of an event and stores them together, something like a snapshot of what's going on at the moment. Without the hippocampus, we are not able to create these snapshots and save them as mementos for later enjoyment.

Hippocampal damage only seems to disrupt the binding of experiences, and thus amnesic patients can still interpret the world and appreciate the moment. They can access semantic knowledge and exhibit normal intelligence and language. Interestingly, these patients retain well-learned skills, such as playing a musical instrument, and they can even learn new rudimentary skills. In one study, Molaison learned a simple sensorimotor skill that involved tracing a star pattern while viewing it through a mirror. To simulate this task, try pointing at various locations on a computer screen with an upside-down mouse. This task is quite difficult for anyone at first, but with practice it becomes easier. Molaison learned this task as well as the control subjects and showed normal retention of the skill over days. When asked about the task, he had no memory of the testing apparatus nor could he remember having performed the task before. Thus, Molaison showed retention of the skill, but he could not link the skill to a prior learning episode.

Alzheimer's disease, the degenerative brain disorder that afflicts 15% of individuals over the age of 70 years, often begins with impairment in episodic memory. Brain pathology occurs in the medial temporal cortex, which disrupts input into the hippocampus. As the disease progresses, damage spreads to other brain regions and impairs many cognitive functions, including semantic

A Seahorse in the Brain

What would it be like if we couldn't store episodic memories? A neurological syndrome known as organic amnesia comes close to characterizing such a deficit. It is caused by damage to the *hippocampus* ("seahorse" in Latin), which is an elongated structure situated along the base of the temporal cortex (see Figure 6.2). In 1953, Henry Molaison, who before his death was known only by his initials H. M.,[4] underwent an experimental operation to relieve severe bouts of epileptic seizures. The operation involved removal of the anterior two-thirds of the hippocampus in both cerebral hemispheres. Following surgery, Henry's seizures were reduced but he was left with a profound memory disorder—he was unable to remember events encountered after his operation. His intelligence, world knowledge (i.e., semantic memory), and most of his prior personal memories were intact. Yet any event experienced after his operation was rapidly forgotten. For example, a half hour after eating lunch he could not recall what he had for lunch or if he had even eaten at all.

Henry was aware of his disorder and reflected upon his condition: *"You see, at this moment everything looks clear to me, but what happened just before? That's what worries me. It's like waking from a dream."*[5] Episodic memories link our current conscious experience with the past. Without this link every

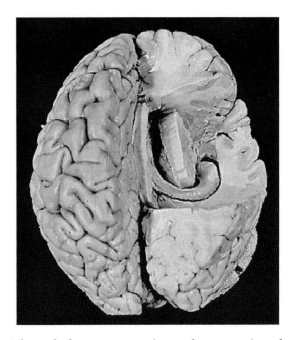

FIGURE 6.2 The right hippocampus (curved structure) as shown with cortical mass above it removed. Brain image reprinted with permission from Digital Anatomist Interactive Atlas, University of Washington, Seattle, WA, copyright 1997.

see, yesterday I had salmon; what did I have the day before?" If you succeeded in retrieving the memory, you were probably able to visualize the event, such as where you ate, your position at the table, and others who were with you. You may even remember conversations, thoughts, and feelings you had during the meal.

Evolutionarily speaking, our ability to reminisce about the past is a rather recent capability. Many animals can remember where they previously hid food and even remember which locations were more recently cached. Yet we have the ability to recreate and imagine past events as if we are reliving them. Such recollections require extensive top-down or metacognitive functions as you must reconstruct the past without much help from your senses. Retrieval depends on hopping from memory to memory in order to pinpoint a specific one. When accomplished, the retrieved memory is often associated with images of the past event. Some psychologists and evolutionary biologists consider this feat a specifically human capability. Whereas other animals appear to be locked to the present, we have the capacity to move flexibly in time and imagine ourselves in the past (as well as in possible futures).

Despite this rather remarkable ability, episodic memories are, unfortunately, neither precise nor continuous. They are not stored like a video recording of our lives. We cannot simply rewind through our past, select a date, and retrieve the event stored at that time. Episodic memories are stored as encapsulated events, each bundled as a collection of what we have sensed, thought, and felt at a particular moment. They are like time capsules filled with mementos and buried until we decide to retrieve them. The problem with these time capsules is that they lack a time stamp. Instead, we retrieve one time capsule after another and try to hone in on a particular one. Some prominent events may be used as anchor points, such as the birth of a sibling, high school graduation, or a wedding. In fact, we retrieve episodic memories much like a scavenger hunt—finding one event which offers a clue to another, then another, until we finally uncover the treasured memory.

Sometimes a mere sensation can recover an episodic memory. In Marcel Proust's autobiographical novel, *À la recherche du temps perdu* (*In Search of Lost Time*),[3] the experience of eating a Madeleine cookie dipped in tea sparked a sequence of childhood memories. We all have had such Proustian flashbacks in which a certain sensory stimulus evokes a strong memory of the past. For me, the smell of new-mown grass takes me back to summer days as a child in suburban California. Movies and television shows use sights and sounds to bring back past experiences. For example, disco music is often used as a marker of the 1970s. When sensory cues are available, they act as potent hooks to past experiences, which is probably why we enjoy taking family snapshots and buying souvenirs on vacations. Such mementos serve as reminders of our past. Artists also offer their own mementos, as Chagall did in his images of childhood.

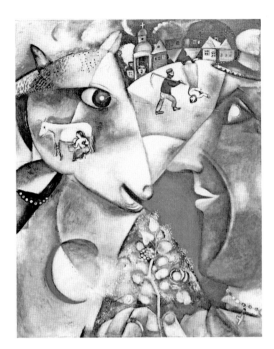

FIGURE 6.1 Chagall's *I and the Village*. Chagall, Marc (1887–1985) ©
ARS, NY. *I and the Village* (1911). Oil on canvas, 6 feet, 3 5/8 inches x 59
5/8 inches. Mrs. Simon Guggenheim Fund. Photo Credit: Digital Image
© The Museum of Modern Art/Licensed by SCALA / Art Resource, NY.
(See color plate section.) (See also note 2.)

different as they are personal and specifically defined as an experience that
occurred at a particular time and place. For example, you have semantic mem-
ory of the concept of *a birthday*; you can describe what it is and tell me how
it is celebrated. You have, however, only one episodic memory of your tenth
birthday (if you have one at all). If you can recollect distinctly a past event,
you can place yourself at that prior time and place and retrieve or "re-collect"
features of it. In cinematic terms, you engage in a *flashback*, re-experiencing a
scene from your past.

Time in a Bottle

What did you eat for dinner two days ago? You may not be able to answer
this question immediately, but with some effort, you may be able to scavenge
through your episodic memory and pinpoint the event. Perhaps you tried to
retrieve the answer by recollecting events of that day. You may have thought,
"Let's see, yesterday was Thursday and the day before was Wednesday. Now
what was I doing Wednesday evening…" Alternatively, you may have tried
to jump back to the event by accessing your memory of past dinners: "Let's

6. REMEMBRANCE OF PAST THINGS

Mental time travel is an apt phrase to describe our ability to reminisce about the past.[1] Our personal memories, or what psychologists call *episodic memories*, are defined by events and experiences anchored in a past time and place. When we retrieve these moments from our lives, we transport ourselves back in time, as if we are reexperiencing them. Many consider our episodic memories as the essence of what defines us as individuals. Of course these memories change with time and are often recast in exaggerated or otherwise distorted form. Core features are generally accurate, but each time we recollect a past experience, we reinterpret and change it. Episodic memories are of course strictly personal, but as we all share many life experiences, our personal scrapbook includes events that are familiar to us all.

Art can function as a vehicle for transporting us back to the past. In *I and the Village* (1911), Chagall offers an amalgam of childhood memories with allusions to myths and classic symbols, such as the tree of life (Figure 6.1). Much like our own recollections, the painting is a jumble of remembered bits that are reconstructed to form an image. H. W. Janson, the noted art historian said: "Chagall relives the experiences of his childhood; these were so important to him that his imagination shaped and reshaped them for years without their persistence being diminished."[2] This quote captures the essence of the way psychologists view episodic memories. In this chapter, we explore the art of personal experiences and how the brain and artist evokes remembrances of past things.

■ Memories Are Made of This

In the previous chapter, we considered semantic memory, which refers to general knowledge about objects, facts, and concepts. Episodic memories are quite

29 Zatorre, R. J., Halpern, A. R., Perry, D. W., Meyer, E., & Evans, A. C. (1996). Hearing in the mind's ear: A PET investigation of musical imagery and perception. *Journal of Cognitive Neuroscience, 8*, 29–46.

30 Johnson, M. K., Raye, C. L., Wang, A. Y., & Taylor, T. H. (1979). Fact and fantasy: The roles of accuracy and variability in confusing imaginations with perceptual experiences. *Journal of Experimental Psychology: Human Learning and Memory, 5*, 229–240.

31 Goodman, N. (1976). (See chapter 1, n. 14.) Langer, S. (1942). (See chapter 1, n. 15).

32 Eviatar, Z., & Just, M. A., (2006). Brain correlates of discourse processing: An fMRI investigation of irony and conventional metaphor comprehension. *Neuropsychologia, 44*, 2348–2359.

33 Rosch, E., Mervis, C.B., Gray, W., Johnson, D., & Boyes-Braem, P. (1976). Basic objects in natural categories, *Cognitive Psychology, 8*, 382–439.

34 Warrington, E. K. & McCarthy, R. A. (1986). Categories of knowledge: Further fractionation and an attempted integration. *Brain, 110*, 1273–1296.

35 Martin, A. (2007). The representation of object concepts in the brain. *Annual Review of Psychology, 58*, 25–45.

36 Lakoff, G., & Johnson, M. (1999). *Philosophy in the Flesh: The Embodied Mind and Its Challenge of Western Thought*. New York: Basic Books.

37 Freyd, J. J. (1987). Dynamic mental representations. *Psychological Review, 94*, 427–438.

38 Danto, A. C. (1998). *Beyond the Brillo Box: The Visual Arts in Post-Historical Perspective*. Berkeley: University of California Press.

13 Cutting, J. E. (2003). Gustave Caillebotte, French impressionism, and mere exposure. *Psychonomic Bulleting & Review, 10,* 319–343.

14 Reber, R. (2011). Processing fluency, aesthetic pleasure, and culturally shared taste. In A. P. Shimamura & S. E. Palmer (Eds.), *Aesthetic Science: Connecting Minds, Brains, and Experience* (pp. 223–249). New York: Oxford University Press.

15 Severance, E., & Washburn, M. F. (1907). The loss of associative power in words after long fixation. *The American Journal of Psychology, 18,* 182–186.

16 Freud, S. (1911). *The Interpretation of Dreams* (translated by A. A. Brill). New York: Plain Label Books.

17 Frey, J. G. (1936). Miro and the Surrealists. *Parnassus, 8,* 13–15.

18 Hughes, R. (2006). Spirit of the age, *The Guardian,* January 26, /2006, http://www.guardian.co.uk/artanddesign/2006/jan/26/art1.

19 Baldo, J. V., & Shimamura, A. P. (1997). Letter and category fluency in patients with frontal lobe lesions. *Neuropsychology, 12,* 259–267.

20 Thompson-Schill, S. L., D'Esposito, M., Aguirre, G. K., & Farah, M. J. (1997). Role of left prefrontal cortex in retrieval of semantic knowledge: A re-evaluation. *Proceedings of the National Academy of Sciences, 94,* 14792–14797.

21 Nelson, T. O., & Narens, L. (1994). Why investigate metacognition? In J. Metcalfe & A. P. Shimamura (Eds.), *Metacognition: Knowing about Knowing* (pp. 1–25). Cambridge, MA: MIT Press; Shimamura, A. P. (2008). A neuro-cognitive approach to metacognitive monitoring and control. In J. Dunlosky & R. A. Bjork (Eds.), *Handbook of Metamemory and Memory* (pp. 373–390). New York: Psychology Press.

22 Haber, R. N. (1979). Twenty years of haunting eidetic imagery: Where's the ghost? *Behavioral and Brain Sciences, 2,* 583–629.

23 Kosslyn, S. M., Brunn, J., Cave, K. R., & Wallach, R. W. (1984). Individual differences in mental imagery ability: A computational analysis. *Cognition, 18,* 195–243.

24 Chase, W. G., & Simon, H. A. (1973). Perception in chess. *Cognitive Psychology, 4,* 55–81.

25 Luria, A. R. (1968). *The Mind of the Mnemonist.* New York: Basic Books.

26 Cytowic, R. E. (2002). *Synesthesia: A Union of the Senses.* Cambridge, MA: MIT Press.

27 Foer, J. (2011). *Moonwalking With Einstein: The Art and Science of Remembering Everything.* Penguin Press: London. See also, *New York Times Magazine,* February 20, 2011, http://www.nytimes.com/interactive/2011/02/20/magazine/mind-secrets.html.

28 Kosslyn, S. M., Ganis, G., & Thompson, W. L. (2001). Neural foundations of imagery. *Nature Neuroscience Reviews, 2,* 635–642; O'Craven, K. M., & Kanwisher, N. (2000). Mental imagery of faces and places activates corresponding stimulus-specific brain regions. *Journal of Cognitive Neuroscience, 12,* 1013–1023.

to understand it. As with literature, the meaning of an artwork may be different for different "readers" as the manner in which one links an artwork to one's own memory can be personal and idiosyncratic. Thus your interpretation will be influenced by your personal, cultural, political, religious, and sexual orientation and may be quite different from another's point of view. When we consider art in terms of conveying concepts, it is no longer art for art's sake. Instead it is art for knowledge's sake. That is, for the sake of imparting a concept or viewpoint for the beholder to acknowledge.

■ Notes

1 Adelson, E. H. (1993). Perceptual organization and the judgment of brightness. *Science, 262,* 2042–2044. For related examples and analysis of such illusions, see also Purves, D., & Lotto, R. B (2003). *Why We See What We Do: An Empirical Theory of Vision.* Sunderland, MA: Sinauer Associates.

2 Kurson, R. (2002). *Crashing Through: The Extraordinary True Story of the Man Who Dared to See.* New York: Rand House.

3 Fine, I., Wade, A. R., Brewer, A. A., May, M. G., Goodman, D. F., Boynton, G. M., Wandell, B. A., & MacLeod, D. I. A. (2003). Long-term deprivation affects visual perception and cortex. *Nature Neuroscience, 6,* 915–916.

4 Fine et al. (2003, p. 916).

5 Rosenberg, H. (1972). *The De-Definition of Art.* Chicago: University of Chicago Press.

6 Locke, J. (2008). *The Works of John Locke,* in ten volumes—vol. IV. New York: Cosimo Classics.

7 Standing, L., Conezio, J., Haber, R. N. (1970). Perception and memory for pictures: Single-trial learning of 2500 visual stimuli. *Psychonomic Science, 19,* 73–74.

8 Grill-Spector, K., Henson, R., & Martin, A. (2006). Repetition and the brain: Neural models of stimulus-specific effects. *Trends in Cognitive Science, 10,* 14–23.

9 Roediger, H. L. III, & McDermott, K. B. (1995). Creating false memories: Remembering words not presented in lists. *Journal of Experimental Psychology: Learning, Memory, and Cognition, 21,* 803–814.

10 Zajonc, R. B. (2001). Mere exposure: A gateway to the subliminal. *Current Directions in Psychological Science, 10,* 224–228.

11 Johnson, M. K., Kim, J. K., & Risse, G. (1985). Do alcoholic Korsakoff's syndrome patients acquire affective reactions? *Journal of Experimental Psychology: Learning, Memory, and Cognition, 11,* 22–36.

12 Brickman, P., & Redfield, J. (1972). Drive and predisposition as factors in the attitudinal effects of mere exposure. *Journal of Experimental Social Psychology, 8,* 31–44.

to the echelon of high art. The fact that these artworks are valuable and promi-
nently displayed in art museums shows that Warhol succeeded. As these art
objects are visually identical to everyday objects, the only thing that could pos-
sibly make them important is the story behind them. As a conceptual meta-art
statement, Warhol's boxes acknowledges the expanding set of items that can be
included in the category of "art."

Meta-art statements became a mainstay during the last quarter of the twen-
tieth century. It is part of the tradition called *Conceptual Art,* and as the name
implies, such works are meant to be understood not felt. Some works blurred
the traditions of painting and sculpture, which traditionally have been viewed
as two distinct categories of art. Others, as in the genre of *Earth Art,* removed
art from the confines of museum walls and placed them within the context of
the real world. Robert Smithson's *Spiral Jetty,* an artificial land mass that juts
out from the banks of the Great Salt Lake is a prime example. Another genre
is *Performance Art,* which became popular in the 1970s, as artists blurred the
border between the visual and performing arts by presenting shows or activi-
ties in museums. With reference to the Dadaist movement, these performances
were often sadomasochistic and meant to shock and disturb the beholder. As
a meta-art statement, performance art denied the principle of the permanency
of artworks.

■ I Get It!

This chapter focused on your knowledge base, which includes your sensory
(implicit) knowledge and your conceptual or semantic knowledge. We often
take such forms of knowledge for granted not realizing how crucial they are in
our appreciation of art. As described by the mere exposure effect, our prefer-
ences may simply be the result of having been exposed to an object many times.
We also apply our conscious, metacognitive processes to guide our experience.
How do we link what we see with what we know? What's the story? What does
an artwork mean? Experiencing art demands thoughtful analysis in order to
interpret the story behind an artwork.

Knowledge of art as well as knowledge of life orients our experiences,
linking what we see with what we already know and expect. When we under-
stand the meaning of an artwork, there is a satisfying feeling of "I get it!" This
feeling marks the point, as with metaphors, when a new encounter has been
successfully linked with our existing semantic memory. Indeed all encoun-
ters, whether in real life or with art, are driven by associating new experi-
ences with prior knowledge, and we should always foster this conceptual
approach.

Artworks, from prehistoric cave paintings to contemporary art, tell a story.
The more you know the background story of an artwork the better you are able

Morton College Library Cicero, ILL

In the 1960s, pop artists turned Duchamp's Dadaist joke into an art move-ment. Blurring the border between art objects and real objects, Andy Warhol took plywood boxes and silk-screened them so that they looked exactly like the container boxes used to ship commercial products, such as *Brillo* soap pads (Figure 5.12). Well over a hundred of such containers were produced at Warhol's studio aptly called the Factory. In 2008, a set of four such container boxes— *Brillo Pads, Campbell's Tomato Juice, Del Monte Peach Halves, Heinz Tomato Ketchup*—sold at a New York auction for a total of $4,750,000 ($1,248,000 per box). Philosophers, most notably Arthur Danto,[38] have asked why such works, which are visually indistinguishable from their real counterparts, should even be considered as art. Warhol's point was to bring the familiar and mundane up

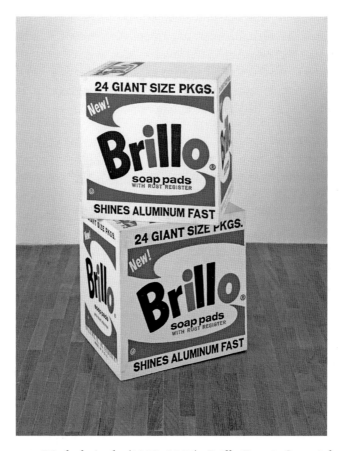

FIGURE 5.12 Warhol, Andy (1928–1987), *Brillo Box*. © Copyright 1964. Synthetic polymer paint and silkscreen on wood, 17 1/8 x 17 x 14 inches. Purchase. © Copyright The Andy Warhol Foundation for the Visual Arts/ ARS, NY. The Museum of Modern Art, New York, NY. Photo Credit: Digital Image © The Museum of Modern Art/Licensed by SCALA / Art Resource, NY.

forces are exquisitely expressed in the painting. We sense movement because we *know* about physical force and the thrust of a boxer. Our knowledge allows us to sense movement in these paintings, even though they are static images.

Art Knowledge

Semantic memory represents all conceptual knowledge, including knowledge about art history. When we apply a conceptual approach, art knowledge is often essential. Some may think that art should impact our emotions immediately, without any thought or interpretation. Yet we are always using conceptual, top-down processes when we experience the world, including the art world. Some of these conceptual processes, such as priming and familiarity, occur so quickly that we are unaware that knowledge is even being used. In fact, we never experience art with an "innocent eye." We know that art is created by another individual, we know that its purpose is to induce a certain kind of experience, and we know that what we are looking at is different than looking at the real world. Finally, it takes time to experience art, as we cannot appreciate an artwork fully within a single eye fixation. We therefore *interpret* an artwork by successive glances, and this storyboard of experiences takes some time, about three fixations per second.

Whenever you experience an unfamiliar object, whether a new car or an unfamiliar painting, you begin by linking it with prior knowledge. You might notice similarities in its styling compared to other items. You might see how specific features have been designed to give the item a new or different look. Of course the more you know about things, such as cars and paintings, the better you are able to determine how new items are similar or different from early versions. Creating new associative links is an essential aspect of a conceptual approach. The more we add to our semantic memory, the better equipped we are in understanding novel experiences.

With many artworks, the underlying conceptual story is essential. If you were to apply a strictly formalist (sensory) or expressionist (emotional) approach to Duchamp's *Fountain*, you probably would be very disappointed (or disgusted). You may wonder, as many have, why this piece is heralded as a prominent work of art? As a conceptual, meta-art statement, however, it represents a breakthrough in the history of art. If Duchamp had lived a hundred years earlier and showcased *Fountain* as "art," he would likely have been considered insane. As a Dadaist work within the zeitgeist of an avant-garde art culture in the early twentieth century, *Fountain* sparked an interest in some in the art world, though it really wasn't until the second half of the century that its significance was most appreciated. If I were to submit a urinal today to an art exhibition, it likely would be considered a trite joke. The significance of *Fountain* as a work of art exists because of its historical context and the way it redefined the meaning of art at that time.

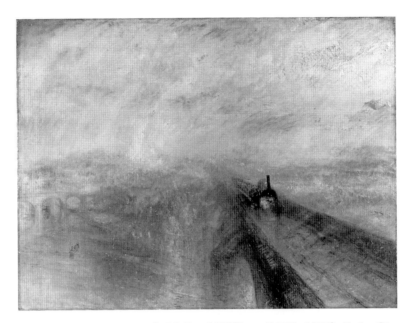

FIGURE 5.11 Turner, Joseph Mallord William (1775–1851), *Rain, Steam and Speed—The Great Western Railway* (1844). Oil on canvas, 91 x 121.8 centimeters. Turner Bequest, 1856 (NG538). National Gallery, London, Great Britain. Photo Credit: © National Gallery, London / Art Resource, NY. (See color plate section.)

With the advent of photography, artists learned how to depict motion in a realistic manner. Eadweard Muybridge was the first to show exactly how animals move. During the 1870s, Muybridge photographed horses and many other animals in motion. He placed as many as 24 cameras along a race track and attached a thread to the shutter of each camera, which was then strung across the track. When a horse galloped along the track it would break the threads and trip the shutters in succession, thus giving Muybridge a stop-action view of the animal in motion. After such photographs were published, artists were able to depict galloping horses more realistically. Étienne-Jules Marey, a French scientist, was influenced by Muybridge's photographs and conducted his own experiments. He invented a camera that could capture up to 12 images in a second. The camera looked like a machine gun and when Marey aimed the camera and pulled the trigger, the camera recorded a sequence of shots that were exposed onto the same piece of film. Such photographs influenced physiologists by showing exactly how bodies move.

Motion creates a perceptual tension, and even a static scene can depict the potential of dynamic movement. Consider again, Bellows's boxers in *Stag at Starkey's* (Figure 4.10 in chapter 4). The sense of movement and the competing

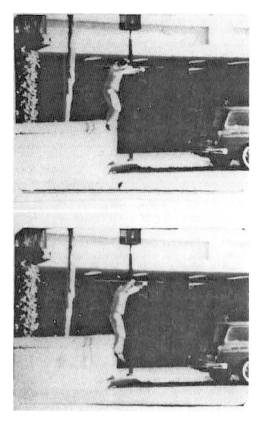

FIGURE 5.10 Stimuli used to assess memory distortions from representational momentum. Reproduced from Freyd, J. J. (1987). Dynamic mental representations. *Psychological Review*, *94*, 427–438, copyright © 1987 with permission from the American Psychological Association.

bottom image), they confused it with the original photograph, as if subjects carried out the momentum of the jumper and imagined him further in flight. When we view any image with implied movement, we have a strong tendency to imagine the action being carried out. In this manner, just as we associate tools with motor activity, scenes with implied action carry their own sense of movement.

How do artists represent movement in a static image? It is difficult to depict fast motion, because our sensory apparatus is not tuned to considering motion as a static image. Artists had to figure out how to *represent* it. Before the invention of photography, movement was depicted inaccurately or simply as a blur. One of the more compelling representations of motion is J. M. W. Turner's *Rain, Steam, and Speed—The Great Western Railway* (1844) (Figure 5.11). Turner painted an expressive rendering of motion, both in terms of the blurred view of the train and of the pouring rain. His style is incredibly modernist, though this work predates Impressionism by decades.

abstract information? According to Plato's idealism, knowledge is separate from our experience with the physical world. Psychologists initially adopted this same view by separating semantic memory from perceptions, emotions, and actions. Concepts were viewed, and are sometimes still viewed, as the linking of abstract ideas and concepts, completely sterilized from the outside world. Yet neuroscience research has changed the way we think about semantic memory. Studies of brain-injured patients suggest that our knowledge is partitioned in specific ways. For example, some patients exhibit severe impairment within a category of knowledge, such as an impairment in knowledge about living things. These same patients exhibit proficient knowledge in other domains, such as knowledge of tools. Other patients, however, have intact knowledge of living things, but they cannot classify or describe tools.[34] These category-specific deficits pose a problem for cognitive theorists, because it rejects the view that semantic memory is an abstract web of knowledge. Consider what would happen if a rather extensive number of sites on the Internet crashed—such as the entire knowledge base in Wikipedia.org. This "deficit" in knowledge might slow us down in retrieving knowledge, but there is enough redundant information on other sites to allow us to retrieve the information we desire.

Different categories of knowledge, such as living things and tools, activate different brain regions. However it is not that each category has its own little folder in a specific part in our brain. Living things are usually encountered as visual forms, whether in pictures, as pets, or at zoos. Tools are manipulated, usually handled, and each one has a specific function. In neuroimaging studies, animal names or pictures activate regions within the ventral path, the brain area that is involved in object recognition. Tools activate these regions as well, because they too are objects, but tools also activate brain regions involved in motor planning and spatial processing.[35] These additional areas include regions in the frontal and parietal cortex. Thus, animals activate primarily visual areas, whereas tools activate visual and motor areas. Such findings suggest that knowledge is intricately tied to the way we experience them. Concepts are not at all abstract ideas but are linked with the sensory and motor processes that we activate when we encounter them.

Cognitive scientists George Lakoff and Mark Johnson have suggested that we are endowed with an *embodied mind*, such that concepts are integrally linked to the way we, as humans, experience the world.[36] According to this view, no aspect of knowledge is purely abstract; all knowledge is intertwined with our bodily experiences, such as the way we perceive, feel, and act. Consider a photograph of a bird in flight or a galloping horse. Such images activate schema that imply movement, and from our knowledge of these actions, we can accurately assess the direction and speed of movement. Thus, even a static picture defines an action. In one study,[37] individuals viewed a photograph of a person jumping from a ledge (Figure 5.10, top image). When they later were shown a photograph of the same person taken a moment later (Figure 5.10,

corner as he plunges into the sea. Icarus is clearly peripheral to the scenic landscape, as the people depicted in the scene appear oblivious to his plight. What is the painting trying to say? There are various interpretations of this painting, though from the depiction, Bruegel clearly intended Icarus' fall to be a rather insignificant incident. Even in this rudimentary interpretation, we applied extensive use of semantic memory. We know about the general structure of paintings, such as knowing that the main theme would typically be a central focus rather than obscurely placed in the periphery. We know how people fall into water. We know how people react to a tragic accident. In this manner, our knowledge of the world and of art gives meaning to the work.

A fuller understanding of Bruegel's painting is achieved with knowledge about the myth of Icarus. As described in Ovid's *Metamorphoses*, he and his father, Daedalus, escaped from imprisonment by flying away on artificial wings that his father made with beeswax to glue feathers onto reeds. Daedalus warned his son not to fly too high as the sun's heat would melt the wax and render his invention useless. In his zest for flight, Icarus forgot his father's warning, flew too high, and plunged to his death. With knowledge of this myth, we derive a fuller understanding of the story told by Bruegel's depiction. Careless delight will lead to an insignificant death. I also consider this painting as an admonition for children to follow the advice of parents.

There is *always* a story behind a work of art, and our interpretation of the story depends significantly on what we know. A painting may tell a story about morality, social conditions, religious conviction, or political affiliation. Deriving meaning from a painting is the goal of a conceptual approach to art, which to some extent we always adopt. Consider the way we experience a novel, such as Dickens's *A Tale of Two Cities*. The novel relates characters, settings, and events during the French Revolution. The theme of the novel centers around the vicissitudes of life during difficult times, something that we all can understand. We can enjoy this novel without knowledge of the historical events that surround it, though we gain a fuller understanding with the added knowledge. Dickens's novel is not a mere description of events, as he enlivens the story with emotional impact and beautifully crafted prose. With a novel, it is rather obvious that knowledge about people, history, and life enhances our understanding of its meaning. We know that novels convey information, offer a way of looking at the world, and do so in interesting ways. In exactly the same manner, artworks can be approached conceptually with the intent of deciphering what they mean, how they convey information, and how they import a particular viewpoint.

Embodied Knowledge

As described, semantic memory can be viewed as a vast, interconnected set of concepts and ideas. To what degree is this knowledge a mere collection of

Our tendency to classify objects makes it easier to store and retrieve knowledge. Rather than having to record every detail of every chair or painting encountered, we simplify learning by linking new information with existing categories. As one adds more information to a category, such as a furniture maker might with categories of chairs or an art historian might with categories of art, initial groupings are subdivided into more refined categories. An expert can be viewed as someone whose extensive experience has created an elaborate associative knowledge base within a particular domain. Such knowledge allows one to identify similarities and relationships among items, which in turn facilitates the learning of new items. Schema are essentially categorizations of knowledge that guide future experiences. For example, from your encounters with art, you may be able to determine whether a painting you've never seen before is an Impressionist work or not. This judgment is most likely not based on memory for any specific artwork but instead on general features that you have gleaned from seeing many examples. With such knowledge, you can evaluate a painting in terms of how it activates associative links in your semantic memory. With extensive knowledge, you may be able to look at a new painting and make an educated guess as to the artist.

When we consider any work of art, we apply our knowledge to interpret its meaning. We link the work with an artist, a style, and perhaps the historical context in which the work was created. Knowledge guides us to the meaning of a painting as it provides a schema or map for understanding the work. Consider *Landscape with the Fall of Icarus* (Figure 5.9), a painting attributed to Pieter Bruegel. When we read the title, the depiction seems rather odd as it may take a few seconds to even notice Icarus' flailing legs near the bottom right

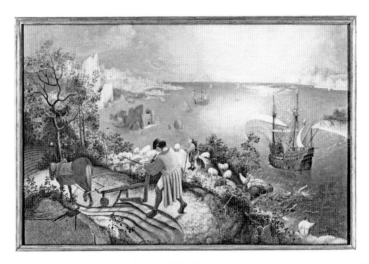

FIGURE 5.9 Bruegel, Pieter the Elder (*c.*1525–1569), *Landscape with the Fall of Icarus.* Musee d'Art Ancien, Musees Royaux des Beaux-Arts, Brussels, Belgium. Photo Credit: Scala / Art Resource, NY.

or abstract, *every picture tells a story*, and it is up to the beholder to develop an understanding of it.

Your Own World Wide Web

Aristotle suggested that knowledge is made up of a chain of associations, such as linking objects that are similar or co-occur in time. If we expand this idea and consider the millions upon millions of such associations accumulated over a lifetime, we start to appreciate the enormous web of knowledge represented in our brains. Psychologists refer to this database as *semantic memory*. It consists of our vast knowledge of objects, words, and concepts. We are incessantly attaching meaning to our sensory experiences, and it seems that this is what our brains are programmed to do. When you read the word *chair*, you cannot help but associate it with an object that you can describe, imagine, and link to other objects. For such familiar objects, you have the ability to access and retrieve countless associations from your private World Wide Web.

The Aristotelian view of knowledge as associative links is still useful as a description of semantic memory. Every experience has the potential of laying down new links. For example, when I suggested that semantic memory is like the Internet, it might conjure up various associations, such as the Internet's enormous size and web-like organization. Yet it turns out that your personal knowledge is exceedingly more dynamic and malleable than the Internet. Every time you retrieve a particular piece of information, you alter its links, making some stronger and others weaker. The more you think about something, such as the more you experience art, the more associative links are created and modified. When we consider the billions of neurons in our brain and the thousands of connections to each, we begin to appreciate the enormous capacity we have for associative links.

One feature of semantic memory is the way we group or categorize information into concepts. The word "chair" likely brings to mind the general concept of chairs rather than any particular one. That is, we generalize the term to refer to a category with certain characteristics or basic features.[33] We construct these categories, as Aristotle suggested, by associating or grouping things in terms of similarity or contiguity. You also know that chairs belong to a more general grouping of objects we call *furniture* and that there are more specific classifications among chairs, such as *dining chairs* and *desk chairs*. In the same way, we have developed categories of art and can identify paintings within the genre of Impressionism or Surrealism. These classifications are based on accumulated knowledge (associative links) from past experiences. They tend to have fuzzy boundaries, as some objects may only partially be related to a particular category. For example, would you categorize an outdoor chaise lounge as a chair? Would you characterize a tree stump as furniture? Is Van Gogh an Impressionist?

FIGURE 5.8 Méret Oppenheim (1913–1985), *Object*, Paris (1936).
© ARS, NY. Fur-covered cup, saucer, and spoon, cup 4 3/8 inches (10.9
centimeters) in diameter; saucer 9 3/8 inches (23.7 centimeters) in diam-
eter; spoon 8 inches (20.2 centimeters) long, overall height 2 7/8 inches
(7.3 centimeters). Purchase. The Museum of Modern Art, New York, NY.
Photo Credit: Digital Image © The Museum of Modern Art/Licensed by
SCALA / Art Resource, NY.

involved in reading. When processing metaphors, activation in these regions
increased, but more importantly there was prominent activation in the pre-
frontal cortex. It is as if when presented an unusual, metaphorical pairing (e.g.,
a hard worker and hurricanes), your brain's executive officer must hold the two
items in mind, consider the novel pairing, and guide thoughts to identify pos-
sible links between the two. Metacognitive control is critical in resolving such
metaphorical references.

■ Every Picture Tells a Story

What does an artwork mean? What is it trying to tell us? In a conceptual
approach, these are the essential questions to ask. When we experience any
artwork we try to attach some kind of meaning to it. If a painting depicts a
naturalistic scene, such as a landscape, still life, or portrait, we identify objects
within it and try to derive meaning in the way the scene is put together. If it
is an abstract painting, we may consider how lines, colors, and shapes suggest
or symbolize real-world objects, though in many instances it is better to leave
the abstractions as such and consider what emotions are evoked via significant
form or what meta-art ideas are represented. Whether an artwork is naturalistic

unavoidable and often visual in nature. Metaphors help link concrete, physical experiences with concepts. For example, we *grasp* an idea, *move* to a new topic, or say that time *flies*.

Metaphors depend on our metacognitive ability to control and manipulate ideas. The appreciation of metaphors has been considered a prominent feature of creative thought. Einstein used metaphorical reasoning to describe his mathematical formulas. For example, he related his theory of relativity with respect to two people, one on a speeding train and the other on an embankment, both seeing lightning bolts hit the train but having different phenomenal experiences. Einstein used such analogies to understand abstract concepts by relating them to concrete experiences. In this way, metaphors link two distinct schema. In the *Forrest Gump* quote, we have a schema for life—what it entails and what it means. We also have a schema for boxes of chocolates acquired from experiences of having given or received them as gifts. What is it about our schema of life that links it with picking a chocolate from a box? In this metaphor, the link pertains to the unpredictability of both.

Familiar objects, such as boxes of chocolates, candles, and flowers, evoke many thoughts and references. By combining them with other objects, artists convey metaphorical references that the beholder must decipher. Some philosophers, such as Nelson Goodman and Suzanne Langer,[31] suggested that an entire artwork acts as a symbol or metaphor for a specific concept or emotion. Thus, a painting is one side of a metaphoric reference, as its entirety is meant to symbolize a thought or feeling. With a conceptual approach, the goal is to understand what thought or emotion an artwork symbolizes. In Méret Oppenheim's *Object* (Figure 5.8), we are confronted with a fur-lined cup, saucer, and spoon. What does this artwork mean? Conceptually, furs and cups have little in common and seeing such objects together creates an oddly disturbing appearance. Although this combination is discomforting, the two separate features are rather comforting. That is, furs are pleasing to touch and teacups are pleasing objects from which to drink. Oppenheim, in her creative juxtaposition of two sensual objects, produced an entirely different, oddly disturbing sensation.

When we understand a metaphor, we have then established a link between two domains of knowledge. To do this, we must not only consider two branches of our knowledge but we must also figure out how they are linked. The more obscure the metaphor, the harder it is to find a link. How do our brains deal with metaphors? In a neuroimaging study, individuals read two literal sentences and were then presented a sentence with a metaphorical reference.[32] For example, subjects read: "In the morning John came to work early. He started to work right away at a fast pace." Subjects then read, "His boss said, 'John is a hurricane.'" On other trials, individuals read only literal sentences: "Betsy and Mary were on the basketball team. Mary scored a lot of points in the game. Betsy said, 'Mary is a great player.'" Processing literal sentences activated left hemisphere brain regions in the temporal and occipital cortex known to be

Foer had never been involved in such a competition, but he interviewed past champions, consulted psychologists with expertise in memory, and acquired the kind of skill necessary for such events, which always involved visual imagery. In fact, the title of the book makes reference to a visual image that he used to remember a sequence of three playing cards. By linking such bizarre images, Foer was able to remember the order of a deck cards in 1 minute, 40 seconds, which broke the US record, and ultimately contributed to his winning the 2006 US Championship.

How does the brain form mental images? Neuroimaging studies have shown that imagery activates brain areas used when we are actually seeing objects.[28] In these studies, individuals are asked to form a mental image, say of a famous person's face. These imagery trials are compared to trials in which photographs of faces are presented. Areas in the ventral visual path involved in face perception are active during mental imagery, even when subjects have their eyes closed. Imagining different kinds of objects activates different areas along the ventral path. In studies of the auditory modality, neuroimaging findings show that brain regions active when we mentally sing a song to ourselves are the same ones active when we are listening to music.[29] Thus, the brain regions used to manufacture bottom-up sensory information are also involved during the top-down generation of mental images.

There are, however, differences between perceiving and imagining. When we are actually looking at an object, there is greater activity in posterior cortical regions compared to times when we imagine the same object. These regions are particularly involved in early visual processing. Also, when we use imagery, the prefrontal cortex is more active than when we are seeing objects. This finding suggests that top-down signals from the prefrontal cortex are implemented to act as a substitute for sensory signals. Differences in these neural patterns of activation allow us to distinguish perceptions from mental imagery. We rarely misattribute our imagined world with the real one, though in some instances, such as with vivid dreams, we might encounter some confusion. In fact, people who are very good imagers do tend to show greater confusion between mental images and perceived ones.[30]

Metaphors Be With You

"Life's a box of chocolates …" In this quirky metaphor used in the movie *Forrest Gump*, human experience is characterized as a physical object. To understand this metaphor, we must hold in mind two pieces of knowledge and derive the common link between the two. In this case, the link is rather obscure until Forrest's mother continues with the line, " … you never know what you're gonna get." Metaphors are sometimes viewed as obscure literary devices, cloistered within the domains of poetry and creative writing. Yet in everyday conversation we are constantly bombarded by metaphorical references. They are virtually

at manipulating and rotating images. Regardless of how good (or bad) one's mental imagery, it can be improved with practice.

Chess players are often thought to have extraordinary mental imagery as they must consider many possible board positions when playing a game. Some players excel in *Blindfold Chess* in which the game is played without a board, thus requiring players to keep in mind the current position and update it with each move. An interesting psychological study showed that a chess player's imagery ability is rather specific.[24] Three groups: (1) master chess players, (2) class A players (i.e., advanced tournament players), and (3) beginners were presented chess positions from the middle of a game. They viewed a position for five seconds and were asked to reconstruct the board from memory given a blank chessboard and chess pieces. As expected, master players performed better than class A players, who performed better than beginners. On other trials, however, the groups were shown the same number of chess pieces, but now they were placed randomly on the board. For beginners, these positions would not look much different from a position in an actual game. When memory for these random positions were tested, beginners actually performed slightly better than the master players. These findings suggest that a chess player's mental imagery depends on extensive prior knowledge of chess positions rather than a general ability of spatial imagery. Tournament players must learn a vast database of prior positions and their outcomes. They are then able to categorize new positions in terms of this database. For randomly placed pieces, chess knowledge is irrelevant and, if anything, may disrupt memory.

In *The Mind of a Mnemonist*, the Russian neuropsychologist Alexander Luria described his investigation of S. V. Shereshevskii, an individual who had extraordinarily vivid visual imagery. This individual could memorize long lists of items, such as a string of 100 random digits in one presentation and recall it perfectly both forward and backward.[25] Shereshevskii stated that the numbers evoked shapes and colors. Luria suggested that Shereshevskii had an unusual form of *synesthesia*, a condition in which information from one sensory modality involuntarily activates or primes features in another modality. A common occurrence among synesthetes is the sensation of seeing colors while hearing words. Synesthesia has a genetic component and occurs in approximately 4% of the population.[26] In Shereshevskii's case, a variety of sensory stimuli evoked visual images. These images were potent and memorable, as in one instance Luria surprised Shereshevskii by asking him to retrieve a 50-word list presented to him 15 years ago. Shereshevskii was flawless in his recall.

Imagery facilitates memory, even among non-exceptional visualizers. In Joshua Foer's fascinating book, *Moonwalking With Einstein: The Art and Science of Remembering Everything*,[27] he describes his experience as a contestant in the United States Memory Championship in which individuals try to outdo one another in such feats as remembering the most lines of poetry, the most random digits, and the sequence of a shuffled deck of cards in the fastest time.

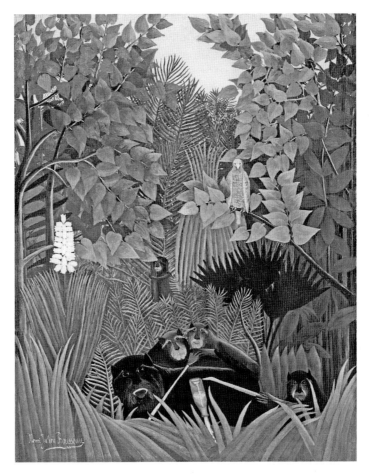

FIGURE 5.7 Rousseau, Henri (1844–1910) *Le Douanier* (The Merry Jesters) (1906). Oil on canvas, 57 3/8 x 44 5/8 inches (145.7 x 113.3 centimeters). The Louise and Walter Arensberg Collection, 1950. Philadelphia Museum of Art, Philadelphia, Pennsylvania. Photo Credit: The Philadelphia Museum of Art / Art Resource, NY. (See color plate section.)

there are some who excel and others who are less adept. When you read a novel do you imagine a movie of the plot? Those who do often feel disappointed when they actually see a movie based on a novel they've read, because the actual movie is never as good as their imagined one. Some people can look at a picture very briefly, then afterwards describe many details, as if they are holding the picture in hand. These so-called *eidetic imagers* have an extraordinary capacity to do this, as they can imagine pictures very accurately. About 6%–8% of children are classified as eidetic imagers, though this capacity loses strength during the teenage years, perhaps due to the salience of conceptual processes.[22] In adults, individuals vary in their ability to use visual imagery.[23] Some people are good at generating and keeping an image in mind, while others are good

This metacognitive model is useful in describing the distinction between bottom-up and top-down processing. Bottom-up processing refers to the manner in which sensory signals move through cortical processing units. The dorsal and ventral paths are prime examples of visual bottom-up processing paths. Yet along these paths at each stage of processing there are prefrontal projections back to these areas. Through these feedback paths, the prefrontal cortex can activate some processing units and suppress others. Note how the metacognitive model shown in Figure 5.6 looks very similar to the corporate brain model shown in Figure 1.9 and the schematic of top-down processing in Figure 1.7a, both in chapter 1. In fact, the metacognitive model offers a useful way to show how we are able to control our thoughts and guide behavior. Artists often act as the beholder's metacognitive controller by directing attention to specific parts of an artwork.

Imagine That

Imagine yourself on a tropical beach swinging in a hammock listening to gentle waves lapping onto the shore. We have an amazing capacity to conjure up fantastic scenes, as if we've transported ourselves to the place. Even if you've never been to a tropical beach, you have knowledge of such places and can create (and enjoy) your own mental imagery whether accurately portrayed or not. Top-down (metacognitive) processes are essential in guiding imagery, as you need to generate these scenes without any sensory input. In fact, imagery is easier with your eyes closed, as if you are better able to work with a blank canvas. Although most of the time we control what we imagine, sometimes images just pop into our minds. Such unconscious activations occur in the form of priming effects and are common interruptions as in the case of daydreaming.

With your imagination, you are the artist of your own mental "artwork." The images you generate may be completely novel, though they are always based on past experience and knowledge. If I were to ask you to imagine an alien from another planet, you can do so easily by accessing the hundreds if not thousands of images from your encounters with aliens in movies, television, and books. Even if you have never watched a science fiction movie or read such a book, you can use your knowledge of terrestrial animals to conjure up an image, as did the artists and novelists who first described such beings. If you had access to paint and canvas (and artistic skills), you could physically display your mental images. Henri Rousseau did just that in his paintings of jungle scenes (Figure 5.7). Although he never ventured outside of France, Rousseau created imaginative views of the jungle based on his readings about such places and trips to the zoo and botanical gardens. His works have a playful, child-like quality that reinforces their imaginative nature.

Are some people better than others at controlling their mental imagery? As with all skills, the majority of us have more or less average abilities, though

word meaning, and maneuvering in space. In a large corporation, the CEO is minimally involved in the day-to-day details of the business but becomes important in the event of unexpected or novel occurrences. Likewise, the prefrontal cortex is particularly involved when something unexpected occurs or when there's a conflict between two processing units. In neuroimaging studies, regions within the prefrontal cortex become active when individuals try to respond to two separate tasks at the same time or try to retrieve from memory one of several possible answers.[20] These tasks require executive control because processing units must be coordinated for efficient processing.

Our ability to implement executive control suggests a kind of knowing that was described by Descartes. We know what we are thinking about and, based on that knowledge, we can decide what to do next. In this sense, we know about what we know. Psychologists describe this kind of self-conscious awareness as *metacognition* (*meta* is Greek for *after* or *beyond*). Metacognition can be viewed as a multi-level process that involves communication between the prefrontal cortex and the rest of the brain. The prefrontal cortex acts as an overseer or *meta-level* processor that monitors and controls the rest of the brain, which is involved in various *object-level* analyses.[21] Figure 5.6 illustrates the notion of a meta level and how it can be used to monitor and control information processing. Object-level units comprise the various mental functions involved in specific aspects of cognition, such as form perception, speech recognition, and visual imagery. Object-level processes are distributed in various regions within the posterior cortex. Rather than one overarching CEO controlling all brain functions, there appears to be a board of prefrontal supervisors, each one responsible for controlling a particular facet of cognitive processing. These meta-level supervisors monitor activity, and in the event of conflict or an unexpected occurrence, can send feedback control to object-level units.

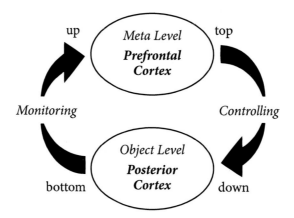

FIGURE 5.6 Metacognitive model showing interaction between meta-level and object-level processes.

making intended movements. We can do all these things without any sensory involvement. Despite such mental feats, our consciousness is limited in that we can only keep in mind one or a few things at a time. Considering the vast amount of knowledge we have stored in memory, why is our conscious awareness so limited? One possibility is that it may be more efficient to isolate and attend to a limited amount of information than to deal with too many things at once. Just as our sensory processes select certain features in the environment and filter out irrelevant information, we also need to select and filter information in memory. We have so much information in our storehouse of knowledge that it would be, excuse the phrase, mind-boggling to apprehend at any moment even a small fraction of it. By analogy, you wouldn't want all of your computer files open on your desktop at once. Rather, you would only want the ones relevant to your current interests.

To move thoughts in and out of conscious awareness, we need to guide and control how we access our knowledge. Try the following task: name as many types of animals that you can in a minute. Most of you will be able to retrieve well over 20 animals in that time. This ability does however takes a good deal of conscious control. First you had to access your knowledge of animals. Frequently encountered animals, such as pets (e.g., dog, cat), may come to mind first, but at some point you probably needed to direct your search in a conscious manner, perhaps starting with subcategories, such as animals you see at a zoo, farm, or aquarium. Moreover, you needed to keep track of the animals you've already named. If you simply retrieved the animal that first popped into mind, you'd never get past the ones that were easily retrieved. You can only perform well on this task if you consciously control and monitor your responses.

Such control depends on selecting, maintaining, and manipulating information in the mind. The prefrontal cortex is essential in performing these mental feats. We know much about the prefrontal cortex from patients with damage to this region, as they have difficulty selecting information from memory, keeping things in mind, and manipulating them. Even in the seemingly simple task of retrieving animal names, patients with prefrontal damage can generate only 8–10 animals in a minute, despite the fact that they have normal intelligence, good language skills, and intact knowledge about animals. The problem is that they cannot control access to this knowledge. It is akin to looking for information on the web without a search engine. Without the ability to control one's thought processes, accessing our knowledge is haphazard and inefficient. In the animal naming task, patients with frontal lobe damage often say the same animals over and over, as if they cannot monitor and suppress items they've already said.[19]

Neuroscientists describe the conscious control of thoughts as *executive control*. This term was introduced in chapter 1 in our analogy of the brain as a corporation. Regions within the posterior cortex (parietal, temporal, and occipital cortex) have specific processing duties, such as perceiving forms, deriving

chapter 1), one could blithely say, yes of course, the artist was in denial of sexual references, as it was *unconscious* desires that infused the work with such symbolism.

Robert Rauschenberg's *Monogram* is an artwork that includes a stuffed Angora goat with a car tire around its middle. Rauschenberg scavenged trash bins and shops in his New York neighborhood searching for objects to put in his artworks. Robert Hughes, the eminent art critic, suggested that *Monogram* contains overtly homoerotic symbolism.[18] Others have suggested that the artwork contains biblical, not sexual, symbolism in its reference to the Old Testament's scapegoat. As beholders, we interpret symbols in art based on our personal and cultural experiences. In many ways, it is not relevant what sort of symbolism the artist intended and indeed we may never know what was intended. Thus, to paraphrase an oft-cited Freudian statement, sometimes a goat with a tire around it is just a goat with a tire around it. Who knows what symbolic interpretation would have been generated if Rauschenberg had found a stuffed owl instead of a goat?

■ Hold That Thought

The well-known quote by Rene Descartes, *Cogito ergo sum* (*I think therefore I am*), laid the foundation for a seemingly obvious but very contentious construct, namely human consciousness. Descartes argued that we cannot know for certain if there is a reality out there filled with people and objects. The only thing we know for certain is that we, at this moment, are thinking—we know that we know. During the reign of behaviorism in psychology during much of the twentieth century, psychologists tried to ignore conscious experiences. Later, those with interest in cognitive psychology began to considered it. We all have a sense of consciousness, as we feel we can control our actions and thoughts. We can volitionally direct our attention to the conversation next to us or decide to scratch our nose at this moment (or not). The scientific conundrum is that one can never get inside another person's head and know exactly what that person is thinking. Scientists require observable phenomena, and conscious awareness is not observable. Psychologists have resorted to studying behavior as an observable response to a mindful event. Neuroscientists cannot look into the mind, but they can observe brain activity to mindful events. Here we consider what we know about the psychological and biological underpinnings of conscious control and attention.

Who's in Control?

An essential feature of consciousness is the ability to control our thoughts. We are mindful of retrieving memories, thinking of what we'll do tonight, or

nightmarish moods. These surrealistic scenes are infused with odd combinations of symbolic references, often portrayed within a strange landscape.

Artists have considered various interpretations of their dreams and fantasies. In a cheerful depiction, Marc Chagall's *L'Anniversaire* (*The Birthday*) (Figure 5.5) mixes fantasy, memory, and symbolism in a celebration of love for his wife. Many of Chagall's paintings include deep personal references. His paintings appear like pleasant fantasies rather than surrealistic nightmares. Another artist, Joan Miro, directly applied Freud's notion of the unconscious by experimenting with *automatism*, in which he let his brush be guided by whatever unconscious forces compelled it, perhaps not unlike Pollock's work. Miro made "automatic drawings" and used these sketches in his paintings. He thought that automatism brought out the true nature of his psyche, unencumbered by conscious editing or moral obligations. Similarly, Dali once said his paintings were "snap-shot photographs in color of subconscious images."[17]

Freud argued that artists paint because it provides a socially acceptable outlet of their unconscious sexual desires. Considerable effort has been devoted to deciphering sexual symbolism in artworks. The difficulty with applying such Freudian implications is that *any* object can be interpreted as a sexual symbol. Indeed, one could even find a way to interpret an abstract squiggle or blob in terms of some sexual reference. Moreover, even if an artist explicitly denied that an artwork had anything to do with sex, as did Weston (see Figure 1.5 in

FIGURE 5.5 Chagall, Marc (1887–1985), *L'Anniversaire* (1915). Oil on canvas. 31 3/4 x 39 ¼ inches. © ARS, NY. Acquired through the Lillie P. Bliss Bequest. The Museum of Modern Art, New York, NY. Photo Credit: Digital Image © The Museum of Modern Art/Licensed by SCALA / Art Resource, NY. (See color plate section.)

demonstrates that familiarity carries an emotional response—we like things that are familiar. Advertisers have of course capitalized on this effect, as commercials repeatedly expose us to certain products. Yet repetition of an initially unfavorable stimulus can actually increases its dislike. In one study, individuals were asked to judge how much they liked various works of abstract art.[12] For paintings that were initially judged as neutral, repeated exposure increased pleasantness ratings. However, works that were initially judged as unpleasant were rated even more unpleasant after repetitions. Thus, repeated exposure increases liking or dislike, depending on your initial disposition.

Psychological findings suggest that preferences in art are significantly driven by our familiarity or *fluency* with certain artworks. Art that is easily processed or familiar is generally preferred. The psychologist James Cutting obtained a mere exposure effect for Impressionist paintings. He found that paintings that were preferred tended to be those that were frequently seen in media, such as in art books.[13] Moreover, paintings presented in his university course were later rated more pleasing than ones that were not shown. Another psychologist, Rolf Reber, has suggested that asesthetic preferences for artworks are laregly driven by fluency or the ease with which they are perceived.[14] He suggests that fluency is an implicit, unconsciously driven process that contributes to our aesthetic experience, particularly to our appreciation of beauty.

One of the oldest investigations of fluency is a phenomenon called semantic satiation, in which words lose their meaning when they are repeated.[15] If you say any word, say "horse," over and over again, it will begin to lose its meaning and merely sound like a nonsense utterance. In such cases, overfamiliarity breeds habituation, as if there is so much expectation of what is presented that you shut down your conceptual processes. How many times have you seen a cartoon or parody of the *Mona Lisa*, the *Venus de Milo*, or *The Scream*? These icons of popular culture have become so overused as parodies that to appreciate their aesthetic value as actual artworks we have to shake ourselves from the "semantic saitiation" effect and try to look at them anew. Sometimes overfamiliarity prevents us from developing a full aesthetic experience.

Where All Your Dreams Come True

Freud, in his *Interpretation of Dreams*,[16] described how unconscious motivations and desires, particularly those pertaining to sex, bubble up in our dreams. He said that dreams contain vivid symbols of sexual fantasies intermixed with everyday experiences. The psychoanalyst's job is to decipher these symbols. The Surrealist movement paid tribute to Freud by suggesting that artworks, like dreams, represent unconscious wishes and desires. It is often the role of the beholder, not unlike the psychoanalyst, to decipher symbols in art that pertain to deeper meanings. Many surrealistic works take on dream-like qualities. Savalor Dali's paintings, such as *Persistence of Memory*, depict dreamy, even

How does the brain detect familiarity? Perhaps, unexpectedly, it is a *reduction* in brain activity that signals a familiar stimulus.[8] In particular, the activity of brain regions along the ventral path is reduced when the same stimulus is re-presented. This reduction occurs for all kinds of recently presented stimuli, such as objects, faces, and spatial locations. When one sees a novel stimulus, an activation path is laid down in the brain that connects the sensory, conceptual, and emotional processes involved while viewing the new stimulus. When the same stimulus is repeated it is easier to retrace this path as it has just been activated (i.e. primed). With further repetitions, such as when a person becomes a friend or a place becomes a favorite vacation spot, the neural paths become very strongly entrenched. With repetition, previously activated neural paths become easier to access and take less energy to traverse. In many ways, familiarity breeds fluency. These paths also become sharper and activations more precise.

Our sense of familiarity sometimes leads us astray. In a clever psychological experiment, individuals were presented a series of words to remember, such as *door, glass, pane, shade, ledge, sill, house, open, curtain, frame, view, breeze, sash, screen, shutter*.[9] After being exposed to this list, more than half of the subjects had a false memory that the word *window* had been presented. Of course, *window* is related to all of these words, and when subjects experienced the list, the path to the word *window* was highly activated, thus causing a familiarity response, even though the word itself was never presented. This illusion of familiarity may help explain that eerie sense of *déjà vu* when a place feels familiar though it is known to be novel. This false sense of familiarity may be due to the confluence of perceptual, conceptual, and emotional paths that are activated at this novel place, because these activations just happen to mimic activations linked to a different, familiar place. Just like the word *window* in the experiment, *déjà vu* experiences involve the activation of neural paths that inadvertently lead to a new location, thus creating a sense of familiarity.

Familiarity also influences our preferences. Why do we like one brand of detergent over another or one painting over another? Preferences are based on a multitude of factors both consciously and unconsciously driven. The fragrance of a detergent or the colors in a painting may influence our preferences. Yet another factor is the mere repetition of a stimulus. We tend to prefer things that are familiar, and a neutral stimulus can become pleasing just by repeated exposure.[10] In one study, individuals listened to unfamiliar Korean melodies. Later, these repeated melodies and new ones were played. When individuals were asked to rate how much they liked the melodies, the ones they had previously heard were preferred over new ones.

Such preferences are often made without any conscious awareness. In fact, neurological patients with severe amnesia exhibit preference judgments to repeated melodies, even though they have no memory of having previously heard the melodies before.[11] This phenomenon, called the *mere exposure* effect,

the energy that was involved in creating them. Moreover, many of Pollock's canvases are large and cannot be appreciated fully as book reproductions. When viewed at a museum, the dynamic trails of paint and textures give his paintings a strong visual rhythm. In Pollock's works, we can appreciate the unconsciously driven sensory skills that he used to create the impression of an artistic dance.

Feeling Familiar

John Locke, the seventeenth century British philosopher, described an experiment in which one hand is placed in hot water while the other is placed in cold water.[6] After a few moments, both hands are placed in lukewarm water, yet two different sensory experiences occur. The hand that was previously in hot water feels cool, whereas the one previously in cold water feels warm. This experiment demonstrates how prior experience can influence what is perceived. Psychologists refer to such unconscious influences as *priming*. Unlike skills, priming does not require many prior experiences. A single exposure can prime a stimulus and later create a sense of familiarity. There are various kinds of priming effects. In Locke's experiment, there was a change in sensation caused by a very recent experience. In other situations, priming can occur after an extended lapse of time. For example, go back to Figure 1.7b in chapter 1, and you will likely recognize the cow very quickly. Unlike the first encounter, there is now little effort as you easily recognize the features of the cow's head. Prior experience has tuned (i.e., primed) your brain to see the object.

From an evolutionary perspective, survival depends on our ability to recognize signals quickly, such as threatening predators, ripe fruit, and willing mates. This ability depends on knowledge and this knowledge informs our response (e.g., run, eat, or mate). The absence of familiarity, that is the feeling that something is novel, is just as important. Novel situations demand greater attentional focus so that the new experience—and the consequences of our actions to this new stimulus—will be remembered. For instance, if we encounter a new fruit and take a bite, we need to pay close attention to the consequences of this action, as our survival might depend on later remembering whether the fruit was good or bad.

We have been exposed to and can remember innumerable people, places, and objects. As a demonstration of this capacity, one psychological study showed individuals 2500 unfamiliar snapshots for 10 seconds each. Three days later, they were shown these photographs paired with ones they hadn't seen. Incredibly, after just this one exposure, subjects were able to recognize the ones they had seen before at a proficiency of over 90% correct.[7] Even for unfamiliar faces, one can recognize 71% of them after only one exposure. Considering the detail in photographs, it is amazing that we have such an enormous capacity to recognize them so easily.

in perspective, such as perceiving the tabletops in Figure 5.3 as having different dimensions.

May's primary impairment was his inability to recognize 3-D objects from his 2-D retinal image. He could see visual patterns, but he could not put them together to recognize objects. In an fMRI study, regions along the ventral path that normally respond to objects were not active when May was shown common objects. Even after several years of restored vision, his ability to recognize objects is still impaired. He can use his vision to move around and detect forms, though his capacity to recognize what these forms are is still poor. He states: "The difference between today and over 2 years ago is that I can better guess at what I am seeing. What is the same is that I am still guessing."[4] We all make "guesses" about what we're seeing, because images on our retina are fleeting and ambiguous. May's difficulty in object recognition shows that early sensory expereince has made our guesses quick and highly accurate.

Sensory skills are reflected in the way artists paint. Unlike the brain, however, artists must be consciously aware of how to apply linear perspective and render shape from shading. Moreover, artists must know how to guide the beholder to pertinent regions in a painting. Another way to link sensory skills with artistic ability is to consider the work of Jackson Pollock (Figure 5.4). Pollock placed large canvases on the ground then jumped and danced around them dripping paint from his brush along the way. The noted art critic Harold Rosenberg called Pollock's art *action painting*, an apt term as it describes the automatic and seemingly unconscious manner in which Pollock created his paintings.[5] Some may find Pollock's style haphazard or random. I admit to having little appreciation of his works when I first encountered them, I didn't sense

FIGURE 5.4 Pollock, Jackson, *Number 14: Gray.* Yale University Art Gallery, Katharine Ordway Collection.

FIGURE 5.3 Roger Shepard's Table Illusion. The tabletops are identical in shape, as the sides indicated by the letters across the two are the same length. From *Mind Sights* (1990). New York: W. H. Freeman and Co.

horizontal sides of the right table (also labeled a and c), because we interpret the sides of the left table to be extending in depth. As we have learned from our linear perspective exercise, edges that extend in depth must be foreshortened. Thus, if these were real tables, the edges a and c should appear foreshorted on left table. Since these edges are not foreshortened, we *perceive* them to be longer. Similarly the sides labeled b and d are the same length on the two tables, though these lengths look longer on the right table because those edges would be foreshortened if it were a real table.

These illusions make clear the point that we are inextricably tuned to the regularities of our 3-D spatial world. Our brains have become exceedingly skilled at predicting what we *should* see. Usually, these top-down expectations make perceiving much more efficient. Yet sometimes our brains are misled, and we see things that are not really there. As with our facility in reading this sentence, once we have acquired such skills, object recognition is fast and seemingly an unconscious act. Sensory skills are acquired early in life, a fact made clear by individuals who were blind during childhood but had sight restored as adults. One such case is Michael May,[2] who was blinded at the age of three from a chemical explosion that caused corneal scarring. Despite this impediment, May led an active adult life, succeeding as a businessman, athlete, and spokesperson for the blind. At the age of 43, he underwent corneal replacement that restored his vision. After the operation, his retina was responsive and functional as he could perceive colors, motion, and patterns.[3] Yet his vision was not normal. He could not recognize objects or interpret spatial relationships. Interestingly, he was unable to see visual illusions that depended on seeing objects

Edward H. Adelson

FIGURE 5.2 Checkerboard shadow illusion. We perceive the illustration as a real cylindrical block on a checkerboard casting a shadow. In actuality, squares labeled A and B are exactly the same shade of gray as shown on the left when they are taken out of context. Also, the squares labeled C are the same shade and identical to the top left corner square on the checkerboard. ©1995, Edward H. Adelson.

other squares, though in actuality it is the same shade as the other lighter squares. What's going on? We *know* that when a shadow is cast on a surface it will appear darker, not because the surface has changed color but because it is exposed to less light. Square B on the checkerboard is percevied lighter than square A, because we believe it is darkened by the shadow and would be lighter otherwise. Likewise, our brains *see* square C as very light, because it too is in the "shadow." In other words, baseed on implicit knoweldge of how shadows are cast and our belief that the picture represents a real scene, our brains color the world accordingly. I can tell you, as Magritte would, "this is not a real checkerboard," but nevertheless our brains perceive it as such using implicit knowledge of light and shadows.[1]

We are exceedingly familiar with the way things appear in 3-D space, even though colors, shapes, and sizes change drastically as we move around. This familiarity causes distortions when 3-D objects are depicted on a flat surface. In Figure 5.3, the table on the left appears longer and narrower than the one on the right, though the shape of the two tabletops are identical. If you rotate the left tabletop clockwise by 90 degrees it would overlap perfectly with the tabletop on the right. Our brains are so well trained to see pictures as depictions of 3-D space, that we interpret the tables as real objects shown in perspective. Thus the long sides of the left tabletop (labeled a and c) appear longer than the

FIGURE 5.1 Magritte, René (1898–1967), *Ceci n'est pas une pipe* (1929). © ARS, NY. Oil on canvas. Overall: 25 3/8 x 37 inches. (64.45 x 93.98 centimeters). Unframed canvas: 23 11/16 x 31 7/7 inches, 1 1/2 inches deep, 39 5/8 inches diagonal. Purchased with funds provided by the Mr. and Mrs. William Preston Harrison Collection (78.7). Los Angeles County Museum of Art, Los Angeles, California. Photo Credit : Digital Image © 2009 Museum Associates / LACMA / Art Resource, NY.

awareness. In this section we explore ways in which implicit forms of knowledge act on our perceptions and preferences.

Sensory Skills

Frequent exposure to the sensory world has molded our brains so that constant features are readily detected. We know how light is reflected off objects, how shadows cast dark regions upon surfaces, and how an object's size varies with distance. We know these things because in just about every waking moment we experience them via sensory input. Such experiences are so regular that our brains habitually use this knowledge to guide what we see. From these regularities, we form expectations of what we *should* see, sometimes at the expense of what is actually sensed. It is as if our brains are always making educated guesses about what we might encounter.

Consider the illustration in Figure 5.2. We interpret it as a 3-D view of a checkerboard with a cylindrical block in one corner. On the checkerboard, squares A and B appear as different shades of gray, but when the same squares are placed outside the checkerboard, it is evident that they are the same shade. Square C on the checkerboard stands out as it appears much lighter than the

5. WHAT DO YOU KNOW?

The object depicted in Figure 5.1 is obviously a pipe, but the fact that Margritte added *Ceci n'est pas une pipe* (*This is not a pipe*) forces us to reevaluate what the painting represents. Magritte offers a conceptual, meta-art statement about the dual nature of paintings. We *know* that it is a pipe, but we also *know* that it is just a painting of one. Whenever we experience art we use knowledge, which includes sensory knowledge about the way light impinges on our retina, conceptual knowledge about objects, and even specific knowledge about art itself. Much of this knowledge is universal—we all experience the sun rising, the night sky, and the vagaries of the weather. We also experience life, birth, happiness, sadness, and death. Such knowledge allows us to prepare for new experiences both in daily life and and in our encounters with art.

▪ Unconsciously Yours

Much of our conceptual knowledge is so familiar that we are not even aware of it being used. These aspects of knowledge include the habits, skills, and preferences that guide our behavior. For example, as you read this sentence, you are rapidly processing the meaning of words and relating them to your existing knowledge. This feat requires extraordinary sensory and conceptual skills, yet we are so fluent with this process that we are not even conscious of converting the little black symbols you are currently seeing as meaningful words. Likewise, when we ride a bicycle, play a musical instrument, or perform a sports skill, we don't have to *remember* how to do it, we simply enact a well-learned program. Psychologists refer to these forms of knowledge as *implicit*, as they occur unconsciously and with seemingly little effort. Findings of implicit memory suggest that a substantial amount of brain activity is beneath our conscious

ACT II

THE ART OF KNOWING

34 Gordon, I. E., & Gardner, C. (1974). Responses to altered pictures. *British Journal of Psychology, 65,* 243–251.

35 Ross, B. M. (1966). Minimal familiarity and left-right judgment of paintings. *Perceptual and Motor Skills, 22,* 105–106.

36 Subjects made decisions of Janssen's *Reading Woman* along with 39 other paintings. Shimamura, unpublished data.

37 Locher, P., Krupinski, E. A., Mello-Thoms, C., & Nodine, C. F. (2007). Visual interest in pictorial art during an aesthetic experience. *Spatial Vision, 21,* 55–77. Olivia, A., & Torralba, A. (2007). The role of context in object recognition. *Trends in Cognitive Science, 11,* 520–527.

38 Buswell, G. T. (1935). *How People Look at Pictures.* Chicago: University of Chicago Press. Yarbus, A. L. (1967). *Eye Movements and Vision.* New York: Plenum Press.

39 Nodine, C. F., Locher, P. J., & Krupinski, E. A. (1993). The role of formal art training on perception and aesthetic judgment of art compositions. *Leonardo, 26,* 219–227. Zangemeister, W. H., Sherman, K., & Stark, L. (1995). Evidence for a global scanpath strategy in viewing abstract compared with realistic images. *Neuropsychologia, 33,* 1009–1025.

17 Poore, H. R. (1903). *Pictorial Composition and the Critical Judgment of Pictures*. New York: Baker and Taylor.

18 Puttfarken, T. (2000). *The Discovery of Pictorial Composition*. New Haven, CT: Yale University Press. Tyler, C. W. (2007). Some principles of spatial organization in art. *Spatial Vision*, *20*, 509–530.

19 Field, G. (1835). *Chromatics*. London: Moyes & Barclay.

20 Krages, B. (2005). *Photography: The Art of Composition*. New York: Allworth Press.

21 Livio, M. (2002). *The Golden Ratio: The Story of Phi, the World's Most Astonishing Number*. New York: Broadway. Plug, C. (1980). The golden section hypothesis. *American Journal of Psychology*, *93*, 467–487.

22 Livio (2002).

23 Fechner, G. T. (1876). (See chapter 1, n. 19.)

24 Plug (1980), p. 486.

25 Kandinsky, W. (1979). *Point and Line to Plane*. Mineola, NY: Dover.

26 Gross, C. G., & Bornstein, M. H. (1978). Left and right in science and art. *Leonardo*, *11*, 29–38.

27 Gaffron, M. (1950). Right and left in pictures. *The Art Quarterly*, *13*, 312–331. Gaffron, M. (1956). Some new dimensions in the phenomenal analysis of visual experience. *Journal of Personality*, *24*, 285–307.

28 Adair. H., & Bartley, S. H. (1958). Nearness as a function of lateral orientation in pictures. *Perceptual and Motor Skills*, *8*, 135–141. Bartley, S. H., & Thompson, R. (1959). A further study of horizontal asymmetry in the perception of pictures. *Perceptual and Motor Skills 9*, 135–138.

29 Levy, J. (1976). Lateral dominance and aesthetic preference. *Neuropsychologia*, *14*, 431–445. Beaumont, J. G. (1985). Lateral organization and aesthetic preference The importance of peripheral visual asymmetries, *Neuropsychologia*, *23*, 103–113. Meade, A. M., & McLaughlin, J. P. (1992). The roles of handedness and stimulus asymmetry in aesthetic preference. *Brain and Cognition*, *20*, 300–307.

30 Chokron, S., & De Agostinic, M. (2000). Reading habits influence aesthetic preference. *Cognitive Brain Research*, *10*, 45–49. Heath, R., Mahmasanni, O., Rouhana, A., & Nassif, N. (2005). Comparison of aesthetic preferences among Roman and Arabic script readers. *Laterality*, *10*, 399–411.

31 Christman, S., & Pinger, K. (1997). Lateral biases in aesthetic preferences: Pictorial dimensions and neural mechanisms, *Laterality*, *2*, 155–175. Freimuth, M., & Wapner, S. (1979). The influence of lateral organization on the evaluation of paintings. *British Journal of Psychology*, *70*, 211–218.

32 Chatterjee, A., Maher, L. M., & Heilman, K. M. (1995). Spatial characteristics of thematic role representation. *Neuropsychologia*, *33*, 643–648.

33 Palmer, S. E., Gardner, J. S., & Wickens, T. D. (2008). Aesthetic issues in spatial composition: Effects of position and direction on framing single objects. *Spatial Vision*, *21*, 421–449.

■ **Notes**

1 The painting has been attributed to Piero Della Francesca, though some suggest that the underlying drawing was made by Leon Battista Alberti. See Morris, R. C. (2012). If a city were perfect, what would It look like? *New York Times*, May 8, 2012.http://www.nytimes.com/2012/05/09/arts/09iht-conway09.html?pagewanted=all

2 Saegusa, T., & Chikatsu, H. (2004). 3D modeling and representation of "Ideal City" painted by Piero Della Francesca. Proceedings of the Youth Forum. *International Society for Photogrammetry and Remote Sensing* (http://www.isprs.org/proceedings/XXXV/congress/yf/papers/941.pdf).

3 See Kemp, M. (1982). (See chapter 2, n. 11.)

4 See Kubovy, M. (1986). *The Psychology of Perspective and Renaissance Art.* Cambridge, MA: Cambridge University Press.

5 Alberti, L. B. (1435). *On Painting.* (J. R. Spencer, Trans.). New Haven, CT: Yale University Press.

6 Figure from Ogden, R. M. (1938). *The Psychology of Art.* New York: Charles Scribner's Sons.

7 See Kubovy, M. (1986). Steinberg, L. (1973). Leonardo's Last Supper. *The Art Quarterly, 4*, 397–409.

8 Panofsky, E. (1998). *Perspective as Symbolic Form.* Cambridge, MA: MIT Press.

9 Gibson, J. J. (1971). The information available in pictures. *Leonardo, 4*, 27–35. Gombrich, E. H. (1972). The "what" and "how": Perspective representation and the phenomenal world. In R. Rudner & I. Scheffler (Eds.), *Logic and Art: Essays in Honor of Nelson Goodman* (pp. 129–149). Indianapolis, IN: Bobbs-Merrill.

10 Goodman, N. (1976). (See chapter 1, n. 14.)

11 Pirenne, M. H. (1970). *Optics, Painting and Photography.* Cambridge, UK: Cambridge University Press.

12 Loran, E. (1963). *Cezanne's Composition: Analysis of His Form With Diagrams and Photographs of His Motifs.* Berkeley: University of California Press.

13 Aguirre, G. K., & D'Esposito, M. (1997). Environmental knowledge is subserved by separable dorsal/ventral neural areas. *The Journal of Neuroscience, 17*, 2512–2518.

14 Bisiach, E., & Luzatti, C. (1978). Unilateral neglect of representational space. *Cortex, 14*, 129–133.

15 Arnheim, R. (1988). *The Power of the Center.* Berkeley: University of California Press.

16 Locher, P. J., Stappers, P. J., Overbeeke, K. (1998). The role of balance as an organizing design principle underlying adults' compositional strategies for creating visual displays. *Acta Psychologia, 99*, 141–161. Wilson, A., & Chatterjee, A. (2005). The assessment of preference for balance: Introducing a new test. *Empirical Studies of the Arts, 23*, 165–180.

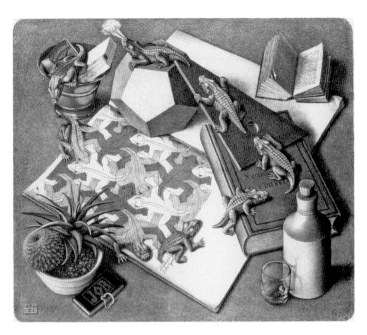

FIGURE 4.14 M.C. Escher's "Lizards." © 2011, The M.C. Escher Company-Holland. All rights reserved, www.mcescher.com.

a host of neural processes bring back a 3-D representation of objects. We also showed how modern artists reversed this process by stripping 3-D representations down to fundamental features and ultimately down to a flat 2-D canvas. In the brain, the ventral path is essential for turning the retinal image into nameable objects. Lines, colors, and edges are grouped and outlined to create recognizable forms. The dorsal path processes primarily low spatial frequencies and facilitates the impression of spatial depth in a scene. The final stage of visual processing (and for artists who create realistic scenes) is the construction of an egocentric viewpoint that defines recognizable objects placed appropriately within a spatial environment.

In our exploration of the art of seeing, it is clear that our brains "see" more than what is projected onto our retina. When we experience the world, including artworks, a dynamic interplay occurs as sensory inputs coalesce and resonate with knowledge. As such, our perception of space involves both bottom-up and top-down influences. Yet our viewpoint is rather restricted. We almost always see the world from an elevation of three to six feet above the ground, and we typically pay attention to objects at rather close distances. Moreover, the light source is almost always above us, thus providing regularities in the formation of shadows and highlights. These constancies allow the brain to be more efficient in isolating forms and perceiving space. We use this past experience to predict what we'll likely see in the future. These and other knowledge-based features will be explored next when we consider the art of knowing.

shown Ilya Repin's painting *An Unexpected Visitor*, which depicts an exiled husband returning to his family. The painting was well known in Russia, and viewers were familiar with it. From eye movement recordings, it was clear that viewers did not fixate randomly but focused on salient features. In particular, the viewer fixated on the visitor and the faces of the other individuals portrayed. Yarbus also showed that eye movement behavior could be manipulated by task demands. When asked to "estimate how long the unexpected visitor has been away from the family," individuals made many more recurrent eye movements from person to person than when asked to "estimate the ages of the people shown in the picture."

How does a beholder's artistic knowledge influence eye movement behavior? Compared to nonexperts, individuals with professional art training elicit longer fixations at objects and make longer saccadic eye movements between fixations.[39] These findings suggest that prior knowledge changes one's expectations and strategies. As these studies used well-known artworks, it is not clear whether these findings are the result of a general expertise in looking at art or whether they occurred because of familiarity with the specific works.

Form, lines, color, and knowledge all play a role in determining where we look. Artists use various techniques to direct the beholder's gaze, as exemplified by global compositional rules (such as those suggested by Poore), by directionality in the implied movement of objects, and by the eye gaze of the people depicted. Other techniques are used to bring the eye back to the central regions of the canvas. For example, aerial perspective is the term used to describe the way artists depict objects as hazy and losing detail as they recede to the background. This technique is used to mimic the scattering of light in the air when objects are seen from a distance. By reducing the detail and contrast of distant objects, beholders are encouraged to return their gaze to the foreground. Rembrandt made exquisite use of this technique by defocusing peripheral areas in his portraits and painting the eyes of his subject in very sharp detail. This technique mimics the drop-off in acuity from foveal vision to the periphery. By defocusing parts of his paintings, Rembrandt guided our looking to features that he deemed important. This effect accentuates the realism of paintings and keeps one's gaze at the center. Even Ansel Adams, known for his "straight" landscape scenes, is famous for darkening broad regions around the edges of his photographs. This technique of "burning the edges," though subtle, can significantly enhance the aesthetic appearance of a photograph as it reduces the significance of distracting details in the periphery.

■ Sense and Sensibility

Much like the creatures depicted in M. C. Escher's drawing in Figure 4.14, we've described how our brains transform a 3-D world on a 2-D surface, and through

When asked to draw a picture illustrating action verbs, such as "giving" or "shooting," subjects typically draw the agent (i.e. the giver or shooter) on the left in such a way that the action is portrayed as moving from the left to right.[32]

Other factors influence the directionality bias. In the photographs of the windsurfer, the two photographs on the left are cropped so that the windsurfer is moving into the picture (i.e., toward the center), whereas the two photographs on the right are cropped so that the windsurfer is moving out of the picture. Palmer and colleagues[33] showed that in addition to the general rightward directionality bias, people prefer to have objects appear to be moving into the picture (toward the center) rather than moving out of it. For nondirectional objects, such as a frontal view of a person or cat, a center placement is most preferred.

These findings suggest that our scanning behavior plays a significant role in aesthetic analysis. How strongly do these biases influence our preference? Will an artist's original version tend to be favored over its mirror-reversal? When subjects view paintings with the original and its mirror reversal side by side and are asked to determine which of the two they prefer, they do not consistently prefer the original version over its mirror-reversed version.[34] In fact, when asked to select the original version of an unfamiliar painting, they perform no better than chance. The only time subjects showed a preference for the original was when the painting was familiar.[35] In fact, even in an analysis of Janssen's *Reading Woman*, subjects (1) do not prefer the original over its mirror reversal, (2) do not know which one is the original version, and (3) do not agree as to which version shows greater spatial depth.[36] These findings suggest that the left–right bias influence is just one of many aesthetic features, and when we consider actual paintings as a whole, they do not necessarily guide aesthetic preferences.

Looking Around

When you look at an artwork, your eyes will fixate on a spot for about a third of a second and then jump to another spot, fixate, then jump again, and so on. These jumps are called *saccadic eye movements*, which are rapid, taking only 3/100 of second to complete. The rest of the time—about 95% of the time—your eyes are stable and fixated at a point in space. Recall that during any fixation, you can only clearly see a focused area amounting to three or four words on a page. Thus, the sequence of eye movements while viewing a picture offers a record of salient points of interest. Despite this limitation, we comprehend the general gist of a picture very quickly, often within a single fixation.[37] We probably use both central fixation and our less clear peripheral vision to identify the gist or context. For example, even with a fuzzy photograph, one can identify the general context of a scene (e.g., outdoor versus indoor) and whether or not the scene includes people. We then use this blurry information to direct us to salient objects in a scene.

The Russian scientist Alfred L. Yarbus recorded sequences of eye movements while individuals looked at pictures.[38] In one analysis, individuals were

It has also been suggested that left–right asymmetries are based on the way our two cerebral hemispheres process information.[29] It is true that spatial disorders, such as unilateral neglect syndrome, occur after right hemisphere damage more often than left hemisphere damage. Thus, there may be a spatial bias to process features in the left visual field, as this information enters the right hemisphere more directly. Although findings have corroborated a left–right scanning bias in aesthetic analyses of pictures, specialized hemispheric processing does not appear to drive this effect. Instead, such biases appear to be guided by reading behavior, because people who read from right to left, such as Israeli and Arabic readers, adopt a right–left scanning bias during picture viewing and show the opposite aesthetic preferences than those who read from left to right.[30] Interestingly, it is not that one side is considered weighted more than the other, rather it is the *directionality* of the perceived movement in a scene. French (left–right) readers preferred objects that had a right facing directionality, such as truck in the center of a picture facing as if it were moving to the right, whereas Arabic (right–left) readers showed the opposite bias, preferring a truck that appeared to be moving to the left. Yet reading behavior did not influence preferences in drawings of landscapes that were weighted on one side as opposed to the other.

Other findings point to the importance of the directionality of movement as the prominent factor that influences left–right biases.[31] Directionality is determined by the perceptual forces (lines, objects) that move your attention. As one who reads from left to right, you likely prefer pictures that move in a left-to-right direction. In the various photographs of the windsurfer shown in Figure 4.13, most English readers would prefer the windsurfer moving to the right (top images) rather than moving to the left (bottom images). Interestingly this directional bias is even embedded in the way we imagine scenarios.

FIGURE 4.13 People tend to prefer implied movement into a scene, particularly from left to right, such as the top left image of the windsurfer.

appear balanced or weighted heavily to the left or right side. Balance is of course a subjective quality as the saliency or weight of an object depends not only on its perceptual qualities, such as size, color, or relation to the foreground, but also on its *conceptual* weight, such as the thematic saliency of a person or object. Consider the painting *Reading Woman* by P. Janssens (Figure 4.12), which is shown in its original orientation (left panel) and in mirror-reversal (right panel). Gross and Bornstein suggested that the painting's orientation changes the way it is interpreted. They state: "In the original, the viewer stands naturally at the woman's back looking over her shoulder."[26] When the orientation is reversed, the woman seems further away, less central, and the shoes in the foreground take on an inadvertent importance. There does appear to be a difference in the way the two versions are interpreted, though these differences are quite subtle and not everyone would agree with the interpretation. Does the balance of a painting depend on the right–left placement of objects?

We seem to scan paintings from left to right, perhaps with an upward glance, thus starting from the bottom left and moving to the top right.[27] When scanned in this manner, the left side takes on greater saliency or weighting because it is scanned first. This scanning pattern can explain Gross and Bornstein's view of the Janssen painting, as it would make the woman on the left in the original version appear more salient than she would be when placed on the right. In the mirror-reversed version, the shoes are on the left and seem too strongly weighted as a central feature. Psychological studies have suggested that objects placed on the left side are interpreted as being closer, clearer, and more salient.[28]

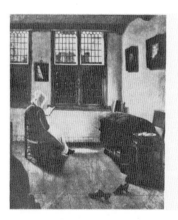

FIGURE 4.12 *Left* painting is the original, and *right* painting is the mirror-reversed image of P. Janssens (1640–1700), *Reading Woman*, Alte Pinakothek, Munich, used to evaluate changes in pictorial space due to left-right orientation. Reprinted from Gross, C.G., and Bornstein, M. H. (1978). Left and right in science and art. *Leonardo*, *11*, 29–38. © 1979 by the International Society for the Arts, Sciences and Technology (ISAST).

$a/b = (a + b)/a$. There is only one value of the ratio (a/b) that solves the equation, and that number is an irrational number which is approximately 1.62. A rectangle based on the golden ratio would have its sides a and b, such that the ratio of the two sides (a/b) equals 1.62. Thus, if the length of the short side is 1 foot, then the length of the long side would be 1.62 feet. The golden ratio has been considered the optimal proportion for aesthetic appeal. It has been claimed that Stonehenge, the Parthenon, and Notre Dame Cathedral in Paris all include the golden ratio in their proportions, though these claims have been strongly refuted as well.[22]. Fechner[23] conducted psychological experiments to determine if people prefer rectangles defined by the golden ratio over other proportions. The rectangle with proportions based on the golden ratio (1.62:1) was preferred most often, though only selected 35% of the time. Plug[24] reviewed many studies of the golden ratio and determined that so many other factors drive visual aesthetics that "the golden ratio hypothesis should die a natural death."

In his book, *Point and Line to Plane*,[25] the artist Wassily Kandinsky described compositional rules that motivated his abstract art. He said that many aspects of the natural world can be characterized in abstract paintings, including rhythm in dance and harmony in music. He also noted visual similarities across natural objects, such as cosmic galaxies as seen through a telescope and clusters of microbes as seen through a microscope. He contrasted curved, natural forms from angular, man-made forms. For example, he showed how "free wave-like" lines with the addition of angular ones can produce a dynamic and aesthetic flow (Figure 4.11), which is so common in Kandinsky's paintings. Thus, in abstract compositions, indeed most inherently in abstract works, we experience the formal application of balance, harmony, and rhythm.

Left and Right, In and Out

An intriguing aspect of pictorial composition is the left–right balance of an artwork. Depending upon the placement of objects in a scene, a picture can

(a) (b)

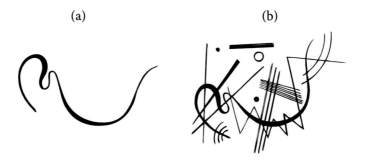

FIGURE 4.11 Drawing from Kandinsky, W. (1979). *Point and Line to Plane*. Dover: New York. Diagrams 16 and 17 (Appendix), reprinted with kind permission from Dover Publications, Inc.

There are, of course, symbolic associations, such as the mystique of the pyramid and Christian symbolism. Perceptually, the triangle induces a dynamic force, which is generally stronger than that which can be obtained with a circular or rectangular composition. A stroll through an art museum with triangles in mind will suddenly make apparent the ubiquity of this composition. A favorite example of the dynamics of a triangular composition is George Bellows's *Stag at Sharkey's* (Figure 4.10) in which multiple instances of the triangular motif are apparent The off-balanced triangle formed by the two boxers exemplifies Arnheim's notion of perceptual force. The boxer on the left appears to be pushing the triangle as much as he's pushing his opponent. Thus, the formal features of the composition create perceptual dynamics that match and reinforce emotional and conceptual ones.

As early as 1835, the "rule of thirds" has been used as a compositional guideline.[19] The rule states that a picture should be divided into thirds, both vertically and horizontally, and points of interest should be positioned at the intersections of these dividing lines. Even today, particularly in landscape photography, the rule of thirds has been suggested as a guideline for the horizon and object placement.[20] Its usage among art instructors is probably to discourage students from creating fully balanced compositions with objects placed at the midline, which tend to produce static pictorial scenes without much perceptual force.

A widely debated compositional rule is based on the golden ratio,[21] which is a specific value, like the value of *pi*. The ratio is defined by the proportion of two values, say *a* and *b* (with *a* being the greater value), such that

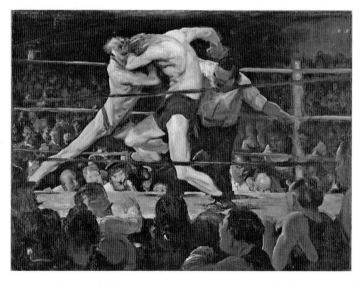

FIGURE 4.10 George Bellows (American, 1882–1925). *Stag at Sharkey's* (1909). Oil on canvas, 92.0 x 122.6 centimeters. The Cleveland Museum of Art. Hinman B. Hurlbut Collection 1133.1922.

Putting Things in Proper Places

When we first encounter a work of art, the perceptual balance or flow of the piece is often the first feature that captures our interest. In this way, a formalist approach is considered in which lines, colors, and forms drive our aesthetic response. A useful exercise when approaching a new work is to pay attention to where your eyes move. Eye movements are driven by both sensory (bottom-up) and thought (top-down) processes, thus offering clues to what makes the piece interesting to you. There are features in every artwork that the artist would like you to consider—be they perceptual, conceptual, or emotional in nature. By noticing where your eyes move, you can identify these critical signposts.

Rudolf Arnheim[15] described the role of *perceptual forces* in driving our art experience. These forces are created by the placement of objects in a scene. Balance and tension are created by the way forms relate to each other and to the picture as a whole. As mentioned in chapter 1, a circle slightly off-center within a rectangular frame creates a dynamic relationship that suggests perceptual tension. Generally, good balance of objects within a frame is favorable,[16] and a central focal point is the most important location. Perceptual forces emanate out from this point or gravitate toward it. Importantly, the center of a composition need not be the exact center of the picture, though generally it is near it. Also the general shaping of a painting is important. Curved or circular compositions move around the frame, whereas angular compositions create movements toward their corners or sides.

Many artists provide signposts that direct you to important features. Like a magician's sleight of hand, artists use the eye gaze and body position of people depicted in paintings to direct attention. For example, many of Raphael's paintings of the Madonna and Christ use the gazes of those in the scene to manipulate the beholder's gaze pattern. Also, the placement and curvature of arms and bodies will move the beholder's gaze around the scene and create a dynamic flow. It is clear that Raphael applied these compositional principles intentionally as a way to guide the beholder's experience.

In the charming book entitled *Pictorial Composition and the Critical Judgment of Pictures*,[17] Henry Rankin Poore provided a "handbook for students and lovers of art." The book, which he suggested should be read by painters and photographers, covers general principles of composition. Poore described fundamental forms of construction, such as left–right balance and the aesthetic application of triangles, circles, crosses, S-curves, and rectangles in scenes. He suggested that artists apply these fundamental forms to get the beholder "into the picture." He also described how these forms accentuate a sense of space and linear perspective. Though written over 100 years ago, the text still provides a thoughtful analysis of composition.

Of Poore's principles of composition, the triangular motif is the most common. Some have speculated about the reason for this particular tendency.[18]

FIGURE 4.9 Anton Raderscheidt, self-portraits following brain damage resulting in spatial neglect syndrome. From H. W. Kisker, J. E. Meyer, G. Muller, and E. Stromgren (Eds.). (1980). *Psychiatrie der gegenwert* (2nd ed., pp. 753–1103). New York: Springer, reprinted with kind permission from Springer Science+Business Media B.V.

himself at a familiar location, the Piazza del Duomo in Milan where the cathedral is located.[14] While in a testing room he was asked to imagine himself looking at the cathedral from the opposite end of the piazza and describe what he saw. The patient described the buildings on the right side but neglected those on the left. He was then asked to imagine himself standing on the steps of the Cathedral and looking out to the piazza. When asked to describe the view from that perspective, he reported buildings on the right, which were the ones he previously neglected. This finding suggests that the patient had an intact map-like, allocentric knowledge of the entire area. However, when asked to construct an egocentric view of the area, he exhibited a neglect of one side of space.

The parietal cortex is essential for egocentric processing. It is the final processing stage along the dorsal path in the manufacturing of a stable spatial world. The parietal lobe is *multisensory*, integrating information from cortical regions that process vision and touch. Interestingly, these two sensory domains are most critical for our perception of egocentric space, as vision provides a wide angle picture plane of the world and touch provides more local analysis of personal, egocentric space.

■ A Question of Balance

Harmony, balance, rhythm—these terms have often been used to describe the spatial qualities of art. They are generally meant to characterize the overall composition of an artwork and also to link perceptual features with emotional responses. In film and theater, the term *mise-en-scène* (to *put in scene*) refers to the balance and flow of a scene in terms of lighting, placement of objects, and visual dynamics. Here, we analyze how artists create a sense of balance (or imbalance) in an artwork, and how beholders respond to different aspects of pictorial composition.

are also depicted in multiple perspectives, and the background gives an odd sense of depth as ceiling lines converge strongly but the lines that define the side walls converge only slightly.

The Neuroscience of Space

Close your eyes and then point to the north. For most people, this task is rather simple and direct. It involves egocentric spatial processing as you must orient yourself with respect to your environment and current position. As mentioned in the beginning of this chapter, egocentric representations define a first-person (Google street view) perspective. It is thought to be a rather early evolutionary process as many animals need to navigate around a spatial environment. We seem to have an almost automatic sense of where we are with respect to a familiar environment. Moreover, when we move around, we maintain a stable view of the world, despite erratic head and eye movements. It is, of course, the brain that creates this stable world and allows us to navigate through it. In particular, it is the dorsal visual path that is important for egocentric spatial processes. In one study,[13] individuals "wandered" around a virtual reality similar to those used in first-person video games. After developing a familiarity with the environment, they were asked questions that pertained to an egocentric viewpoint. It would be as if one showed you a familiar *Google* street view and asked you what building was to the right of the present view. While performing such egocentric tasks, the dorsal visual pathway is particularly active.

Consistent with these neuroimaging findings are studies of patients with brain injuries who develop disorders of egocentric space. In the case of *unilateral spatial neglect syndrome*, patients have severe impairment in attending to one side of space. This impairment usually occurs with damage to the right dorsal path and thus impairs the left side of space. These patients will disregard food placed on the left side of a plate and will not acknowledge people or objects on the left. It is not that these patients are blind, they just don't seem to attend to one side of space. If you direct them to a point on their neglected side they will perceive it. Anton Raderscheidt, a German artist who incurred right parietal damage following a stroke, documented his recovery from spatial neglect syndrome in self-portraits painted 2 months, 3.5 months, 6 months, and 9 months following his stroke (Figure 4.9). Note that the first painting is completely restricted to the right side of the canvas, and even on that side, he neglected the left half of his body. The second self-portrait shows improvement in covering the canvas, though much of the left side is still empty. The third and fourth self-portraits are markedly improved, though even the last painting shows some left-sided neglect.

Interestingly, the spatial neglect syndrome can extend to visual imagery. An Italian patient with unilateral neglect syndrome was asked to imagine

viewpoints which give them their unique spatial aesthetic.[12] There is an elegant imbalance to Cezanne's paintings, as if he is demonstrating the appeal of breaking out from the window of realism.

It is, of course, Picasso who offered multiple views in portraiture. In the painting of his mistress and muse *Dora Maar* (Figure 4.8), and in many other of his portraits, facial features are simultaneously depicted in profile and in frontal view. Unlike Van Gogh's or even Cezanne's distortions, the effect of multiple viewpoints in Picasso's portraits is strikingly obvious and appears as a double image of the same face. The eyes and nose are drawn from different viewpoints as frontal and profile views merge. Interestingly, the fingers on the right hand

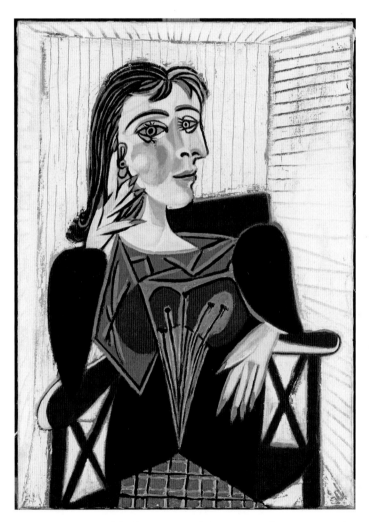

FIGURE 4.8 Picasso, Pablo (1881–1973), Portrait of Dora Maar (1937). Oil on canvas, 92 x 65 centimeters. © ARS, NY. Photo: Jean-Gilles Berizzi. Musee Picasso, Paris, France. Photo Credit: Réunion des Musées Nationaux / Art Resource, NY. (See color plate section.)

a real one would look to you. Thus, Van Gogh's style could not be based purely on the way he saw things, because if he had painted that way, his use of brightly colored paints would have appeared even brighter to him than what he would have perceived in a real scene. It is possible, but rather unlikely, that Van Gogh saw accentuated colors and halos and rendered his paintings the way he did, *with the knowledge* that individuals with normal perceptions perceived things differently. That is, he could have painted an *interpretation* of what he saw for people without his supposed afflictions. It is more likely, however, that Van Gogh perceived his paintings much as we perceive them, and his artwork is a product of his unique creativity.

From Van Gogh we turn to Cezanne who furthered the modernist approach of distorting spatial relations. We have already considered in chapter 3 the breakdown of form in his depictions of Mont Sainte-Victoire (Figure 3.8). In his still life paintings, such as *Still Life With Cherries and Peaches* (Figure 4.7), Cezanne distorted space by rendering multiple viewpoints in a single painting. Note that the bowl of cherries appears to be depicted from above, as its rim is hardly foreshortened. Yet the table and bowl of peaches are viewed from a lower angle. If this were a real scene, the cherries would have fallen out of the bowl and onto the floor! Many of Cezanne's still life paintings embody multiple

FIGURE 4.7 Cezanne, Paul (1839–1906), *Still Life With Cherries And Peaches* (1885–1887). Oil on canvas, 19 3/4 x 24 inches (50.165 x 60.96 centimeters). Gift of Adele R. Levy Fund, Inc., and Mr. and Mrs. Armand S. Deutsch (M.61.1). Los Angeles County Museum of Art, Los Angeles, CA. Photo Credit: Digital Image © 2009 Museum Associates / LACMA / Art Resource, NY. (See color plate section.)

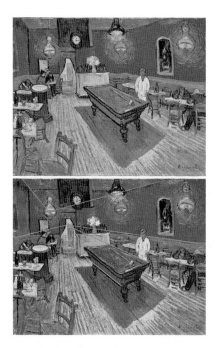

FIGURE 4.6 *Top*: Vincent Van Gogh, *Le café de nuit* (The Night Café). Yale University Art Gallery. Bequest of Stephen Carlton Clark, B. A. 1903. *Bottom*: Three different vanishing points based on receding lines. (See color plate section.)

was " … one of the ugliest I have ever done." The colors are stark and the disquieting nature of *The Night Café* is amplified by distortions in perspective. If one follows the receding lines that make up the room's ceiling, floor, and side panels, they actually lead to three different vanishing points, as opposed to one point as would be the case if one were viewing the actual room. The appearance of multiple viewpoints creates a distortion in the room's dimensions, which adds to the disturbing, unbalanced quality of the painting. It has been suggested that Van Gogh's unique style was caused by an impairment in visual perception. For instance, it has been stated that his extraordinarily bright colors, odd halos, and strangely proportioned objects was due to a mental disorder that caused sensory distortions. Van Gogh did suffer from hallucinations, paranoia, and mental instability that culminated in his suicide at the age of 37.

The conjecture that Van Gogh's unique style was caused by a sensory impairment cannot be true. If he had such afflictions and wanted to paint exactly what he saw, the resulting painting would look just like a realistic scene. Imagine if you had a sensory deficit that made straight lines look curved, so that a house or table looked rounded. If you were to paint a table that depicted the same impression as you see it, then you would draw it with straight lines. If you drew curved lines, then the table would look overly curved from the way

The debate about the significance of linear perspective in rendering realistic scenes comes down to the degree one presumes that perception is largely a bottom-up process or a top-down process. Those who argue for the natural correspondence between the optics of light and the method of linear perspective hold more to a bottom-up view in which information about spatial depth is assumed to be inherent in the projected image. Those who emphasize the role of knowledge in our ability to perceive pictures rely more on top-down processing.

In fact, pictures appear to embody two distinct representations,[11] and it is this dual nature that gives us the ability to appreciate them fully. First, we are rarely fooled that we are looking at a picture as opposed to the real world as its optical properties, such as its surface appearance and our own optical mechanics (accommodation, convergence, binocular stereopsis), define it as a 2-D surface. Yet pictures also represent natural scenes offering a realistic window to a different location. This dual reality actually facilitates our perception of pictures. When we look at pictures we can imagine ourselves at the viewpoint defined by them, perhaps imagining a mountain valley or waves crashing on a sandy beach. At the same time, we of course know that we are looking at a picture and we know that pictures are flat and can be seen at various angles. As I have emphasized, when we experience art we rely on bottom-up *and* top-down processes as both are critical in our perception of art.

Bending the Lines

We are accustomed to looking at pictures as mimicking the way we view natural scenes. Yet pictures do not have to conform to this kind of representation. In classic Egyptian art, we are given more than that which could be attained by a single viewpoint. Recall that in form perception we are best able to recognize objects if they are presented in their canonical or preferred viewpoint. Canonical views maximize distinctive features of objects. In Egyptian art, heads are portrayed in profile, a hallmark of the style, which allows for a fuller view of head shape, hair, and facial features. Yet, torsos are portrayed in a frontal view, which permits better detail of body shape, decorations, and garments. When canonical head and torso views are combined, we see the pictorial representation so common in Egyptian art. People often think Egyptian art is crude as it doesn't portray people in natural poses. However, it may not have been the intention of these ancient artists to depict objects in a natural, mimetic manner. Instead, they may have opted to maximize distinctive features, regardless of the naturalness of the depiction. In this way, these artists foreshadowed modern interpretations of space by bending the lines away from viewing scenes from a single, egocentric viewpoint.

In *The Night Café* (Figure 4.6), Van Gogh mixed color and space to create a rather disorienting scene. He wrote to his brother, Theo, that the painting

line is curved. To resolve these issues, Panofsky suggested that perspective in art should be viewed as a *symbolic form*, a term that carries a connotation that perspective is rather arbitrary or simply a convention that painters have developed to describe spatial depth.

Since Panofsky's essay, many have argued both for and against perspective as a symbolic form or representation.[9] Panofsky himself was not willing to go as far as to say that the method was purely arbitrary, though others have. For example, Nelson Goodman[10] seems to suggest that perspective is merely a symbolic reference of space. It is our knowledge that allows us to interpret how space is portrayed, and pictures become labels or metaphors of familiar scenes, settings, and locations. By Goodman's view, perspective is simply a set of instructions or symbols that tell us how to perceive pictures. Others rejected the notion of perspective as purely symbolic and affirmed the natural correspondence between the physics of the real world and the method of linear perspective. That is, linear perspective is not arbitrary, and realistic pictures must honor how light rays are projected onto a 2-D plane.

It is true, however, that linear perspective is only an approximation to these optical properties, and distortions, such as Mantegna's depiction of Christ's body, can enhance the aesthetics of a scene. If one truly described the optics in paintings as projected onto a picture plane, then all lines should be rendered with some miniscule amount of curvature, as we live on a sphere. Yet as these subtle exactitudes can be ignored for most pictorial scenes, linear perspective offers a simple and accurate approximation of how a 3-D world is projected onto a 2-D surface. Perhaps an analogy can be drawn between our use of linear perspective to define the visual world and the use of Newtonian physics to define rules of motion and force. Both mathematical systems are worthy rules that describe the way the real word operates, though both are approximations.

The fact that our visual perception starts with an image projected onto a curved retina is an interesting one, and it is true that straight lines projected onto this surface would appear curved. Yet these distortions are regular and predictable and our brains have transformed these distorted projections into a geometric mapping of the visual world with straight vertical and horizontal lines. This kind of re-mapping apparently occurs in the cortex, because neurons in the occipital cortex do respond most strongly to true horizontal and vertical lines. Indeed we are very sensitive to alterations from these cardinal axes as exemplified by our ability to detect a slightly crooked picture frame on the wall. Thus, although the image projected onto the retina may not conform exactly to the way light rays are projected onto a flat plane, the mind's image is consistent with a view comparable to looking at a flat 2-D picture plane. This transformation from the retina to the brain should not seem too outrageous once we remind ourselves that we see an upright world based on an image projected as upside-down and mirror-reversed.

FIGURE 4.5 *Left*: Mantegna, Andrea (1431–1506), *Dead Christ*. *Right*: Photograph of man in similar position. Reproduced from Ogden, R. M. (1938). *The Psychology of Art*. New York: Charles Scribner's Sons. Pinacoteca di Brera, Milan, Italy. Photo Credit: Nimatallah / Art Resource, NY.

beholder to take the same viewpoint as depicted by the painting—that is, to be situated with respect to scale at the same distance and elevation that matches the viewpoint if the painting were truly a window to the real scene. Yet even Leonardo violated his own suggestion, as shown by analyses of *The Last Supper*, which was painted on a wall 15 feet above the ground in a church in Milan. The vanishing point is placed at the center of the fresco, and thus, to match the viewpoint defined by the fresco, viewers would need to stand on a ladder.[7] Despite the mismatch between the viewpoint defined by the artist and the one taken by the beholder (i.e., standing on the ground looking up), one can still appreciate the exquisite spatial depth depicted in *The Last Supper*.

A Picture's Worth a Thousand Viewpoints

We are actually extremely flexible in the viewpoint we take as beholders. As we walk around in a museum gallery, our perception of a painting does not change drastically as we look at it from an oblique angle or even as we move by it. The ease with which we perceive realistic scenes in paintings suggests that the optical rules that define the viewpoint that the artist takes do not necessarily apply to the beholder's viewpoint. Erwin Panofsky, the eminent art historian, was cognizant of the special nature of perceiving pictures. He wrote a provocative essay entitled *Perspective as Symbolic Form*,[8] in which he described the evolution of linear perspective and initiated a debate that has yet to be fully resolved about the role of perspective in pictures. Panofsky began by questioning whether linear perspective defines the way we actually perceive the real world. Realistic paintings do present a single viewpoint described by a specific angle of view. Yet the retina itself is actually curved, and thus even at the beginning of sensory input, the raw image violates linear perspective because *every*

depicted on the picture plane. Thus, ambiguities can occur because a change in height may mean that an object is either elevated or farther away. Typically, we don't have much confusion as we are familiar with the size of objects and where they tend to be located in a scene. For example, we know that people are generally the same height, so if one is depicted as much smaller, we perceive the person as being farther away. Another quirk of perspective is the ambiguity in perceiving right-angled corners when viewed in depth. In our perspective sketch, the square tiles recede to a central vanishing point and are thus drawn as trapezoids. Even though the tiles are drawn this way, we *know* they are square and only look angled because they recede in depth. Many works by M. C. Escher as well as William Hogarth's engraving entitled *Satire on False Perspective* illustrate the ambiguities associated with perceiving differences in height versus distance and rectangles versus trapezoids.

The problem of depicting objects in space in a realistic manner is difficult enough to have many instructional how-to manuals published over the centuries. Our simple sketch of a room in one-point perspective is only the beginning of depicting objects in scenes. For example, if the viewpoint were from a corner of our room, then the floor tiles would look like distorted diamonds, similar to those depicted in Vermeer's painting in chapter 2 (Figure 2.4). To depict this viewpoint accurately, the tiles would have to be drawn with two sets of receding lines to two different vanishing points—or two-point perspective. Even more difficult is the way curved objects, such as parts of the body, recede in depth. Many early how-to manuals included illustrations of full figures, heads, and other body parts shown in various orientations and degrees of foreshortening. Leonardo was a master at depicting accurate geometric proportions of body parts as he carefully studied anatomy and learned how curved shapes appear from various viewpoints.

An interesting case of intentionally violating the rules of foreshortening is Andres Mantegna's *The Lamentation over the Dead Christ* (Figure 4.5 (left panel). In this exquisite painting, Christ is portrayed at a close viewpoint with his body extending in depth. Figure 4.5 (right panel) shows a photograph of a person in a similar position.[6] Note that Mantegna, though well trained in the geometry of linear perspective, veered from a true rendering of Christ's body. Compared to a what an actual reclining body would look like, Christ's head is too large, his feet are too small, and the legs are not correctly elongated. This intentional straying from the mathematical precision of linear perspective accentuates the painting's dramatic expression.

■ Spatial Considerations

To depict an egocentric viewpoint, artists learned how to construct a representation of real space onto a picture plane. As we have shown, many artists, including Leonardo, Brunelleschi, and Masaccio, seemed to encourage the

that the viewpoint is 6 feet above the ground (eye level) and the viewer is stand-ing 10 feet from the picture plane (PP). Thus, in an elevation view of our room drawn to scale, the height of the viewpoint will be 3 inches above the ground line and the distance from the viewer to the picture plane will be 5 inches. To sketch this viewpoint, take a full notebook page in landscape orientation and make a tick mark 3 inches above the bottom left corner. This point marks the position of the eye of the viewer. Starting at that bottom left corner, move 5 inches along the bottom and draw a 6-inch vertical line. This line represents a side view of our picture plane. Now make five tick marks at 1-inch intervals along the bottom edge to the right of the picture plane. These marks define each row of our floor tiles as they recede in depth from the viewer. Now draw lines from the viewpoint to each of the receding tick marks (see Figure 4.4b).

As shown in the elevation sketch, the lines to the viewpoint represent light rays projected from the edge of each row of floor tiles to the eye. Note that each line crosses the picture plane at a higher point. Note also that the vertical dis-tance between these lines diminishes as they move up the picture plane. Alberti instructed artists to use the elevation sketch to measure on the picture plane the height of each line from the base. In our sketch, these heights are precisely 0.55 inches, 1.0 inch, 1.38 inches, 1.71 inches, 2.0 inches and 2.25 inches. Now on your original drawing, draw horizontal lines above the ground at each of these heights (see Figure 4.4c). You have now calculated geometrically the six rows of square tiles as foreshortened by true linear perspective. In Figure 4.4d, the lines that extend outside the floor have been erased, and tiles are colored in checkerboard fashion. In Figure 4.4e, the tiled grid was duplicated and rotated to make side walls and a ceiling. These grids can now be used as guidelines to depict to scale the height of objects in the scene.

Alberti's method employed one-point perspective, in which a single van-ishing point defines the lines that recede in depth. As illustrated in our sketch, this vanishing point represents the point in space at which the viewer's eye is fixated. If we actually built a 12 foot by 12 foot by 12 foot room with 2-foot square checkerboard tiles and then looked at it from 10 feet away at an eleva-tion of 6 feet, the image on our retina would match very close to our drawing when placed 5 inches away from us. That is, the method of linear perspective acts to match almost exactly the geometry of light rays reflected off real objects in a 3-D environment. As with Leonardo's window and Brunelleschi's panel, our drawing mimics a specific viewpoint that corresponds in scale to a view-point taken by someone viewing the actual room. This specificity in matching viewpoints is important for many trompe-l'oeil works as well as with the kind of seventeenth century Dutch paintings described in chapter 2.

The Problem of Foreshortening

With our sketch we see how space is compressed or foreshortened as objects recede in depth. The further objects are from the viewer, the higher they are

Linear Perspective for Dummies

In *Della pictura,* Alberti described the geometry of linear perspective by show-
ing how to draw a tiled room in one-point linear perspective. To gain a bet-
ter understanding of the mathematics involved in this method, we will do the
same. With a piece of notebook paper, ruler, and pencil, draw a 6-inch by 6-inch
square, which will define a picture plane. Along the bottom of the square, place
tic marks at 1-inch intervals. These points define the width or edge of the room
tiles as projected onto the picture plane. Let's assume that the tiles in real life
are 2 feet square, and thus the scale of our drawing is 1 inch equals 2 feet. Draw
a horizontal line that splits the square in half, and place a tic mark at the mid-
point of the line. This line is the "horizon line," and the midpoint of that line
will be defined as our vanishing point (VP). Now draw lines from the vanish-
ing point to each of the floor tile marks. These lines define the side edges of the
floor tiles as they recede in depth (see Figure 4.4a).

Just as architects construct sketches of a building from many angles, art-
ists must consider multiple views in order to draw objects to scale. An eleva-
tion or side view of a scene shows the viewpoint's elevation or height from the
ground (H) and distance from the picture plane (D). It also shows the angle of
light rays from the viewpoint to various objects in the scene. We will assume

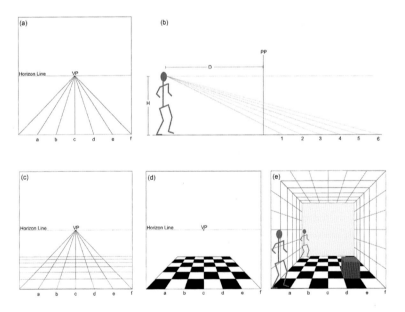

FIGURE 4.4 Constructing a tiled room using linear perspective:
(*a*) Draw receding lines to vanishing point (VP); (*b*) With elevation view,
draw lines from eye level (H) and distance (D) to edges of tiles and note
heights of eye lines on picture plane (PP); (*c*) Draw horizontal lines at
heights of eye lines; (*d*) Remove lines extending outside of floor and color
tile; (*e*) Duplicate floor pattern on walls and ceiling to define room depth.

on which the two people are kneeling. In the Santa Maria Novella church in Florence where this fresco is located, the vanishing point is at eye level at about 1.8 meters (5 feet, 11 inches) from the ground. As the application of linear perspective requires geometric precision, artists often drew guidelines to the vanishing point to sketch out a scene. There is evidence that Masaccio prepared his fresco by anchoring ropes to the vanishing point and stringing them tautly along critical receding lines. By lifting the ropes and snapping them onto the wet plaster, he would create straight lines to the vanishing point, such as the ones that define the vaulted ceiling. Remnants of anchor points and guidelines are still visible on the church wall.

Prior to Brunelleschi and Alberti's discovery, artists had difficulty creating realistic scenes. Medieval works often depict spatial relationships awkwardly, as receding lines do not appear to converge correctly to a vanishing point. As an example, the thirteenth century fresco in Figure 4.3 shows a semblance of spatial depth, as the houses in the background are small and appear to have 3-D shape. Yet the houses are oddly placed as there is no single vanishing point. Such pre-Renaissance works often appear compressed, as if everyone is situated at the same distance from the viewer. Also, limited use of shading often creates a flattened, comic book appearance. As one strolls through an art museum's Medieval and Renaissance galleries, one can witness the evolution of how artists learned to create realistic 3-D scenes on a flat surface.

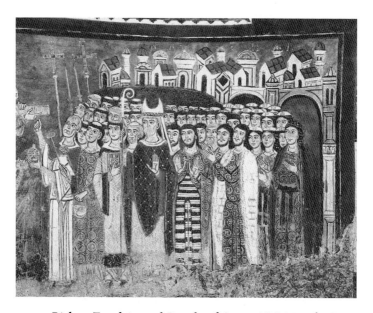

FIGURE 4.3 *Bishop Zaudria and People of Anagni Waiting for Restitution of Remains of St. Magnus.* Fresco detail from the crypt. Photo: A. Dagli Orti. Duomo, Anagni (Lazio), Italy. Photo Credit: © DeA Picture Library / Art Resource, NY.

There is no existing evidence of Brunelleschi's panel and no other documents that described his method of painting as involving mathematical precision.

With no confirming evidence of Brunelleschi's method, most attribute Alberti's book *Della pictura*[5] (*On Painting*) as the first geometric description of linear perspective. Written in 1436, Alberti offered rules for artists that showed how they could create scenes with accurate linear perspective. Some artists had already discovered these rules, most likely from Brunelleschi, though Alberti was the first to provide a how-to book on the technique. He described how light rays project onto the eye, how the picture plane is akin to looking through a window, and how shading can enhance the portrayal of depth. As an exercise, he demonstrated how to draw a room using the geometry of linear perspective. In his introduction, he gave noteworthy praise to Brunelleschi for fostering the ideas and dedicated the volume to him.

Masaccio's *Holy Trinity* (Figure 4.2) is considered the earliest existing example of linear perspective in art. It is believed that Masaccio learned the method from his friend Brunelleschi. In the painting, spatial depth is depicted in precise perspective, as if one were looking up at the real scene. Even the two circular medallions at the upper corners are slightly foreshortened (oval shaped) as they would appear if one were looking up at the scene. As defined by the receding lines of the vaulted ceiling, the vanishing point is situated at the level of the step

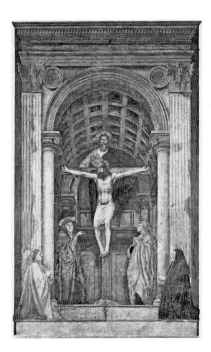

FIGURE 4.2 Massacio (Maso di San Giovanni) (1401–1428), *Holy Trinity* (*c*. 1425). Fresco. S. Maria Novella, Florence, Italy. Photo Credit: Alinari / Art Resource, NY.

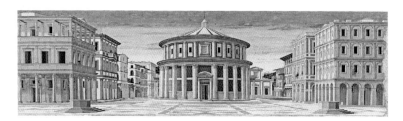

FIGURE 4.1 Piero della Francesca (*c.*1420–1492), *The Ideal City, named the City of God.* Galleria Nazionale delle Marche, Urbino, Italy. Photo Credit: Erich Lessing / Art Resource, NY. (See also note 2.)

■ The Geometry of Space

Painting realistic scenes requires knowledge about the way light rays reflect off objects and enter our eyes. This knowledge was known as early as the fourth century BC when Euclid described mathematical principles of how light is projected onto the retina.[3] His analysis formed the basis for the geometry of linear perspective, which gave Renaissance artists the method for depicting realistic 3-D scenes onto 2-D surfaces.

A Florentine Discovery

In the fifteenth century, two architects, Filippo Brunelleschi and Leon Battista Alberti, developed the geometry of linear perspective for artists. It is perhaps not surprising that architects would figure out how to create a scene on canvas, as their occupation demands precision in all three spatial dimensions. Brunelleschi is best known for designing the immense dome of the cathedral in Florence. His biographer, Antonio di Tuccio Manetti, an architect himself, related a story about Brunelleschi's discovery.[4] Brunelleschi took a 12-inch square panel and painted in precise linear perspective the Baptistery, which is the octagonal building next to the cathedral. He then asked an individual to stand outside the cathedral and, while facing the Baptistery, he placed the backside of the panel in front of the person and instructed the viewer to look through a peephole on the backside, which was positioned at the vanishing point of the painted scene. At the same time, Brunelleschi held a mirror in front of the canvas so that the viewer saw the painting of the Baptistery as reflected in the mirror in the same perspective, as if the viewer was looking at the building itself. The illusion of 3-D was so convincing, according to Manetti, that viewers felt they were looking at the actual building. The setup was clever, as the illusion was enhanced by using a peephole, which reduced accommodation cues for depth (i.e., pupil size), and a mirror, which increased the distance between the viewer and the panel, thus reducing convergence cues (i.e., eye rotation). The mirror may also have mimicked the appearance of looking through a glass window.

4. MAKING A SCENE

The Ideal City (Figure 4.1) is a testament to mathematical precision in art.[1] This Renaissance painting depicts a cityscape in accurate linear perspective. The rendering of depth is so precise that from this painting one could construct an actual 3-D model of the buildings. To build such a model accurately, it is necessary to determine (1) the distance from the viewer to the *picture plane*, which is the imaginary window in front of the viewer onto which the scene is projected, (2) the elevation of the viewpoint from the ground, and (3) the dimensions of the buildings in the model with respect to the scale presented in the painting. Two computer scientists established these reference points and constructed a virtual 3-D model of the scene as depicted.[2] With the computer model, one can take a virtual stroll around the plaza and view the scene from different vantage points. Interestingly, art historians have described the painting as an individual's view of the city. Yet according to calculations of the elevation, to see the scene from this perspective you'd have to have be over 10 feet tall!

How does the brain construct a realistic scene? In the previous chapter, object recognition was identified as an essential product of visual processing. In this chapter, we consider how objects are situated within a spatial environment. Scientists refer to two different ways of representing spatial relationships. An *egocentric* or first-person perspective defines objects in relation to the viewer. Google street views (and the view depicted in Figure 4.1) are examples of egocentric perspectives. An *allocentric* or third-person perspective defines objects in relation to each other in a map-like manner, such as the topographical views found on Google Earth. The primary focus of this chapter is egocentric space and how artists (and brains) create realistic first-person views of the world.

22 Newhall, N. (Ed.). (1927). *The Daybooks of Edward Weston, Vol. 2* (p. 32). New York: Aperture, Inc.

23 Loran, E. (1963). *Cezanne's Composition*. Berkeley: University of California Press.

24 Wiesmann, M., & Ishai, A. (2010). Training facilitates object recognition in Cubist paintings. *Frontiers of Human Neuroscience, 2*, 11.

S. E., & Rock, I. (1994). Rethinking perceptual organization: The role of uniform connectedness. *Psychonomic Bulletin & Review, 1*, 29–55.

8 Biderman, I. (1987). Recognition-by-components: A theory of human image understanding. *Psychological Review, 94*, 115–147.

9 Bar, M. (2003) A cortical mechanism for triggering top-down facilitation in visual object recognition. *Journal of Cognitive Neuroscience, 15*, 600–609.

10 Further information on computer vision can be found in Mori, G., & Malik, J. (2006). Recovering 3D human body configuration using shape context. *IEEE Transactions on Pattern Analysis and Machine Intelligence, 28*, 1052–1062. Szeliski, R. (2010). *Computer Vision: Algorithms and Applications.* New York: Springer.

11 Galleguillos, C., & Belongie, S. (2010). Context based object categorization: A critical survey. *Computer Vision and Image Understanding, 114*, 712–722. Jones, M. J., Sinha, P., Vetter, T., & Poggio, T. (1997). Top-down learning of low-level vision tasks. *Current Biology, 7*, 991–994.

12 Tootell, R. B., Hadjikhani, N. K., Mendola, J. D., Marrett, S., & Dale, A. M. (1998) From retinotopy to recognition: fMRI in human visual cortex, *Trends in Cognitive Science, 2*, 174–183.

13 Hubel, D. H., & Weisel, T. N. (1962), Receptive fields, binocular interaction, and functional architecture in the cat's visual cortex, *Journal of Physiology, 160*, 106–154.

14 Malach, R., Reppas, J. B., Benson, R. R., Kwong, K. K., Jiang, H., Kennedy, W. A., Ledden, Brady, T. J., Rosen, B. R., & Tootell, R. B. H. (1995). Object-related activity revealed by functional magnetic resonance imaging in human occipital cortex. *Proceedings of the National Academy of Sciences, 92*, 8135–8139.

15 Grill-Spector, K., Kourtzi, Z., & Kanwisher, N. (2001), The lateral occipital complex and its role in object recognition. *Vision Research, 41*, 1409–1422.

16 Ryan, T. A., & Schwartz, C. B. (1956). Speed of perception as a function of mode of representation. *The American Journal of Psychology, 69*, 60–69.

17 Palmer, S. E., Rosch, E., & Chase, P. (1981). Canonical perspective and the perception of objects. In J. Long and A. Baddeley (Eds.), *Attention and performance IX* (pp. 135–151). Hillsdale, NJ: Erlbaum).

18 For further details, see Ramachandran, V. S. (1988). Perceiving shape from shading. *Scientific American, 256*, 76–83.

19 Taira, M., Nose, I., Inoue, K., & Tsutsui, K. (2001), Cortical areas related to attention to 3D surface structure based on shading: An fMRI study. *NeuroImage, 14*, 949–966.

20 O'Craven, K. M., Downing, P. E., & Kanwisher, N. (1999). fMRI evidence for objects as the units of attentional selection. *Nature, 401*, 584–587.

21 Haxby, J. V., Gobbini, M. I., Furey, M. L., Ishai, A., Shouten, J. L., & Pietrini. P. (2001). Distributed and overlapping representations of faces and objects in ventral temporal cortex. *Science, 293*, 2425–2430.

FIGURE 3.10 Adams, Ansel, *Frozen Lake and Cliffs* (1932). Photograph ©
2010 The Ansel Adams Publishing Rights Trust.

of stimuli that activate neurons at the initial stage of visual processing (i.e., V1)
in the occipital cortex.

■ Notes

1 Gombrich (1960). *(See chapter 1, n. 25.)*
2 Todd, J. (2004). The visual perception of 3D shape, *Trend in Cognitive Science*,
 8, 115–121.
3 This and other artworks by Roger Shepard can be found in Shepard, R. M.
 (1990). *Mind Sights*. San Francisco: W. H. Freeman Press.
4 Artworks that play on figure-ground segregation include Dali's *Slave Market
 with the Disappearing Bust of Voltaire*, Escher's *Sun and Moon*, and Magritte's
 Carte Blanche.
5 Kanizsa G., & Gerbino W. (1976). Convexity and symmetry in figure-ground
 organization. In M. Henle (Ed.),*Vision and Artifact* (pp. 25–32). New York:
 Springer. Peterson, M. A., Harvey, E. M., & Weidenbacher, H. (1991). Shape
 recognition contributions to figure-ground organization: Which routes count?
 Journal of Experimental Psychology: Human Perception & Performance, 17,
 1075–1089
6 Oliva, A., & Torralba, A. (2007). The role of context in object recognition.
 Trend in Cognitive Science, 11, 520–527.
7 For further analysis of Gestalt principles, see Lowe, D. G.(1985). *Perceptual
 Organization and Visual Recognition*. Boston: Kluwer Academics. Palmer,

the context of meta-art, *Onement III* represents a bold statement of what art can be. Gone is any sense of 3-D representation, and even the stripe, which could be considered the lone object in the painting, is minimized. Further experiments by Newman, as with his almost completely black painting, *Prometheus Bound*, showed that art can be devoid of essentially all representations of form.

Newman and other "color field" compatriots, such as Ad Rhinehardt and Mark Rothko, anticipated Minimalism, the art movement forwarded in the latter half of the twentieth century. Minimalism broadened the concept of a "painting." As represented by the works of Frank Stella, Agnes Martin, and Sol LeWitt, Minimalism focused on the supreme flatness of canvases. Even the paint's surface appeared smooth with light hues appearing as subtle tints. Some paintings, such as Anges Martin's almost completely white canvases, suggested a representation of nothingness. Although visually sparse, these paintings extended art's boundaries and represent perhaps a limit as to what a 2-D canvas can represent, which is itself.

■ Form and Function

In mimetic art, just as in brain processes, the illusion of form is created by turning a 2-D image into recognizable 3-D objects. For centuries, artistic skill was measured by how well one could perform this feat. As later artists strayed from the depiction of realistic forms, they disassembled the manufacturing stages of object recognition. Consider Ansel Adams's *Frozen Lake and Cliffs, The Sierra Nevada, Sequoia National Park, California.* (Figure 3.10). Interestingly, this photograph is one of a natural landscape, though it is rendered in a way that flattens the perspective. The objects in the scene—the cliff, snow, and water—appear almost as abstract forms and patterns. I suggest that Adams did not want us to engage in object recognition and thus acknowledge that the scene depicts a beautiful scenery, such as in Church's *Twilight in the Wilderness* (Figure 2.1). Instead, the photographer invites us to take a formalist approach and appreciate the forms and patterns as abstract features that give the image "significant form."

During the twentieth century, we have witnessed in art the breakdown of object recognition. Cezanne, Picasso, and Braque suspended this process at the level of basic 3-D building blocks, such as those described by geon theory. Kandinsky, Malevich, and Newman flattened space by reducing forms to 2-D shapes, lines, and colors. When we consider these artworks we seem to have stopped processing at the level of the LOC, where neurons respond to object-like forms but do not distinguish between recognizable and abstract shapes. Finally, in Minimalism we see the entire dissolution of form on canvas. These canvases are reduced to light tracings, soft hues, and subtle textures, which are the kinds

FIGURE 3.9 Malevich, Kazimir (1878–1935), *Suprematism*, (*c.* 1917). Oil on canvas, 80 × 80 centimeters. Museum of Fine Arts, Krassnodar, Russia. Photo Credit: Erich Lessing / Art Resource, NY. (See color plate section.)

shapes are arranged so precisely that one could accurately reproduce the image with cutout pieces of colored paper laid on top of one another. Thus, although the objects are reduced to flat 2-D shapes, they still maintain the appearance of being depicted in a realistic spatial environment.

Minimally Flat

Clement Greenberg encouraged modernist artists to break away from the illusion of space on canvas. By Greenberg's standards, even Malevich's *Suprematism,* with its layered shapes, could be considered not flat enough. By the mid-twentieth century, artists took Greenberg's notion to heart and stripped painting down to its fundamental features, lines and colors. Various examples can be found in modern art museums. For example, in Barnett Newman's *Onement III* we are given a lonely vertical line in the middle of the canvas. There is minimal reference to spatial depth as the line extends fully from top to bottom. As a result, there isn't even a sense of a completed object, only a line that appears to extend vertically forever.

Visually sparse works, such as *Onement III*, when considered from a formalist approach, could barely be viewed as examples of stunning significant form. One might sense the stark beauty of this isolated stripe in the middle of a vast monochromatic canvas, but this feeling may be driven more by symbolic reference than significant form. On the other hand, some might suggest this work be placed in the category of "my-kid-could-paint-that" art. Yet, in

FIGURE 3.8 Braque, Georges (1882–1963), *Les Usines du Rio-Tinto à L'Estaque* (The Factories of Rio Tinto at L'Estaque) (1910), © ARS, NY. Oil on canvas, 65 × 54 centimeters. Musee National d'Art Moderne, Centre Georges Pompidou, Paris, France. Photo Credit: CNAC/MNAM/ Dist. Réunion des Musées Nationaux / Art Resource, NY.

amorphous clouds in the sky, brain regions along the ventral visual pathway important for object recognition are activated.[24]

The artistic experiments by Cezanne, Picasso, and Braque force us to decompose scenes and reverse the process of manufacturing 3-D forms. Cubism offers a world built with primitive, geon-like building blocks. By withholding the complete rendering of real-world objects, we see how forms are put together. Other twentieth century artists halted the process even earlier by dissolving 3-D forms into more abstract renderings of color and shapes. In Kandinsky's *Composition IV* (see book cover), colors, shapes, and lines are displayed in a dazzling abstract array. Yet there still appears to be a semblance of spatial depth, as colors act as shading and some forms appear occluded by others. Thus, Kandinsky furthers the Cubist movement toward the breakdown of space, though there are still hints of a 3-D world.

In Kasimir Malevich's *Suprematism*, we are offered geometric shapes devoid of shading or perspective (Figure 3.9). Interestingly, we can still define a spatial arrangement of shapes as the forms exhibit figure-ground segregation through occlusion. Notice that the shapes appear to lie on top of one another. For example, we perceive the circular shape as placed underneath the others. In fact, the

A Cubist World

The straying from realism and the breakdown of recognizable objects began with Manet and the Impressionists and continued with Post-Impressionists, such as Cezanne and van Gogh. Cezanne experimented with form in his many renditions of Mont Sainte-Victoire, the imposing mountain ridge in the south of France. Near the end of his life, he rendered objects in the scene as basic geometric forms, as seen in his 1906 painting (Figure 3.7). Houses are reduced to cubes and trees are depicted simply as brushstrokes. Cezanne stated that he wanted to treat "nature by the cylinder, the sphere, and the cone."[23] In Cezanne's work, we see the rendering of objects as abstracted forms, though he placed them within the context of a recognizable land-scape scene.

In Cubism, Picasso and Braque furthered Cezanne's studies by depict-ing the entire world as bits and pieces of primitive forms. Consider Braque's *Les Usines du Rio-Tinto à L'Estaque* (Figure 3.8), which by its title is presumed to portray factories in the town of L'Estaque, a small village in the south of France. The entire scene has been reduced to basic geometric forms. There is still the representation of 3-D structure and spatial depth, as indicated by shad-ing and angular perspective. The painting, however, is so abstracted that any semblance of a recognizable scene is lost. Interestingly, when individuals look for recognizable objects in Cubist paintings, just as we might do with seemingly

FIGURE 3.7 Cezanne, Paul, (1839–1906), Mont Sainte-Victoire (*c.* 1902–1906). Oil on canvas, 22 1/2 × 38 1/4 inches (57.2 × 97.2 cen-timeters). The Walter H. and Leonore Annenberg Collection, gift of Walter H. and Leonore Annenberg, 1994, bequest of Walter H. Annen-berg, 2002 (1994.420). The Metropolitan Museum of Art, New York. Photo Credit: Image copyright © The Metropolitan Museum of Art / Art Resource, NY. (See color plate section.)

Anonymous Forms

The analysis of form for form's sake became a mainstay for twentieth century artists. A particularly compelling medium to explore formalism is photography, because photography can perfectly depict real objects in natural scenes. Whereas a painter chooses what lines, colors, and forms to place on canvas, the formalist photographer begins with familiar objects and chooses a viewpoint that forces us to consider their sensory qualities. Early twentieth century "formalist" photographers, such as Edward Weston (Figure 1.5 in chapter 1), Imogen Cunningham, and Paul Strand, created images of ordinary objects, such as shells, fruits, and bowls, and turned them into sensual abstractions. These photographs were clearly not taken for the purpose of conveying the meaning of shells, fruits, and bowls. Our brains want to manufacture and recognize these forms as objects, but to appreciate such artwork fully, it seems that the artist is asking us to suspend this process and focus on the visual design of the image.

In painting, Georgia O'Keefe exemplifies the formalist credo of beauty in significant form. Regardless of the object, in many cases close-ups of flowers, O'Keefe's style is a graceful rendering of colors, lines, and forms. Interestingly, many perceive references to erotic symbolism, yet O'Keefe denied any intention of such sexual overtones in her paintings. Similarly, Edward Weston was accused of sexual symbolism in his photographs of shells, yet he too denied such suggestions and stated in his published diaries, "For I can say with absolute honesty that not once while working with the shells did I have any physical reaction to them; nor did I try to record erotic symbolism."[22] Of course, one could offer a Freudian commentary about unconscious sexual intentions in their artworks. I would suggest that their images have an organic quality that could be considered sexual and certainly sensual in nature. For example, the curvature of their forms are similar to the curves and contours of a nude body. In any event, in order to appreciate such artworks from a formalist approach, it is best to consider the forms as nameless abstractions.

Even today formal qualities are important features of art. Many contemporary artists are still concerned with sensual abstractions. Yet many art experts these days have rejected a formalist approach, because early proponents of this view, such as Clement Greenberg and Clive Bell, considered it the *one and only way* to experience art, thus completely rejecting the content or nature of the objects represented. Clearly, the ideas and feelings conveyed by objects and scenes depicted in artworks must also drive our art experience. Yet adopting a formalist approach and acknowledging the aesthetic appeal of abstract forms does not necessarily mean one has to deny the fact that we gain from a conceptual or expressionist approach at the same time. Considering the I-SKE framework, we can appreciate that there are multiple ways to approach an artwork.

configural or holistic properties, such as the fixed positions of the eyes, nose, and mouth on faces, so that even a simple line drawing of a happy face or the ambiguous Sara Nader (Figure 3.3a) can be recognized easily. Interestingly, in neuroimaging studies, the fusiform gyrus, an area in the ventral path is particularly responsive to faces compared to other objects.[20] Other areas along the ventral path respond to other objects.[21]

Damage along the ventral path causes deficits in object recognition, a disorder known as *visual agnosia*. Patients with visual agnosia have normal acuity and can even read text. Moreover, they can copy and reproduce line drawings as well as you or I. What these patients cannot do is *recognize* what they have just drawn. In fact, when they draw, it is as if they are copying an abstract form. For example, if you were to copy a drawing of a face, you would likely draw the overall shape and then focus on critical features, such as the eyes, nose and mouth. An agnosia patient does not distinguish essential features from less relevant ones (e. g., eyebrows, wrinkles) and would simply copy lines without any reference to what is being drawn. Their disorder is restricted to the visual modality, as they can recognize objects by touch or sound. It is as if these patients have lost the ability to assign meaning to visual forms. Our brains are geared to attach meaning to forms, and in some respects, this ability is almost too efficient. Consider our desire to see meaningful objects in cloud patterns and abstract paintings.

All through the manufacturing of objects, there is a dynamic interplay between bottom-up and top-down processes. Even early visual processes are facilitated by the use of prior knowledge, which helps us make predictions or inferences about what to expect to see in a visual scene. Thus, we must keep in mind the importance of knowledge in our ability to recognize forms, just as we must keep in mind its importance in experiencing art.

■ Abstracting Forms

From the Renaissance through most of the nineteenth century, artists were praised for their skill in depicting realistic renderings of a 3-D world onto a flat canvas. The aesthetic appeal of mimetic art was, and still is, the ability of an artist to depict a realistic scene. In a formalist approach, however, we disregard whatever objects are represented and instead appreciate form for form's sake. Clive Bell, in his formalist manifesto, *Art*, went so far as to state that the sensory quality of an artwork (i.e., its significant form) should be the *only* basis for aesthetic experiences. Thus, in one sense the goal of a formalist approach is just the reverse of what our brains are built to do. Instead of manufacturing lines, colors, and shadings for the purpose of creating meaningful objects, a formalist approach takes objects and disassembles them into more primitive descriptions of abstract forms composed of lines, colors, and shadings.

dorsal pathway that analyzes low spatial frequencies and gives us a sense of spatial depth. Some regions in the ventral pathway were also active, suggesting that information about shape from shading interacts with regions involved in high spatial frequency analyses of object recognition.

Shading offers subtle yet detailed information about objects, including information about the texture and pliability of surfaces. Shiny surfaces are seen as sharp highlights, because they reflect more direct light to the eye than rough surfaces. Rough or pliable material like dirt or fabric disperse light in many directions and thus are seen as smoother transitions of light and dark. Leonardo described his technique of gradual changes in shading as *sfumato*, the Italian term for smoky. He applied *sfumato* by painting multiple overlays of blended colors so that a smooth transition of shading was produced. In many of his paintings, including the *Mona Lisa*, Leonardo applied coats of translucent oils to create very subtle transitions of shading.

Dramatic use of shading as defined by expressive chiaroscuro creates a scene laden with emotional tension. Caravaggio, the Baroque painter known for his gritty portrayals of biblical scenes, developed an expressionist style in which shadings and shadows play a significant role. His style anticipates later cinematic techniques, as in the stark shadows used in German expressionist films and later in American film noir. As demonstrated by recent animated films, computer graphic programs can model shape from shading with incredible precision. What is required is an exact model of the 3-D world in which the characters and other objects are defined mathematically with precise information about the location of objects and light sources. With such a model, these programs calculate how light would reflect off objects and be detected from a specific viewpoint, which involves knowledge about angles of reflection and the surface properties of objects (e.g., whether they are shiny or rough). Such computer-generated worlds begin with a version similar to the polygon mesh of the hand depicted in Figure 3.5b. By rendering texture, shading, and coloring, present-day animators can create computer-generated scenes that give a remarkable impression of realism. Such processing takes massive amounts of computations, which our brains accomplish with rapid and unconscious abandon.

Recognizing Forms

The end point of form perception is the ability to recognize familiar objects. Up to this point, visual processes have been described that segregate figures from backgrounds, that group parts that belong to the same object, that outline edges and shapes of forms, and that enhance shapes through shading. How do we impart meaning onto these manufactured forms so we can recognize everyday objects in our environment? Our understanding of this final process is limited, though scientists have uncovered important clues. Of course top-down processing plays a critical role. For example, we base object recognition on

FIGURE 3.6 Crater-mound illusion. When viewed upside-down, the crater turns into a mound.

an area where the sun is occluded. Yet when the same photograph is viewed upside-down (bottom photograph), the crater becomes a mound. It is the shading and highlights that define what we see as the object. Our brains perceive forms by applying our knowledge about lighting and shadows. We know that a light source comes from above, as it always does in nature. Thus, when we look at the bottom photograph, we don't see an upside-down crater because we assume the sun as the light source and perceive the lighter areas on top of the "mound" and on left side as being caused by sunlight hitting a raised surface. Our brains automatically apply this knowledge and it defines the entire spatial layout of the scene.[18]

The perception of shape from shading relies on smooth transitions of light and dark. Thus, it is low spatial frequencies that contribute to this perception. In an fMRI study, individuals determined whether the front surface of a form appeared to be protruding out or in, as defined only by shading.[19] Brain responses to shading were observed along the dorsal visual pathway, beginning in the LOC and extending into the parietal cortex. You may recall that it is the

a hand is represented by a *polygon mesh*. When these polygon tiles are made smaller and smaller they more closely approximate curved surfaces. The creation of such wire frames helps to conceptualize and simplify the way 3-D forms appear from a specific viewpoint.

When an object moves or when we move, the image on our retina changes considerably, though we still perceive a stable visual world. Our ability to maintain a constant percept is so immediate and unconsciously driven, we don't appreciate what an enormous computational feat it is. Moreover, we don't fully understand how it is done. Some psychological theories, including geon theory, suggest that we recognize objects by picking out their distinctive features. Other theories depend more on applying top-down knowledge to aid in this analysis. That is, we expect heads to be attached to bodies and faces to include eyes, a nose, and a mouth, so even if we see the rough outline of person, we know enough about its structure to make a quick identification. As long as we can detect enough distinctive features, we should be able to recognize objects from various viewpoints.

Nevertheless, we are influenced by viewpoints, as shown by a psychological experiment in which individuals saw photographs of common objects shown from different angles.[17] Subjects generally agreed on a preferred or canonical viewpoint. For example, a frontal view was preferred for a clock, a telephone, and a house, whereas a slightly angled view was preferred for a horse. For other objects, such as a face, a car, and a chair, subjects preferred an even greater angle of rotation. When other individuals were shown these objects and asked to identify them as quickly as possible, reactions times were fastest when they were presented in the preferred view. Two factors appear to drive these effects. First, preferred views tend to be ones that are more frequently observed, and thus stored more strongly in memory. Second, preferred views tend to best show distinctive features of an object.

Shape from Shading

As described in chapter 1, *chiaroscuro* is the term used by artists to describe the realistic portrayal of objects through subtle application of shading and highlights. This technique defines the smooth transitions of light as it reflects off objects. *Shape from shading* is the term used by psychologists and computer scientists to refer to the same process. Shading gives a form its sense of depth by accentuating 3-D contours. Look again at Leonardo's sketch of a woman's head (Figure 1.3 in chapter 1). Note how the rendering of shading gives form to the face and a subtle sense of depth. Without such rendering of shape with shading, the form would look like a simple cartoon, flat and without texture.

In rendering a spatial world, both artists and brains must define 3-D forms with shading. Consider the top photograph in Figure 3.6, which is easily perceived as a crater, as the dark shading on the left side of the rim defines

shown each version briefly and asked to mimic the hand position. Stylized cartoons were as effective as photographs in performing the task. Indeed, cartoons were often better recognized than the more accurately rendered line drawings, which demonstrates the ease of identifying caricatures.

Interpreting 3-D forms from 2-D images requires knowledge about the way objects appear from various viewpoints. Our brains easily recognize objects from many viewpoints even though the retinal image may be drastically different from moment to moment. For artists, the accurate depiction of 3-D objects requires knowledge about the geometry of space, a topic discussed more fully in the next chapter. With respect to forming forms, it is essential to understand how 3-D shapes change when they are projected onto a 2-D surface. Consider the exquisite drawing of a chalice (Figure 3.5a) by the Renaissance artist, Paolo Uccello, who was described by the historian Vasari as being "intoxicated" by the geometry of perspective. Note how the 3-D rendering of shape is characterized by small tile-like polygons that are put together to give the impression of curved surfaces.

These days computer graphic programs apply a similar tiling method to model the appearance of 3-D objects. The basic premise is to construct the surface of 3-D objects by keying in on edges (lines) and vertices (angles)—in other words, keying in on high spatial frequencies. Such computer programs use simple polygons or mosaic pieces to approximate small segments or facets of an object's surface. In this manner, a rendering of an object's contoured surface can be modeled. In Figure 3.5b, a computer-generated 3-D model of

(a) (b)

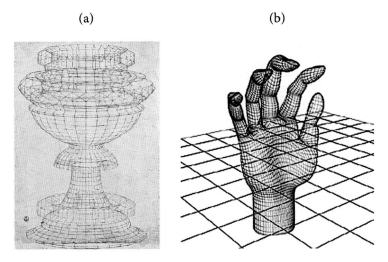

FIGURE 3.5 (a) Uccello, Paolo (1397–1475), Chalice. Perspective drawing. Gabinetto dei Disegni e delle Stampe, Uffizi, Florence, Italy. Photo Credit: Scala / Art Resource, NY. (b) Computer-generated image of polygon mesh of a hand. Reprinted courtesy of HowStuffWorks.com.

models, in which more precise analyses of retinotopic maps can be obtained. In these animal studies, neurons in the occipital cortex are not only retinotopic, but they also separate visual information in terms of spatial frequencies. David Hubel and Torsten Wiesel[13] won the Nobel Prize for discovering that V1 neurons respond to specific visual stimuli, such as a bar moving in a particular direction. Such neurons appear to aid in the perception of edges and offer a neural basis for the Gestalt principle of common movement. Other V1 neurons are sensitive to different colors. In both animal and fMRI studies, multiple retinotopic maps have been identified within the occipital cortex.

A critical region for the beginning of form perception is the *lateral occipital complex (LOC)*, which is adjacent to V1 (see Figure 3.4). In fMRI studies, this region responds to forms more strongly than nondescript shadings or texture patterns. In one study,[14] subjects were shown abstract blobs, common objects (a teddy bear, a face), or textures. When individuals viewed either the blobs or real objects, there was increased activity in the LOC. This activity occurred regardless of whether the form was recognizable or just an abstract blob.[15] Moreover, this region is active for line drawings of objects. Thus, the LOC contributes to manufacturing forms, though at this point the forms are just nameless blobs.

Visual processing in the occipital cortex helps to isolate figures from backgrounds and group features into forms. At this point it appears that the brain is desperately trying to disambiguate the buzzing confusion of retinal activity into a semblance of a visual world made up of solid surfaces, edges, and objects. As such, these brain regions do not appear to respond any greater to a recognizable object than to a nameless blob.

■ Forming Forms

In the real world, we recognize objects readily even though they may be viewed from many different orientations and distances. Visual processes beyond those occurring in the occipital cortex help us impart meaning onto forms. To accomplish this feat, neurons along the ventral path use high spatial frequencies to define forms as outlined drawings, whereas neurons along the dorsal path use low spatial frequencies (i.e., shading and highlights) to define spatial properties important for contour analysis and depth perception.

Outlining Forms

It is not a coincidence that we readily recognize line drawings and cartoons, even though they may be quite stylized in form. Picasso was a master at creating recognizable objects from just some curvy lines. In a psychological study,[16] four different representations of a hand were presented: a photograph, a drawing with shading, an outlined drawing, and a stylized cartoon. Individuals were

processing of more complex object properties, such as how faces and bodies are identified.[11]

The Visual Brain

Shown in Figure 3.4 is V1 as seen from a rear view of the cerebral cortex. The layout of neurons in this region is *retinotopic*, which means that a spot of light on the retina activates a specific region in V1. Given this mapping, damage to a region in V1, which can occur from stroke or disease, produces a blind spot (or *scotoma*) in the visual field. This mapping, however, is not uniform as more neurons are devoted to processing information from the central point of fixation (i.e. the fovea) than from other retinal areas. In this way, the area of greatest visual acuity is given the greatest amount of cortical processing.

In fMRI studies, retinotopic maps have been identified by flashing lights to different locations in space and determining where in the occipital cortex activity is registered.[12] These fMRI findings corroborate earlier studies using animal

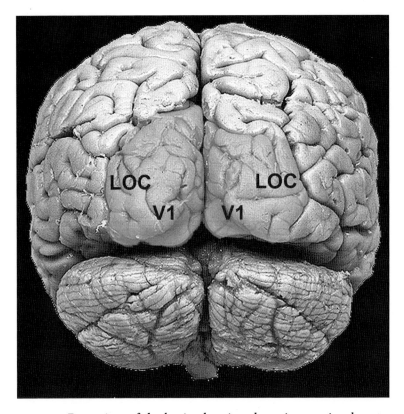

FIGURE 3.4 Rear view of the brain showing the primary visual cortex (V1) and the lateral occipital cortex (LOC). Brain image reprinted with permission from Digital Anatomist Interactive Atlas, Seattle: University of Washington, copyright 1997.

Perceptual Groupings

To progress beyond figure-ground segregation, we must construct the internal structure of common regions. We do this by grouping visual features as parts of the same object. Gestalt psychologists defined principles of perceptual grouping as a way to organize visual scenes. These principles draw on perceptual regularities, such as the notion that objects are comprised of features that are close to each other (proximal), similar in color or texture, or that move together. In particular, similarity offers a strong cue to the perception of form, as similar looking features are likely to belong to the same object.[7]

The psychologist Irving Biederman developed an influential theory of form perception that involves recognition by parts or *geons*.[8] Short for *geometric icons*, geons are a set of building blocks that can be put together, like *LEGO* pieces, to form everyday objects. According to this theory, high-spatial-frequency filtering and figure-ground segregation identify edges and common regions that are grouped to form these primitive building blocks. The geons are then scaled, oriented, and combined to create more complex 3-D forms. These forms are matched to objects in memory for identification. An important feature is that geons are 3-D representations and thus can be scaled and rotated to build many different objects. The theory, however, does have some deficiencies, as it does not easily account for the fact that we can discriminate objects within categories that have very similar forms (types of dogs or automobiles). Also, we view objects from many different viewpoints, and geon theory alone may not be able to account for the vast array of objects we can recognize in real world settings.

In general, psychologists view object recognition as a hierarchically constructed grouping process, such that edges and regions are first connected to form primitive building blocks (e.g., geons), which themselves are grouped to a form blob-like objects, which are then recognized as familiar artifacts in the real world. Throughout this manufacturing process, it is acknowledged that top-down processing plays a critical role in trying to interpret what objects are out there. There may in fact be a separate, very fast brain system that is continually making guesses or predictions about the visual scene.[9] Thus rather than assuming that we view scenes simply by piecing visual features together, our brains likely take a more active role by using what has been seen before and making predictions about what we expect to see, even before we see it.

These days computer programs can perform very sophisticated analyses of visual scenes, such as isolating and tracking moving objects from video camera images.[10] Edge detection (high spatial frequency analysis), surface texture analysis (shape from shading), and recognition by parts (e.g., geon theory) have all been useful in developing such programs. Also, Gestalt principles, such as proximity, similarity, and common motion, are applied to segregate figures from backgrounds. Top-down knowledge is critical, from knowing about basic optical properties, such as how shadows affect the appearance of objects, to the

FIGURE 3.3 Figure-ground segregation: (*a*) Shepard, Roger. *Sara Nader.* From *Mind Sights* (1990), New York: W. H. Freeman and Co.; (*b*) black forms defined by symmetry; (*c*) white forms defined by convexity. (*b*) and (*c*) adapted from Kanizsa G., & Gerbino W. (1976). Convexity and symmetry in figure-ground organization. In M. Henle (Ed.). *Vision and Artifact.* New York: Springer, with kind permission from Springer Science+Business Media B.V.

convexity to determine which areas are in front of others. This strictly bottom-up process provides a beginning to object recognition. Yet figure-ground segregation is substantially accelerated by top-down processing, as we make predictions about what forms are in the environment.[6] We know that certain objects will appear in a room or an outdoor scene. Such influences enable us to perceive forms rapidly, such as the stylized silhouette of the saxophone player in *Sara Nader.* In this case, a strictly bottom-up computer analysis would have difficulty recognizing the black area as an object, but we easily match this form with knowledge (e.g., of saxophone jazz players). Also, a strictly bottom-up analysis would likely miss completely the woman's face in this figure-ground illusion, though we easily put the facial features together when we consider the white area as part of an object.

■ Isolating Forms

In the manufacturing of objects, the brain must first determine the relative position of objects in the scene or what psychologists call *figure-ground segregation*. Much of this process takes place in the occipital cortex where perceptual features such as color, edges, and motion are used to create boundaries between objects. In this way, forms are isolated from one another through the grouping of perceptual features. Even in these early stages, we rely on knowledge about the world (i.e. top-down processing) to guide of object recognition.

Figure-Ground Segregation

If you put your hand out in front of you, you readily interpret it as a "figure" and everything behind it as the "background." Our ability to segregate objects from each other is based on numerous perceptual cues, though sometimes confusions occur, and the brain must make an educated guess by selecting one possibility over another. At first glance of Figure 3.3a, you might see the stylized silhouette of a saxophone player. However, if you interpreted the white area as the foreground, you'd see a woman's face. This drawing titled *Sara Nader* by Roger Shepard,[3] the noted psychologist (and extraordinary artist), creates a figure-ground ambiguity, because one could interpret either the black or white area as belonging to an "object." In such cases your brain decides on one possibility or the other, though it seems you cannot see both at the same time. Other artists such as Salvador Dali, M. C. Escher, and Rene Magritte have played on the ambiguities of figure-ground segregation.[4]

Psychologists consider factors that drive our ability to segregate objects from their background. Symmetry is a primary cue, as both artificial and natural objects (e.g., clocks, trees, and our bodies) are generally symmetrical when viewed from the front. Thus, when we look at the black and white squiggly areas of Figure 3.3b, we tend to see the black areas as forms in front of a white background, because the black areas are symmetrical along the vertical axis. It is possible to shift your attention and see the white areas as objects, though this percept is not your brain's first choice. Another cue is convexity or the degree to which forms curve outward. In Figure 3.3c, we more readily perceive the white regions as forms, as they depict bulging, worm-like regions, even though the black regions are symmetrical.[5] Thus, all else being equal, convexity seems to trump symmetry during figure-ground segregation. Whenever we view the world, our brains rapidly make decisions as to what objects are in front of others.

Basic bottom-up features, such as symmetry and convexity, facilitate figure-ground segregation. Indeed, a robot could take a raw video image, use high spatial frequency filtering to identify edges, and connect these edges to mark areas that seem to belong together. It could then use symmetry and

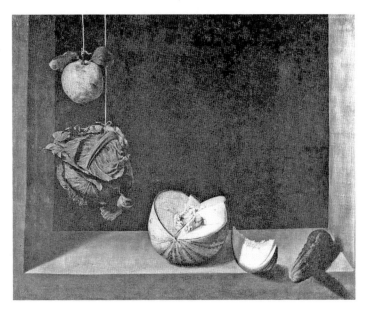

FIGURE 3.1 Juan Sánchez Cotán, *Quince, Cabbage, Melon and Cucumber* (*c.* 1602), San Diego Museum of Art. Gift of Anne R. and Amy Putnam.

FIGURE 3.2 Three-dimensional representations of objects: (*a*) abstract blob with shading and highlights; (*b*) line drawing of face; (*c*) form defined by distorting black "circles"; (*d*) curved surface defined by distorting "parallel" lines. Reprinted from Todd, J. T. (2004). The visual perception of 3D shape. *Trends in Cognitive Science, 8*, 115–121, with permission from Elsevier.

3. THE ILLUSION OF FORM

Look around and describe what you see. Instead of the edges, shadings, and spatial frequencies that are registered by your brain, you perceive solid objects placed in a spatial environment. Likewise, in Sánchez Cotán's still life *Quince, Cabbage, Melon, and Cucumber* (Figure 3.1), you easily recognize a cucumber and sliced melon on the window ledge and hanging from above there is a cabbage and some other fruit (a quince?). Our ability to identify the objects in this painting is facilitated by shadings and highlights, which define a light source, presumably the sun, situated above and to the left. The sense of depth is reinforced by the shadows cast on the ledge, which defines the position of the cucumber and small melon slice as protruding past the window's edge. Yet as Gombrich astutely noted in *Art and Illusion*,[1] such paintings are merely visual illusions of spatial scenes manufactured by artistic application of lines, colors, and shadings on a flat canvas.

Like artists, our brains create the illusion of forms. Psychologists call this process *object recognition*, which begins with the retinal image and ends with our ability to say "that's a melon" or "that's my friend Bill." Figure 3.2 depicts some of the ways in which images create the illusion of 3-D objects.[2] In Figure 3.2a, shading and highlights define the shape of an abstract blob, and even though this form is unfamiliar, we easily perceive its 3-D structure. Figure 3.2b uses high-frequency contour lines to depict edges that define features of a face. In Figures 3.2c and 3.2d, what appear to be circles and parallel lines are distorted as if they were placed on curved surfaces. Of course, all of these impressions of solid objects are illusions, as each figure is merely a drawing printed on a flat surface.

24 Hochberg, J., & Brooks, V. (1962). Pictorial recognition as an unlearned ability: A study of one child's performance. *The American Journal of Psychology, 75,* 624–628.

25 Richter, G. *The Daily Practice of Paintings: Writings 1962–1993* (p. 37). London: Thames & Hudson.

26 Brennan, S. E. (1985). Caricature generator: Dynamic exaggeration of faces by computer. *Leonardo, 18,* 170–178.

27 Benson, P. J., & Perrett, D. I. (1991). Perception and recognition of photographic quality facial caricatures: Implications for the recognition of natural images. *European Journal of Psychology, 3,* 105–135. Rhodes, G., Brennan, S., & Carey. S. (1987). Identification and ratings of caricatures: Implications for mental representations of faces. *Cognitive Psychology, 19,* 473–497.

28 Zeki S. (1999). *Inner Vision: An Exploration of Art and the Brain.* Oxford, UK: Oxford University Press.

29 See Brown, S., Gao, X., Tisdelle, L., Eickhoff, S. B., & Liotti, M. (2011). Naturalizing aesthetics: Brain areas for aesthetic appraisal across sensory modalities. *NeuroImage, 58,* 250–258. Chatterjee, A. (2011). Neuroaesthetics: Growing pains of a new discipline. In Shimamura & Palmer (2012), pp. 299–317. Skov, M., & Vartanian, O. (Eds.). (2009). *Neuroaesthetics.* Amityville, NY: Baywood Publishing Company. For an art historical perspective, see Onians, J. (2007). *Neuroarthistory: From Aristotle and Pliny to Baxandall and Zeki.* New Haven, CT: Yale University Press.

30 Ramachandran, V. S., & Seckel, E. (2011). Neurology of visual aesthetics: Indian nymphs, modern art, and sexy beaks. In Shimamura & Palmer (2012).

11 In 1668, van der Heyden painted a nearly identical view of the town hall, though the perspective of the cupola was "corrected." See Kemp, M. (1982). *The Science of Art: Optical Themes in Western Art from Brunelleschi to Seurat*. New Haven, CT: Yale University Press. Sutton, P. C. (2006). *Jan van der Heyden: 1637–1712*. New Haven, CT: Yale University Press.

12 Newton, I. (1672). A new theory about light and colors. *Philosophical Transactions of the Royal Society of London*, *80*, 3075–3087. Reprinted in the *American Journal of Physics*, *61* (1993), 108–112.

13 Hence the mnemonic, ROY G. BIV, to remember the order of the colors in the rainbow. It has been suggested that indigo should not really be considered as one of these basic colors, but Newton was interested in numerology and wanted a seventh color.

14 For further detail on theories of color perception, see Palmer, S. E. (1999). *Vision Science: Photos to Phenomenology*. Cambridge, MA: MIT Press.

15 Chevreul, M. E. (1855). *Principles of Harmony and Contrast of Colours, and Their Applications to the Arts* (translation by Charles Martel). London: Longman, Brown, Green, and Longmans.

16 Ball, V. K. (1965). The aesthetics of color: A review of fifty years of experimentation. *The Journal of Aesthetics and Art Criticism*, *23*, 441–452; Guilford, J. P. & Smith, P. C. (1959). A system of color-preferences. *The American Journal of Psychology*, *72*, 487–502. Wypijewski, J. (Ed.). (1998). *Painting by Numbers: Komar and Melamid's Scientific Guide to Art*. Berkeley: University of California Press.

17 Bornstein, M. H., Kessen, W., & Weiskopf, S. (1976). Color vision and hue categorization in young human infants. *Journal of Experimental Psychology: Human Perception and Performance*, *2*, 115–129.

18 Adams, R. J. (1987). An evaluation of color preferences in early infancy. *Infant Behavior and Development*, *10*, 143–150. Zemach, I. K., & Teller, D. Y. (2007). Infant color vision: Infants' spontaneous color preferences are well behaved. *Vision Research*, *47*, 1362–1367.

19 Wells, D. L., McDonald, C. L., & Ringland, J. E. (2008). Color preferences in gorillas (*Gorilla gorilla gorilla*) and chimpanzees (*Pan troglodytes*). *Journal of Comparative Psychology*, *122*(2), 213–219.

20 Hill, R. A., & Barton, R. A. (2005). Red enhances human performance in contests. *Nature*, *435*, 293.

21 Palmer, S. E., Schloss, K. B., & Sammartino, J. (2011). Hidden knowledge in aesthetic judgments: Preference for color and spatial composition. In A. P. Shimamura & S. E. Palmer (2012). (See chapter 1, n. 2.)

22 Schloss, K. B., Poggesi, R. M., & Palmer, S. E. (2011). Effects of university affiliation and "school spirit" on color preferences: Berkeley versus Stanford. *Psychonomic Bulletin and Review*, *18*, 498–504.

23 Hockney (2001) argued that Ingres used an optical device called a camera lucida, an optical tracing device, as the way the lines were stroked and their apparent accuracy suggest tracing rather than "eyeballing."

input, that is, by bottom-up activation from the photoreceptors. The brain also depends upon the prefrontal cortex, our CEO, to monitor and control activity all along the manufacturing process (see Figure 1.9). This form of executive control uses top-down processing (i.e., knowledge and expectations) to guide visual processing (discussed further in chapter 5). Thus, our perceptions are facilitated by "knowing" what to expect at all times. The combined influence of bottom-up input and top-down control enables us to manufacture in an extraordinarily fast and efficient manner a spatial 3-D percept.

■ Notes

1 The image from your camera obscura will appear brighter if you cover yourself with a heavy jacket leaving only the pinhole exposed to a sunny scene.

2 The term *tilt-shift* refers to a special camera lens that optically tilts the focusing plane. For a psychological study of this illusion, see Held, R. T., Cooper, E., O'Brien, J., & Banks, M. S. (2010). Using blur to affect perceived distance and size. *ACM Transactions on Graphics 29*, 2–19.

3 Smith, P. C., & Smith, O. W. (1961). Ball throwing responses to photographically portrayed targets. *Journal of Experimental Psychology, 62*, 223–233.

4 DaVinci, L. (2008). *Notebooks.* Oxford: Oxford University Press.

5 Durer, A. (1977). *The Painter's Manual* (translated by Walter S. Strauss). Norwalk, CT: Abaris Books.

6 See Alper, S. (1984). *The Art of Describing: Dutch Art in the Seventeenth Century.* Chicago, IL: University of Chicago Press. Schama, S. (1988). *The Embarrassment of Riches: An Interpretation of Dutch Culture in the Golden Age.* Berkeley, CA: University of California Press.

7 A perspective box by the seventeenth century Dutch artist Samuel van Hoogstraten can be seen at the National Gallery website: http://www.nationalgallery.org.uk/paintings/samuel-van-hoogstraten-a-peepshow-with-views-of-the-interior-of-a-dutch-house

8 Steadman, P. (2001). *Vermeer's Camera: Uncovering the Truth Behind the Masterpieces.* New York: Oxford University Press.

9 David Hockney, the noted contemporary artist, suggested that many old masters, including Vermeer, used optical aids. Hockney, D. (2001). *Secret Knowledge: Rediscovering the Lost Techniques of the Old Masters.* New York: Viking Studio. For counterarguments, see Tyler, C. (2004). Rosetta Stone? Hockney, Falco, and the sources of "opticality" in Lorenzo Lotto's Husband and Wife. *Leonardo, 37*, 397–401.

10 Gopnik, B. (2009). "*Pride of Place*": *Dutch Cityscapes of the Golden Age at the National Gallery of Art*, Washington Post, February 3, 2009. http://www.washingtonpost.com/wp-dyn/content/article/2009/02/02/AR2009020203455.html

FIGURE 2.12 Statue of Parvati (courtesy of Vilayanur S. Ramachandran).

as beholder, creates a *percept*—that is, a story about objects placed within a spatial layout. Neural interactions act to highlight, accentuate, and distort the raw sensory input. These interactions amplify critical features, such as colors, edges, and contours. A further division of labor involves spatial frequency analysis in which the visual input is segregated in terms of smooth transitions (low frequencies) and sharp, outlined contours (high frequencies). As mentioned in chapter 1, the brain processes visual information much like the way a business or corporation manufactures a product. Raw material is taken in and various divisions process the material, often more or less independently from one another. This process continues and is directed toward the goal of manufacturing a representation of the spatial world around us.

Visual input enters the cerebral cortex at the most posterior end (V1), which is the starting point for cortical processing. It then proceeds along two main pathways. The ventral or "what" path is critical for object recognition and uses high-frequency information to amplify edges and help distinguish one object from another (discussed further in chapter 3). The dorsal or "where" path is critical for spatial depth perception and uses low-frequency information to identify subtle changes in contours and depth (discussed further in chapter 4). The ventral and dorsal paths work independently to some degree but also together work to construct a representation of a spatial environment.

The corporate brain operates efficiently by parceling out specific duties to different cortical regions. Much of this processing is driven by the visual

Morton College Library Cicero, ILL WITHDRAWN

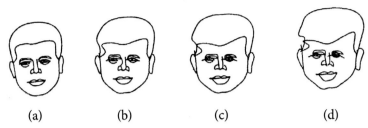

(a) (b) (c) (d)

FIGURE 2.11 (*a*) Line drawing of John F. Kennedy; (*b–d*)
computer-generated caricatures with increasing exaggerations of distinc-
tive facial features. From Brennan, S. E. (1985). Caricature generator:
Dynamic exaggeration of faces by computer. *Leonardo, 18*(3), 170–178,
© Figure 6 (p. 175), 1985 by the International Society for the Arts,
Sciences and Technology (ISAST) with permission from MIT Press.

to create a 3-D scene and suggested that artists do the same. Zeki is known for
important research showing how different brain regions have particular roles
in visual perception. He is now perhaps more widely known for spearheading
an interest in *neuroaesthetics*, the analysis of art and aesthetics from a neuro-
biological perspective.[29]

Another prominent neuroscientist, Vilayanur Ramachandran, has sug-
gested that the brain's role in accentuating or amplifying visual input is the key
to understanding the essence of art.[30] Ramachandran considered neurobehav-
ioral findings such as the *peak-shift* effect, a phenomenon observed in animal
learning. If an animal is trained to discriminate two similar stimuli, such as a
circle and an oval, the animal will distort the difference between the two stimuli
and respond more vigorously to ovals that are even more elongated than those
used as stimuli. The animal's response is thus an amplification of the differ-
ence between the two stimuli. One can see how the peak-shift effect is similar
to caricatures. Ramachandran suggested that the defining nature of art is the
amplification or accentuation of real world experiences. He applied his theory
to all kinds of art, including Indian sculpture, such as the one of Parvarti, the
Hindu goddess, shown in Figure 2.12. Ramachandran argued that as a god-
dess of femininity and fertility, Parvarti is represented with exaggerated female
characteristics, such as large breasts, narrow waist, and broad hips. The same
could be said for the much older Venus of Hohle Fels (Figure 1.6 in chapter 1).
Ramachandran asserts that the hallmark feature of all art is the accentuation or
amplification of natural objects. He aptly states that "all art is caricature."

■ The Corporate Brain

We began this chapter with the retinal image, our small 2-D canvas onto which
a 3-D world is projected. The essence of this raw input is light, and the brain,

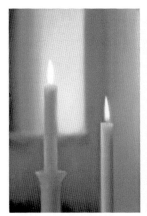

FIGURE 2.10 *Left*: Richter, Gerhard. *Two Candles (Zwei Kerzen)* (1982). *Right*: Richter, Gerhard. *Station* (1985). Both images reproduced with permission from © Gerhard Richter 2012. (See color plate section.)

the kaleidoscope of colors and shapes that dance upon our retina, the need for selecting and highlighting relevant features becomes apparent. As shown in the spatial frequency analysis of the photograph of Groucho Marx (Figure 2.9), it is the high spatial frequencies that accentuate outlines and contours. They enables simple line drawings, such as Ingre's sketch (Figure 2.8), to be identified with extraordinary ease.

It turns out that exaggerations of features actually make perception easier. Susan Brennan, a computer scientist and caricaturist, developed *Caricature Generation,* a computer program that makes caricatures.[26] The program calculates the extent to which a person's facial features deviate from those of the average face and then exaggerates discrepant features even more so. Thus, someone with a larger than average nose will be caricaturized as having a really big nose. Shown in Figure 2.11 is a series of computer-generated caricatures of John F. Kennedy. The first drawing is an undistorted rendering of Kennedy's facial features. The other images are generated by *Caricature Generator*, which increasingly exaggerates the parts of Kennedy's face that deviate from an average face. Interestingly, caricatures of famous people can be recognized faster than realistic portrayals of the same individuals.[27]

The brain's propensity to exaggerate and highlight critical features casts doubt on the idea that we perceive an exact copy of the real world. Not only are we restricted to a 2-D rendering of a 3-D world, the brain distorts what is projected onto our retinas by exaggeration, distortion, and substitution. Perhaps through evolution such distortions have become adaptive as they facilitated attention to critical features in our environment. Artist have become attuned to the way attention can be directed to perceptual features.

Semir Zeki, a noted neuroscientist, considered parallels between visual perception and artistic styles in his book *Inner Vision*.[28] He described how the brain selects, highlights, and discards aspects of the raw visual input in order

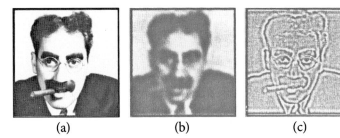

<div align="center">(a) (b) (c)</div>

FIGURE 2.9 (a) Photograph of Groucho Marx; (b) low spatial frequency image; (c) high spatial frequency image. Reprinted from Frisby, J. P. (1979). *Seeing: Illusion, Brain, and Mind*. Oxford, UK: Oxford University Press.

chalk to outline the face. In the brain, spatial frequencies are segregated as they enter the cortex, and this segregation is maintained as information is processed in other parts of the cortex. An advantage of processing high and low spatial frequencies separately is that each one serves different functions. Low frequencies help define spatial depth as subtle shifts in shading reflect changes in the contour of a surface. High frequencies sharpen edges, thus helping to outline objects. This division of labor enables different cortical regions to key on specific features such as depth perception and object recognition.

The contemporary artist Gerhard Richter seems to conduct his own analysis of spatial frequencies. Richter is known for softly focused photorealistic paintings, not unlike the blurry, low-frequency image of Groucho Marx. Such low-frequency, out-of-focus images require the rendering of subtle tonal gradations of shading. Lines blur as objects merge with backgrounds. Yet Richter also creates purely abstract works, but in this case his paintings consist of stark streaks and saturated colors. These abstract paintings emphasize high spatial frequencies. Richter's realistic and abstract styles are interesting by themselves, but paired together they stand as an interesting contrast in the use of spatial frequencies (Figure 2.10). I do not suggest that Richter is intentionally commenting on the nature of high and low spatial frequencies. He has said, "I blur things to make all the parts a closer fit."[25] Also the soft contours and subtle tones of the realistic paintings call to mind the careful use of chiaroscuro that the Old Masters used skillfully. In contrast, the abstract paintings are bold and modern with stark edges and saturated colors. It is an interesting fact that our brains segregate these two features of visual information, just as Richter appears to have done so in his two prominent styles.

Accentuate the Positive

As the brain attempts to manufacture a 3-D world from a 2-D image, it exaggerates and highlights critical features. In fact, selective distortion is a mainstay of brain processing, just as it is with artistic renderings. When one considers

FIGURE 2.8 Ingres, Jean-Auguste-Dominique, *Mrs. Charles Badham* (1816). Graphite on wove paper, 26.3 × 21.8 centimeters (10 3/8 × 8 9/16 inches). The Armand Hammer Collection, 1991.217.20.

change is highlighted edges. Early in sensory processing, our brains apply similar edge sharpening.

For both colors and edges, the brain does not give us an entirely realistic view of the world. Instead, it manipulates and manufactures a world of colors bleeding into others, exaggerated edges, and illusory borders. These transformations occur in the service of efficient processing of visual information. In fact, the brain separates the raw visual input into critical features, such as color, edges, and forms, and packages them for further processing. With such a division of labor, the brain is made more efficient by relegating specific processes to different brain regions. A particularly important stage in early visual process is analysis by *spatial frequencies*. In its simplest form, spatial frequency refers to the number of light and dark bands per unit of width. These gratings can vary in frequency (i.e., bands per width) and amplitude (i.e., the degree of lightness or darkness between bands). Just as a musical score can be broken down as a combination of tones with various sound frequencies, an image can be decomposed in terms of a combination of gratings with different spatial frequencies.

Shown in the left (a) panel of Figure 2.9 is a photograph of Groucho Marx. This image was then filtered to show only low or broad bands of spatial frequencies (Figure 2.9b) or only high spatial frequencies (Figure 2.9c). Note that the low-frequency image blurs the face and depicts subtle shadings, whereas the high-frequency image defines edges, almost as if one used white

Color combinations in paintings often can make or break an aesthetic experience. The abstract expressionist Wassily Kandinsky once said, "A picture is nothing more and nothing less than organized colors." Many modern artists have keyed in on highly saturated colors, perhaps because we like saturated colors and also as a reaction against the de-saturated colors inherent in natural scenes. In fact, the *Fauves* (French for *Wild Beasts*), led by Henri Matisse, André Derain, and Maurice de Vlaminck, stressed the application of saturated color combinations. For the *Fauves*, color became the focal point and they used it with wild abandonment.

■ More Than Meets the Eye

Have you ever watched someone's home video of a vacation or birthday party, with its constant jiggling, bobbing, and swaying? It is amazing to think that the images projected onto our retina are even more erratic, as we are constantly moving our head and eyes. Despite this incredibly jumbled input, our brain creates a stable visual world in front of us. As in color perception, early stages of visual processing act to integrate and mix visual information over time and space. In fact, the brain as beholder is constantly highlighting, sharpening, and accentuating the ever changing images projected onto our retinal canvas.

Sharpening the Edges

Consider the drawing by Ingres in Figure 2.8. Other than the soft shading of the face, the rest of the drawing is a series of bold, well-composed lines.[23] In this sketch, we immediately recognize objects in the scene, such as the woman's dress, her hat, and the background cityscape. The various lines that define the woman's dress mark changes in the light rays that reflect off creases and folds. How do we interpret with such immediacy solid objects from such a rough drawing? In reality, the world is composed of subtle variations in shadings and colors. Interestingly, our brains are actually geared toward detecting and accentuating edges. This ability develops very early, as suggested by a case study of a 19-month-old child who was never exposed to pictures or drawings. Despite this inexperience, the child could easily recognize simple line drawings of common objects.[24]

Our ability to detect edges is critical, as they not only define borders between objects but also define separations in depth. By exaggerating these separations, the brain enhances our perception of space. In fact, photographers use image sharpening tools, such as those found in commercial software like *Photoshop*, that mimic the way the brain sharpens edges. These tools increase contrast by amplifying the borders between light and dark regions. Sharpened images have the appearance of a shot taken with better focus, though the only

colors, such as red, may be closer to skin tones and such preferences may be associated with attachment to the mother. Thus, it may be that color preferences are more a learned phenomenon than a genetic one.

If we consider other species, most other mammals have only two sets of cones, though our close primate relatives, chimpanzees and gorillas, have visual systems similar to ours. The advantage of three cone types over two may be linked to an increased ability in foraging, such as picking out ripe fruit from foliage. In one study, chimpanzees and gorillas (living in a zoo) were exposed to boxes and cloths colored red, green, and blue.[19] They preferred blue and green objects over red ones. In another study, monkeys preferred blue lights over red. As with color preferences in infants, it is not clear exactly how to interpret such preferences. Some have suggested that an aversion to red may be related to its negative association with blood, fire, or the evening sky (when predators are more active).

The color red has more associations with human characteristics than any other color. In one provocative study,[20] the outcome of combat sports (boxing, wrestling, tae kwon do) during the 2004 Summer Olympics was assessed as a function of the color of the athletes' uniform. For these events, competitors were randomly assigned to red or blue uniforms. Those who wore red uniforms won more competitions than those wearing blue uniforms. This effect was consistent across the different combat sports and weight classes. The authors suggested that red is linked with testosterone-dependent male virility. Of course, athletic ability was the prime factor in the competitions, as indicated by the finding that the red advantage occurred most reliably when the competitors were closely matched in ranking. Physical or biological associations with colors, such as being red-faced with anger, are universal experiences among all humans. Other associations are based on cultural or personal experience. For example, Americans often associate red with love (e.g., valentines) and blue with sadness.

Steve Palmer and colleagues[21] have shown that color preferences are indicative of ecological factors driven by the way people associate colors to objects. Blues are associated with clear skies and pristine lakes. Browns and dark oranges are associated with rotting food and feces. These associations strongly influence color preferences. To test this hypothesis, individuals were shown various colors and asked to come up with objects associated with each one. For example, bright red might be associated with strawberries. Other individuals were shown the names of these objects (e.g., "strawberries") and asked to rate how much they liked them. Color preferences were strongly linked with preferences for objects of the same color. That is, there are more things in the world that we like that are blue compared to things that are brown. Cultural preferences also occur, such that Americans might prefer the combination of red, white, and blue, whereas Brazilians might prefer green, yellow, and blue. In fact, color preferences were even biased toward the hues associated with one's college affiliation.[22]

of color frequencies, thus supporting the trichromatic theory, other neurons further downstream operate like a seesaw signaling one of two color frequencies, just as predicted by the opponent-processes theory. For example, Russell DeValois and colleagues found "opponent-process" neurons in the lateral geniculate nucleus (LGN), a way station for visual information traveling from the retina to the cerebral cortex. In the LGN, some neurons were excited by green light but shut down when exposed to red light (green-on/red-off neurons). Other LGN neurons, showed the opposite response, as they were excited by red light and inhibited by green light. There were also blue-on/yellow-off neurons and yellow-on/blue-off neurons. Finally, some LGN neurons were color-blind but fired generally in response to brightness. Thus, whereas the trichromatic theory was affirmed by the finding of three different cone types, the opponent-process theory was affirmed by the finding of neurons with opponent properties further down the visual path to the cerebral cortex. Such opponent-process neurons can account for simultaneous color contrast effects and color aftereffects. They prepare the cortex for further processing of color information, which assists in our ability to recognize objects.

What's Your Favorite Color?

We respond strongly to colors, and the way we respond to them has been one of the most heavily studied topics in aesthetic science. Early studies of color preferences were inconclusive as they did not consider secondary factors such as saturation (most people prefer saturated over de-saturated colors) and brightness (most people prefer bright over dark colors). When these influences are controlled, studies show that people prefer blue over all other colors, with red and green tied for second place, purple in third, and yellow and orange coming in last. The statistics are rather compelling. For the basic set of saturated colors, roughly 44% of individuals prefer blue over any other color, and only 11%–12% report red or green as their favorite.[16]

Where do these color preferences come from? Are they genetic? Children by the age of three years exhibit color preferences similar to adults. One question is whether even younger children categorize colors in the same way as adults. It may be that color categories are learned when we learn color names. Keep in mind that it is our brain that "sees" the distinct color bands of the rainbow, as in reality the visible light spectrum is simply a continuously varying range of electromagnetic energy. It turns out that infants respond to the same color boundaries as adults (e.g., such as distinguishing "blues" from "greens"),[17] however they do not show exactly the same color preferences. For example, newborns do not show any preference in looking behavior of one color over another, though they do prefer colored patches over gray ones. By three months of age, infants look more at blue and red objects over other colored objects.[18] Preference for green over yellow and orange is not observed in infants. Certain

colorés (The Principles of Harmony and Contrast of Colors).[15] Chevreul was an organic chemist who, among other things, synthesized an early version of margarine and a wax used in candles. He was a member of the French Academy of Science and a foreign member of the Royal Society of London. Following a professorship at the Lycée Charlemagne, a prestigious prep school in Paris, he became superintendent of the color dyeing department of *Goeblins,* the Royal tapestry and carpet manufacturer. At *Goeblins,* Chevreul was responsible for the accuracy and consistency of colored dyes. As such, he found himself dealing with complaints from customers about inconsistencies in some of the dyes. Upon inspection, Chevreul found that the dyes were both accurate and consistent but that a color actually looked different depending on the color that surrounded it.

Chevreul developed a theory of "simultaneous color contrast," which asserted that every color, not just the primary colors, has its own complement, and when any two colors are placed next to each other, a bit of the complement bleeds into its neighbor. Thus, a yellow patch surrounded by green will have a reddish tinge as green's complement, red, would bleed into the yellow. What Chevreul's customers noticed was that dyes sometimes appeared less saturated (washed out) when they were placed next to others. Of course, when the adjacent color is its exact complement, such as a yellow patch surrounded by blue, the yellow will appear highly saturated, because in this case the color is mixed with itself. Also, as demonstrated by the "stained-glass" illusion, colors will appear more saturated if they are separated by black stripes, because neighboring colors can't bleed into each other (Figure 2.7). Artists, such as George Seurat and Robert Delaunay, were influenced by Chevreul's theory. In fact, Dulaunay paid an homage to Chevreul by naming one painting *Simultaneous Contrasts: Sun and Moon.*

For many decades, psychological scientists were split between those who advocated the trichromatic theory and those who advocated the opponent-process theory. Although the cones do code for different ranges

FIGURE 2.7 Stained-glass illusion. (See color plate section.)

shades, though from up close one can see that the painting is a mosaic of individually colored dots.

Perceiving colors is a rather curious phenomenon as there is nothing in the physical environment that would warrant us having this experience. Our brains just happen to interpret a specific range of electromagnetic energy into bands of distinct colors (x-rays and microwaves are part of this spectrum, but we don't register them as colors). Even stranger is that we perceive a "ring" of colors so that the two end points—red and violet—wrap around, and the resulting color is interpreted as purple. It is unclear exactly why we connect the two end points, as it is purely a property of human perception and not a property of the physical energy. We also perceive different tones or shadings as defined by two other dimensions: saturation and brightness. Saturation refers to color purity and can be viewed as the degree to which white light is added to a color. For instance, the color of a fire engine is a highly saturated red, whereas pink is a desaturated red. The other dimension, brightness, refers to the perceived luminosity of a color (from saturated to dark). Thus, when fire engine red is lowered in brightness, it turns into maroon.

Contrasting Colors

You might think that the output from the three cone types was all we needed to perceive colors. In fact, two nineteenth century scientists, Thomas Young and Hermann von Helmholtz, independently developed just such a "trichromatic" theory to account for color perception.[14] Yet psychologists found that there was more to color perception than meets the cones. Early psychophysicists found that if you stared at a saturated red for a half minute then fixated on a white page, you will actually see a green afterimage. If you stared at green you would then see a red afterimage. Yellow and blue showed the same afterimage relationship. Ewald Hering used these findings to suggest that color perception is based on three contrasting dimensions: a red-green dimension, a yellow-blue dimension, and a third dimension of brightness that varied from black to white. Each of these dimensions acts like a seesaw, balancing the degree to which a spot of light leans to one side or the other. Thus, red and green oppose each other, so that an equal amount balances the two, and an unequal amount accentuates one or the other. Hering's "opponent-process" theory offered an alternative to the trichromatic theory. It explained color aftereffects by suggesting that when one stares at a color, it diminishes or fatigues its signaling, which then tips the seesaw to its opposing color. Thus, a color afterimage will always elicit the opposite color from the one that was presented. This complementary view of color perception was noted by Leonardo, who felt that red-green, yellow-blue, and black-white acted as opposing pairs.

In 1839, Eugène Chevreul (1786–1889) wrote an extraordinary treatise entitled *De la loi du contraste simultané des couleurs et de l'assortiment des object*

FIGURE 2.6 Seurat, Georges (1859–1891). Sitting model, profile. Musee d'Orsay, Paris, France. Photo Credit: Erich Lessing / Art Resource, NY. (See color plate section.)

Seeing Colors

How do we see colors? As mentioned earlier there are three types of cones in the retina, each sensitive to a different range of color frequencies. These cones are abbreviated as "blue," "green," and "red" cones, as each type is sensitive to a different part of the frequency spectrum (or with respect to wavelength, "short," "medium," and "long" cones, respectively). When light strikes a cluster of these three cone types, the combined signal acts as a neural code for millions of colors. Just as with paints, a combination of lights can mix to produce different colors. Whereas the mixing of colored paints is *subtractive* (i.e. removing light energy when reflected off the surface), the mixing of colored lights is *additive*. In this way, a combination of blue, green, and red light produces white light. By coding light as the amount of energy striking each of three cone types, the brain can define millions of colors. In a digital camera, the same color identification scheme is used by three adjacent light sensors that together can code millions of different colors.

Following Impressionism, George Seurat developed a pointillist style that illustrated additive rather than subtractive color mixing. Seurat was aware of the effects of color mixing and realized the discordance between the way the eye adds colors and the way the mixing of paints subtracts them. Thus, rather than mixing pigments, Seurat placed dots of different colors nearby and let the eye mix them in an additive fashion, as exemplified by *Sitting Model* (Figure 2.6). From a distance, the colored dots do mix and produce varying

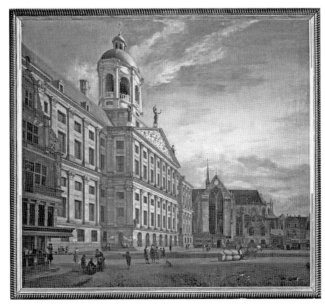

FIGURE 2.5 Heyden, Jan van der (1637–1712). *The City Hall in Amsterdam*. Uffizi, Florence, Italy. Photo Credit: Scala / Art Resource.

viewpoint, much like the location of a peephole on a perspective box.[11] Gopnik suggests that the cultural intent of many seventeenth century Dutch works was for the beholder to take the same point of view as depicted by the artist, which then gives the illusion of placing the viewer directly in a realistic urban scene. Indeed, during a visit to the Netherlands, I was thoroughly engaged in various seventeenth century cityscapes as I peered at paintings with one eye at rather oddly slanted positions, much to the bewilderment of other museum-goers.

■ Color My World

In a letter to the Royal Society in 1672, Isaac Newton[12] described experiments with light as it passed through a glass prism. He darkened a room except for a small hole through which a beam of light was let in. When he placed a prism in front of the beam, he saw a glowing rainbow projected onto the opposite wall. Newton was not the first to conduct this experiment but he developed a theory of color perception based on the results. He identified the colors as red, orange, yellow, green, blue, indigo, and violet.[13] Newton also reported that a magnifying lens placed after the prism would focus the rainbow of light back to a bright white spot. He concluded that the prism spilt sunlight into elemental parts, defined by the hues, which were then combined again by the magnifying lens. He also showed that combinations of certain colors produced others, such as red and yellow light producing orange.

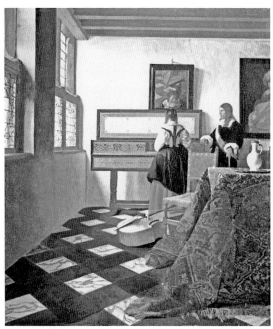

FIGURE 2.4 Vermeer (van Delft), Jan (1632–1675), *The Music Lesson* (*c.* 1662–1665). Oil on canvas, 74.6 × 64.1 centimeters. Ann Ronan Picture Library, London, Great Britain. Photo Credit: HIP / Art Resource, NY. (See also note 8.)

the viewpoint defined by the painting. For example, we might assume that floor tiles are square, though they may be depicted from the side and thus painted as diamond-shaped forms as in *The Music Lesson*. Having constructed the 3-D models, Steadman then photographed the scene from a particular viewpoint. Amazingly, the resulting photographs often matched almost perfectly Vermeer's actual paintings in dimension and perspective, which Steadman argues would have been virtually impossible without optical aids.[9] Yet, regardless of whether or not Vermeer used such aids, the application of subtle tones and the visual aesthetics of the scenes could not be accomplished simply by good tracing ability.

An artist's point of view stands as an essential feature of our art experience. Interestingly, how we "look" at an artwork may not be same as the artist's intended point of view. The art critic Blake Gopnik[10] has argued that we may not be "looking" at seventeenth century Dutch art as the artists had intended. Consider Jan van der Heyden's 1667 painting of the town hall in Amsterdam (Figure 2.5). The viewpoint is so angled that the cupola on top of the building appears oddly distorted. If, however, you look at the painting from very close and near the bottom right corner, preferably with one eye, the distortion vanishes and the façade of the building appears to pop out of the picture plane. When this painting was sold to the Medici Grand Duke, it came with an iron attachment to the frame which presumably indicated the "proper"

knowledge and skill as geometric precision is essential in representing a 3-D world onto a 2-D surface. Leonardo suggested that one way to learn this skill was to place a window in front of a scene and copy the scene onto the glass.[4] In this way, the artist could simply trace the contours and textures of objects in the scene onto a flat surface. Such tracings would reproduce exactly the way light rays reflect off objects and pass through the surface (i.e., the picture plane) en route to the eye. The artist would then literally be painting a "window" to the real world.

In *The Painter's Manual*,[5] written in 1525, Albrecht Dürer described a similar technique in which a lined grid is placed on a window, and instead of tracing directly onto the window, the artist draws on a paper with similarly placed grids. With the grid pattern, copying is simplified as the artist can key in on what is seen in separate sections of the grid. For this (and Leonardo's) method to work, it is necessary for the artist to maintain exactly the same viewpoint while drawing, as any shift in the eye's position alters the scene that is projected onto the window. In Durer's setup, he added a stand with an eyepiece through which the artist peers so that the view is stabilized. As a demonstration, make a rectangular window with your thumbs and fingers, as if you are framing the scene in front of you. Close one eye and move your head from side to side. Notice how the scene within the frame shifts with head movements. All realistic paintings, just as all snapshots taken from a camera, have a defined single viewpoint from which the scene is depicted.

Realism and the mimetic approach to art has been a mainstay throughout the centuries. Even today, we are entertained by the sense of realism viewed through 3-D glasses at the movies. In Holland, during the seventeenth century, illusions of realism were also admired. At that time, the Dutch culture prospered through successful commerce and industry.[6] With affluence comes art, which could be purchased and placed in the home for pleasure and recognition of one's status. Secular art flourished as many familiar genres in painting, such as landscapes, portraits, and city scenes, became hallmark examples of Dutch art. Further evidence of the interest in trompe l'oeil art was the perspective box in which the interior was painted on the sides and floors in such a manner that when one looked through a peephole, the beholder was presented with the illusion of seeing an interior of a home in 3-D.[7]

Among the Dutch artists of this era, Johannes Vermeer best exemplifies the exquisite rendering of realism in painting. As shown in *The Music Lesson* (see Figure 2.4), Vermeer excelled in depicting people in interior settings, as if we are voyeuristically privy to a private moment. The spatial realism is enhanced by what appears as an exact rendition of geometric perspective. Indeed, art scholars have suspected that Vermeer used optical aids, such as a camera obscura, to help trace his scenes. In one analysis, Philip Steadman[8] created miniature 3-D models of scenes depicted in Vermeer's paintings. The construction of such models is complicated by the fact that the shape of objects depends critically on

FIGURE 2.3 Tilt-shift illusion. Photograph courtesy of Samuel House.

By restricting these cues to depth, psychologists have shown that a realistic picture can provide a rather convincing illusion of a 3-D scene. To prevent binocular stereopsis, subjects must view stimuli with one eye. Convergence can be controlled by having photographs appear at a far enough distance so that eye rotation is minimized. Accommodation can be controlled by having subjects look through a small aperture, which acts as an artificial pupil. Finally, the head can be stabilized to prevent motion parallax. Under such restricted viewing, a photograph of a room can look so real that subjects can accurately throw a ball at targets as if they were actually viewing a real 3-D environment.[3]

Even when viewing 2-D images naturally, it is possible to "fool the eye." In art, the term *trompe l'oeil* (French for "trick the eye") is used to describe artworks that create a strong illusion of spatial depth. For the full impact of the illusion, these artworks are best viewed from a specific position. In some cases the illusion of depth can be very powerful. A superb example of trompe l'oeil can be found in the Santa Maria presso San Satiro, a small church in Milan, Italy. As you enter from the rear, you see a front chamber as a rather expansive area with a barrel vault ceiling and retreating pillars. In reality, this area is a flattened scene painted by the Renaissance architect Donato Bramante only to appear as if it extends in depth. Exaggerated converging lines painted on the ceiling create the illusion of an expansive barrel vault, though this "space" is actually only two-and-a-half feet in depth. When viewed more closely and from the side, the illusion disappears, as the trick only works from a specific viewpoint.

A Point of View

As described by the mimetic approach, we relish a painting that presents a scene in a realistic manner. To create such views, artists must acquire extensive

us, and these displacements produce slightly different images projected onto our two eyes, a phenomenon known as binocular stereopsis. As a demonstration, look at your index finger at arm's length with one eye and then with the other. Notice that your eyes receive slightly different images as evidenced by the difference in the position of your finger relative to the background. Despite receiving these different images from your eyes, your brain fuses them into one. The extent of the mismatch of objects seen in each eye is actually a cue to depth. The greater the displacement of an object between views (such as your index finger relative to the background), the closer the object is to you. A popular toy in the 1960s was the *View-Master*, which showed photographic slides that appeared to exhibit spatial depth (i.e., photographs in 3-D). The toy simulated binocular stereopsis by presenting slightly different images to each eye that when fused produced the impression of depth. Movies presented in 3-D use the same method. Such artificial methods do not give a truly realistic 3-D quality, as objects do not appear to extend smoothly into the distance. Moreover, binocular stereopsis only provides a strong cue to depth for objects that are within 10 to 20 feet from you.

Other physiological processes give us cues to the spatial relationship of objects. For example, fixate with both eyes onto your outstretched finger and keep looking at it as you move your finger closer. As you do this your eyes will rotate in their sockets. The amount of rotation or *convergence* offers a cue to distance. Also, as mentioned above, with your iris, pupils can vary in size, between 2 and 4 mm in diameter, a process called *accommodation*. Pupil size can affect how much of the visual scene is in clear view. Photographers know this optical property as *depth of field*. Small apertures enable more objects at various distances to be in focus. At close range, such as looking at objects on your desk, there is a limit to the depth of field, and if you fixate on one close object, others at different distances will appear out of focus. A curious visual illusion, known as the *tilt-shift* illusion, plays on this phenomenon (Figure 2.3). One can take a photograph of a distant scene, such as a street scene, so that all of the objects are in focus. If one then blurs the outer edges of the image so that only one "fixation" area is in sharp focus, much like we would see objects on our desktop, then the objects in the scene actually appear as if they are small and toylike.[2]

A fourth cue to depth operates when we move around. Look at your outstretched finger with one eye and move your head from side to side. You will notice that the background will move with you, whereas your finger appears to move in the opposite direction. This phenomenon is called *motion parallax*. Of course, if you were viewing a life-sized photograph of your outstretched finger, motion parallax would not occur as the position of your finger against the background will stay fixed. Thus, by moving about we can readily perceive differences between a real world scene and a photograph of it, as real world objects appear to move at different speeds depending on their distance from us.

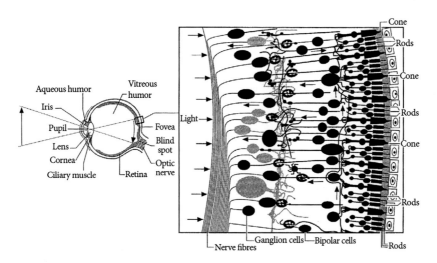

FIGURE 2.2 The eye and retina. From Solso, Robert L. *Cognition and the Visual Arts*. Figure 1.12 (p. 18). © 1994 Massachusetts Institute of Technology, by permission of MIT Press.

to adjust completely to low-light conditions. You may have observed latecomers entering a darkened movie theater fuddling about blindly as they look for seats, though you see them quite clearly. In this situation, your vision is much more sensitive because your rods have already adjusted to the darkness.

Whereas the optics of a camera and eye are similar, the manner in which light is further "processed" by the brain is quite different from any camera. As shown in Figure 2.2, a complicated network of retinal neurons (e.g., bipolar and ganglion cells) send electrochemical signals from the photoreceptors to the cortex. Oddly, these neurons are positioned in front of the photoreceptors in such a way that light coming into the eye must pass through them, though they are relatively translucent. If flattened, the retina is only 5.6 centimeters in diameter. Thus, the entire visual world is projected onto a very small canvas. Even worse, sharp visual acuity is restricted mainly to the fovea, which is a mere 1 mm in diameter. We are not aware of the rapid reduction in visual acuity in the periphery, as eye movements and our brains work to give us the impression of a visual scene that is stable and fully focused. In reality, our acuity is so poor that as you read this text you can perceive at most only three or four words at any given moment.

In Depth

Despite the similarities in viewing a natural landscape and viewing a painting (or a photograph), we can easily distinguish between reality and art. When we view a real scene, objects are physically located at various distances from

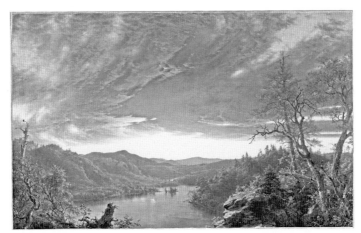

FIGURE 2.1 Church, Frederic Edwin (American, 1826–1900), *Twilight in the Wilderness* (1860). Oil on canvas, 124 × 185 centimeters. The Cleveland Museum of Art. Mr. and Mrs. William H. Marlatt Fund 1965.233. (See color plate section.)

small tabletop viewers, while others were chambers large enough so that the artist could stand inside and trace images projected onto a surface. Even today, at tourist sites in Edinburgh and San Francisco, you can enter a room-sized camera obscura and view the outside world projected onto a flat surface.

Sensing Light

If you made the hole in your camera obscura slightly larger and placed lenses at the opening, you would have the makings of a camera and a crude model of the optics of the eye. Both camera and eye start with a small opening referred to as the aperture on a camera and the eye's pupil (see Figure 2.2). The iris, which is the pigmented membrane that gives the eye its color (brown, blue, hazel), surrounds the pupil and changes its diameter, thus allowing more or less light into the eye. Two lenses help focus the image onto the retina (back surface) and increase the brightness of the projected image. The *cornea* is the larger lens at the front of the eye and contributes to most of the eye's focusing power. A second lens behind the cornea, called the *lens*, is used for fine-tuning, as its curvature is adjustable by tiny ciliary muscles around it. Through these optics, light rays invert so that the image projected is upside down.

The retina, like the back of a digital camera, is covered with a dense array of light-sensitive receptors. There are two types of receptors, *cones* and *rods*, which describe their shape (Figure 2.2). Cones are used primarily in bright light and are concentrated in the *fovea*, the central fixation point on the retina which gives us our sharpest area of visual acuity. There are three classes of cones, each sensitive to a different range of color frequencies. Rods are distributed in the periphery and operate only in dim light. It takes about 20 minutes for our rods

2. THE EYE AS CANVAS, THE BRAIN AS BEHOLDER

Consider the landscape painting *Twilight in the Wilderness,* by the American painter Frederic Church (Figure 2.1). Now imagine yourself actually standing at cliff's edge admiring this river valley at sunset. There is much in common when we look at a painting and when we look at the actual scene it depicts. Both begin with a flat image—one created by an artist and the other projected onto our retina by nature. In both instances we take a 2-D image and construct a 3-D spatial environment into which objects are placed at various distances from us. It is remarkable that from our miniscule retinal canvas, we are able to perceive with clarity and detail the world around us and, more importantly, move through it with extraordinary ease. We begin the art of seeing with light projected to the back surface of the eye. We will come to appreciate how much that image is "processed" as the brain takes over.

■ Camera Obscura

Find an empty soda can and cut it in half. Take the bottom half and make a tiny pinhole at the center of the bottom using a small nail and hammer. Get a piece of a white plastic grocery bag (or some other translucent sheet), and place it over the large opening securing the sheet tightly with black electrical tape. Tape the two halves back together making sure that light cannot leak in from the sides. Point the pinhole toward a sunny scene and look inside the can from the top opening. You should see a dim upside-down image of the outside world projected onto the sheet[1]. You have just built a *camera obscura* (Latin for dark chamber). Descriptions of such devices were made as early as the fourth and fifth century BC by Aristotle and the Chinese philosopher, Mo Jing. By the seventeenth century, sophisticated versions were built as artist's aids. Some were

ACT I

THE ART OF SEEING

23 Berlyne, D. E. (1971). *Aesthetics and Psychobiology*. New York: Appleton-Century-Crofts.

24 Gardner, H. (1987). *The Mind's New Science*. New York: Basic Books. Miller, G. A. (2003). The cognitive revolution: A historical perspective. *Trends in Cognitive Science, 7*, 141–144. Norman, D. A. (1980). Twelve issues for cognitive science. *Cognitive Science, 4*, 1–32.

25 Gombrich, E. H. (1960). *Art and Illusion* (p. 73) Princeton, NJ: Princeton University Press.

26 Some use the term *schemata* for the singular form, though here we will use *schema* for both singular and plural forms.

27 Rensink, R. A., O'Regan, J. K., & Clark, J. J. (1997). To see or not to see: The need for attention to perceive changes in scenes. *Psychological Science, 8*, 368–373.

28 Ramón y Cajal, S. (1989). *Recollections of My Life*. Cambridge, MA: MIT Press.

29 Ramón y Cajal, S (1911). *Nerveux de l'Homme et des Vertebretes*, Vols. 1 and 2. Paris: A. Maloine.

30 Brodmann, K. (1909). *Vergleichende Localisationslehre der Grosshirnrinde in ihren Prinzipien dargestellt auf Grund des Zellebaus*. Leipzig: Barth.

31 Livingston, M. (2002). *Vision and Art: The Biology of Seeing*. New York: Harry N. Abrams.

32 Fairhall, S. L., & Ishai, A. (2008). Neural correlates of object indeterminacy in art compositions. *Consciousness and Cognition, 17*, 923–932. See also Vessel, E. A., Starr, G. G., & Rubin, N. (2012). The brain on art: Intense aesthetic experience activates the default mode network. *Frontiers in Human Neuroscience, 6*, Article 66; Nadal, M., Munar, E., Capo, M. A., Rossello, J., & Cela-Conde, C. J. (2008). Towards a framework for the study of the neural correlates of aesthetic preference. *Spatial Vision, 21*, 379–396. Vartanian, O., & Goel, V. (2004). Neuroanatomical correlates of aesthetic preference for paintings. *NeuroReport, 15*, 893–897.

33 As we will be dealing exclusively with the beholder's experience, it suffices to assert that *The Artist* is a human, because intention is a human characteristic (though a human could offer for aesthetic evaluation an artwork painted by some other animal or by a computer). *The Artwork* must be sensed and thus cannot be a thought or dream (though a written or visual description of a thought or dream would suffice as an artwork).

7 For further development on an expressionist approach, see Robinson, J. (2005). *Deeper Than Reason: Emotion and Its Role in Literature, Music, and Art*. New York: Oxford University Press.

8 Greenberg, C. (1965). Modernist painting. *Art and Literature, 4*, 193–201.

9 Roche, H.-P., Wood, B., & Duchamp, M. (Eds.). (1917). *The Blind Man, Vol. 2*. New York City.

10 Duchamp's Urinal Tops Art Survey, *BBC News* [Online]. Rev. December 1, 2004. Retrieved from http://news.bbc.co.uk/2/hi/entertainment/4059997.stm.

11 After making this term up, I came across a similar usage in Piper, A. (October 1973). In support of meta-art. *Artforum, 12*, 79–81. Also relevant is an analysis by Kosuth, J. (1975), *The Fox, 1*, 87–96.

12 Conrad, N. J. (2009). A female figurine from the basal Aurignacian of Hohle Fels Cave in southwestern Germany. *Nature, 459*, 248–252. Interestingly, in the same cave was found a bone flute crafted during the same time and thought to be the oldest known musical instrument.

13 As used here and throughout the book a conceptual approach is not meant to refer only to the twentieth century genre known as "conceptual art." Instead, whenever we consider the meaning of an artwork, we are applying a conceptual approach.

14 Goodman, N. (1976). *Languages of Art*. Indianapolis, IN: Hackett Publishing Co.

15 Langer, S. (1942). *Philosophy in a New Key*. Cambridge, MA: Harvard University Press.

16 Tom Wolfe (1975). *The Painted Word* (p. 6). New York: Bantam Books.

17 For further discussion on the viability of a science of aesthetics, see Shimamura & Palmer (2012).

18 Fechner, G. T. (1907). *Elements of Psychophysics*. Leipzig: Druck und Verlag von Breitkopf, & Hartel.

19 Fechner, G. T. (1876) *Vorschule der Aesthetik*. Leipzig: Druck und Verlag von Breitkopf, & Hartel.

20 The following are excellent books on the psychology of art. Funch, B. S. (1997). *The Psychology of Art Appreciation*. Denmark: Museum Tusculanum Press. Kreitler, H., & Kreitler, S. (1972). *Psychology of the Arts*. Durham, NC: Duke University Press. Solso, R. L. (1994). *Cognition and the Visual Arts*. Cambridge, MA: MIT Press. Winner, E. (1982). *Inverted Worlds: The Psychology of the Arts*. Cambridge, MA: Harvard University Press.

21 Koffka, K. (1922). Perception: An introduction to the Gestalt-theorie. *Psychological Bulletin 19*, 531–585. Wertheimer. M. (1932), Untersuchungen zur Lehre von der Gestalt II, *Psycologische Forschung, 4*, 301–350. Translation published in Ellis, W. (ed.). (1938). *A Source Book of Gestalt Psychology* (pp. 71–81). London: Routledge & Kegan Paul.

22 Arnheim, R. (1974). *Art and Visual Perception*. Berkeley: University of California Press.

artist's intention (I) to offer an artwork for aesthetic evaluation and the behold-
er's share with respect to sensations, knowledge, and emotions (SKE).

Throughout this book, we will consider the beholder's experience in terms
of how the mind and brain interpret artworks. The chapters are divided into
three sections: *The Art of Seeing*, *The Art of Knowing*, and *The Art of Feeling*,
which correspond to the I-SKE framework. It will be useful to refer back to
the model on occasion, as it provides a schema for the information presented.
Importantly, we must accept that our experience with art is varied and can be
approached in different ways. Moreover, we never view art in a vacuum but
instead use our knowledge to guide experiences. In the following chapters, we
will explore how brain processes operate and interact to enhance the way we
experience art.

■ Endnotes

Portions of this chapter were previously published in Shimamura (2012).
Approaching a science of aesthetics: Issues and ideas. In A. P. Shimamura &
S. E. Palmer (Eds.). *Aesthetic Science: Connecting Minds, Brains, and Experience*
(pp. 3–28). New York: Oxford University Press.

■ Notes

1 Barasch, M. (1998). *Theories of Art: Vol. 3, From Impressionism to Kandinsky*.
 New York: Routledge.

2 Shimamura, A. P. & Palmer, S. E. (Eds.). (2012). *Aesthetic Science: Connecting
 Minds, Brains, and Experience*. New York: Oxford University Press.

3 Gopnik, B. (2012). Aesthetic science and artistic knowledge. In A. P. Shimamura
 & Palmer, S. (Eds.).*Aesthetic Science: Connecting Minds, Brains, and Experience*
 (pp. 129–159). New York: Oxford University Press.

4 Dissanayake, E. (1992). *Homo Aestheticus*. Seattle, WA: University of Wash-
 ington Press. Dutton, E. (2009). *The Art Instinct*. New York: Oxford University
 Press. Turner, M. (Ed.). (2006). *The Artful Mind*. New York: Oxford University
 Press.

5 For more detailed information concerning philosophical approaches to art, see
 Barrett, T. (2008). *Why Is That Art?* New York: Oxford University Press. Beardsley,
 M. D. (1966). *Aesthetics from Classical Greece to the Present*. Alabama: University
 of Alabama Press. Graham, G. (2000). *Philosophy of the Arts: An Introduction to
 Aesthetics* (2nd ed.). New York: Routledge Press. Levinson, J. (Ed.). (2003). *The
 Oxford Handbook of Aesthetics*. New York: Oxford University Press.

6 Flam, J. (1995). *Matisse on Art* (p. 66). Berkeley, CA: University of California
 Press.

■ A Conceptual Framework for Experiencing Art

In this introductory chapter, we considered philosophical and scientific approaches to art. Aesthetic experiences can be captured in the ways in which we evaluate art, which include: (1) a mimetic approach —how well does an art-work portray realistic scenes?; (2) an expressionist approach—how well does an artwork evoke emotional responses?; (3) a formalist approach—how well does an artwork highlight sensations?; and (4) a conceptual approach—how well does an artwork represent thoughts or conceptual statements? The beholder may consider art from any or several of these approaches.

Shown in Figure 1.12 is a flow diagram that describes the way we experience art. The *Artist* has the intention to offer an *Artwork* for aesthetic evaluation. Various definitions of Artist and Artwork could be discussed ad infinitum. I will simply assert that the Artist is a human and the Artwork must be sensed.[33] Our essential concern is how we experience art—that is, the beholder's experience. I argue that the beholder's experience is best understood by considering the ways in which an artwork enhances sensation, knowledge, and emotion. These three psychological processes relate directly to the approaches we have considered. Mimetic and formalist approaches emphasize sensation, conceptual approaches emphasize knowledge, and expressionist approaches emphasize emotion. I will refer to this framework as the I-SKE model, capturing the

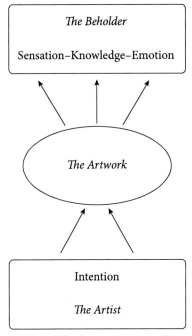

FIGURE 1.12 The I-SKE Model of our art experience (adapted from Shimamura, 2012).

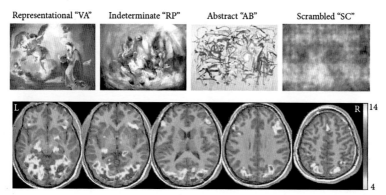

FIGURE 1.11 In a fMRI study, subjects viewed various types of paintings (representational, indeterminate, and abstract) and a scrambled visual image (*top row*). Brain images (*bottom row*) show horizontal scans at five levels with heightened activations when the viewing of paintings is compared to the viewing of a scrambled visual image. Reprinted from Fairhall, S. L., & Ishai A. (2008). Neural correlates of object indeterminacy in art compositions. *Consciousness and Cognition*, *17*, 923–932. Copyright (2008) with permission from Elsevier. (See color plate section.)

in a style midway between representational and abstract art, as there are object-like forms in the painting (see Figure 1.11). Individuals were shown paintings one at a time and asked whether they recognized any familiar objects. In the lower panel of Figure 1.11 are horizontal scans at five levels of the brain (from lowest to highest scan) with activations shown as colored regions (brighter colors indicate greater activity). These fMRI scans represent the activity observed during all three types of paintings compared to the activity observed during scans when individuals viewed scrambled scenes (SC). As shown in the fMRI scans, there is a pattern of activation that included multiple brain regions, though predominantly in the posterior cortex along the ventral ("what") visual path.

An important point about fMRI analyses is that the brain regions shown to be active depend critically on what you ask the individuals to do. In the Fairhall and Ishai study, individuals were asked to try to recognize objects in the paintings. One could have instead asked them to rate their aesthetic judgment or determine the emotional impact of a painting. The particular task or cognitive process used during scanning will have important and interesting influences on brain activity. Another point is that for any complex behavior, such as looking at paintings, we would not expect to see just one brain region active. There is not an "I'm-looking-at-art" brain region. Instead, there is a pattern of brain activity at multiple sites that is involved in registering various aspects of aesthetic experiences.

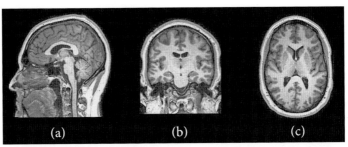

FIGURE 1.10 The author's brain as seen by MRI: (*a*) sagittal view, (*b*) coronal view, and (*c*) horizontal view.

In fMRI, the scanner detects changes in blood oxygen levels, allowing neuroscientists to visualize brain regions that have recently been active. At any given moment, however, there are tens of thousands of neurons active just to keep us alive, such as allowing us to regulate heart rate, respiration, and body temperature. Other neurons are processing what is happening at the moment, such as perceiving, thinking, and feeling (the myth that we use only 10% of our brain at any given moment is in fact a myth). An image of the brain's overall activity would not be very informative as we would not know which areas are related to a specific mental process and which are active merely to keep us alive.

To identify brain regions specific to a task or cognitive process, neuroscientists take fMRI scans from one condition and compare them to another. For example, one could compare scans when individuals have their eyes open with scans when they have their eyes closed. By subtracting the eyes-open scans from the eye-closed scans, one can assess brain activity that is specific to having the eyes open. All other activity would be cancelled out because they would have occurred during both conditions. In such comparisons, brain regions involved in vision, such as V1, are particularly active in the eyes-open condition compared to the eyes-closed condition. This subtraction method has allowed neuroscientists to identify brain areas that are related to specific processes. Importantly, whenever one sees an fMRI scan, the image is showing brain activity from one condition over and above another "baseline" condition. Thus it is not the case that the bright areas in a fMRI scan are the only brain areas active at a given moment.

The application of fMRI to study human behavior has completely changed psychological science. Now we can readily relate mental processes to brain activity, and exciting new discoveries of brain-behavior relationships have emerged. Fairhall and Ishai[32] assessed fMRI activity while individuals viewed different kinds of paintings. In the scanner, individuals viewed representational art from various artists (VA), abstract art from various artists (AB), and "indeterminate" art by one artist, Robert Pepperrell (RP), who paints

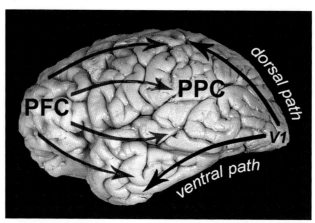

FIGURE 1.9 In the cerebral cortex, visual input enters at the most posterior region (V1) and is processed along two major pathways, the dorsal and ventral path. The prefrontal cortex (PFC) controls processing through feedback projections to posterior regions, such as the posterior parietal cortex (PPC) which acts as a convergence zone for multisensory integration. Brain image reprinted with permission from Digital Anatomist Interactive Atlas, University of Washington, Seattle, WA, copyright 1997.

connections to various posterior regions implements top-down processing by guiding sensory processes toward appropriate goals or actions. The combined influence of bottom-up sensory paths and top-down prefrontal cortex control enables us to interpret the sensory world and direct our attention to relevant features.

In recent years, the advent of sophisticated neuroimaging techniques has enabled neuroscientists to explore aspects of the mind that would have been relegated to science fiction only 20 years ago. Figure 1.10 shows the "exquisite" detail of my own brain as imaged by magnetic resonance imaging (MRI). The left image (Figure 1.10a), a sagittal scan, shows the medial (middle) surface of my brain as seen from the side. The center image (Figure 1.10b) is a coronal scan, which shows my brain as if one were looking directly at my face after having my head sliced from ear to ear. Figure 1.10c shows an axial or horizontal scan and shows my brain as if one were looking down at my head with it sliced from front to back a little above the eyes (the front of my brain is shown at the top). From these scans one can identify brain structures and differentiate gray matter (neuronal cell bodies) from white matter (the fibers that connect neurons). Note that the white matter fibers, best seen in the coronal and axial views, make up a large proportion of the human brain.

In functional MRI (fMRI), the scanner is tuned to detect subtle changes in blood flow. When a neuron becomes active it commands greater blood flow to specific regions, thus extracting oxygen from blood for energy.

FIGURE 1.8 Drawing of the rat hippocampus. Ramón y Cajal, S (1911). *Nerveux de l'Homme et des Vertebretes,* Vols. 1 and 2. Paris: A. Maloine.

visual paths and is also adjacent to regions that process auditory information. This region acts as a convergence zone that links or integrates information processing from different sensory paths. We engage the PPC when we use our imagination, such as thinking about the future or reminiscing about a past experience. The most anterior portion of the cortex, the *prefrontal cortex,* acts as a central executive officer (CEO) that monitors and controls activity. When one considers the cacophony of neural signals at any given moment it becomes obvious how important it is to have a mechanism that modulates and controls cortical activity. The prefrontal cortex with its feedback

Neuroscience

For over a hundred years, neuroscientists have investigated the workings of the brain, from analyses of individual neurons to the study of human brain activity. In the late nineteenth century, staining techniques were developed that enabled neuroscientists to visualize individual neurons in brain tissue so that their shape, size, and connectivity could be observed. Ramón y Cajal was one of the first to illustrate the exquisite detail of neurons.[28] As a youth, Cajal enjoyed drawing and actually wanted to be an artist. Yet through his father's rather forceful encouragement, he entered medical school. Shown in Figure 1.8 is Cajal's drawing of the rodent hippocampus, an area of the brain that is intricately involved in learning and memory.[29] The exquisite rendering and accuracy of his drawings made Cajal the premier artist of brain anatomy. His work offered glimpses of the complexity of brain circuitry and was acknowledged in 1906 when he won the Nobel Prize for detailing the anatomy of the brain.

In 1909, Korbinian Brodmann[30] published a seminal atlas of the human cerebral cortex. The cortex ("bark" in Latin) is the outer sheet of neurons that comprises most of the surface of the human brain. The convoluted topography of the cortex, with its ridges (gyri) and valleys (sulci), is caused by fitting a rather large and flexible sheet of neurons into the curved space within the skull. If the cortex were flattened, it would be equivalent in area to an extra large (very thin) pizza (about 20 inches in diameter, 2 mm thick). Brodmann analyzed the shape and density of neurons in different parts of the cerebral cortex and identified 52 distinct areas, zip codes if you will, that are defined by their structural properties. These regions are known as Brodmann areas, and we still use them to identify cortical areas.

Brodmann showed that the cerebral cortex is not a homogenous sheet of neurons. From his studies, we now know that different regions in the cortex have distinct functional properties. Much like a large business or corporation, there is a division of labor such that some cortical regions serve sensory processes, others are involved in storing what is experienced, and still others are involved in attaching emotion to sensations, thus determining which stimuli are good and which are dangerous. Visual information enters the cerebral cortex at the most posterior end, identified as V1 (see Figure 1.9). From there, visual processing proceeds along two main pathways—a ventral (lower) path that courses down through the temporal lobes and a dorsal (upper) path that extends up through the parietal lobes. The ventral or "what" path is involved in identifying and recognizing objects. The dorsal or "where" path is involved in space perception. The ventral and dorsal paths work independently to some degree, yet together help to construct a spatial scene with recognizable objects within it.[31]

Recent advances have identified an important region called the *posterior parietal cortex* (*PPC*), which is situated between the ventral and dorsal

about the sensory inputs we encounter at any given moment. Such processes are so ingrained that we are not always conscious of using knowledge as we perceive the world around us.

Consider the image shown in Figure 1.7b. If you have never seen this image before, it will be extremely difficult to recognize any meaningful objects from the scattered black and white blotches. You may try to figure out what is depicted from the forms, but without clues to scale or content, it is quite difficult because you are only given fragmented bottom-up information. The image is actually a high contrast picture of the head of a cow, with dark areas forming the cow's ears, eyes, and snout. Once you *know* what to look for, the head is fairly easy to see. That is, knowledge guides attention and orients you to critical features that allow you to perceive. This is top-down processing as knowledge is driving sensations.

Ernst Gombrich, the noted art historian, was the first to apply principles of cognitive science to our understanding of art and aesthetics. In his seminal book *Art and Illusion*,[25] he emphasized the importance of top-down processing when we look at art. Gombrich considered background personal and cultural knowledge as the *beholder's share* in the art experience. He applied the psychological concept of *schema*[26] to characterize how prior knowledge influences aesthetic experiences. Schema are conceptual frameworks or road maps that we use to guide perception and understanding. They form the basis for predictions and assumptions about what we expect to see. For example, as you enter a movie theater you apply a schema that outlines a sequence of expected events, such as standing in line, paying for a ticket, entering a darkened room, finding a seat, and enjoying a moving picture. Gombrich applied findings from psychology, art history, and philosophy in his analysis of the beholder's share and in particular how schema influences the way we interpret art.

Interest in the cognitive science of aesthetics has gained in recent years, particularly with the commercial application of digital animation and web design. Digitally generated scenes depend on computer models of chiaroscuro, which cognitive scientists call *shape from shading*, which have provided realistic animations used successfully in movies and video games. In web design, commercial ventures depend on attracting and maintaining clients to their sites. People tend to dislike modifications in the color and style of frequently visited websites. Web designers appreciate this sentiment and apply findings from cognitive science to reduce the impact of design alterations. For example, cognitive studies of *change blindness*[27] show that seemingly obvious alterations of visual displays can go unnoticed when they are done gradually, one feature at a time. In 2008, Yahoo.com gradually introduced a new look to their home page by subtly changing features across days. Similarly, eBay.com took 30 days to change its background from gray to white. It is likely that many did not notice these changes. Cognitive science can address the manner in which we process sensory experiences, including our experiences with artworks.

inputs, stores information, and performs computations, the mind could be viewed as a similarly programmable device that takes in sensory information, recognizes objects and speech, and remembers events. Psychologists thus began to consider mental (i.e., cognitive) processes from an *information processing* approach. During the 1960s and 1970s, this approach became so pervasive across all domains of psychological science that we often regard this era as the *cognitive revolution.* It soon became apparent, however, that a full understanding of cognition required scholarly analyses beyond those considered within the domain of psychology. Thus, *cognitive science* emerged as a multidisciplinary approach that also considered advances in computer science, neurobiology, philosophy, anthropology, and linguistics.[24] The goal of the cognitive scientist is to study mental abilities from an information processing perspective. Such a view does not purport that the brain is literally a digital computer. Instead, the computer is viewed as a metaphor for the way information is encoded, stored, and retrieved in the brain. With the reliance of this computer metaphor, aspects of emotions were neglected. However, it soon became evident that emotion plays an important role in driving human cognitive processes.

One essential feature of human cognition is *top-down processing,* which refer to our use of knowledge to direct what we perceive (see Figure 1.7a). Early on, cognitive scientists adopted a purely bottom-up view of cognition, such as starting with sensory input (the bottom), and then piecing the data together into meaningful information, such as being able to locate your car in a parking lot. Computer engineers once thought they could build human-like robots that could recognize objects simply on the basis of bottom-up processing, perhaps starting with an image from a video input and segregating the image into recognizable objects. Although these bottom-up models could function in very restricted domains, it soon became apparent that the way we interpret complex, everyday visual scenes depends largely on imparting our knowledge onto what we see. We are always using top-down processing to help us make predictions

FIGURE 1.7 (*a*) Bottom-up and top-down interactions between sensation and knowledge. (*b*) The object depicted is difficult to recognize without top-down knowledge (see text).

Koffka and Wolfgang Köhler, these psychologists adhered to the well-known Gestalt credo that the whole is more than the sum of its parts.[21] For a Gestalt psychologist, the perceptual world is ambiguous and subject to many different interpretations. Thus it is the way viewers organize or interpret a visual scene as a whole that determines how it is perceived.

The psychologist, Rudolf Arnheim, extended Gestalt principles to analyses of art and aesthetics. In his seminal book *Art and Visual Perception*,[22] he described how artworks conform to Gestalt principles in the way we group and organize objects in a scene. He analyzed paintings with respect to the "perceptual forces" that artists create through object placement, balance, and harmony. Such forces can evoke a sense of perceptual calm or tension. For example, a circle placed at the center of a rectangle is balanced and reduces tension, whereas a circle moved to one side heightens tension. A Gestaltist view can accommodate such interpretations, because it is the organization of visual elements that yields a unique perception rather than any specific one. Arnheim did not emphasize the emotional expressiveness of tension-reducing or tension-heightening features, perhaps because Gestalt principles were based on perceptual dynamics inherent in the stimulus rather than a part of the beholder's emotional disposition.

Other psychologists studied the way art impinges on our emotions. Daniel Berlyne[23] evaluated aspects of perceptual tension in terms of the way we prefer some artworks over others. He suggested that aesthetic experiences are influenced by the degree to which we accommodate tension or arousal. Consider a new painting that you have just encountered. If it does little to arouse you or causes minimal tension, then you will probably feel rather indifferent to it. On the other hand, if the painting is terribly arousing or causes too much tension, it may be interpreted as too disturbing and ugly. According to Berlyne, optimally pleasing artworks are those that create some arousal but not so much as to create discomfort. He suggested that arousal is determined by an artwork's psychological features, such as its novelty, complexity, surprise, uncertainty, and incongruity.

Since Fechner's initial foray into a scientific approach to aesthetics, empirical analysis regarding the psychology of art has had periods of growth and stagnation. Arnheim, Berlyne, and many others have stimulated interest in the field and have offered important theoretical frameworks. Various perceptual and emotional features have been analyzed and will be discussed in subsequent chapters. Interestingly, the ways in which our knowledge contributes to aesthetic experiences have been less well studied, though recently some have considered such things as cross-cultural influences or the role that familiarity plays on aesthetic judgments.

Cognitive Science

In the 1950s, the advent of the digital computer offered an intriguing device that could be used to model psychological processes. Just as a computer receives

by evaluating small-scale models of wind currents. Heart disease is studied by evaluating the structure and processes of individual biochemicals. Aesthetics has been studied by assessing basic features of art, such as preferences for colors and elemental shapes. Psychologists (and neuroscientists) have even studied the complexities of viewing drawings, paintings, and other artworks.

Science offers a means of analyzing the beholder's experience, though you might ask, how could one explain in scientific terms what happens when we view a Leonardo or Picasso? Psychologists have, for over a century, analyzed the nature of perception, memory, and emotion, and now with advances in brain imaging, we can visualize the brain regions active during complex experiences. Often the complexities of our daily perceptual, conceptual, and emotional experiences are distilled in the laboratory by investigating pieces of such experiences. With respect to experiencing art, science may not answer all pertinent questions, though it can and has helped to explain many aspects. In this section, methods and findings from psychological science, cognitive science, and neuroscience are introduced as a way to motivate an *aesthetic science*.[17]

Psychological Science

In 1860, Gustav Fechner set out to develop a *psychological* science, which he called *psychophysics*,[18] an apt term as he was interested in how the physical world is translated into psychological experience. He, along with others such as Ernst Weber and Hermann von Helmholtz, studied human perception with mathematical rigor, much like the way an engineer might try to understand the optics of a camera. For example, these scientists studied the smallest amount of light that one could detect or the ability to discriminate different colors.

Fechner also established the first research program in aesthetic science. In 1876 he published *Vorschule der Aesthetik (Primer of Aesthetics)*,[19] an extensive volume in which he applied his new methods to our appreciation of art. Fechner argued that aesthetics should be studied empirically from the bottom up (*von Unten herauf*). That is, rather than developing lofty philosophical concepts about beauty and art, Fechner studied preference for elemental perceptual features that lead to pleasurable experiences. He conducted experiments on preferences for different colors and basic shapes. By understanding our hedonic response to these basic perceptual elements, Fechner hoped to build a psychological science of aesthetics. He paved the way for many empirical investigations in the psychology of art.[20]

One could argue that the piecing together of the various elements that drive preferences (e.g., to colors or basic shapes) will not lead to a full understanding of the complexities of art. Indeed, Gestalt psychologists during the early twentieth century was founded on the principle that experiences cannot be broken down into elemental features and must be considered as a whole. Founded by the German psychologist, Max Wertheimer, along with his associates, Kurt

understand the language and history of art. Nelson Goodman's *Languages of Art*[14] and Suzanne Langer's *Art in a New Key*[15] characterized this new approach wherein artworks are viewed as conceptual statements or symbolic representations.

If art is a language or symbol system used to describe itself, then the aesthetic value of an artwork is diminished and perhaps even eliminated. That is, meta-art becomes exceedingly close to nonfiction writing—a vehicle for transmitting a conceptual point. In this way, it is not the artwork you receive, it's the thought that counts. In his amusing and incisive treatise *The Painted Word*, Tom Wolfe described his epiphany when he realized that we can only appreciate modern artwork by understanding the theoretical position embodied by it. As he stated: *"Not 'seeing is believing,' you ninny, 'believing is seeing.'"*[16] With a conceptual approach, the beholder must "read" the meaning behind an artwork. As a result, an artwork has the potential of being interpreted in a variety of ways. One could consider Freudian symbolism in the artist's portrayal of sexual symbols. One could read an artwork in terms of the sociological or political symbols it portrays. Does it represent issues of class or ethnic struggles? Does it reflect a misogynist view? With a conceptual approach, the artist symbolizes theoretical issues and the beholder interprets them.

In summary, beholders have, over the centuries, approached artistic creations from various perspectives. With a mimetic approach, the beholder interprets an artwork as a window to the world and evaluates the degree to which it succeeds in depicting realistic scenes and events. With an expressionist approach, the beholder seeks an emotional experience, such as beauty or the sublime. With a formalist approach, rather than seeing objects or scenes within an artwork, the raw sensual qualities of colors, lines, and abstract shapes are brought to the forefront. With a conceptual approach, it is the thought or story behind an artwork that is crucial. Today, as we stroll though an art gallery, we may adopt any one or all of these approaches. Thus, anything goes, from interpreting mimetic representations to conceptual meta-art statements. Importantly, these approaches highlight aspects of the beholder's mental processes, such as sensory processes with mimetic and formalist approaches, emotional processes with expressionism, and memory or thought processes with a conceptual approach.

■ The Science of Aesthetics

We *experience* art, and thus scientific analysis of how we engage ourselves mentally is essential in our understanding of aesthetic responses. From this perspective, we must consider psychological science, and moreover the biological mechanisms that underlie our aesthetic response to art. In all scientific disciplines, experiments are conducted to evaluate models and theories that describe general principles of nature. For example, global weather patterns are studied

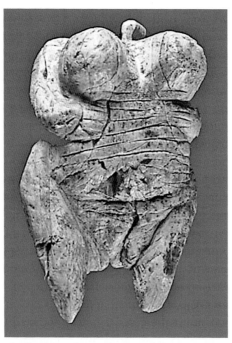

FIGURE 1.6 Female figurine from the basal Aurignacian of Hohle Fels Cave in southwestern Germany. Reprinted by permission from Macmillan Publishers Ltd: *Nature, 459*, copyright 2009.

communicating with supernatural forces, such as making a plea for food, fertility, or other survival need. Take for example, the recently excavated figurine given the name *Venus of Hohle Fels* (Figure 1.6).[12] This statuette made of mammoth ivory depicts a woman with exaggerated breasts and hips and was likely used to symbolize fertility. It was exquisitely carved approximately 35,000 years ago and is considered one of the earliest works of "art." (It predates the well-known *Venus of Willendorf* by at least 5000 years.) Such works are best considered from a conceptual approach, as it is the meaning of these creations that drives our interest. For these and, indeed, for any work of art, when we, as beholders, search for the underlying meaning of an artwork, we apply a conceptual approach.[13]

 With respect to twentieth century art, it took the art world several decades to appreciate fully the meaning of conceptual works such as *Fountain*. Duchamp offered these "ready-mades" (i.e., everyday objects that he proclaimed as art) primarily as Dadaist jokes, a way of teasing and rattling the art establishment. It was not until the latter half of the twentieth century that many artists began to express themselves as conceptual theorists interested in using art to define art. The goal of such postmodern artists is in many ways similar to the goal of a philosopher—namely to conceptualize and characterize the nature of art. Rather than writing philosophical tomes about the meaning of art, the postmodern artist uses art itself to make a point about it. To interpret postmodernist works, one needs to

photograph of *Fountain* was published with an article entitled, "The Richard Mutt Case." The article stated:

> Whether Mr. Mutt with his own hands made the fountain or not has no importance. He CHOSE it. He took an ordinary article of life, placed it so that its useful significance disappeared under the new title and point of view—created a new thought for that object.[9]

Fountain was discarded, and the only evidence of the original piece is a photograph by Alfred Stieglitz published in *The Blind Man*. Later in the 1950s, Duchamp commissioned several replicas, which are now displayed in prominent art museums. In 2004, a survey of 500 art experts voted *Fountain* as "the most influential modern art work of all time,"[10] thus surpassing any work by Picasso, Matisse, or Warhol. Why? Clearly, to consider the piece as a work of art, the very definition of art had to be radically changed. The urinal was not created by an "artist," not intended to express a sense of beauty, and not even intended to elicit a sense of significant form. Duchamp's intention was to make people *think* and question the meaning of art. You may find beauty and significant form in *Fountain*, but that certainly was not Duchamp's intention. His selection of a urinal was intended to disturb and disgust viewers, which adhered to his alliance with Dadaism, the art movement that intended to shock and poke fun at the beholder.

One could view *Fountain* as an early example of *postmodern* art. This term has many meanings beyond the fact that a work was created after *modern* art. One attribute of postmodernism is the role of the artist as a conceptual theorist who attempts with art to define the meaning of art itself. I will refer to this notion as *meta-art*[11] or art about art. Although some art historians would argue that all art is essentially a comment about art, I view the strong notion of meta-art as an outgrowth of early modernist views, which started with artists experimenting with the nature of the medium. Postmodern artists continued the quest by addressing the very nature or concept of art by extending its boundaries: Does art need to be created by an "artist"? Does it need to be beautiful or have significant form? Can one distinguish art from nonart? Postmodernism, which some suggest is still with us, intellectualizes the practice of art. It is thus anti-expressionist, antiformalist, and indeed anti-aesthetic. Issues of beauty, significant form, and other aesthetic (e.g., sublime) experiences give way to conceptual statements about the meaning of art.

Long before postmodern art, indeed long before Plato's conceptualization of a mimetic approach, a conceptual approach was practiced, as evidenced by prehistoric paintings displayed in deep underground caverns and by "artworks" placed in tombs or found in archeological digs of ancient cultures. Although it is not entirely clear what function these artifacts had for their original creators, many were not even designed for human beholders. Instead, these artistic creations were most likely made to symbolize a concept or act as a way of

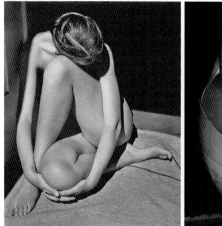

FIGURE 1.5 Weston, Edward. *Left*: *Nude* (1936), gelatin silver print by Cole Weston. *Right*: *Two Shells* (1927), gelatin silver print by Cole Weston. From the collection of Arthur P. Shimamura.

formalist approach as they discounted content and emphasized the interplay of lines, shadings, and forms. Consider two of Edward Weston's photographs (Figure 1.5). These images, one of a nude and the other of shells, have little in common in terms of content or objects depicted but have much in common in terms of the lines, contours, and shape that give the objects their form. In other words, these images express aesthetic appeal in terms of significant form. We are not asked to "look at the woman" or "look at the shells," we are instead invited to consider the flow of the lines, shapes, and shadings in an abstract manner. Formalism describes this approach to art, as we suspend attempts at deriving meaning from the objects depicted and instead experience the objects represented as raw sensory impressions.

The Conceptual Approach: It's the Thought That Counts

In 1917, Marcel Duchamp submitted a piece entitled *Fountain* to an art exhibition sponsored by the Society of Independent Artists, a group of avant-garde artists who eschewed juried exhibitions and awards. The piece was actually a men's urinal that Duchamp bought at the J. L. Mott Iron Works in New York City. For his "artwork," Duchamp merely turned the urinal on its back and signed the piece with the pseudonym R. Mutt. The Society stated that they would show all submitted works, though *Fountain* was never exhibited, as some board members refused to consider the piece as art. If one claimed *Fountain* was art, then Mr. Mutt must be guilty of plagiarism, as the piece was obviously a commercially manufactured product. In *The Blind Man*, a short-lived publication edited by Marcel Duchamp, Beatrice Wood, and Henri-Pierre Roché, a

realistic representations to "impressions" of them. From these then-renegade painters we now appreciate that art can transcend reality. Post-impressionist artists such as Van Gogh, Gauguin, and Cézanne experimented further with the dissolution of realism by exaggerating color, perspective, and form. It is virtually impossible to appreciate a Van Gogh painting without noticing the force of his brush strokes and application of paint on canvas. For these artists, it was the nature of the sensory quality of paint and the representation of form that motivated their art.

Clive Bell, the art theorist, who, along with Clement Greenberg, defined the nature of modern art, described the essence of aesthetic experiences as the perceiving of *significant form*. For Bell, the purpose of art was not the depiction of realistic scenes, but instead the ability of the artist to magnify sensation—to give the artwork significant form. According to this *formalist* approach, the content of a painting is irrelevant; what is critical is the sensual quality of the lines, colors, and shapes produced by the artist. This approach offered a means of interpreting abstract art, because the objects depicted in a painting are irrelevant. From a formalist perspective, one appreciates an artwork solely on the basis of the raw visual stimulus—that is, the aesthetic interplay of colors, lines, textures, and shapes.

What motivated the shift from a mimetic approach to a formalist one? Historians have suggested that the advent of photography acted as a catalyst for this movement. Photography made realistic paintings look inadequate and outdated. By the 1860s, photographic snapshots were in the mainstream as evidenced by the popularity of the *carte-de-visite*, inexpensive postcard-sized photographs that could be kept as souvenirs or sent to family and friends. At the same time, landscape photographers, such as Carleton Watkins and Francis Frith, were showcasing magnificent views of distant lands. Why should an artist paint a realistic scene when a photograph could do the job with perfect rendering of perspective and shading? Given the popularity of the *carte-de-visite* and large-scale landscape photography, artists during this time period, such as the impressionists, may have decided to offer a different approach from that which could be accomplished by this new technology.

Ironically, art photographers during the nineteenth century tried to de-emphasize the exquisite detail of their medium and instead mimicked the appearance of paintings. To give their work an "artistic" feel, they created soft, out-of-focus images that emulated oil paintings or scratched their prints with fine needles to make them look like etchings. It was not until the twentieth century that "straight" photographers, such Edward Weston and Ansel Adams, used the medium to its fullest. These two photographers were part of "Group f.64," an informal cadre of photographers who advocated sharp focus and detail of form (the term f.64 refers to the lens aperture these photographers used to create extended depth of field in images). These photographers considered a

he rejected the traditional finishing touches that made paintings look like 3-D scenes. Consider Manet's *The Fifer* (1866) (Figure 1.4), which was rejected by the *Académie des Beaux-Arts* as a result of its failure to render a realistic sense of depth. The background is bare, with only a vague sense of where the wall ends and the floor begins. The representation of the young child is certainly recognizable, though the use of chiaroscuro is minimal, thus denying shaded contours that could define depth in the face and clothing. Critics at the time considered the painting crude and unfinished. If the purpose of art was to represent a natural, realistic figure in a 3-D space, then Manet failed miserably.

Yet *The Fifer* now stands prominently at the Musée D'Orsay and represents a significant breakthrough in the story of art. Manet's rendering of color and form, though odd with respect to the aesthetic temperament of his time, is bold and accentuated. Gone is the representation of spatial depth through linear perspective, gone is the extensive use of chiaroscuro to enhance depth, gone is the heavy glazing of paint in order to conceal brushstrokes. Manet emphasized the sensual quality of paint, which foreshadowed Impressionism, the tradition that he embraced later in his life.

From Manet's innovative style and on to Impressionism, we see the application of paint on canvas in a new and dynamic manner. Forms change from

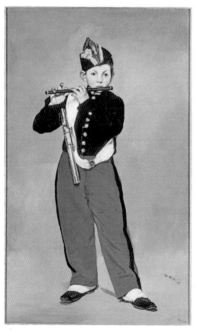

FIGURE 1.4 Manet, Édouard (1832–1883), *The Fifer* (1866). Oil on canvas, 161 × 97 centimeters. RF 1992. Photo: Hervé Lewandowski. Musee d'Orsay, Paris, France. Photo Credit: Réunion des Musées Nationaux / Art Resource, NY.

The term is misleading as it does not mean without interest. Instead, it refers to the appreciation of an object without reference to its function or other practical purpose, such as satisfying one's hunger, physical comfort, or sexual desire. According to Kant we approach art with the purpose of instilling a feeling of beauty or sublimity and nothing else; hence the saying, *art for art's sake*.

I suspect many people, when asked about the purpose of art, take a Kantian view and claim that art is meant to evoke a (disinterested) sense of beauty or sublimity in the beholder. The tradition of Romanticism, which flourished in the nineteenth century, exemplifies this viewpoint. A Beethoven symphony, a Wordsworth poem, or a Delacroix painting (such as *Liberty Leading the People* or *Death of Sardanapalus*) characterizes that pull-out-all-the-stops kind of expressionist art in which events or scenes are depicted as heroic and magnificently dramatic. Such works amplify emotions, thus going beyond the mere imitation of reality. A century later, Abstract Expressionism emerged as a nonmimetic style meant to represent the unadulterated embodiment of emotion. Artists, such as Wassily Kandinsky (see book cover), Jackson Pollock, and Helen Frankenthaler, created dramatic interplays of colors, lines, and shapes, thus putting on canvas their feelings as depicted by abstract designs. Many artists consider the representation of feelings as their primary motive. When asked about his view of art, Matisse stated: "Well, take that table, for example ... I do not literally paint that table, but the emotion it produces upon me."[6] With an expressionist approach, the beholder expects an artwork to evoke emotions.[7]

The Formalist Approach: Keying in on the Sensory Experience

During the second half of the nineteenth century, a new approach to art emerged. Artists began experimenting with the visual quality of their paintings and rejected the traditional techniques and skills used to create mimetic art. Artistic methods, such as linear perspective and chiaroscuro, were viewed by avant-garde artists during the mid-nineteenth century as mere tricks to create an illusion of the real world on canvas. Why should artists be required to paint the world as we see it? Clement Greenberg, the noted art critic, in his seminal treatise entitled *Modernist Painting* wrote:

> Realistic, illusionist art had dissembled the medium, using art to conceal art. Modernism used art to call attention to art. The limitations that constitute the medium of painting—the flat surface, the shape of the support, the properties of pigment—were treated by the Old Masters as negative factors ... Modernist painting has come to regard these same limitations as positive factors that are to be acknowledged openly.[8]

According to Greenberg, the essence of modern art is its flatness: the acknowledgment that the canvas is a 2-D surface on which paint is brushed, dripped, or smeared. Greenberg identified Manet as the first Modernist painter, because

Does everyone see beauty in the same way? The Latin phrase *De gustibus non est disputandum* ("About taste there's no disputing") sets the stage for David Hume's seminal essay *Of the Standard of Taste*, written in 1757. Hume considered a totally subjective view: "A thousand different sentiments, excited by the same object, are all right: Because no sentiment represents what is really in the object." Yet he rejected this position and argued that there are universal standards by which we evaluate and judge beauty. Good taste depends upon expert knowledge, training, and having a "delicate" sense. Moreover, the ideal beholder avoids personal prejudices and cultural biases. With such rules for guiding one's aesthetic experiences, Hume asserted that there is a common basis (i.e., a standard) for evaluating beauty.

Many regard Immanual Kant's writings about the mind as some of the most important works in Western philosophy. In his *Critique of Pure Reason* (first published in 1781), Kant wrote: "Though all our knowledge begins with experience, it by no means follows that all arises out of experience." By this view, Kant argued that there is more to our experiences than the lights, sounds, and smells that impinge on our senses. We interpret the world by linking sensory experience to preexisting concepts or ideas. In this way, Kant extolled a view that we are *cognitive* (i.e., thinking) beings. In *Critique of Judgment* (1790), Kant applied this notion to aesthetic experiences. He asserted that many things give us pleasure, such as fine food, a lovely home, and sex, but such things are appreciated for other reasons, such as sustenance, shelter, and procreation. Kant identified three means by which objects give us pleasure: they can be agreeable, good, or beautiful. Aesthetic judgments are specifically based on our evaluation of beautiful things. For Kant, beauty is an innate ideal that is shared by all individuals and is thus a universal concept. In this way, he echoed the sentiments of Baumgarten and Hume.

In addition to our appreciation of beauty, Kant considered sublime feelings as aesthetic experiences. When we experience the sublime, we develop an overwhelming feeling of boundlessness. Kant said we experience the sublime when we appreciate the immensity of nature, such as the seemingly infinite array of stars in the night sky, the expanse of the ocean, or the power of a volcano. Unlike feelings of beauty, which are always pleasurable, the sublime may include a sense of fear or pain, as when we compare the enormity of nature with the inadequacy of our own existence. Although many associate sublime feelings with religious or spiritual experiences, Kant took a decidedly secular interpretation by referring to our aesthetic response to natural phenomena. With respect to art, he argued that artworks themselves cannot be sublime, but in representing magnificent objects or events, they can elicit sublime feelings.

Kant claimed that aesthetic judgments are completely dissociated from an object's function or purpose. A sunrise is not beautiful because it offers warmth nor is a woman in a painting beautiful because we desire to have amorous relations with her. Aesthetic responses are made in an entirely *disinterested* manner.

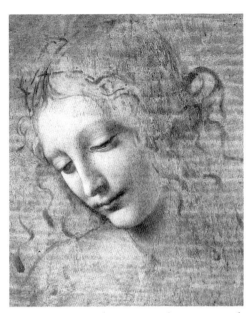

FIGURE 1.3 Leonardo da Vinci (1452–1519). Drawing depicting the Head of a Maiden. Photo: George Tatge, 2000. Galleria Nazionale, Parma, Italy. Photo Credit: Alinari / Art Resource, NY.

Leonardo's exquisite use of chiaroscuro, the face would look flat, like a simply drawn cartoon. His rendering of shading suggests a light source from above and to the left. With his subtle application of chiaroscuro, the sense of realistic depth is heightened. Leonardo's artistry demanded knowledge about the properties of reflected light and how such effects can be rendered onto a canvas. These days, computer programs can determine the properties of reflected light and help animators render characters and scenes with subtle shadings that look quite natural, as exemplified in digitally enhanced movies and video games.

Beauty and the Expressionist Approach

We sense beauty in many things—in nature, in people, in ideas, and in art. Our response to beauty is inherently an emotional one, such as the feeling you may have experienced while viewing Leonardo's drawing. Many feel that the primary purpose of art is to instill a sense of beauty in the beholder. In the eighteenth century, the philosopher Alexander Baumgarten coined the term *aesthetics* to describe his new investigation into the "art of thinking beautifully" (*ars pulchre cogitandi*). In his book *Aesthetica* (1750), Baumgarten argued that the appreciation of beauty is the endpoint of aesthetic experiences. He stated that aesthetics is that state of mind in the beholder as we experience beautiful things. An *expressionist* approach keys on the emotional qualities of artworks.

mathematical principles that define the geometry of representing spatial depths on a flat surface. It was Florentine artists during the fifteenth century, such as Brunelleschi, Alberti, Masaccio, and Leonardo da Vinci (henceforth referred to as Leonardo), who conceptualized the rules of linear perspective with both mathematical and artistic acumen. Consider Raphael's painting *School of Athens* (Figure 1.2), which depicts Plato and Aristotle strolling among students and scholars in this depiction of ancient academic life. The receding lines that define the walls of the great hallway give a strong sense of depth. The lines converge to a vanishing point located between Plato and Aristotle, thus accentuating the importance of these two figures. To paint such a realistic scene, Raphael needed to learn the geometry behind linear perspective and use it to create a 2-D image that mimicked what our eyes would see if we were looking onto the actual scene.

Another significant advance was the technique of *chiaroscuro*, which refers to the use of subtle shading to heighten the sensation of three dimensionality in objects (in Italian, *chiaro* means "light" and *oscuro* "dark"). In the real world, contoured surfaces reflect light in many directions, and those that reflect light more directly to the eye appear lighter, whereas those that do not appear darker. Thus, information about the shape and orientation of objects can be gleaned by accurate rendering of shading. Leonardo was a master of chiaroscuro as illustrated in the sketch of a woman's face in Figure 1.3. Note how the gradations of light and dark define the contours of the face and heighten the sense of depth (and beauty). Highlights on the nose, forehead, and chin, along with the darker shades on the woman's cheek and around the eyes accentuate contours. Without

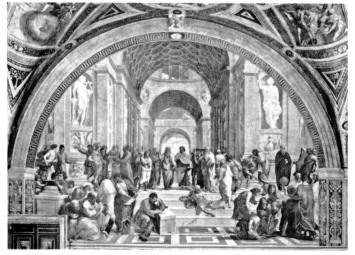

FIGURE 1.2 Raphael (Raffaello Sanzio) (1483–1520). *The School of Athens* (*c*. 1510–1512). Fresco. Stanza della Segnatura, Stanze di Raffaello, Vatican Palace, Vatican State. Photo Credit: Scala / Art Resource, NY.

mimicry). He denigrated art because it was an exceedingly poor imitation of reality. According to Plato's central philosophy of Idealism, there exists perfect or ideal forms. A draftsman can draw a circle or a carpenter can build a bed, but there is only one true form of a circle or bed, and such ideal forms cannot be realized by human hands. Thus, a carpenter's bed is merely a copy of the ideal form, and a painting of one is even worse, as it is a copy of a carpenter's bed, and indeed a rather poor one. It lacks the function of a bed and is depicted from only one viewpoint. As such, artists grossly under-characterize the nature and function of objects as their works are at best twice removed from ideal forms.

Plato advocated the banishment of all art from his idealized Republic. Poets and dramatists were just as far from the truth as the lowly painter as they imitated human experiences in fictional portrayals. Even worse, artists stir emotions, thus clouding our ability to think rationally. Plato argued that even great works of art, such as the epic poems of Homer, were to be banished from his utopian society. In essence, artists, according to Plato, are unworthy rivals of philosophers. They try to reveal truth but do so with poor descriptions of reality. Plato's negative view of art is extreme, yet his definition of art as mimesis—as an imitation or representation of the real world—could be applied to much of Western art.

As in many philosophical dilemmas, Aristotle offered a viewpoint diametrically opposed to Plato's position. In *The Poetics*, Aristotle acknowledged that art is a form of mimesis, but rather than condemning it as a perversion, he viewed art as a natural form of pleasure. We delight in listening to a poem or watching a good drama. Moreover, we can learn from art—from imitations of reality. A dramatic play may depict what could happen just as much as what has happened. We can learn from the mistakes and virtues of others, such as the hero in a tragic drama. Indeed, art depicts and rarifies essential universals of the human condition. For Aristotle, art should be valued, not vilified, as an imitation of reality.

Both Plato and Aristotle defined the nature of art as creating imitations of the real world, as if we are looking at a copy of reality. With respect to painting, the ability to do this proficiently requires extensive knowledge and skills, which were not fully developed until the Italian Renaissance. The critical problem is the depiction of a three-dimensional (3-D) world onto a two-dimensional (2-D) surface. Interestingly, we perform this feat virtually every waking moment, as vision begins with light projected onto our retina, that 2-D sheet of neurons at the back of our eyes. Our brains transform this ever changing upside-down and mirror-reversed image into a spatial world with fine rendering of depth and shading. Similarly, a painter interested in creating realistic scenes must acquire technical skills in creating the illusion of the canvas as a window to the world.

Before the Renaissance, artists had acquired some of technical skills of painting, such as how to apply shading and foreshortening to create the impression of depth. Yet they had a limited understanding of *linear perspective,* the

philosophers and art critics consider terms such as *aesthetics* and *beauty* to be outdated and irrelevant to the way we experience art today.[3] These days art can evoke a variety of emotions, such as sadness, anger, surprise, and even disgust. It can corral our sensory experience through artistic balance and form. It may even deny emotions altogether and make us *think*—such as when it reminds us of our cultural background or forces us to think about the world in a different way. By this view, art offers a wonderful opportunity to gain from our senses, learn new things, and become emotionally engaged.

In all likelihood, the artwork hanging on your wall exemplifies what you like to see, know, and feel. Such things give us pleasure, as do many activities, such as listening to music, reading novels, and watching movies. We *experience* art, and this book considers what goes on in our mind and brain as we do so. We will refrain from discussions about the artist's creative experience and thus sidestep such thorny questions as what drives one to make art or what role art plays in society and human evolution. To address such questions adequately, we would need to delve deeply into a variety of intellectual domains, such as sociology, art history, evolutionary biology, and cultural anthropology.[4] The primary focus here will be the ways in which we appreciate art, particularly painting and photography, as different art forms have their own sensual properties, and I'm particularly interested in the way these art forms drive aesthetic experiences. In this way, the goal will be to analyze the psychological processes and corresponding brain mechanisms that are in play when we experience art. Although we will focus on the visual arts, much of what will be discussed pertains to other art forms, including music, film, theater, dance, and literature.

■ Philosophical Approaches to Art

When we encounter a painting at a gallery, we do so with certain expectations. We assume that a person, namely an artist, produced it and did so for the purpose of instilling an "art" experience in the beholder. We, as the beholder, experience the artwork and make an evaluation based on the sensations, thoughts, and emotions evoked by it (i.e., we elicit a hedonic response). Philosophers over the centuries have considered the ways in which we evaluate art.[5] Of course, the very concept of art has evolved over the centuries and the way we behold art has changed with it. Here we consider four general approaches to art: mimetic, expressionist, formalist, and conceptual approaches.

The Mimetic Approach: Viewing a Window to the World

As early as the fifth century BC, philosophers, such as Plato and Aristotle, considered the meaning of art and its role in society. In the *Republic*, Plato described art as an imitation of reality or what he termed *mimesis* (Greek for imitation or

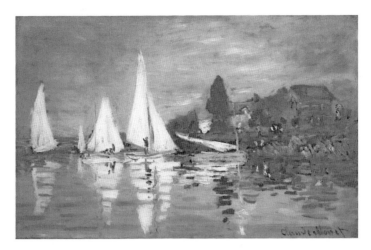

FIGURE 1.1 Monet, Claude (1840–1926). *Regatta at Argenteuil* (*c.*1872). Musee d'Orsay, Paris, France. Photo Credit: Erich Lessing / Art Resource, NY. (See color plate section.) (See also note 1.)

find it hard to appreciate or comprehend, as an entirely novel piece may not be easily incorporated into our knowledge base. Indeed, it is not uncommon to overhear a visitor at a contemporary art museum snicker and say to another, "Is that art?" Changes in aesthetic appreciation over time—within a culture and within ourselves—force us to consider the importance of knowledge when we experience art. We all agree that our senses and emotions are engaged when we look at art, but we do not readily appreciate the prominent role that knowledge plays in this experience.

What exactly is aesthetics? Is it that overwhelming, almost spiritual sense of perfection that we experience perhaps while viewing Michelangelo's *David* or listening to a Beethoven string quartet? Such "wow" moments may be considered the epitome of an aesthetic response, yet if they were the one and only kind of aesthetic experience, most of us would be waiting months if not years between them. Our experience with art is much more than these occasional moments. When we visit an art museum or simply appreciate an image in a newspaper or on the web, we do so to stimulate our senses, stir our emotions, or make us think in new ways. Put very simply, we invite an aesthetic experience whenever we encounter something of interest or pleasure.

Philosophers, psychologists, and recently neuroscientists have thought deeply about the nature of aesthetics, and a worthy review of such endeavors would take volumes to summarize.[2] For our purposes, we will consider aesthetics as an *hedonic* response, which is simply a judgment of preference or interest. When we look at art, we elicit such a response as when we say, "I like it," "Very interesting," or "I don't get it." Such responses can be graded from very positive to very negative or from very interesting to very dull. Given this definition, art does more for us than merely evoke that "wow" feeling. In fact, many

1. OVERTURE

■ "That would look nice on my wall …"

Why do we adorn our walls with such things as paintings, photographs, and posters? What determines our choice of such *artworks*? For many years, in numerous college apartments and beyond, I had a poster of Claude Monet's *Regatta at Argenteuil* (Figure 1.1) hanging on my wall. For me, the painting embodied the essence of aesthetic beauty. I loved the scenery, its colors, and particularly Monet's brushwork. Those splotches of paint, when placed within the context of the scene, rendered the impression of the water's reflection, though in the real world we would never see water in such a manner.

Many people resonate with Impressionism, as evidenced by the crowds who flock to the Musée D'Orsay in Paris to see some of the best recognized paintings within this genre, including *Regatta at Argenteuil*. But it wasn't always that way. The cadre of painters who initiated Impressionism, such as Monet, Édouard Manet, and Pierre-Auguste Renoir, were scorned and ridiculed during their day. Their paintings were considered unworthy by the *Académie des Beaux-Arts* (*Academy of Fine Arts*), the organization that controlled the French art scene during the nineteenth century. Critics at the time described their work as crude, unfinished, and lacking skill.[1] Indeed, many purported that these paintings could hardly be called art. Now, in the same paintings, we see beauty, grace, and harmony. What's changed?

We must experience art within the realm of our cultural and personal knowledge. To a large extent, what we know determines what we like. In the eyes of nineteenth century beholders, Impressionism was a radical departure from the paintings that were coveted by the established art community. Yet in the span of 150 years, a once-ostracized style is now considered by many as the epitome of visual aesthetics. These days, we may encounter a new artwork and

1

Morton College Library Cicero, ILL

EXPERIENCING
ART

ACKNOWLEDGMENTS

I would like to express my gratitude to the many students, friends, and colleagues who have spent time chatting with me about art, mind, and brain. I have learned a great deal from these discussions and would especially like to thank Silvia Bunge, Noël Carroll, Anjan Chatterjee, Eliot Deutsch, Helen Ettlinger, Blake Gopnik, Julian Hochberg, Rich Ivry, Jerry Levinson, Paul Locher, Jerry Mendelsohn, John Onians, Steve Palmer, Mary Petersen, Bill Prinzmetal, Michael Roush, John Shaw, Gregory Shimamura, Thomas Shimamura, David Whitney, and Lesile Zemsky. Special thanks go to Helen Ettlinger, Gregory Shimamura, and the students of my Psychology of Art course who read and provided comments on earlier drafts, and to the John Simon Guggenheim Foundation for providing financial support. Finally, I would like to thank Catharine Carlin, Joan Bossert, and the production staff at Oxford University Press for helping this project along to its publication.

books have appeared that consider the biological underpinnings of artistic expression and appreciation. In this intellectual atmosphere, I received a fellowship in 2008 from the John Simon Guggenheim Memorial Foundation to explore my own perspective on the links between art and the brain. Most of this book was written during my tenure as a Guggenheim fellow, and I am most grateful to the Foundation for providing resources for this exploration. What follows is a personal account of the ways we experience art.

especially on the works of Edward Weston and his son Brett. Indeed, I realized that my own photographic style was in many ways from the "school of Edward Weston."

During my career as a scientist, I have had the opportunity to explore the workings of the human brain with a wonderful group of students and colleagues at the University of California, Berkeley, and previously at the University of California, San Diego. My investigations of patients with brain injury, and more recently my foray into brain imaging, have led me to insights concerning the nature of perception, memory, and even emotion. My job also affords the opportunity to learn through teaching. At UC Berkeley, professors can teach "Freshman Seminars," which are small courses covering a topic of the professor's choosing. For the past twelve years, I have taught a seminar on the "Psychology of Art." The course considers aesthetics from a psychological perspective. In preparation for the course, I was strongly influenced by Robert L. Solso's extraordinary book *Cognition and the Visual Arts*. Bob was a friend and colleague, and his death in 2005 has prevented me from personally thanking him for his impact on my own explorations in the psychology of art.

One serendipitous encounter led to a merging of my interests in brain, photography, and art history. While preparing for a family vacation to Yosemite National Park, I read a book about its history and encountered tales of nineteenth century photographers, such as Carleton Watkins and Eadweard Muybridge. These pioneers in photography trekked to Yosemite Valley with bulky cameras and brought back stunning images of the Western landscape. As a melodramatic aside, the book mentioned Muybridge's sordid biography, which included the murder of his wife's lover after discovering that the baby his wife bore was likely not his. What interested me was that Muybridge entered a plea of innocence by reason of insanity, which his lawyers argued resulted from a severe head injury that he sustained after a stagecoach accident. When I read that passage, it reminded me of neurological patients who suffered head injury from severe car accidents. Such injuries damage a part of the brain called the orbitofrontal cortex and the result is emotional instability. Muybridge's disposition included inappropriate outbursts, social improprieties, and obsessive-compulsive behavior, all of which are consistent with damage to the orbitofrontal cortex. This intriguing link led me to investigate in greater detail Muybridge's trial proceedings through court documents and newspaper articles. As Muybridge resided in San Francisco, I was able to explore the biography of a local and international celebrity. With this information in hand, I wrote an article that was published in the journal *History of Photography*, suggesting that orbitofrontal damage could have contributed in part to Muybridge's life events.

The link between art and brain has received considerable airplay in recent years. Since 2002, the noted neuroscientist Semir Zeki has organized an annual conference on "Neuroaesthetics," which brings together scientists, artists, historians, and philosophers interested in art and brain. Other conferences and

PREFACE

Spit straight up, learn something. I once heard Robert Haas, the former U. S. Poet Laureate, recite this Vietnamese saying, which came to mind as I considered seemingly straightforward questions about art and aesthetics: What happens when we experience a work of art? Can we agree on great art or is there no accounting for taste? What aspects of sensations, emotions, and knowledge influence our aesthetic experiences? Philosophers, historians, scientists, and artists have sought answers to these questions, with each perspective offering important clues. My goal in writing this book was to explore these questions by considering what we do when we experience art.

Part of my interest stems from my own explorations in photography. When I was a teenager my father bought me a Nikon camera and several lenses. I enrolled in a photography course in high school, and during my senior year I landed a job at a camera store. As might be expected, I put most of my earnings back into the cash register. I built a small darkroom in our spare bathroom and reveled in the art of black-and-white photography. This venture sparked an interest in art history, and in college I took an introductory course and even started a mail-order subscription to the *Time-Life* book series on artists (a few might remember those days before *Amazon.com*). Every month or so, I would receive a book about a particular artist. The first one featured Vincent van Gogh, and I remember savoring that book from cover to cover. I still have those books, though I don't recall reading any of the others with such zeal.

During the remainder of my college years, through graduate school, and, ultimately, as I entered an enveloping career as a scientist, my interest in photography and art diminished to snapshots during family vacations and the occasional visit to an art museum. Be it midlife crisis or otherwise, I renewed my interest in creative photography. I purchased a new camera (just prior to the digital revolution) and treated myself to photography workshops during summer vacations. I also became interested in the history of photography, focusing

CONTENTS

To my family—Helen, Thomas, and Gregory—always my inspiration, compatriots, and provocateurs

OXFORD
UNIVERSITY PRESS

Oxford University Press is a department of the University of Oxford.
It furthers the University's objective of excellence in research, scholarship,
and education by publishing worldwide.

Oxford New York
Auckland Cape Town Dar es Salaam Hong Kong Karachi
Kuala Lumpur Madrid Melbourne Mexico City Nairobi
New Delhi Shanghai Taipei Toronto

With offices in
Argentina Austria Brazil Chile Czech Republic France Greece
Guatemala Hungary Italy Japan Poland Portugal Singapore
South Korea Switzerland Thailand Turkey Ukraine Vietnam

Oxford is a registered trademark of Oxford University Press in the UK and certain other
countries.

Published in the United States of America by
Oxford University Press
198 Madison Avenue, New York, NY 10016

© Oxford University Press 2013

All rights reserved. No part of this publication may be reproduced, stored in a
retrieval system, or transmitted, in any form or by any means, without the prior
permission in writing of Oxford University Press, or as expressly permitted by law,
by license, or under terms agreed with the appropriate reproduction rights organization.
Inquiries concerning reproduction outside the scope of the above should be sent to the
Rights Department, Oxford University Press, at the address above.

You must not circulate this work in any other form
and you must impose this same condition on any acquirer.

Library of Congress Cataloging-in-Publication Data
Shimamura, Arthur P.
Experiencing art : in the brain of the beholder / Arthur P. Shimamura.
 p. cm.
Includes bibliographical references and index.
ISBN 978–0–19–993693–9—ISBN 978–0–19–993694–6—ISBN 978–0–19–998238–7
1. Art and society. 2. Art—Psychology. 3. Visual perception.
4. Aesthetics—Psychological aspects. I. Title.
N72.S6S463 2013
701'.15—dc23
2012034353

9 8 7 6 5 4 3 2 1
Printed in the United States of America
on acid-free paper

EXPERIENCING ART

IN THE BRAIN OF THE BEHOLDER

ARTHUR P. SHIMAMURA

OXFORD
UNIVERSITY PRESS

EXPERIENCING
ART